HENRY MOORE

D1319230

Royal Academy of Arts, London
16 September – 11 December 1988

Sponsored by
Salomon Brothers
and
The Henry Moore Foundation

The Royal Academy of Arts is also grateful to
Her Majesty's Government for agreeing to indemnify
the exhibition under the National Heritage Act 1980
and to the Museums and Galleries Commission for
their help in arranging this indemnity

HENRY MOORE

Susan Compton

with contributions by
Richard Cork and Peter Fuller

Royal Academy of Arts, London, 1988

Catalogue published in association with

Weidenfeld and Nicolson, London

Executive Committee

Roger de Grey, *President of the Royal Academy* (Chairman)
Sir Philip Powell, *Treasurer of the Royal Academy*
Piers Rodgers, *Secretary of the Royal Academy*
Norman Rosenthal, *Exhibitions Secretary*
John Pigott, *Financial Comptroller*
Griselda Kerr, *Trust Officer*
Bernard Meadows, *The Henry Moore Foundation*
Charles McVeigh, *Salomon Brothers International Limited*

Secretary to the Committee: Annette Bradshaw

Advisory Committee

Sir Alan Bowness
Susan Compton
Roger de Grey (Chairman)
Margaret McLeod
Bernard Meadows
Piers Rodgers
Norman Rosenthal
Alan Wilkinson

Exhibition Coordinator: Susan Compton
Exhibition Assistant: Julie Summers

Cover illustration: *Madonna and Child*, from the
Church of St Matthew, Northampton

Copyright © Royal Academy of Arts 1988

The copyright in all works by Henry Moore
reproduced in this Catalogue is owned by
The Henry Moore Foundation

House Editor: Emma Way
Designed by Bridgewater Design Limited
for George Weidenfeld and Nicolson Limited
91 Clapham High Street, London SW4 7TA

Phototypeset by Keyspools Ltd, Golborne, Lancs
Colour separations by Newsele Litho Ltd
Printed in Italy by Printers Srl, Trento
Bound by L.E.G.O., Vicenza

British Library Cataloguing in Publication Data

Compton, Susan
 Henry Moore.
 1. English visual arts. Moore, Henry,
 1898–1986. Catalogues
 I. Title II. Moore, Henry, *1898–1986*
 III. Royal Academy of Arts
 709′ .2′4

ISBN 0–297–79303–9
ISBN 0–297–79304–7 Pbk

CONTENTS

SPONSORS' PREFACES

This exhibition, which resulted from conversations about four years ago between the then President of the Royal Academy, Sir Hugh Casson, and Henry Moore, was intended to be in celebration of the artist's ninetieth birthday and of almost seventy years of work as a sculptor. Unhappily, two years after those conversations and with work on organising the exhibition hardly begun, Henry Moore died and it has become a memorial to the man and his work.

Although his strong preference was for his work to be seen in the open, and in close contact with nature, it will be evident that many of these works – relatively small – could not be shown in this way. Hence he was attracted to the idea of the Galleries at Burlington House, among the best for showing sculpture in the United Kingdom.

Some of the works we should have liked to show have not been available for a variety of reasons, nevertheless the collection now on view is a comprehensive one and offers many proofs of the artist's extraordinary power of invention.

Our thanks, and that of the general public, must go to the President of the Royal Academy and his staff for making this exhibition possible, and above all to the generous help of our co-sponsors, Salomon Brothers International Limited, without whose support, and that of similar benefactors, exhibitions on this scale would become a rarity.

Arnold Goodman
Chairman
The Henry Moore Foundation

Salomon Brothers is honoured to join the Royal Academy of Arts in presenting 'Henry Moore', the definitive exhibition of the work of this world-famous sculptor.

This exhibition and catalogue offer the public an opportunity to see and enjoy the works of the most important British sculptor of the twentieth century. They will also form the reference point for world focus and appreciation of the genius and vision of Henry Moore for many years to come.

We extend our sincere thanks to Professor Bernard Meadows and to Henry Moore's other friends and contemporaries who have contributed greatly towards the preparation of this exhibition. We also want to express our gratitude to The Henry Moore Foundation whose generosity and co-operation throughout the organisation of this project have been extraordinary.

This is a very special exhibition and Salomon Brothers is proud to play a role in its presentation.

John H. Gutfreund
Chairman and Chief Executive Officer
Salomon Brothers Inc.

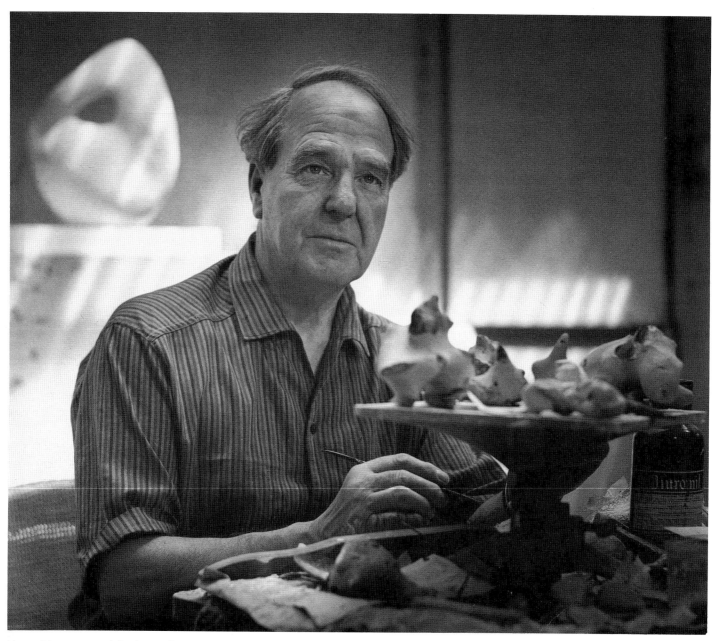

Henry Moore at work in the studio at home in Hertfordshire.

FOREWORD

Although Henry Moore was never a Member of the Academy – and at times during his life out of sympathy with it – when the then President, Sir Hugh Casson, put to him the idea of holding a great exhibition here to mark his ninetieth birthday, many of the assumed differences seemed to fall away. Indeed, he looked forward to seeing his work in the spacious galleries of Burlington House, where he had taken so much pleasure from exhibitions of Turner and of Nigerian sculpture, amongst others. Already his concern for the work being done in our sculpture school, expressed through grants from the Henry Moore Foundation, seemed to have gone some way towards healing the rift that for historical reasons had been an impediment to his membership of the Royal Academy. His collaboration with us was wholehearted and he transmitted this enthusiasm to the Foundation: hence our efforts combined to secure loans of the greatest of his works for this exhibition. For me, once a student at the Chelsea College of Art when Henry Moore was the admired and distinguished Head of Sculpture, it has been an honour to be able to make at least some contribution to this exhibition.

The selection of sculpture has been made from the list drawn up by Bernard Meadows, who has made a personal choice from his unique knowledge of the artist's work, gained over many years, first as Moore's friend and assistant and in recent years, as Acting Director of the Henry Moore Foundation. Professor Meadows's guidance has been invaluable and his intimate knowledge has resulted in the inclusion of many unique pieces. The selector of the drawings, Alan Wilkinson, also worked with the help of the artist, first as a student, then on the occasion of the donation of the Moore collection to the Art Gallery of Ontario and the major travelling exhibition of drawings that was shown in London at the Tate Gallery in 1978. Dr Wilkinson is well qualified for the difficult task of choosing from a vast oeuvre, for he has devoted more time to the study of the drawings than any scholar in the field; his publications have provided a basis without which the present catalogue could not have been written.

I would like, of course, to extend warm thanks to the many museums and private lenders who have so readily helped us with loans. If one may be singled out for mention, we owe especial thanks to Canon Morton, his Parochial Church Council and the Peterborough Diocesan Advisory Committee for their generosity in fulfilling the artist's wish that the Madonna and Child from St Matthew's, Northampton, should be shown at the Royal Academy.

The presentation of sculpture calls for great sensitivity and we have been fortunate in having, in Ivor Heal, a designer who himself trained as a sculptor. It is inevitable also that the transport and installation of such an exhibition should be relatively costly and we are most indebted to our sponsors, Salomon Brothers and the Henry Moore Foundation, who have shown a rare understanding of the problems involved; we have indeed drawn widely upon the Foundation's experience and benefited from the whole-hearted co-operation of its staff.

I must conclude by saying that this exhibition could not have been assembled without the scholarship and insight of Dr Susan Compton, who has worked with the staff of the Royal Academy to produce an exhibition and catalogue remarkable in their breadth and detail.

Roger de Grey
President
Royal Academy of Arts

ACKNOWLEDGEMENTS

We would like to thank the following who have contributed in so many different ways to the organisation of the exhibition and the preparation of the catalogue.

Joachim Büchner

Peter Burman

Giovanni Carandente

Frances Carey

Amanda Carrara

Maria Dawson

Ann Elliott

John Farnham

Jane Farrington

David Finn

Terry Friedman

Patrick Gaynor

Elaine Howard

Katherine Jarvis

Jeffrey Loria

Philip Miles

Magdalena Müller

Michel Muller

Jonathan Roberts

Alex Saunderson

Don Schooling

Lisa Spiro

Jackie Storey

Betty Tinsley

Paul Vogt

Alan Webster

Christina Wilton

Malcolm Woodward

PHOTOGRAPHIC ACKNOWLEDGEMENTS

The exhibition organisers would like to thank the following for making photographs available. All other photographs were kindly provided by the owners of the works.

James Austin, MA FBIPP cat. 26, 96, 148

Malcolm Crowthers colour cat. 102

Prudence Cuming cat. 31, 42, 58, 98, 165; colour cat. 85

M. R. Dudley cat. 163

John Hedgecoe fig. 19

The Henry Moore Foundation cat. 2, 3, 4, 5, 7, 11, 14, 15, 19, 21, 24, 32, 35, 37, 38, 54, 61, 63, 68, 84, 90, 91, 93, 94, 97, 99, 102, 103, 104, 105, 109, 110, 111, 112, 115, 116, 117, 122, 123, 124, 133, 134, 136, 138, 140, 145, 146, 150, 151, 152, 167, 170, 177, 178, 179, 184, 185, 187, 196; figs 1, 2, 3, 4, 6, 7, 8, 10, 11, 11a, 11b, 12, 13, 17, 18, 20, 23, 24a, 24b, 25; colour cat. 2, 7, 8, 10, 12, 14, 15, 17, 19, 20, 30, 33, 63, 110, 119, 121, 122, 126, 140, 141, 145, 157, 177, 179, 180, 185, 187; duotone cat. 27, 135

Errol Jackson cat. 2, 8, 33, 135, 180; fig. 21

Peter Jenkins, Lowestoft cat. 106

Larkfield Photography cat. 118

Leeds City Art Galleries, The Henry Moore Centre for the Study of Sculpture; presented by Lady Hendy fig. 14

J. S. Lewinski portrait, p. 8

Lee Miller Archives, 1985 cat. 41

Michel Muller cat. 10, 12, 30, 45, 46, 48, 51, 54–6, 61, 68, 72, 73, 81, 82, 86–8, 92, 98, 149, 150, 154, 155, 157, 159, 164, 173–5, 202, 205, 207–9, 212–39; figs 15, 16; colour cat. 3, 93, 176

The National Gallery, London fig. 5

Photos NBC S.A. cat. 87

Royal Academy of Arts fig. 22

Barnet Saidman for News Chronicle fig. 9

Julie Summers colour cat. 146

Neville Taylor cat. 167

EDITORIAL NOTE

The author is indebted to Dr Alan Wilkinson, who selected the drawings and generously made available all his published works from which extensive quotations have been made; and also to Roger Berthoud, whose *The Life of Henry Moore* has been a valuable resource. David Mitchinson has been unstinting in his support and help. Practical assistance has been given unsparingly by Jean Askwith and Ann Garrould and also by Christina Wilton; the patience of the publisher's editor, Emma Way, has been invaluable.

Works cited in this book are identified by the appropriate prefix, LH, CGM, or HMF, with its number taken from the three sections of the catalogue raisonné of which publication details are given in the bibliography.

SCULPTURE is catalogued in six published volumes by Lund Humphries, giving to all sculptures the prefix LH.

GRAPHIC WORK is catalogued in four published volumes edited by Cramer, Grant and Mitchinson and all types of prints are prefixed CGM.

An unpublished index of DRAWINGS is held at the Henry Moore Foundation. This gives the prefix HMF to drawings ; these were numbered consecutively from 1921 to 1973, when the artist adopted a new system, indicating the year plus the number of drawing within each year, e.g. HMF 80(31).

Most bronzes exist in several casts; details of editions may be found in Lund Humphries. The patina of casts varies in colour and was sometimes deliberately changed by the artist, thus the colour shown in The Plates may vary from that of the bronze cast on view. Sculptures given by the artist to the Tate Gallery were photographed at Much Hadham prior to 1978; the outstanding views of *Standing Figure* (cat. 122) and *King and Queen* (cat. 126) are the casts on an estate in Dumfries.

Susan Compton

HENRY MOORE: AN INTRODUCTION

The work assembled at the Royal Academy represents all the stages in the life's work of England's most notable sculptor. Moore is famed today for his large bronzes which are to be found in public places in the major cities of the world: here we can provide a more complete display of his work. Sculptures in many styles and a great variety of materials, intimate as well as monumental, give the opportunity to appreciate the many facets of his creative genius. There are half-length figures in primitive style, carved stones conveying an almost primeval force, cast heads of unique vision, warriors, a king and queen, subjects as contrasting as the Crucifixion, the Madonna and Child and Nuclear Energy. The range is extended by drawings for which Henry Moore has always been appreciated and admired.

The arrangement of the sculpture breaks with precedent, for it has been more usual to set it out by theme. Here it is explored as a chronological progression, though certain types of work have been grouped together within the decades, so that, for example, a group of maquettes relating to a single commission can be studied together. The patterns which thus emerge show the different ways that Moore approached his preferred subject – the human figure, standing, seated or reclining – at different times of his life. The drawings are concentrated into three groups: those made from 1921 to 1940, work done as an Official War Artist and afterwards until 1961, and late drawings from 1970–83. There was nearly a decade when Moore made very few drawings, so the three groups are placed at suitable intervals between the sculpture. As well as showing the fecundity of his sculptural ideas, these drawings often reveal a different side of Moore's creative powers. For instance, the early drawings from life provide evidence of his faithful study of women and the rural themes of his last years show his abiding love of the countryside.

Some of the work is widely known – pierced reclining figures, two- and three-piece reclining sculptures, Shelter drawings, Sheep drawings; some will be unfamiliar to all but cognoscenti – masks, rocking chairs, drawings of miners and of mythical figures. Some have not been seen in London for many years – the half-length figure from Tel Aviv, the early

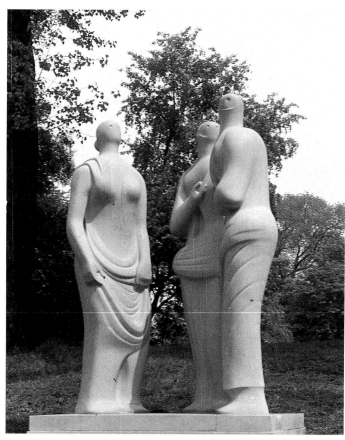

Three Standing Figures, 1947–8, Darley Dale stone, each H.84 in., Battersea Park, London, Gift of the Contemporary Art Society.

elmwood *Reclining Figure* from Buffalo N.Y., carvings from the Museum of Modern Art in New York and the Philadelphia Museum of Art, an important sketchbook page from the Albertina in Vienna. Others make a first appearance in London – the late carving, *Working Model for Animal Form* – and, most notable because never moved since its installation in 1944, the *Madonna and Child* from St Matthew's, Northampton.

The representation of Moore's work would not have been complete without acknowledgement of the many public works which the artist made from 1928 onwards. The

resulting sculptures can only be included in an exhibition in the form of drawings or maquettes and working models, so Richard Cork has devoted his essay to works made for public places. His title 'An Art of the Open Air' is a reminder that, from the fifties onwards, Moore insisted that sculpture is an art of the out-of-doors, facilitated no doubt by the open-air exhibitions organised in Battersea Park, where a major carving remains as a permanent reminder (p.12). Moore's view might be taken as an impediment to a major exhibition held exclusively indoors, but the small size of much of the pre-War work and some of the materials used positively require conditions that can only be provided in a controlled environment.

In his long life, Moore spoke and wrote about his work in an informative and compelling way and this is reflected in the many quotations of his words in the texts. Furthermore, though he often kept the sources of his art to himself, when scholars found them he appears to have enjoyed their discoveries. Any new interpretations put forward here are therefore offered with a profound respect for his memory and in the hope that they may add to the appreciation of the inventiveness of one of the great artists of this century.

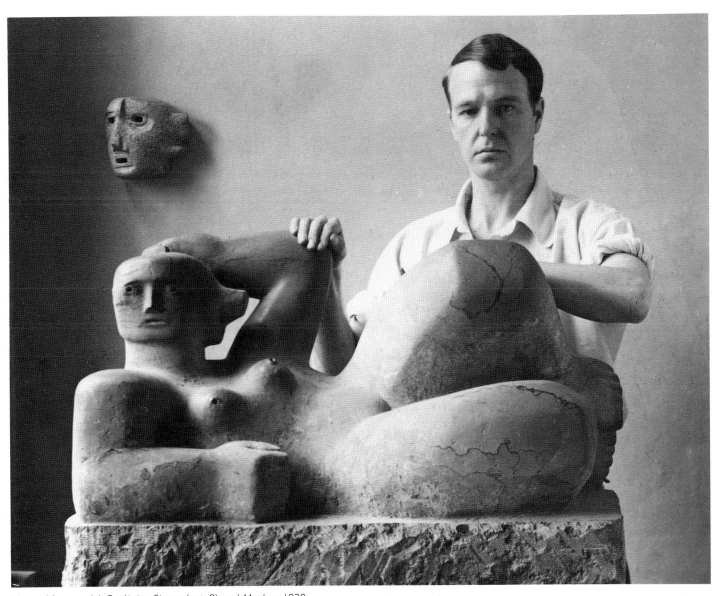

Henry Moore with *Reclining Figure* (cat. 9) and *Mask*, c.1930.

AN ART OF THE OPEN AIR:
MOORE'S MAJOR
PUBLIC SCULPTURE

RICHARD CORK

It is impossible to imagine a sculptor of Henry Moore's robust and expansive inclinations remaining content with work fit for drawing-rooms and galleries alone. 'In its great periods sculpture has been an outdoor art',[1] he once declared; and as soon as invitations provided him with congenial opportunities, he became eager to make work specifically for a remarkable variety of exterior locations. Here, whether in the calm of sequestered rural settings or the most frenetic metropolitan centres, his forms could unfold beyond a domestic scale and realise their full plastic potential. Anyone fortunate enough to have seen Moore's sculpture inhabiting a place as felicitous as the grounds of Dartington Hall, where the elegiac *Memorial Figure* (LH 262, fig. I) has presided since 1946, will appreciate how much his images can gain from installation in sites which enhance their meaning. 'Sculpture is an art of the open air',[2] Moore insisted in 1951, as if to acknowledge that the finest exterior spaces furnished his work with a resonance which museums could never provide.

All the same, he remained wary throughout his life of proposals that threatened to hamper the true expression of his inner vision. Indeed, he preferred to avoid commissions in the usual understanding of the word. When invited to make a sculpture, Moore normally did not enter into any formal agreement for a specific piece. If he liked the project, he would give it his assent with no firm commitment on either side. The considerable hostility aroused by Moore's early work, which forced his resignation from a teaching post at the Royal College of Art in 1931,[3] made him even more determined to defend the imperatives of his singular imagination against any attempt to compromise them. Carving in the privacy of his studio as a young man, Moore had been able to establish a tough-minded identity without interference from anybody seeking to lay down rules about the suitability of his work for public consumption. So he was understandably reluctant to accept invitations which might impede or dilute the resolute direction he wanted to pursue, and pointed out in a 1952 address that 'the difficulty that might cause the modern artist some trouble is due to the shift, at a moment's

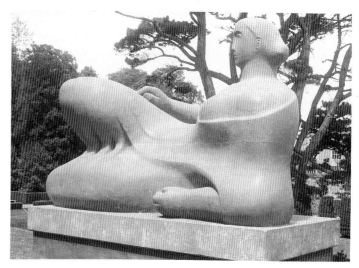

Fig. I. *Memorial Figure*, 1945–6, L. 56 in., Hornton stone in the grounds of Dartington Hall, Devon.

notice, from the freedom of creation which he enjoys as an individual working for the open market of private patrons to the restrictions imposed on him when he accepts a public commission. It is usually assumed that if sufficient commissions were forthcoming from public authorities, all would be well with the arts. It is an assumption that takes no account of the fact that the tradition of modern art is an individualistic one.'[4] By the time he delivered this warning, however, Moore could also look back on a succession of invitations for which he had good reason to feel thankful. Far from impeding his development, they had stimulated and extended it in a whole range of fruitful ways. Indeed, he added in the same address that although the works he had carried out on request led him 'to adapt my conception to the function of the particular piece of sculpture', they were all produced 'without any surrender of what I would regard as my personal style.'[5]

Long before he had any conception of such a 'style', a well-timed approach from his art teacher at secondary school in Castleford prompted him to make, in 1917, what he after-

wards described as 'the first serious wood carving I did.'[6] It was a *Roll of Honour* for the old students who had joined the armed forces during the First World War, and in later life he could still 'vividly remember the pleasure I felt when I first used a hammer and chisel'[7] to cut into the large oak panel. Before then his carving activities had been carried out with a penknife, but wielding the tools provided for the war memorial project helped to reinforce his awareness that 'I like carving as a physical occupation, better than modelling.'[8] Although the *Roll of Honour* can hardly be considered a significant work of art, it therefore played a vital role in encouraging Moore to settle on his future course as an artist.

It did not, however, make him any more willing to welcome his next invitation eleven years later. Having just established his reputation as an emergent sculptor with a loudly praised and vilified one-man *début* at the Warren Gallery, he felt confident enough to demur when the architect Charles Holden first invited him to carve a flying figure in relief of the West Wind for the London Underground Railway's massive new headquarters in Westminster. It was a considerable honour for a young man: Holden's austere building boasted an elaborate scheme of carvings by seven sculptors, Eric Gill and Jacob Epstein the most prominent among them.[9] Moore probably owed his invitation to Epstein, for the older man had already taken an avuncular interest in his progress. But this gratifying support did not prevent Moore from balking at the whole notion of making a relief sculpture, which 'symbolised for me the humiliating subservience of the sculptor to the architect.'[10] Moore's deepest obsessions always led him to invest sculpture with great volumetric richness, and Holden's decision to place the flying 'wind' figures at seventh-floor level meant that they could not be seen properly from the street. Nevertheless, the architect proved persuasive. 'He talked to me like a father', Moore remembered, 'and he was very nice to me. He said: "You're just frightened of doing a carving bigger than anything you've done before." So I had to accept the challenge.'[11]

Moore's acceptance must have been influenced by his respect for Holden's long-standing championship of Epstein,[12] who produced the two most visible carvings over the building's doorways, and for the architect's categorical insistence that 'the figures were to be carved direct in the stone . . . to preserve all the virility and adventure brought into play with every cut of the chisel.'[13] Holden's convictions about sculpture accorded well with Moore's, whose sketchbook for the project testifies to the energy and excitement he thereafter gave the project. Drawings, such as cat. 59, 60, show him exploring an abundance of possibilities, from naked

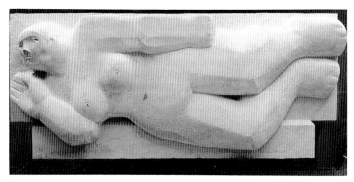

Fig. 2. *West Wind*, 1928, L. 96 in., Portland stone, for the London Underground Railway Headquarters.

stasis to heavily-draped flight, and at one point he wrote himself a reminder to 'make architectural experiments.'[14] Moore's keen awareness of the context his work would inhabit helped to ensure that the final carving is the most impressive of the 'four winds' figures on the seventh floor. Unlike Gill, who supplied his two skilful reliefs with a surprising amount of anatomical detail, Moore produced an image as severe as the megalithic building he embellished. There is nothing playful about this primordial woman, whose left arm extends in a taut horizontal line to chime with the top of the headquarters' wing above. She is a stern embodiment of elemental power, wholly capable of administering the formidable forces at her disposal. The *gravitas* with which Moore endowed his carving shows how determined he was to produce something more than a decorative caprice for an architect. Despite the frustration involved in tackling such a difficult site, he later came to feel that it had provided 'valuable experience'.[15] The venture did, after all, enable him to work on a far larger scale than anything he had tackled before, and the monumentality of form achieved in *West Wind* (LH 58, fig. 2), would remain central to his mature development. Moreover, the proliferation of reclining figures in the sketchbook for the relief testifies to the moment when this particular motif first gained its extraordinary hold over Moore's imagination. Within a year, the new confidence he had gained during the Underground Railway period flowered into the resounding authority of the Leeds *Reclining Figure* (cat. 9), by far the finest carving he produced during the 1920s.

Although Moore received a certain amount of critical abuse for his contribution to the building,[16] most of the obloquy descended on Epstein. He had by then become an automatic butt for the journalists, and their vilification was further envenomed by vandalism when hooligans bombarded his work with glass containers full of liquid tar and feathers. Shareholders' protests then led the directors of the Underground board to make Epstein climb up to one of the carvings

and shorten the boy's penis by an inch and a half.[17] Worse still, Holden found that his subsequent appointment to design London University's new buildings was granted only on the absolute understanding that Epstein would have nothing to do with them. To his credit, Holden persisted in his commitment to modern sculpture by inviting Moore to make eight seated figures, each on a separate stone, for the façade of the Senate House. In 1938 Moore duly carried out some drawings of women holding books for the project, the most elaborate of which contains a figure with drapery (cat. 95) that anticipates the handling of the Northampton *Madonna*'s dress five years later. But then, at a fairly advanced stage in the proceedings, he found himself unable to continue. His old antipathy towards relief sculpture, combined with the fact that the carvings would be about sixty feet above the ground, set him against the plan. 'I couldn't sustain any excitement about it', he explained in retrospect. 'I was trying at this time to achieve form in the round making figures which occupied real space, and I preferred to forego the commission rather than work for a long time on a kind of sculpture that went against the grain . . . The architect said he would go ahead and put up the stones in case I altered my mind. The eight stones cut to the proportions of my drawings are there high up on the Senate House but they remain blank to this day.'[18]

Another reason for the abandonment of the university project may well be found in a proposal he received, the very same year, for a large outdoor carving. The invitation came, once again, from an architect. But this time he belonged to Moore's own generation, and Serge Chermayeff had no intention of obliging the sculptor to attach a relief to his building at an unpropitious height. He asked Moore if a work might be made for the grounds of 'Bentley Wood', a house he was building for himself near Halland in Sussex. The place Chermayeff had in mind was located 'at the intersection of terrace and garden',[19] where he thought a standing figure might be installed. But Moore, after visiting the site, thought that the low-lying character of both the house and surrounding Downs called for a horizontal image instead. He wanted the sculpture to be in harmony with the countryside rather than in contrast with it. Since the principal thrust of his development during the 1930s had been directed towards an ever more integral relationship between the female figure and the earth on which she rests, the Chermayeff venture provided him with an ideal opportunity to take this obsessive fusion one stage further. Until then, he had worked on the central metaphor of woman-as-landscape with no knowledge of his work's destination, and the completed carvings often lingered in his studio for many years before they found a purchaser.[20] Now, by contrast, he knew from the outset

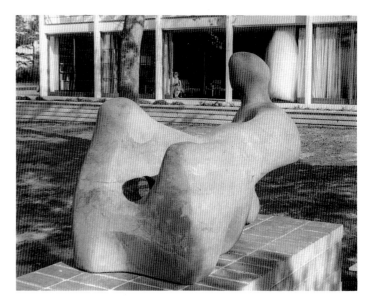

Fig. 3. *Recumbent Figure*, 1938 (cat. 34) on the terrace at Halland, Sussex, in front of Chermayeff's house, Bentley Wood.

precisely where the *Recumbent Figure* (cat. 34) would lie, and the Sussex countryside had an important effect on the form it assumed.

The closest precedent for the Chermayeff sculpture is an especially sensuous *Reclining Figure* (LH 175) carved two years before and now in the Wakefield Art Gallery. Its polished elmwood palpability gives way, just below the woman's breasts, to a sizeable hole. Unlike the tunnels he had burrowed through his work in 1931, where they occur in anatomically predictable positions between arm and trunk, this cavity pierces the part of the body where the thorax or abdomen would normally be located. But Moore's feeling for organic rightness gives the hole in the Wakefield figure a natural, cave-like inevitability. Far from signifying an outrageous violation of her physical being, it seems all of a piece with the supple equation of woman and earth which endows the entire sculpture with gently undulating yet sinuous rhythms. In the Chermayeff carving, Moore felt emboldened to enlarge this cavity as much as he could without subjecting the Hornton stone to unbearable strain. Wider and deeper than the Wakefield hole, its largeness of conception was surely inspired by the 'great sweep of the Downs'[21] which Moore found so impressive at Halland. The knowledge that *Recumbent Figure* would come to rest in a place dominated by a landscape he admired very deeply was bound to nourish his conception of the work. It exudes a sense of imperturbable assurance which must have been indebted, in part at least, to the location Chermayeff provided. The setting also stimulated Moore to bestow on the figure's head a more noble and

far-seeing vigilance than the almost featureless Wakefield carving had possessed. Looking out over the Sussex hills made him determined to ensure that 'her gaze gathered in the horizon',[22] and the omniscient expression he gave *Recumbent Figure* would recur in many of the outdoor works he went on to create in later years.

Even though the carving did not stay at 'Bentley Wood' very long,[23] Moore was convinced that it established there an ideal relationship with the architecture. Freed from an inhibiting and potentially humiliating dependence on the building itself, his carving was able to assert a vital autonomy even as it honoured the Sussex countryside. 'It had its own identity and did not *need* to be on Chermayeff's terrace, but it so to speak *enjoyed* being there', he explained later, 'and I think it introduced a humanising element; it became a mediator between modern house and ageless land.'[24] The rounded fulfilment of his biomorphic forms certainly contrasted with the stern, rectilinear functionalism of Chermayeff's timber-frame façade (fig. 3). Both he and Moore were sufficiently in sympathy with each other's aims to be included in *Circle*, the 'International Survey of Constructive Art' which had appeared the previous year and stressed the shared concerns of artists and architects.[25] But Moore's contribution to *Circle* argued that sculpture, 'not being tied to a functional and utilitarian purpose', could 'more naturally than architecture . . . use organic rhythms.'[26] His *Recumbent Figure* would probably have looked less at home inside Chermayeff's building, where the furniture was designed by Alvar Aalto, Marcel Breuer, Ludwig Mies van der Rohe and Chermayeff himself, even though the house as a whole 'demonstrates convincingly the unity of design for which *Circle* was calling.'[27] Perhaps it is just as well that Berthold Lubetkin's request for an alcove carving at High Point in Highgate never came to fruition. Moore's respect for the quality of this celebrated block of flats doubtless lay behind his willingness to produce 'a small model'[28] of the sculpture he had in mind for the site (see cat. 35). But he wanted it seen at eye level (fig. 4), and the shelf proposed by Lubetkin was eight feet from the ground. This time, the architect was responsible for curtailing the project, thereby depriving Highgate of a masterly elmwood *Reclining Figure* (LH 210) which deserves to be ranked among Moore's most outstanding works. He would never have been happy with the alcove Lubetkin proposed, though. 'When an architect simply wants to fill a space he thinks is too empty', Moore declared in another context, 'the sculpture becomes a decorative thing. I think you've got to have the sense of meeting a sculpture face to face.'[29]

No such problem confronted him in the early 1940s,

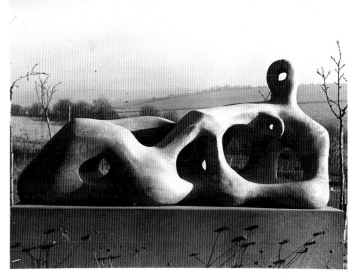

Fig. 4. *Reclining Figure*, 1939, Elmwood, L. 81 in., eye-level photograph by Henry Moore at Burcroft, Kent.

when the vicar of St Matthew's church in Northampton invited him to carve a *Madonna and Child* to celebrate the building's fiftieth anniversary (cat. 102). The sculpture is unequivocally placed on full view in the main part of the late Victorian building. Although a little over life size and resting on a plinth made of the same stone, it invites close and even intimate examination rather than obeisance from a distant vantage. Moore's initial doubts about making a religious image were laid to rest when he realised that the subject was commensurate with his own feeling for the mother and child relationship – a theme which had preoccupied him ever since carving a rough-hewn and overtly 'primitive' interpretation in 1922 (see fig. 20). Moore was, nevertheless, quick to appreciate the distinction between a secular and a sacred approach. While working on the preliminary clay models for the project, he came to the conclusion that it should possess 'an austerity and nobility and some touch of grandeur (even hieratic aloofness) which is missing in the everyday Mother and Child idea.'[30] That is why he finally rejected the urgency with which the infant clings to the Madonna in one of the maquettes. The relationship should be calm, not emotionally turbulent; and the mother in all of the models is already notable for her proud, erect bearing. Even though this carving was intended for an indoor location, unlike most of his other public sculptures, he wanted it to command attention from the instant it is seen by a visitor walking down the aisle. The Virgin acknowledges this priority by turning her head in the requisite direction, and the gaze of both mother and child are deliberately intended to make contact even with viewers far removed from the sculpture itself.

In the last analysis, however, the Northampton *Madonna and Child* is a gentle and, above all, engagingly humane work. Compared with the impersonal mass of the blocked-out figures in a photograph taken at an early stage of the carving process, the final image presents two fully realised individuals. Apart from the area between the infant's legs, left rough perhaps to declare Moore's innate respect for the unpolished brown Hornton stone block which served as his raw material, the entire statue has been smoothed and rounded until it exudes a reassuring warmth. The lap where the child sits is invitingly capacious as it curves in a hollow between one hummock-like knee and the other. He is happy to rest against the higher of the two thighs, secure in the knowledge that the mother's right hand buttresses his shoulder in a steady embrace. Their lack of eye contact is amply compensated by the tactile intimacy they enjoy, and in the most poignant part of the sculpture the madonna's fingers close round her child's small hand as if to affirm an instinctive maternal determination to protect him from harm (fig. 6).

The enlightened confidence shown in Moore by the Reverend Walter Hussey, who was courageously prepared to withstand the inevitable apoplectic criticism after the unveiling of the carving in February 1944,[31] had led the sculptor to assert the full extent of his admiration for Masaccio and the early Florentine Renaissance. For years he had resisted his love of the Carmine frescoes, first encountered during a trip to Florence in 1925, and preferred to derive most of his inspiration from other, less classical sources. But now, confronted by the unprecedented challenge of making a devotional image, he allowed his veneration of the *quattrocento* to rise to the surface. The Masaccio painting which seems to underlie his Northampton carving is the central panel from the Pisa polyptych, an equally imposing *Virgin and Child* familiar to Moore from visits to the National Gallery (fig. 5). In 1928 he had counselled himself to remember this painting as he strove for 'big form'[32] on the London Underground carving, and the tender clasping of hands in Masaccio's panel may well have helped to generate the same gesture in the St Matthew's sculpture. Its overt affection allayed the misgivings of many who came to visit the *Madonna and Child* with scepticism. 'There was enthusiasm from all sorts of people who saw it',[33] recalled Hussey, who thereby became instrumental in extending Moore's reputation among a public often disconcerted by the work he had produced in the 1930s.

His growing stature did not, however, secure him a project suggested by the enterprising educationalist Henry Morris in 1944. He wanted Moore to produce a substantial sculpture for Impington Village College, the innovative building by Walter Gropius and Maxwell Fry which had opened five years before. The village college ideal, centred on the notion of conducting child and adult education in a single institution, appealed to a sculptor so preoccupied with the link between

Fig. 5. Masaccio, *Virgin and Child*, detail, The National Gallery, London.

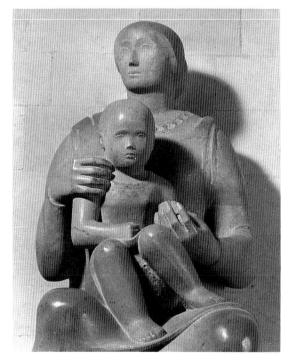

Fig. 6. *Madonna and Child* (cat. 102), detail, Church of St Matthew, Northampton.

offspring and parent. He went ahead with the project at once, and the number of *Family Group* drawings and maquettes produced in 1944 (such as cat. 165, 166, 169) testifies to his involvement with the theme Morris favoured. The mother and infant were here supplemented by the presence of a broad-shouldered father, who in several instances looks after a second child. Sometimes the outcome is a feeling, paradoxically, of dispersal: the compactness of the Northampton carving is dissipated by the arrival of the rather aloof male presence. Throughout his life Moore remained far more at home with female figures, and the father here seems disappointingly detached from his family.

After the Cambridge county councillors refused to provide Morris with the necessary funds, the sculptor was still eager to pursue the Family Group idea when offered an alternative site outside a new secondary school at Stevenage. To Morris's intense chagrin, the Hertfordshire county education officer John Newsom succeeded in eliciting finance from his committee for a substantial Moore (cat. 107). Finally installed in the autumn of 1950, it was the first large-scale bronze he had undertaken and the casting proved complicated. Furthermore, he did not feel entirely happy about its proximity to the curved baffle wall near the school's entrance. Although the architect, F.R.S. Yorke, wanted to place it there, the wall prevented viewers from seeing it in the round[34] (fig. 7). As a result, the all-important gesture which binds man and woman from behind, bringing the father's right hand to rest on his wife's shoulder, remained difficult to see. It was a pity, for Moore had by now made every attempt to fuse his family into a cohesive organic whole. Viewed from the front, the legs of both parents lean inwards at an angle decisive enough to acknowledge each other's presence. Their arms are likewise stretched across the group, linked in a mutual willingness to hold the baby in their grasp. Probably because he felt that an outdoor site required far less individualised expressions than the Northampton carving, their faces are all relatively generalised. Rejecting the surrealist split which so disturbingly fractures the father's head in one of the earlier maquettes, Moore opts for bland characterisation in his search for an archetypal image utterly removed from any attempt to provide a contemporary depiction of post-war family life.

The father's increased involvement in the Stevenage *Family Group* doubtless reflects Moore's own recent experience of parenthood. In March 1946, at the late age of forty-seven, he became a father. His joy was eminently understandable, and yet he was engaged at the time on a major project concerned with death rather than birth. It came from Dorothy and Leonard Elmhirst, the remarkable couple who founded

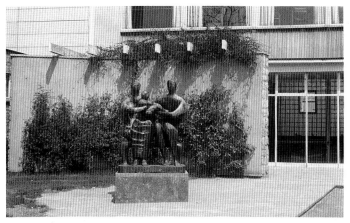

Fig. 7. *Family Group*, 1949, at Barclay School, Stevenage, showing the baffle wall behind it.

the Dartington Hall community experiment near Totnes. They wanted a *Memorial Figure* to honour the memory of Christopher Martin, struck down by tuberculosis after a decade spent running the arts at Dartington (fig. 1). Since Moore had counted him among his friends, he was able to invest the Hornton stone carving with a heartfelt elegiac strain. The recumbent woman, draped more heavily than any of his previous works, broods gravely in the grounds where Martin must have enjoyed walking and savouring the seductive prospect of the countryside beyond. But there is nothing unduly melancholy about this ample figure. Stoical as well as sad, she seems reconciled to the inevitability of death. Unlike the other great *Reclining Figure* (LH 263, fig. 25–6) which Moore carved from elmwood during the same period,[35] no hollows disrupt the majestic palpability of the memorial. Intact, harmonious and entirely unruffled, she presides over her surroundings with a mellowness which honours the softly rolling Devonshire landscape. Her upturned leg complementing the gentle swell of the terrain behind, the figure seems ideally attuned to the setting she occupies. Comforting in its permanence, the memorial implies an almost pantheistic belief in the unshakeable accord between humanity and the earth. Only a year before he started work on the Dartington figure, his much-loved mother had died at the age of eighty-six. He never forgot the sight of her lifeless body, explaining long afterwards that 'she had such dignity, such an eternity feeling about her, that to me it was beautiful but terribly, terribly moving . . . there's something about a dead body which is statuesque.'[36] Far from regarding his mother's corpse as a reminder of inescapable dissolution, he found that it had an obstinate durability which permeates the memorial carved while the memory of her death was still vivid in his mind.

Whenever Moore knew that a sculpture would inhabit a

particular site more or less in perpetuity, he did everything possible at this stage in his career to marry the work with its location. While discussing the genesis of the Dartington carving, he described the place it occupies 'at the top of a rise' and emphasised that 'it was this setting I had in mind when working on the maquettes.'[37] Final sculptures were likewise gauged in relation to their designated spaces, for he recalled that 'I went out to Stevenage while the school was under construction and tried out a rough life-size silhouette made in cardboard of the *Family Group* just for its scale.'[38] When Moore received an invitation from the Arts Council in 1949 to make a sculpture for the Festival of Britain on the other hand, the image he produced was not governed by an awareness of the area. 'I knew that the South Bank would only be its temporary home, so I didn't worry about where it was placed', he wrote later. 'If I had studied a Festival site too carefully, the figure might never have been at home anywhere else. As it was, I made the figure, then found the best position I could.'[39] Nor did he pay any attention to the Arts Council's bizarre suggestion that he carve a family group symbolic of Discovery.[40] It was, mercifully, a tentative proposal and, in a manner typical of his independent attitude, Moore pretended to ponder it while quietly ensuring that he focused all his imaginative energies on a reclining figure (cat. 121).

The outcome, though, was in no sense a predictable image complacently reiterating his previous achievements. Spurning all thought of cultivating facile optimism to meet the mood of a Festival which celebrated Britain's emergence from the prolonged austerity of war and its immediate aftermath, he refused to concoct a sculptural placebo for the entertainment of the crowd. The attenuated figure, which can be counted among his most haunting works, is devoid of any cosy amplitude. Bulk has been replaced by boniness. Divested of all fleshy superfluity, the etiolated body extends itself across the plinth like a figure forced to subsist on minimal nourishment alone. The feeling of strain receives confirmation in the eerily split head, echoing the form previously explored in the most disquieting of the *Family Group* maquettes. She seems to gape up at the sky, in the unlikely hope that reassurance might be discovered there. But Moore knew, as well as any of the younger artists who reflected the unease of the post-war period in their work,[41] that scant comfort could be derived from the uneasy 'peace' Britain now experienced. Although this *Reclining Figure* had escaped from the subterranean realm where he had seen so many Londoners consigned to a weary and defensive half-life in the Tube shelters, its anxiety is still apparent. Exposure to the open air was no longer, in Moore's view, a matter for auto-

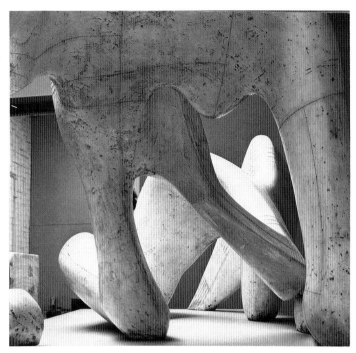

Fig. 8. *Reclining Figure: Festival,* 1951, plaster, (cat. 121), detail photographed by Henry Moore.

matic celebration. Hiroshima had taught him that the sky could now unleash a destructive capacity more devastating by far than anything inflicted on London during the Blitz. Hence the apprehensiveness with which this fractured head looks upwards, seeming to gasp for air even as she draws sustenance from the welcome light and heat of an outdoor setting.

In the end, though, the Festival of Britain sculpture is a resilient image, braced for defiant survival. Its sinuous rhythms denote a woman whose pared-down structure belies her supple strength, and she is nowhere undermined by the space flowing through her with such conspicuous freedom (fig. 8). Rather than carving holes into the figure, as he had done so often before, Moore here gave the forms a toughness of their own. 'Sometimes the form was only the shell holding the hole', he said of earlier works, contrasting them with the attempt in this *Reclining Figure* 'to make the forms and the spaces (not holes) inseparable, neither being more important than the other.'[42] As a result, the *Reclining Figure* possesses a spare self-sufficiency of structure which counteracts her more vulnerable aspects. As if to reinforce the woman's strength, Moore fixed a tracery of fine raised lines to the plaster model before he cast it. These strings run over her body like wire, binding the forms together with a tensile force which appears impossible to sunder.

Nothing could have been more prominent than the grand public site allotted to this outstanding work, in front of Brian O'Rourke's Country Pavilion and opposite the main entrance

of a Festival crowded with excited visitors. When he was approached by Time–Life for his next important project, however, Moore found himself confronted by a limited and private space available only to employees in the building. At first, Time–Life simply wanted a sculpture for the small third-floor garden terrace of its new London headquarters in Bond Street. He decided to model a draped reclining woman (cat. 127), after realising that 'in cold weather a nude – even an abstractish one – might look incongruous to people looking out at her from a warm room.'[43] But that was not the only reason why Moore now explored the possibilities of the draped form with such fascination. A visit to Greece in 1951 had confirmed the interest in the eloquence of folds which he had discovered when making the Shelter drawings during the war. The tautness of some areas could be stressed by their contrast with the flowing looseness of others, thereby accentuating the points of tension within the figure beneath. So, although he enclosed most of the *Draped Reclining Figure*'s body in elaborately crinkled fabric, the coiled energy so evident in his nude forms was not dissipated. The strength of the woman's back – a vital part of the female anatomy for Moore ever since he had rubbed his mother's fleshy back with liniment as a child – is enhanced by the tightness of the folds drawn across it. Elsewhere, particularly in the great ridges travelling down the right side of her torso, the pitted texture of a rock face is evoked. The addition of drapery did not, therefore, divorce the figure from the relationship with the skin of the earth which Moore cherished. Nor did the terrace's size prevent him from investing the woman with a substance more attuned to a landscape than an urban terrace. While making the sculpture, he took care every day to push it out into the garden 'before the light went out, so that I could be sure that it was standing up to an open setting.'[44]

Even though Moore still preferred his work to retain its autonomy, at a suitable distance from the architecture it accompanied, he now responded positively to the idea of carving a Portland stone screen to protect the balcony of the Time and Life building. The architect, Michael Rosenauer, had already held a competition which elicited nothing but ideas for reliefs in a narrative style from artists struggling with the unenviable task of depicting the content of the two magazines. Dismissing the absurdity of such a venture, Moore insisted that the wall should be pierced to disclose the open air beyond. As well as dispensing with the pretence that it was a solid part of the building, the proposal enabled him to escape from the limitations of relief. All four of the maquettes he prepared at Rosenauer's behest made clear that fully-rounded images were envisaged from the outset, each one enjoying an independent existence within its frame. Three

maquettes were predominantly organic in character, lodged in their modern walls like bones or mysteriously weathered stones evoking a far more ancient civilisation. But as he worked on them, Moore realised that they should assume a more severe identity in order, presumably, to complement the extreme rectilinear simplicity of the building itself. The final maquette is the most schematic, and he took this bare structural rigour even further in the finished work (see cat. 125).

Since the screen is ten feet high and over twenty-six feet in width, the whole carving presented a formidable challenge. Each image had to be cut from a pair of superimposed stone blocks, and Moore wanted to produce works worthy of being set on a turntable and rotated regularly on their perches high above Bond Street. It was a revival of a plan he may first have hatched several years before, when the *Family Group* at Stevenage was placed on a restricted site. 'In such circumstances architects might consider the use of a turntable, not to keep the statue slowly turning – that would be a horrible idea – but to present another view of it every month or so', he wrote, explaining that 'if a sculptor knows that his work is going to be seen all round, it is a further impetus to sculpt all round.'[45] But the cost and possible public danger of such a scheme proved prohibitive, so Moore had to settle for a static installation which hid the other side of each carving from public view. He was also obliged to abandon the hope that the carvings might be erected without the screen. After realising, quite rightly, that the wall would end up confining them too harshly, he found to his annoyance that it had already been made and positioned on the building. There the

Fig. 9 Henry Moore carving the Portland stone *Time–Life Screen*, 1952–3, at Much Hadham.

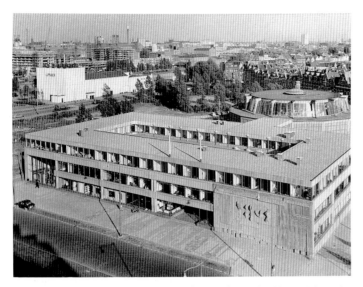

Fig. 10. View of the Bouwcentrum, Rotterdam with Henry Moore's *Relief*; H. 28 ft 3 in, L. 63 ft, brick.

images remain, too high to be noticed by most of the people gazing at shop-windows beneath. Freed from their imprisoning frames, and placed in a location where the viewer is able to apprehend them in the round, they would undoubtedly come into their own (fig. 9). For the time being, though, they resemble an intriguing experiment rather than a wholly achieved fusion of sculpture and architecture. More akin to the semi-abstract carvings of the 1930s than to his post-war work, the enigmatic presences ranged along the screen suffer from their subservience to the architecture they enliven.

No wonder that Moore reacted negatively to an approach from Basil Spence, who sought his advice on a proposal for eight huge relief carvings in the nave of the new Coventry Cathedral.[46] Spence doubtless hoped that Moore would take on the task himself: after all, the rest of the interior was being embellished by old friends like John Piper and Graham Sutherland. But he was so adamant about the inadvisability of the project that Spence abandoned the whole notion of commissioning sculpture for the nave's recesses.[47] Moore's dislike of working in relief had not abated since the period when he carved the *West Wind* for Holden, and his experience with the Time–Life screen only fortified his resistance to making sculpture a fixed part of a building. 'I resented the idea that architecture was "the mother of all the arts" ',[48] he admitted later, so his willingness in 1955 to produce a red-brick wall relief for an extension to Rotterdam's Bouwcentrum comes as a surprise. He may, perhaps, have been won over by the sheer size of the wall placed at his disposal by the architect, J.W.C. Boks.[49] The fact that it was intended for a Building Centre, and would be executed by the most skilled brick-

layers available, must likewise have encouraged Moore to regard the venture with favour. He could also have been stirred into friendly rivalry by the knowlege that his old ally Naum Gabo was working on a vast outdoor sculpture for the Bijenkorf Department Store in the same city.[50] Besides, Boks was willing to give him an absolutely free hand, and Moore had only recently returned from a trip to Mexico where he was very impressed by the Indians' use of similar materials. Visiting a brick-making district in Mexico City, he had been struck by the enormous adobe stoves used for baking the frames of clay. The forms of the stoves reminded him of the nearby mountains,[51] and he may have recalled this stimulating spectacle when invited to contemplate the prospect of working with bricks himself.

At all events, he soon produced nine maquettes for the Rotterdam wall (cat. 129–33), some of which prefigured the Upright Motives (see cat. 134–6) made a few months later. Dissatisfied with this approach, presumably because it established too monotonous a rank of vertical forms along the wall, he began to break up the design and handle it in a less magisterial manner. The individual elements became smaller, and were eventually confined to one part of a surface otherwise animated by brusque clusters of horizontal and upright ribs (figs 10, 11). Freely echoing the verticals of Boks's windows above, these rasping lines are at odds with the organic language which always provided Moore with his most fertile inspiration. Although recalling his experiments with string in the 1930s, they ensure that the *Wall Relief* is one of his most untypical works. Only the fragments of swollen form punctuating the central area relate to his contemporaneous sculpture, and even they evoke animals as much as humans. Strangely enough, they fulfil the aim Moore set himself with the Time–Life screen, where he would have liked the carvings to 'project from the building like some of those half animals that look as if they are escaping through the walls in Romanesque architecture. I wanted them to be like half-buried pebbles whose form one's eye instinctively completes.'[52] If those words suit the Rotterdam project far more than the Bond Street scheme, the whole design still has an unresolved air – exacerbated by the narrowness of a location which hampers satisfactory viewing and curtails the enlivening play of sunlight. Moore may have thought so too, for he did not attend the unveiling in December 1955. But the project did at least demonstrate his readiness to extend himself and attempt innovative departures, at a time when the fifty-seven year-old sculptor might have been tempted to rest content with more familiar, well-tested forms and ideas.

Moore's appetite for challenge remained as boundless as his energy, and in May 1955 he accepted the most demanding of

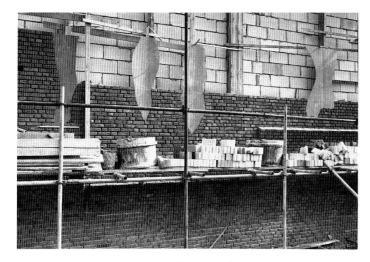

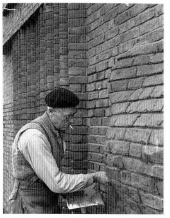

Fig. 11. Details of brick-laying photographed during the construction of the *Bouwcentrum Relief*.

all his public ventures. The sculpture requested by UNESCO for its new Paris headquarters ended by being far larger than any figure he had carved before. Well over sixteen feet in length, its size was dictated mainly by the scale of the seven-storey building which Marcel Breuer, Pier Luigi Nervi and Bernard Zehrfuss had designed as an architectural triumvirate. But Moore had considerable difficulty settling on the subject of the work, even though his old friend Julian Huxley, UNESCO's first Director-General, had told him what the organisation stood for. After completing a rather indifferent *Family Group* for Harlow New Town (LH 364),[53] he set to work on a cornucopia of ideas for the Paris project. Draped and nude, sitting and standing, reading and reclining, the figures were of such a prodigious variety that they provided Moore with sculptural ideas for many years to come. In the end, though, he resolved 'to avoid any kind of allegorical interpretation that is now trite',[54] and to plump instead for a massive recumbent woman on a block supported by three squat columns thick enough to bear the weight of the thirty-nine-ton figure.

It was a wise choice. Overt references to the educational, scientific and cultural aims of UNESCO might well have looked laboured, and the monumental assertion of a womanly alternative to the prevailing patriarchal culture was in itself a salutary gesture. The sheer proliferation of Moore's female figures means that his obsessive involvement with this subject is often taken for granted. But there was nothing accidental about his concentration on recumbent woman: he saw her essentially as a redemptive force, and the unaggressive, nurturing values she personifies coincided well with the spirit of peace and healing which prompted the foundation of UNESCO straight after the Second World War. Having decided on the size of the carving, by trying out an enlarged cut-out of his maquette (cat. 139) on the allotted site, Moore chose to execute the figure in Italy. Financial considerations militated against producing it at Much Hadham; and anyway, he harboured a romantic longing to work near the Apuan mountains where Michelangelo once selected his stone. Ever since Moore's schooldays, the Florentine sculptor had been a particular hero, and the firm of Henraux at Querceta gave him access to the very quarry which Michelangelo visited. Moore venerated the area, and although the honey-coloured travertine for the UNESCO project came from a quarry near Rome, the making of the figure at Querceta inaugurated a relationship with Henraux that was to produce many other carvings in the future.

It also helped to give the completed work a bleached, classical calm utterly different from the wall relief he had carried out in Rotterdam. The UNESCO *Reclining Figure* (LH 416) is perhaps the most imperturbable of all Moore's works, devoid of that northern unrest which runs through some of his sculpture. Serene, straight-backed and gleaming, her clean-cut forms owe much to the inspiration he found in the epic landscape around Querceta. The Apuan peaks, culminating in the appropriately named Monte Altissimo, reinforced a fundamental urge which he had first defined in words over a quarter of a century before. 'The sculpture which moves me most is full blooded and self-supporting', he had written in 1930, declaring that 'it is static and it is strong and vital, giving out something of the energy and power of great mountains.'[55]

It was an ambition he had inherited from the previous generation of sculptors in Britain, for Epstein announced in 1912 that 'I want to carve mountains'[56] and Gaudier-Brzeska reiterated the ambition soon afterwards when he proclaimed in *Blast*: 'Sculptural energy is the mountain.'[57] The sheer size of the UNESCO undertaking proved so exhausting that Moore

did not carve anything for several years after it had been in-stalled in Paris (fig. 12), but the advent of the 1960s witnessed an intensification of his interest in woman-as-mountain. Mod-elling a sequence of two-piece and three-piece reclining figures, he pushed the analogy between female body and land-scape further than ever, taking the division into separate sections as an opportunity to stress the most rock-like aspects of the forms. The starting-point now was not to be found in the Mediterranean peaks which had inspired his UNESCO carving. Rather did he turn to memories of an outcrop of rock called Adel Crag near Leeds, seen during his boyhood and never forgotten.[58] Paintings of cliffs at Grand-camp and Etretat, by Seurat and Monet respectively,[59] likewise nourished his predilection for rugged and primordial imagery. He was encouraged to pursue this direction on a grand scale when Frank Stanton, the President of CBS Inc., approached him in 1961 with an invitation to make a pool sculpture for the new Lincoln Center in New York. Situated outside the Vivian Beaumont Theater and Library Building, the enormous stretch of water constituted a setting quite unlike anything Moore's work had inhabited before. He had always thrived on allying his work as firmly as possible with the solidity of the land, and yet the Lincoln Center was now

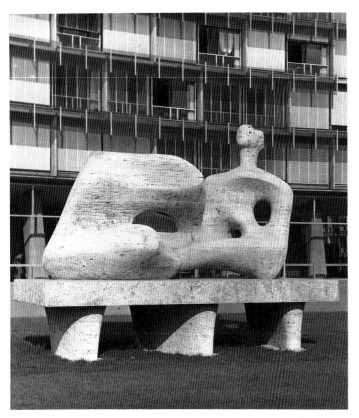

Fig. 12. *Reclining Figure*, L. 16 ft, Travertine marble, outside the headquarters of UNESCO, Paris.

asking him to come to terms with a site where the sculpture would rest on nothing firmer than a dark reflection in the often wind-ruffled pool.

Moore, however, must have realised how closely the location accorded with his new interest in cliff fragments and outcrops. It stimulated him enough to produce one of his most energetic later bronzes, a two-piece work which counters the lower, boulder-like part with the diagonal thrust of a figure rearing high above its craggy base (LH 519). Taut and vigilant, she remains unencumbered by the bulk which sometimes burdens Moore's large bronzes with an excess of furrowed mass. Seen from the side she takes on a near-athletic poise, her flamboyant mane of hair crowning a torso which narrows down to a surprisingly thin point before bursting into sinewy upheavals around the base. The sprung tension in this half of the sculpture, which might look too eruptive on its own, is brought to rest in the second half where human references give way to an image of hollowed rock eroded by the action of wind and sea. It looks thoroughly at home and inevitable in the pool, even though the water caused endless problems and only reached the correct level in 1983. The irritation it caused Moore bore out the misgivings he had already harboured in 1960, when Prince Philip asked him to design a fountain for Windsor Castle and he replied that complex waterworks were best left to specialists.[60]

Contrary to the prevailing idea that Moore accepted every invitation for work in public spaces, he displayed a healthy wariness of unpropitious locations. During the 1950s he aban-doned a proposal from Olivetti for a sculpture near its Milan office once he had discovered that the site would be cluttered with parked cars.[61] Even the most prominent metropolitan location could be turned down: nearly twenty years later Moore declined an invitation from the Pompidou govern-ment to make a 'really monumental' work which would 'balance the Arc de Triomphe at the far end of the avenue cul-minating in the futuristic, high-rise development known as La Défense'.[62] Inspection of the setting was enough to turn him against the proposal, and his enthusiasm swiftly evaporated. But as he grew older and his fame burgeoned, Moore became increasingly ready to furnish sites throughout the western world with his work. Most of them could not be described as commissions in the sense of making a sculpture specifically for a given space; rather than entering into a commitment, he decided what to do and a deal would be made when the piece was finished. With large bronzes, a number of casts were almost invariably produced, so they are not as a rule unique even in the grandest of public locations. When the Finnish ar-chitect Viljo Revell asked him for an important piece to stand beside Toronto's new city hall and civic square, the two men

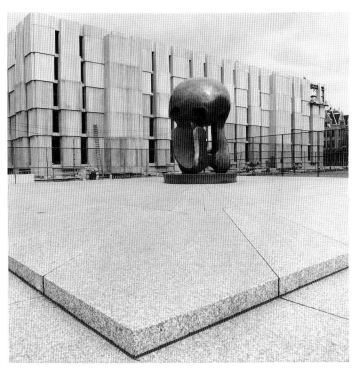

Fig. 13. *Nuclear Energy* on the University of Chicago campus.

chose an *Archer* (LH 535) which already existed as a working model at Much Hadham.[63] Moore did, on the other hand, make a special response to a subsequent request, from the University of Chicago, for a bronze commemorating the first controlled nuclear chain reaction. The sculpture *Nuclear Energy* (LH 526), at first entitled *Atom Piece* (cat. 184), reflected the attitude of a sculptor who had always supported the Campaign for Nuclear Disarmament. Growing out of his earlier helmet series, which had conveyed profound misgivings about war, the sinister image at Chicago fused a mushroom cloud with references to a human skull. When installed on the site of the underground squash court where the physicist Enrico Fermi had achieved the chain reaction in 1942, it offered an eerie reminder of human vulnerability in the face of terrifying destructive power (fig. 13).

On the whole, though, even the most important 'commissions' of Moore's final years resulted in expanded adaptations of work already made. When the UNESCO carving was first discussed, he had balked at Breuer's suggestion that it should be eight metres long: 'I was a little nervous about making something larger than it should be', he explained, 'blowing it up more than it deserved.'[64] During the 1970s, by contrast, he showed no hesitation in coping with the extraordinary international demand for his work by supplying civic piazzas with enlargements rather than sculpture conceived specially for particular settings. When the Director of the National Gallery of Art in Washington made a point of

asking him for a new work, conceived with the identity of I.M. Pei's new East Building in mind, Moore went so far as to assert that 'I have never done that'.[65] So Pei's architecture received an outsize version of *Knife Edge: Two Piece* (cat. 182), interchanged and 'flopped' but not, in the end, a sculpture which had been initiated in response to the Washington brief. Although Pei went on to enjoy a warm working relationship with Moore, he never succeeded in eliciting a wholly new work from the sculptor. For the outside of Pei's severe yet elegant city hall in Dallas, Moore supplied a rearrangement of the 1968 *Three Piece No. 3: Vertebrae* (cat. 185)[66] and, in 1983, when the sculptor was infirm, Pei persuaded him to produce a vastly expanded version of a lead reclining figure which was only thirteen inches long when Moore made it in 1938 (cat. 36).[67] The outcome, a bronze thirty-four feet in length, sprawls beside Pei's Singapore headquarters for the Overseas Chinese Banking Corporation. The architect took pride in the claim that it introduced contemporary western art to the Far East, but the sculpture itself compares very poorly with the earlier projects where Moore had made every effort to meet the challenges posed by the purpose of the work and the character of the site alike.

As if in final acknowledgement of the fact that an important request deserves something more than a blown-up repetition of previous achievements, his last public sculpture received Moore's full attention. Although now very frail, he was sufficiently excited by the request for a Madonna and Child in St Paul's Cathedral to give the venture all the energy he had left. Realising that it might be his final work, he was happy to let the sculpture 'give the feel of having a religious connotation'.[68] Carved in travertine by the artisans of Henraux, it inevitably lacks the sense of close personal engagement which had made his Northampton *Madonna and Child* so impressive and heartfelt forty years before. For all its bland limitations, though, this highly simplified image still manages to offer an affirmation of Moore's lifelong preoccupation with the maternity theme (see cat. 201). While completing the Northampton carving, he had claimed that of the two great subjects dominating his work, the mother and child was 'a more fundamental obsession'[69] than the reclining figure. So it was an appropriate choice of theme for the St Paul's sculpture, which returned the old man's work from the rigours of the 'open air' to the hushed protection of a hallowed interior. Partially reminiscent of a far more abstract 1938 elmwood piece,[70] and yet restated in the smoothed-out form-language so characteristic of his late stone carvings, this gentle swansong celebrates the intimacy of the mother-child relationship with hooded serenity. Despite its considerable height and bulk in the cathedral's north choir aisle, the

octogenarian sculptor managed here to put aside his former involvement with rugged, earthbound mass and concentrate on spiritual beneficence alone.

Although Moore was always careful to protect his freedom of manoeuvre when accepting invitations for public sculpture, the projects he undertook often played a crucial generative role in the development of his work as a whole. Even the early carving for the Underground headquarters, where the allotted site was far more constrained than anything he would be prepared to contemplate later, provided him with an important stimulus. The unprecedented size of the figure requested by Charles Holden gave him the assurance, in subsequent years, to work on a significantly grander scale than before. Moore might otherwise have been slower to arrive at the breadth and monumentality of his mature style. The Holden scheme also marks the key moment when reclining female figures came to dominate his thinking; and after Chermayeff approached him a decade later, he evolved an equally fruitful response to the challenge of landscape sculpture. His great *Recumbent Figure* of 1938 arrives at such an intimate correspondence between woman and the earth she inhabits that it had profound implications for the direction Moore went on to pursue.

Even when he agreed to a religious proposal which at first seemed removed from his central concerns, the Northampton *Madonna and Child* initiated a signal decision to involve himself more closely with the Renaissance tradition. The consequences were momentous, leading to a more accessible form of figuration which won him a wider reputation than anything he had produced during the 1930s. The proliferation of maquettes for the Northampton carving testifies to the nourishing effect of Walter Hussey's invitation, and a similar wealth of preliminary studies attended Moore's future public sculpture as well. The *Family Group* project, the Time–Life screen, the Rotterdam wall and the UNESCO figure were all accompanied by a prodigious outpouring of ideas, many of which became the genesis of other important works like the Glenkiln Cross. So the sculpture carried out in response to approaches from architects, clergymen, members of universities and others fed, in turn, the images he produced on his own initiative. Rather than interrupting or obstructing the flow of work Moore would have made regardless of outside prompting, the public ventures encouraged him to experiment with possibilities which immeasurably enriched his overall achievement. Without the inspiration derived from the requests he felt able to accept, his career might well have been less adventurous in scope, more content with the limits imposed by the demands of gallery exhibitions alone.

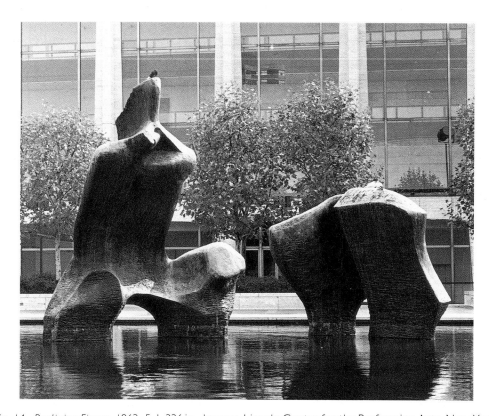

Fig. 14. *Reclining Figure*, 1963–5, L.336 in., bronze, Lincoln Center for the Performing Arts, New York.

DRAWING AND SCULPTURE:
A TIMELESS ART OF OUR TIME

S U S A N C O M P T O N

The working life of Henry Moore spanned six decades; during that time he drew, he carved, he modelled, he painted, he cast work in lead and bronze, he worked with the etching needle and explored lithography. His energy and his powers of invention were formidable; in mid-life he filled his studios with small plaster models of which only a fraction were finally enlarged. Both earlier and later, drawing provided a reservoir of ideas and there were times when he was as well known for his works on paper, particularly his Shelter and Sheep drawings, as for his sculpture. In addition to his art work, Moore recorded his ideas, first in published statements and later on in conversations which were printed, often in conjunction with photographs. As a very young man Moore wrote poems and even a play[1] and although he gave up literary work in favour of fine art, his writings form an important part of the context for his art.

In the twenties the majority of his drawings were from life. They are in the careful academic style that he learned in the Leeds College of Art where, in 1919, even the angle of pencil shading was considered of the greatest importance. When he won a scholarship to the Royal College in London two years later, his approach was transformed by different teachers, by his discovery of 'primitive' art and by his study of Cézanne (see cat. 51) and, to a lesser extent, of Picasso. On occasional visits to Paris he spent days working at two Académies, where the model would pose for shorter lengths of time as the day wore on, and he made outline sketches such as one in terracotta wash, cat. 56. Usually he used pencil and pen and ink, with chalk and wash to emphasise modelling, for which his preferred colour was green. Further modifications in his working practices were made as a result of developing his own teaching methods when he was appointed to a lectureship in Sculpture at the Royal College of Art on the completion of his training there in 1924. In particular he invented what he called 'sectional lines' which run in two directions down and across the figure so as to emphasise the three dimensions that form free-standing sculpture. The lines are particularly clear in the monumental Seated Woman (cat. 61) of 1928; they were to reappear in many drawings from the forties, including the

Page from Madonna and Child Sketchbook (cat. 161) and they are still present in late drawings such as Four Ideas for Sculpture (cat. 235) from 1982.

Many of the early life drawings are works of art in their own right (for instance cat. 58). In his first exhibitions, in 1928 and 1931,[2] Moore not only showed drawings as well as sculpture but sold more of the former than the latter. His aim, however, was to be a sculptor and the prime purpose of drawing was to explore his chosen subject, the human body. The importance he attached to drawing was made clear in later life: 'If you are going to train a sculptor to know about the human figure, make him do more drawing to begin with than modelling'.[3]

This advice reflects the standard method of teaching sculpture in the twenties, by modelling rather than carving. As a student Moore was determined to practise carving direct, without the intermediary of a clay model and mechanical enlarging devices. This meant that he needed to be as familiar as possible with the human model, though a surviving carving was derived from a Renaissance Virgin and Child (see cat. 1). Furthermore, he had experienced a conflict of loyalties when he discovered 'primitive' art in the British Museum, where he spent much of his free time. When he took up a travelling scholarship to Italy in the first six months of 1925, he was therefore surprised to find that he admired early Renaissance art. In Florence he studied the work of Masaccio, in Padua, that of Giotto and he made a few careful copies of figures from early Renaissance drawings (cat. 52, 53). The rare portrait drawings of his sister (cat. 54) and, later, of his mother (cat. 55), echo something of the gravity of these models. For several months in 1925 he experienced a painful conflict between the classical tradition exemplified by Florentine art and the non-classical, 'primitive' sculpture he found in the British Museum which finally won his enduring allegiance.

Following Roger Fry, whose collection of essays Vision and Design[4] had already caught his attention in Leeds, he became sure that the principle of vitality should replace that of classical beauty, which he felt had detracted from the essential character of carving. He filled sketchbooks with ideas jotted down on visits, in London to the British Museum, in Paris to

the Musée Guimet, and used them as the basis for sculptural ideas (see cat. 50). There was no room for storytelling, nor for subject matter other than vital organic forms, which he continued to study in life drawings.

He made his position clear in a statement that he published in the *Architectural Association Journal* in May 1930. Under the heading 'Contemporary English Sculptors', Moore stated that revitalisation would come about through the removal of the 'Greek Ideal' which had permitted the contemporary sculptor to look at the whole history of sculpture, embracing the whole world from Paleolithic times to Gothic, for the originals are to be found in museums and in photographs, from which he can derive a 'world view ... never previously possible'.[5]

The role of the modern sculptor took on primary importance during 1930 when the critic R. H. Wilenski visited Moore's studio to discuss a series of lectures he planned to give at Bristol University. Furthermore, in December Wilenski published 'Ruminations on Sculpture and the work of Henry Moore' in *Apollo* magazine and identified the concern of sculptors for rhythmic relations to be found in the organic world.[6] This is a pointer towards a new interest in nature which proved of profound importance to Moore from 1930 onwards. Whether he read the English translation of *Foundations of Modern Art* by Ozenfant which appeared in 1931[7] must remain a matter for speculation, but although written in the name of Purism (a movement that found little following in London), Ozenfant's words match the new approach and subject matter that Moore began to explore at this time: 'Art must be more dogmatic than ever before and more precise' ... 'no vague empiricism or wavering traditionalism will serve ...'. Furthermore, Ozenfant gave a recipe: '... the study of biology, psychology, and the profoundest analysis of how things function, helps to a more exact understanding of the complex mechanism of modern man' ... 'since the artist wishes to be judged on all fours with the scientist, he must take his stand accordingly.'[8]

Discussion of such texts and the all-important illustrations (which included magnifications of natural phenomena as well as some of Moore's favourite images – the prehistoric Venus of Willendorf and one of Cézanne's Bathers) were more likely to take place outside the Royal College, and it can be no coincidence that the change in Moore's subject matter occurred when he finally left the institution which had been his base for ten years. After his resignation was accepted in January 1931, it is not clear whether he continued at the College for the two terms until he took up his new part-time position as head of sculpture at Chelsea School of Art in Autumn 1932.[9] A sketchbook which dates from this time

includes studies of natural forms which provided the starting point for the revolutionary approach to the human figure which he developed in 1932. These drawings, called 'Transformation' drawings, consist of careful renderings of precise natural forms, such as bones, pebbles and shells, drawn from the life but then subtly modified so that the inanimate objects begin to take human shape. As the artist pointed out in later life, 'It is what I see in them that gives them their significance.'[10] Thus *Studies of Shells and Pebbles* (cat. 71) is barely more than a faithful record of objects which had excited Moore by their shapes. The transformation of the shell in the centre occurs in another drawing, fig. 15, misleadingly entitled *Ideas for Sculpture: Transformation of Bones* (HMF

Fig. 15. Detail from *Ideas for Sculpture: Transformation of Bones*, 1932, collage and pencil, The Henry Moore Foundation.

965), where the same shell forms the core of the central 'figure'. Such metamorphosis is at the heart of the Transformation drawings and became the touchstone of Moore's art, the magic that underlies most of the sculptures and drawings he made until the end of his working life.

As early as 1932 he was hailed as a 'poet–sculptor of a new kind' when, in his *The Meaning of Modern Sculpture*, Wilenski wrote: 'I have done my work badly if the reader does not regard Moore's *Composition* ... as an enlargement of experience by imaginative organisation of form symbolic of human–animal–vegetable life.'[11] Wilenski also made a telling criticism of modern sculptors who continued to devote as much attention to the head of a figure as had ever been the case in traditional Western art. He saw no reason why the head should receive more detail than any other part of the body and he felt that singling it out detracted from the three-dimensionality of a sculpture. From the early thirties a reduction in the detail of heads and faces became characteristic of Moore's drawings as well as sculpture.

It is not surprising that in his next published statement of 1934, Moore extended the views that he had expressed in 1930. To '*Truth to material*' and '*Full three-dimensional realisation*' he added '*Observation of Natural Objects*': 'The observation of nature is part of an artist's life, it enlarges his form-knowledge, keeps him fresh and from working only by formula, and feeds inspiration.' While admitting that the human figure interested him 'most deeply', he added 'I have found principles of form and rhythm from the study of natural objects, such as pebbles, rocks, bones, trees, plants, etc.'[12] For Moore, human forms were now latent in nature: the study of a jaw bone could result in a reclining figure (cat. 72). In addition, the juxtaposition of new forms derived from stones or shaped wood could convey tensions and relationships identifiable by analogy as emotions of attraction or dependence, for instance, in *Ideas for Two-Piece Composition* (cat. 74).

Moore's declaration of the new importance of nature appeared in the book published in 1934 under the title, *Unit One*. The name had been chosen for a group of artists and architects formed by Moore's friend the painter Paul Nash, who had recognised the isolation of British artists from current developments in European art and had attempted to remedy it. Although Unit One, which Nash formed by personal invitation, did not take shape until 1933, a nucleus was already created by the proximity of artists living in Hampstead: Ben Nicholson and Barbara Hepworth had a studio only a few doors away from Moore, who had moved to Parkhill Road after his marriage in July 1929.[13] In 1933 they were joined by the writer Herbert Read, who wrote the introduction to *Unit One*; his books *The Meaning of Art* (1931)[14]

and *Art Now* (1933)[15] undoubtedly widened the theoretical background of contemporary British art. Read was also the author of the first monograph on Moore, a slim volume that came out in 1934 under the imprint of Zwemmer,[16] in whose bookshop Moore exhibited drawings in 1935. Zwemmers was at that time the principal London stockist of European art magazines such as *Minotaure*, *Cahiers d'Art* and *Verve*, which brought reproductions and the latest artists' statements from Paris to London.

Although ideas among avant-garde artists in London were becoming increasingly linked to those of artists on the Continent, there is a difference between Moore's 'form inventions' and those of Picasso with which some of his drawings have been compared. For instance, the numerous small sketches which border the reclining figure in cat. 73 have been frequently linked to Picasso's drawings entitled *Une Anatomie*, of which three double sheets were published in *Minotaure* No. 1, 1933. However, Moore's inventions are typically based on natural forms; he avoided the witty transposition of man-made objects which Picasso used for some of his own analogies for the human figure.[17] No doubt, however, the appeal of such inventions made available in reproduction in the early thirties, was not only Picasso's prodigious power of invention, but his role as a leading Surrealist.

Moore's work, with that of Nash and Nicholson amongst others, was shown alongside Surrealist work by Arp, Miró and Ernst when the Mayor Gallery re-opened in April with a large, international exhibition. In an article in *The Listener*, Nash summed up a 'contemporary spirit' on the one hand of abstract art and, on the other, of Surrealism. He identified the first with 'the pursuit of form', describing it as 'the expression of the structural purpose in search of beauty in formal interaction and relations apart from representation'. In Surrealism he saw 'the pursuit of the soul, the attempt to trace the "psyche" in its devious flight', and he recognised that artists were engaged in psychological research 'parallel to the experiments of the great analysts'.[18]

Nash had already equated Surrealism with psychology two years before when he had written about the work of de Chirico: 'This "world" exists by virtue of the functions of the subconscious mind ... [and] is now inhabited and extended by an ever-increasing number of painters and writers who are recognised under the rather misleading title of the surrealist movement.'[19] His assumption that the average reader of *The Listener* would have no trouble with the idea of the subconscious mind or the comparison of an artist's work to that of a psychoanalyst is a reminder that by the end of the twenties, a knowledge of analytical psychology was commonplace among

intellectuals in Britain. It can therefore be assumed that Moore himself was no stranger to the general ideas of the leading figures, Sigmund Freud, Carl Jung and Alfred Adler. A familiarity with Jung's ideas is likely in the circle round Herbert Read, who became one of the editors of his complete works in English translation[20] several years later, when he also edited the first volume of Moore's collected work.[21]

It is not surprising therefore, that Moore used the terminology of psychoanalysis in his next statement on art, published in *The Listener* in August 1937. He discussed drawing as well as sculpture and expanded on the importance of natural forms that he had outlined in *Unit One*. Moreover, he took the role of the 'subconscious part of the mind' for granted, both in creation and in the receptivity of the viewer:

There are universal shapes to which everybody is subconsciously conditioned and to which they can respond if their conscious control does not shut them off.

And the sensitive observer of sculpture must also learn to feel shape simply as shape, not as description or reminiscence. He must, for example, perceive an egg as a simple single solid shape, quite apart from its significance as food, or from the literary idea that it will become a bird. And so with solids such as a shell, a nut, a plum, a pear, a tadpole, a trunk, a bird, a bud, a lark, a ladybird, a bulrush [sic], a bone.[22]

In the first part of this quotation there is a clear connection with Jungian analysis. In the second, the list of random objects unlikely in Moore's oeuvre as subject matter may point towards the method of free-association described by the poet André Breton, the initiator of Surrealism. Breton's ideas had become available in English in 1936 with the translation of several of his essays as *What is Surrealism?*[23] Moreover, Breton's practice of sitting down in a passive and receptive state of mind and writing uncritically what came into his head is not unlike Moore's description of his own drawing methods in *The Listener*: 'I sometimes begin a drawing with no preconceived problem to solve, with only the desire to use pencil on paper, and make lines, tones, and shapes with no conscious aim'.[24] He could, of course, record ideas on paper far more quickly than he could make sculptures and, he explained, 'My drawings are done mainly as a help towards making sculpture – as a means of generating ideas for sculpture, tapping oneself for the initial idea; and as a way of sorting out ideas and developing them.'[25] By itself this might have resulted only in his filling sketchbook pages to provide a ready-reference of form-ideas for carvings but, although there are sketchbook pages which are just that, Moore continued to make finished drawings.

The evolution of the arrangement on the page progressed from a simple one of two figures (cat. 51) in 1924 to the montages of the late twenties. One of these, cat. 64, was made from ideas cut from his sketchbooks by the artist's wife, Irina, who was herself a trained painter. In 1931 Moore made two woodcuts (CGM 1, fig. 16; 2) which entailed 'carving' a drawing by incising the lines on the woodblock. The experi-

Fig. 16. *Figures Sculptures*, 1931, woodcut, The Henry Moore Foundation.

ence resulted in a new approach to design and, by 1934, his compositions became more elaborate. A favourite arrangement was a large central form surrounded by many smaller ones, sometimes in an asymmetrical arrangement as in *Study for Recumbent Figure* (cat. 75). This method, however, has the disadvantage of suggesting that one idea is dominant and the others subsidiary and Moore seems quickly to have adopted a more symmetrical arrangement of rows of larger forms, as in the *Ideas for Metal Sculpture* (cat. 80). Here, somewhat surprisingly in view of his avowed dislike of relief sculpture, he suggested a shallow background; the elements are less organic than usual and he may have been considering the additive method of making sculpture by welding one segment to another. Indeed, his exploration of methods seems most adventurous in drawings of 1934: the cavernous head in cat. 81 is a conglomeration of separate planes that would have had to have been assembled rather than carved or cast, whilst, in a sketchbook page of *Ideas for Reliefs* (cat. 79), he seems to have considered using metal alone to provide linear abstractions. These drawings of sculptural ideas based on experimental methods did not result in three-dimensional work, but they reveal Moore's interest in the rival claims of 'instinctive' and 'considered' compositions which he elaborated in his *Listener* article.

His description of a balance between automatic procedures and the control and ordering which followed when 'some idea becomes conscious and crystallizes',[26] can be related to

contemporary Surrealist and Constructivist practice. His familiarity with Surrealism has already been discussed and he became more aware of the 'Constructive idea' when it was made manifest in London by the visit of Naum Gabo in 1935, and his settling in Hampstead the following year.[27] Gabo proposed and became an editor of the book *Circle, International Survey of Constructive Art*, published in 1937, to which Moore contributed some photographs and a statement.[28] From that year Moore extended his range in drawing and sculpture by incorporating strings. Although the acknowledged source was the mathematical models in the Science Museum, he subverted the original purpose of the nineteenth-century models. He attached his own threads to structures based not on geometric forms but on the imaginative transformation of organic forms. A number of sheets of drawings for this type of sculpture show his prolific ideas in this vein (for instance, cat. 90); moreover, in these drawings he also considered the arrangement of the forms on the page, placing some of the most austere (cat. 88) in a stage-like setting with a background reminiscent of contemporary white reliefs made by Ben Nicholson.[29] Thus, as Moore maintained in *The Listener*, it was not a matter of a 'quarrel between the abstractionists and the surrealists' which 'seems to me quite unnecessary. All good art has contained both abstract and surrealist elements, just as it has contained both classical and romantic elements – order and surprise, intellect and imagination, conscious and unconscious.'[30]

It is clear that the choice for Moore was not the superficial one of whether he could think of new methods of working that might be more interesting or more modern, but whether new ideas would expand and extend the range of his deepest concerns in sculpture making. His preoccupation with the human figure – usually female – standing, seated and reclining, was already paramount. As he wrote in *The Listener*: 'Each particular carving I make takes on in my mind a human, or occasionally animal character and personality, and this personality controls its design and formal qualities, and makes me satisfied or dissatisfied with the work as it develops.'[31] When he had spoken of the human association, it was not physical resemblance that was in question, even though to this quotation can be added words found on a drawing (cat. 97) of 1940: 'The human body is what we know most about, because its [sic] ourselves: and so it moves us most strongly we can make complete identity with it.' On the same drawing he averred that just because the human body is sculptural (no doubt because it is three-dimensional), 'the sculptor cannot be a copyist, but has to make changes and re-create it.' Drawings show that the re-creation consisted in replacing formal likeness by the manifestation of psychological reality,

fulfilling Nash's description of artists being engaged in work, 'parallel to the experiments of the great analysts'.[32]

An all-important sketchbook dating from 1939–40 shows that Moore had by then become obsessed with the opening out of forms, horizontal, vertical, half-length or less, as well as full size. The opening out would permit him to make vertical forms analogous to his sinuous reclining figures. Particularly in the vertical figures in these drawings a curved form, solid like a shield, encloses a skeletal, apparently separate structure within; this can be seen most clearly in *Two Standing Figures* (cat. 100) of 1940. The invention is potent: by opening the solid 'body' and displaying the vulnerable interior form, Moore conveyed the duality of conscious and unconscious that he had alluded to in *The Listener*.

Moore's conception of an external form enclosing an internal one, so clearly expressed in his ideas for vertical sculptures drawn in 1939–40, reflects psychoanalytical thought, whether by intention or by chance. The outer form hiding an inner one reflects the relationship between the persona and the anima. The persona can become a mask or disguise behind which the real nature is concealed and had thus been defined by Jung: 'The persona is a compromise between the individual and society based on that which one appears to be.'[33] In his drawings Moore reveals the half-hidden internal 'structure', the 'anima' which is found inside every human being; he may even have intended to convey the duality of conscious and unconscious.

As well as a link with contemporary analytical psychology, other connections can be made: these are not mutually exclusive, but together create a rich context for the internal and external form idea. For instance, from his study of 'primitive' art, Moore must have been aware that the idea of one form enclosing another is central to many cultures, often expressed in the mask. Furthermore, in a sketchbook page of about 1935, Moore drew a type of 'framework' sculpture called a 'Malanngan' from New Ireland, of which an example was on view at the 'Exposition Surréaliste d'Objets' held in Paris at the Galerie Charles Ratton in 1936.[34] He inscribed the page *forms inside forms* (HMF 1226), so, from the beginning, the idea found roots in 'primitive' art.

There is still another precedent for the internal and external form in the plates of an authoritative handbook of English medieval sculpture by Arthur Gardner, published in 1935,[35] where the majority of the carved and bronze effigies of knights have helmeted heads. Whether made of chain mail or metal plate, these helmets enclose the heads so that little of the face remains visible; many of the accompanying female effigies have faces surrounded by headdresses that partially hide their features. Moore's *Two Heads, Drawings for Metal*

Sculpture (cat. 93) of 1938 can be interpreted as the heads from such a pair of effigies: the one on the left wearing a helmet, the one on the right enclosed by a wimple. Unlike their medieval prototypes, however, they lack all facial features, the hollow 'shells' protect an embryonic structure, suggestive of the 'real' person inside the rigid persona that they have constructed as a defence against the world.

Another approach to the head is found in Moore's slightly more representational drawing, *Spanish Prisoner* (cat. 94), where the head inside a 'helmet' expresses a haunting vision of imprisonment, with barbed wire running across the face. This narrative element was no doubt included because the image was intended for a deliberately political gesture, a lithograph to be sold in aid of Republican soldiers who had been interned after escaping to France; in the end, very few copies were printed (CGM 3). At this time Moore was active against pacifism, which he felt was inappropriate in the face of the suffering in Spain; like many artists he had signed a manifesto produced by the Artists International Congress in 1936. His concern to reach a wide public may have lead him to re-read Herbert Read's article, 'What is Revolutionary Art?'[36] Read had made a case for abstract art being more revolutionary than surrealist art, which he felt would not endure and he had named Moore among true revolutionary artists, 'whom every Communist should learn to respect and encourage' in spite of his being a '"so-called" abstract artist'.[37] In his 1937 article for *The Listener* Moore explained why he had come to favour abstraction: 'My sculpture is becoming less representational, less an outward visual copy, and so what some people would call abstract; but only because I believe that in this way I can present the human psychological content of my work with the greatest directness and intensity.'[38]

The declaration of war with Nazi Germany in September 1939 and the shattering blow sustained by left-wing intellectuals when Stalin formed an alliance with Hitler shortly before, was clearly an impetus for artists to reconsider the fundamental premise of their work. Moore later admitted that, 'Without the war, which directed one's direction [sic] to life itself, I think I would have been a far less sensitive and responsible person. The war brought out and encouraged the humanist side in one's work.'[39]

An opportunity for a humanist approach came unexpectedly in 1941, when Moore became aware of the shelterers in the London Underground and began making drawings of the scenes. Kenneth Clark, chairman of the War Artists' Commission, recommended that Moore be made an Official War Artist.[40] Moore had come upon the subject quite by chance, while taking the Underground train home after going out to dinner one evening. The scenes on the platforms fascinated

Fig. 17. *Drawing*, c. 1942, pen and wash, Private Collection.

him, for he saw there rows and rows of reclining figures – his favoured sculptural subject, which, in these poignant drawings, he treated in a more lifelike way. Yet he did not altogether forsake the idea of metamorphosis: in cat. 152 the blankets enclosing the figure on the right share the convoluted curves of the shells that Moore had studied in a Transformation drawing ten years before (fig. 15). What is new is his formal grouping of figures in *Grey Tube Shelter* (cat. 147), or *Group of Shelterers During an Air Raid* (cat. 151); they have a sense of conventional pictorial composition which had only been hinted at before. However, the drawings are not strictly literal, for instance, in *Tube Shelter Perspective* (cat. 149) the tunnel is reduced to a vortex which seems to suck the figures into its centre. Londoners were able to identify with Moore's vision of their plight and an exhibition of Shelter drawings at the National Gallery (emptied of its treasures for the duration and a venue for lunchtime concerts) helped many people unexpectedly to enjoy 'modern' art.

Today's younger writers, who did not experience the sensation of being marooned on an island with a constant threat of invasion, often imagine that War Artists were involved in propaganda. It is true that this war work had to fall within a range of subject-matter chosen by the War Artists' Advisory Committee, though the way they treated it was left to the artists, and the resulting work was approved for purchase for the nation both for its artistic quality and as a record of the times.[41]

After the London Underground had been turned into formal air raid shelters, fitted with bunks and canteens, Moore felt he had extracted as much as he could from the subject; two others were proposed to him by the War Artists'

Advisory Committee, one, special first-aid posts, the other, coal-mining.[42] Moore favoured the first which, however, did not materialise; the second, which did, resulted in a visit to his boyhood town, Castleford, to the very coal-mine where his father had worked, Wheldale Colliery. No doubt, as he recalled, the visit was a traumatic experience, but it gave him the opportunity to study men at work and widen his subject-matter which up to that time had been oriented almost exclusively towards the female figure.

During the war years Moore continued to use drawing as a vehicle both for noting sculptural ideas and exploring his own range of attitudes to the making of sculpture. 1942 was a particularly fruitful year; he extended a favourite maxim 'Sculptural energy is the mountain'[43] with three drawings of sculpture in front of huge rocks, which later provided him with a source for his first two-piece reclining figure (cf cat. 160 and cat. 177). He also drew one of his most surreal and enigmatic images, with uncarved stones lying in the field next to the group of figures gazing at a tied-up object (see cat. 167). In total contrast to *Crowd Looking at a Tied-Up Object* (HMF 2064) is the multi-part drawing (fig. 17, HMF 2025 *verso*) which includes three views of a representational reclining figure, seen both out of doors and in the studio or museum. In the view shown bottom right, the sculpture, though female, is closely related to the river-god Ilissus from the Parthenon pediment, which had been taken in 1939 for safe keeping to the London Underground with the rest of the Elgin Marbles.[44]

Such a reconsideration of classical Greek sculpture by Moore at this time is perhaps surprising, considering the need to deny the 'Greek Ideal' that he had identified in 1930. Yet the drawing of Ilissus anticipates a connection that he crystallised in slightly later drawings made as a result of an invitation to provide illustrations for *The Rescue* by Edward Sackville-West, a play originally performed as a radio drama in November 1943, with music specially composed by Benjamin Britten. When it was published in 1945 it was subtitled 'A Melodrama for Broadcasting based on Homer's Odyssey'. In his Preamble the author made no apology 'for the startling parallel between the story, as I have told it, and the present state of Greece.'[45]

As well as providing him with a new vein of subject-matter, Moore's illustrations for the book mark a watershed in his work, for they are among the most openly narrative drawings that he ever made. He filled a sketchbook with ideas and made a number of larger, finished drawings, though only six were published. In the last (fig. 18), drenched in glowing cardinal red, Penelope's suitors, slain at the hand of Odysseus, are lying in disarray, across tables, on the floor, in a composition reminiscent of the Shelter drawings. The dying men also

Fig. 18. *Penelope's Suitors*, drawing for Plate 6 of *The Rescue*, 1945. The Cecil Higgins Museum, Bedford.

anticipate the warrior sculptures that Moore made in the fifties (cat. 138), an analogy noted by Robert Melville.[46]

Although nothing like as dramatic, the opening illustration seems to have had an even more lasting effect on Moore's work. He drew Telemachus, the son of Odysseus and Penelope, standing in a landscape with the poet Phemius, whose role is discussed by Sackville-West:

The role of Phemius has an importance in the play far outweighing that allotted to him by Homer. . . . As Prologue and Epilogue he speaks for myself, and indeed throughout the play his role is ambiguous and Harlequinesque. He is the Poet, rather than any particular one, and I have tried to invest him with something of the mysterious timelessness, the knife edge balance between being and not being, which only the poetic imagination seems able to achieve. In what is on the whole a most objective work, Phemius alone is given the licence to express some of my own feelings about the world which is common to us both.[47]

Moore distinguished the head of Phemius from that of Telemachus by removing particularities of feature, giving him mystery, or 'the knife edge balance between being and not being', a description which must have had a particular resonance to himself, the poet-turned sculptor. Indeed, the 'knife edge' became one of his most potent symbols and he appropriated the title in major sculptures such as cat. 182.

Just as the pre-war drawings for upright figure sculptures were brought to fruition in the *Upright Internal/External Form* (see cat. 118) in 1952, the concept of the knife edge, set out so poetically by Edward Sackville-West in 1945, took many years of gestation before finding a triumphant embodiment in a heroic modern 'Winged Victory' in 1961. Moore liked the comparison made by some people between the *Standing Figure: Knife Edge* (cat. 179), based on the transformation of a bone, and the *Winged Victory of Samothrace* in the Louvre. It is unlikely that such a connection would have been acceptable to the artist in the years before the Second World War, yet some of his works from the thirties were given new interpretations linking them to Greek mythology when, in 1951, the British Council organised an exhibition of Moore's work in Athens.[48] A Greek critic recognised 'blocks of stone' such as *Square Form* (cat. 27) as realisations of a 'mythological vision', in particular, he recalled the legend of Deucalion and Pyrrha who had 'repopulated the earth after the Flood by throwing down behind them stones which they had picked up and warmed. "Can one depict these stones at the moment of their amazing transformation" Procopion asked, and concluded, "Moore's sculptural works are realizations of such a mythological vision."'[49]

The immediate trigger for this analogy in 1951 was surely Moore's most recently completed graphic work, illustrations for Goethe's play on a classical theme, *Prometheus*. The French translation by André Gide had been published the year before, with lithographs printed in Paris (CGM 18–32).[50] As well as the title role, the characters include Pandora, whose beautiful body had been fashioned by Epimetheus from clay and water like a sculpture. In one lithograph, Moore chose to show her as a nubile girl standing beside the immediate precursors of the *Upright Internal/External Form*. He gave the lithograph the title *Pandora and the Imprisoned Statues* (CGM 31) which creates yet another context for this potent sculptural idea. The text is redolent with myth, but, although Moore wrote titles on the proofs, these were not included on the final prints. When *Prométhée* came to be documented in the catalogue raisonné of Moore's graphic work, anodyne titles, then in current use, were given for many of the pages, such as *The Four Sketches* (CGM 23).[51] Perhaps by that time Moore had genuinely forgotten the

details of the story; alternatively, he may have wanted to suppress allusions to a subject whose influence was strong for a comparatively short period and subsequently waned.

None the less Moore never repudiated the influence of classical mythology which was set out in a study of his work by the Jungian analyst Erich Neumann in 1959.[52] In Moore's drawings made between 1944 and the mid-fifties, Neumann named the groups of three woman as the Three Fates, the daughters of Night (whom Homer had identified as the individual and inescapable destiny that followed every mortal being). Neumann particularly drew attention to the *Three Standing Figures in a Setting* (cat. 170) of 1948 where he saw the 'prison' walls of pre-war drawings such as cat. 88 newly pushed open, the figures emerging into the light of day with the sea behind them a symbol of the creative unconscious. Moore declined to read further than the first chapter of Neumann's book on the grounds that 'it explained too much about what my motives were and what things were about.'[53] Moreover, from the late fifties onwards he made no further drawings that can be related to myth, though his love of the landscapes of Greece remained and is the subject of drawings from 1957 and c.1972 (cat. 206).

His experience of making lithographs from the late forties onwards had a lasting practical effect, for it evidently encouraged Moore to reconsider technical procedures; as in the late thirties, colour began to play a different role. He used it again as he had in *Drawings for Stone Sculpture* (cat. 87) from 1937, which he had embellished with areas of coloured crayon, unrelated to the forms and as freely applied as in comparable work by the most abstract painters. Although there are a few other examples from the thirties of this uninhibited attitude to colouring, based then, no doubt, on Surrealist 'automatic' procedures, Moore's renewed exploration of such techniques in the late fifties coincided with the general interest in American Abstract Expressionism. (The paintings of Jackson Pollock were shown in London at a retrospective held at the Whitechapel Gallery in 1959.[54]) However, long before younger artists had again discovered the power of automatism, Moore had been an adept, and he now built upon his own precedents to create strong drawings. Thus, in the background of *Reclining Figure: Bunched* (cat. 175), indecipherable figures are scrawled across the paper in coloured chalk, apparently emanating from unconscious regions of the mind.

Whereas in drawings such as the *Family Group* (cat. 169) of 1948, figures in a more classical style had provided ideas for sculpture, in 1961 Moore drew the foreground reclining figure of the title from his own existing maquette. This was a new departure and is a reminder that from the late fifties onwards maquettes took the place of drawings as a means of

trying out his sculptural ideas. Instead of transforming them in drawings he began to incorporate found objects such as bones and flints in the sculpture models themselves (fig. 19).

His rejection of drawing was preceded by the publication of an enlarged sketchbook, *Heads, Figures & Ideas*, which was 'completed and designed in 1957 by Henry Moore' with an 'autolithograph frontispiece drawn in 1958'.[55] With its large format, this was a departure from the usual books on art, for it had no printed text except a 'comment' by Geoffrey Grigson; it was simply a faithful reproduction of sketches, drawings and hand-written notes by the artist. Pages from two Shelter sketchbooks had already been published in 1945[56] but the new book was distinguished by a surprisingly didactic approach. One page included a tipped-in photograph of an eighteenth-dynasty Egyptian head of a woman from the Archaeological Museum in Florence, which shared the page with Moore's handwriting:

I would give everything, if I could get into my sculpture
the same amount of humanity & seriousness,
nobility & experience,
acceptance of life, distinction, &
aristocracy
with absolutely no tricks
no affectation
no selfconsciousness
looking straight ahead, no movement, but more alive
than a real person.

This is only one of several injunctions to himself, likewise arranged on the page as though they were prose poems, or possibly following the example of Ozenfant's seminal treatise, cited above, which had been reissued as a paperback with similar arrangements of printed aphorisms in 1952.[57] Especially revealing in Moore's sketchbook is:

the great (the continual, everlasting)
problem (for me) is to combine
sculptural form (POWER)
with human sensitivity & meaning
i.e. to try to keep Primitive Power with humanist content[58]

Such soul-baring none the less smacks of a certain naïvety of thought that must have seemed old-fashioned, if not beside the point, in 1957, to a younger generation of artists. For, in the following years when Moore reached an apogee in his creativity, as well as achieving international recognition, his erstwhile assistant Anthony Caro challenged the whole premise of carved and modelled sculpture.[59] His example was followed by Phillip King, who was himself working as Moore's assistant during those very years (1958–60). Furthermore, from 1961–4 the young sculptor Isaac Witkin worked as his assistant, so Moore must have been aware of the rise of a 'New

Fig. 19. Bone and clay maquette on which *Working Model for Standing Figure: Knife Edge* (cat. 179) was based.

Generation' with a totally fresh conception of sculpture. In 1961 King described this as based on admiration for the 'message of hope and optimism, large scale, less inbred' American abstract painting.[60] Another protagonist, William Tucker, saw its 'precedents in painting and poetry' rather than the tradition of sculpture.[61]

There are so few sketchbooks from about 1961–71 that there are no clues to Moore's response which might have been found in annotations. Moreover, when the edited collection of polished writings and interviews with Philip James was published in 1966 as *Henry Moore on Sculpture*,[62] issues of contemporary art were ignored. That book, with another that followed two years later with photographs by John Hedgecoe,[63] established the 'myth' of Henry Moore. No longer was he seen as searching for means of expression, but presented as the master twentieth-century sculptor. When James's book was published in a paperback edition,[64] an end-on view of the *Standing Figure: Knife-Edge* (cat. 179) was placed next to Michelangelo's *Rondanini Pietà* on the cover, a juxtaposition which today must surely harm rather than help the reputation of Moore. Such crassness, however, cannot

finally damage Moore's stature, which deservedly increased in the sixties because of his powerful, less representational images cast in bronze. Sculptures, such as *Atom Piece* (cat. 184) and *Oval with Points* (cat. 186), reflect a vision based on nature, whose transformation into art he had first discovered in drawings in the early thirties.

With a never failing demand for his work abroad and his reputation in Britain enhanced by the major retrospective exhibition held to celebrate his seventieth birthday in 1968,[65] Moore began making drawings again. He drew now for pleasure, rather than to note down ideas for sculpture, starting with what he called Pen Exercises (like cat. 203) to get his hand back into practice (though he had made numerous engravings during the sixties). He told Pat Gilmour that he had been inspired both by the abstract calligraphy of Rembrandt's pen drawing and the Harari collection of Japanese art which he visited at the Victoria and Albert Museum.[66] The body of drawings from 1970 to 1983 is enormous, partly because as he became more infirm, drawing became more and more his days' work. Some drawings, for instance cat. 205, were intended as preparatory works for etchings and lithographs; others had prints made from them. There were frank reworkings of earlier ideas – cat. 208 is one of a series worked up from drawings inspired by his daughter doing school-work in the fifties; there were also entirely new subjects like the sheep in the field next to the studios where he worked.

At first sight there is no 'context' for the sheep drawings other than Moore's free choice; in the late sixties he had reshaped the landscape the better to place a sculpture in the field overlooked by windows from his studios, from which he could see the grazing sheep. It is tempting, therefore, to provide a possible trigger, a cartoon made about 1968 by Glyn Foulkes, entitled *St Martin's-in-the-Fields*.[67] The title is a pun on the art school higher up Charing Cross Road, St Martin's, where, under Anthony Caro and Phillip King, the new approach to sculpture was flowering, and, in Foulkes's drawing a sheep, labelled '1968', stares across a five-barred gate at sculptures by Caro, Tucker, King and Barry Flanagan, whose uncoiled rope creeping under the gate points towards the Conceptual Art of the following years.

Certainly Moore's sheep took the place of the life-models from which he had worked in the twenties; they provided a subject for life drawing, though occasionally more sentiment crept in to them than he had allowed himself as a young man (cat. 225, 226). When he also turned to landscape in his last years, he began to explore mountains themselves where he had previously used woman to illustrate the maxim 'Sculptural energy is the mountain'.[68] Often drawn from photographs or his imagination, the rocky outcrops double as figures, sometimes outlined in black and white, sometimes rendered in lyrical Turneresque watercolour, such as cat. 230 and 231. Moore also found human forms in the trees which he observed near his home in Hertfordshire (see cat. 211).

In these last years he did not abandon the female form, seated, standing and reclining, which had so often provided the subject for sculpture and drawings. His adoption of the theme in the twenties had coincided with the publication of novels by D. H. Lawrence, which Moore had read avidly[69] and it seems likely that he had derived his obsession for the subject from that other son of a miner, who had risen to fame and notoriety through his novels about women. Moore had read the classics, even the modern classics such as the complete works of Thomas Hardy, but Lawrence was the pioneer who unravelled intricacies of thought and temperament in his heroines. For most of his life, some words from *Women in Love*, published when Moore was in his first year at the Royal College of Art, might have served as his motto: 'Hermione saw herself as the perfect Idea, to which all men must come; and Ursula was the perfect Womb, the bath of birth, to which all men must come!'[70]

The liberation of women followed upon Lawrence's analyses of their capacity for relationships; it also followed, in parallel, Moore's investigations into the 'Idea' and 'Womb' in his new forms of drawing and sculpture. The eighties mark a time when woman finds the need to restore to herself some of the gentleness which she had herself earlier suppressed; this was a quality that Moore had very often denied her in the work of his earlier years. At the end of his life he was able in part to return it to her, while continuing to acknowledge her underlying strength. She became for him more human than goddess, more mother than harpy, though she still remained an archetype, as much the artist himself as his creation. Moore's sculpture and drawings will continue to be admired, not only for their stylistic innovations but as an embodiment of universal psychological truths.

HENRY MOORE:
AN ENGLISH ROMANTIC

PETER FULLER

By the time that Henry Moore died in 1986, his work had been distributed more widely throughout the Western world than that of any other sculptor, living or dead. No city seemed complete without some gargantuan cast of a Moore dominating one of its choice, civic positions; but long before Moore's death, many prominent artists, critics and intellectuals were arguing that his work had become remote from the concerns of a contemporary artistic culture.

In one sense, perhaps, they were right; for, in retrospect, though Moore was a highly original artist, he was not, as has sometimes been suggested, a pioneer of modern sculpture; on the contrary, despite his rhetoric and that of his protagonists, his achievement was realised largely against the grain of modernity. But if Moore's reluctance to espouse the modern world in all its aspects – the very 'avuncularity of his modernism' as Charles Harrison described it[1] – was once construed as a weakness, a failure of nerve, today it is beginning to appear as among Moore's greatest strengths; for, these days, modernism itself has begun to look as current jargon has it, 'problematic'. Moore is beginning to be seen in his true colours as the greatest twentieth-century exponent of a continuing, British, romantic tradition . . . a tradition which, with the choking of the motor of modernism, may be undergoing something of a Renaissance.

One of the earliest sculptures by Henry Moore is *Mother and Child* of 1922 (LH 3, fig. 20); an appeal was recently made for information concerning the whereabouts of this work, but, at the time of writing, that remains unknown. Even from a photograph, however, it is easy enough to see how both the imagery of the piece, and the way in which it was cut from the stone, were of a kind which was to dominate Moore's imagination and his working practices, throughout the 1920s.

The work shows a woman seated on the ground with her arms around her knees; a baby's head and hands protrude incongruously from the side of the mass of stone which represents her body. The shape of the sculpture follows closely that of the block of stone from which it has been coarsely, if vigorously, hewn. There is no sense of finish to the forms or the surfaces and the tracks of the claw chisel are

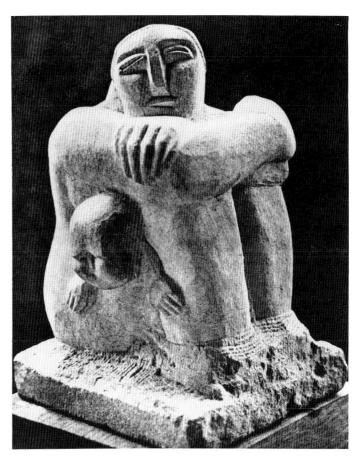

Fig. 20. *Mother and Child*, 1922, H. 11 in., Portland stone (lost).

visible everywhere, although they are especially clear at the base of the woman's stumpy legs. The work is closely related to a fifteenth-century Aztec sculpture of a seated man, believed to be the god Xochipilli, from the Bullock Collection in the British Museum and reveals how intently Moore had been looking at 'primitive' sculpture in the visits he made there at this time.

In one sense, this *Mother and Child* set the agenda for Moore's oeuvre in the 1920s. He carved masks, stone heads, and animals; but his favoured themes were pursued within a surprisingly narrow range. 'There are three recurring themes in my work,' Moore himself once said, 'the "Mother

and Child'' idea, the ''Reclining Figure'' and the ''Interior/Exterior'' forms.'[2] At least two of these were markedly present in this 1922 *Mother and Child*; all were to emerge strongly during Moore's first decade as a practising sculptor.

However, these carvings of the 1920s still present problems for evaluative criticism. They have been heralded as the foundation of the modern movement in sculpture in this country yet are they really 'modern' at all? Certainly they are not in Nikolaus Pevsner's sense: 'The Modern Movement . . .,' he wrote, 'in order to be fully expressive of the twentieth century, had to possess . . . the faith in science and technology, in social science and rational planning, and the romantic faith in speed and the roar of machines.' This 'Modern Movement' ('anti-Gothic', Pevsner says, in that it eschewed all 'other-worldly speculation') was expressive of 'this world in which we live and work and which we want to master, a world of science and technology, of speed and danger, of hard struggles and no personal security.'[3]

Moore's early sculptures were almost the antithesis of such ideals. Far from seeking to be 'fully expressive of the twentieth century' Moore seemed to want to turn his back on the modern world and all its works. As John Rothenstein once pointed out, were, say, *Mask*, 1924 (LH 21), 'placed with others in a collection of ancient Mexican sculpture, it would take an experienced scholar to pick it out as a modern derivation.'[4] Moore's imagination shows no concern with, let alone faith in, science, technology, social science, or rational planning, and is devoid of any suggestion of 'romantic faith in speed and the roar of machines', which, as far as Moore's sculptures were concerned, might never have existed. His techniques, after all, involved the rehabilitation of the claw chisel, the use of which in sculpture had been in steady decline since the Renaissance. So, far from being 'anti-Gothic', Moore complained in a letter of 1924 of the 'wilful throwing away of the Gothic tradition'[5] in the West. Nothing about his sculpture suggested a desire to triumph over the world of nature, or to dispense with a sense of personal security: rather, from the beginning, Moore's work seemed inspired, at least in part, by a yearning for harmonious fusion between image and matter, infant and mother, figure and ground, subject and object. His sensibility was not only unmodern; it was, in many ways, profoundly anti-modern – and this, perhaps, was one reason why at first it seemed to many so scandalous, indeed so 'primitive'.

Nevertheless, this is not to say that when Moore's work began to appear in the London galleries it was unprecedented; Gaudier-Brzeska had long since revived the idea of 'truth to materials': I say 'revived', because Gaudier-Brzeska was an admirer of Ruskin and almost certainly first came

across the doctrine in *The Stones of Venice*.[6] ('Sculptural energy,' Gaudier once declared, seemingly echoing Ruskin, 'is the Mountain.'[7]) Eric Gill was engaged upon his crusade for direct carving, through which he hoped to 're-sacralise' human labour, and restore it to its medieval condition. Jacob Epstein – the exemplars for whose architectural sculpture were the medieval cathedrals of France[8] – put such archaising sculptural practices onto a wider and more public stage.

The twentieth-century British sculptural 'pioneers' were, then, in aesthetic terms at least, reactionary, in that they took their standards from the past; their strengths were rooted in their unswerving desire to restore lost sculptural values, to re-affirm the vitality and spirituality of pre-Renaissance art. Indeed, the best British sculpture in the early decades of this century was, in terms of its cultural stance, rather more like PreRaphaelitism, or at least the Gothic Revival, than it was like an avant-garde movement. Moore's work can, I think, best be understood in these terms: indeed, the comparison with PreRaphaelitism is, I think, peculiarly appropriate in his case, as what was new, original and fresh about his work was that imaginative and spiritual vision of nature which it embodied. But at first, this was by no means evident; as John Rothenstein has written:

If those . . . who had the perception and the foresight to acquire Moore's work in the 1920s were to compare examples of it with examples of the Mexican and other ancient sculpture which he assiduously studied and which he has always been ready to admit to be the very foundation of his art, it would be plain that many of them were little more than exercises – powerful and perceptive, but exercises none the less – in various early styles.[9]

They are exercises because neither the imagery, nor the forms, are yet Moore's own.

But as the 1920s became the 1930s Moore's work turned. Look, for example, at the marvellous little alabaster of a *Suckling Child* (LH 96) which once belonged to Canon Walter Hussey: there is no precedent, or prototype, for this moving piece in the art of the ancients; or compare the well-known *Reclining Figure* of 1929 from Leeds (cat. 9), with the *Reclining Woman* (LH 84) in green Hornton stone, from the National Gallery of Canada, which Moore made the following year (fig. 21). The Leeds figure is much better known, perhaps because it is easily and immediately related to a Mexican Chacmool carving, certainly known to him in a photograph, and a cast of which Moore may have seen in Paris; but the Ottawa *Reclining Woman* is, I believe, a greater sculpture: there was no precedent from the past for this audacious bunching up, and peaking of breasts and knees of a sculpted reclining figure into a mountain range.

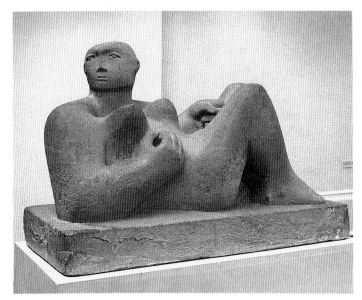

Fig. 21. *Reclining Woman*, 1930, L.37 in., green Hornton stone. The National Gallery of Canada, Ottawa.

How, therefore, did Moore arrive at these compelling sculptural images and forms? He himself always placed great emphasis on his first reading of Roger Fry's essay on 'Negro Sculpture', in *Vision and Design* in 1921, while he was a student at Leeds. 'Once you'd read Fry,' Moore commented, 'the whole thing was there'.[10] (Fry had stressed the 'complete plastic freedom' of African art, and the way in which the African artists 'really conceive form in three dimensions'.[11]) Everything else, Moore liked to imply, came from his visits to the British Museum while he was a student at the Royal College in the early 1920s.

Moore's comments on Fry have always been taken at face value, yet Moore's understanding of art was radically unlike Fry's; for Fry's doctrine of 'Significant Form' propelled him towards a position from which he defended the autonomy of art, and its separation from other levels of life and experience. Moore, on the other hand, always retained a more ethical conception of high aesthetic experience; indeed, in 1951, an exhibition of African tribal art led Moore to conclusions almost exactly the opposite of those of Fry: 'I do not think . . . ,' Moore said, 'any real or deeply moving art can be purely for art's sake.'[12] Again and again Moore distinguished between 'the provision of pleasant shapes and colours in a pleasing combination' and art which was 'an expression of the significance of life, a stimulation to greater effort in living'.[13]

There were, needless to say, influences other than those of Fry which Moore rarely acknowledged; the depth of his debt to Epstein (which Moore himself consistently underplayed) has been explored elsewhere.[14] Moore was, in most respects, a generous man; but he manifested an almost compulsive

need to ablate the memory of those artists who had a significant short range influence upon him, preferring to admit to having learned only from the likes of Michelangelo and Masaccio. Moore's few comments on British Victorian sculpture suggest that he agreed with the judgment of his friend, Herbert Read, that, 'The practice and appreciation of sculpture in England has been virtually dormant, if not dead, since the Middle Ages.'[15] There are, however, indications that Moore was in fact more deeply influenced by, say, G.F. Watts than he acknowledged. Compare, for example, the Titans in Watts's 'House of Life' designs with Moore's handling of the reclining figure; or Watts's *Mother and Child* of 1903–4 with a drawing like Moore's *Mother with Child holding Apple II* (HMF 81 (253)), of 1981. But whether or not there was any direct influence, both these artists shared similar aesthetic ambitions: Moore, we might say, was closer to Watts than he ever was to Fry. Moore longed to create a spiritual and yet humanist art which touched upon the universal truths which lay behind the trappings of myth; for Moore, as for Watts, abstraction was a means to this end, rather than an end in itself.

Moore liked to give the impression that he followed a lonely path while he was at the Royal College between 1921 and 1931, inspired only by remote prototypes in the British Museum, but I am convinced that insufficient emphasis has been placed on the influence of his teachers and colleagues at the Royal College of Art, who were not all, as they are sometimes represented, ossified academics. Leon Underwood, for example, had a spiritual and imaginative view of art, not significantly different from Moore's own. In 1928 Underwood went to Mexico, and in 1929 he painted an oil, *Chacmool's Destiny*, which immediately preceded Moore's sculpted version of this subject.[16] Gilbert Ledward, professor of sculpture at the College from 1926 until 1930 is often said to have been antagonistic to Moore; and yet the similarities between

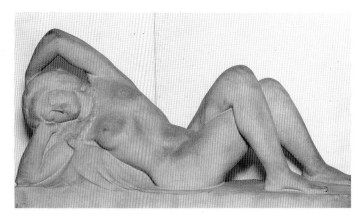

Fig. 22. Gilbert Ledward, *Earth Rests*, 1930 Royal Academy of Arts, London.

Ledward's private (rather than his commissioned) work and Moore's at this time are striking. For example, in 1930 Ledward completed a Roman stone sculpture, *Earth Rests* (fig. 22). 'The subject of this piece', Ledward explained, 'is "Earth rests, the ancient fires are still; her jewels are set, her knees drawn up like hills." ' He added that the 'solidity of the figure' was 'definitely established by the original block of stone' and that this shape had been deliberately retained to the end, so that 'the prominent parts of the figure combine to form outer planes which still represent the original surfaces of the stone.'[17] That is, he recognised the appropriateness of 'truth to materials', rather than classical canons of beauty, in depictions of the Earth Mother as a reclining figure.

Equally, however, the influence of Underwood, and Ledward – who were neither academics, nor modernists – on Moore should not be exaggerated. For, as Underwood himself well recognised, the ideas, and indeed the imagery, with which they were preoccupied in the late 1920s had a long history within the English romantic tradition; Ruskin had always seen in the mountain ranges the quivering presences of the women he never knew. He had found in the lowlands 'a spirit of repose', but saw 'the fiery peaks' as 'heaving bosoms and exulting limbs, with the clouds drifting like hair from their bright foreheads.'[18] 'Living art,' Underwood once wrote, 'feeds upon life and imagination. Past styles can be but mere spices in its frugal diet.'[19] Moore's work was coming to resemble Ruskin's words in another way too: 'Moore,' Herbert Read wrote, '. . . believes that behind the appearance of things there is some kind of spiritual essence, a force or immanent being which is only partially revealed in actual living forms.'[20] It was as if Moore was, albeit unwittingly, beginning to realise his own version of Ruskin's imaginings in stone. The stuffy aroma of the museum, and the ghosts of studied prototypes which cling to Moore's early sculptures, despite the boldness of their handling, begin to evaporate. We start to feel the energy of Moore's remembered response to the craggy landscape of his native Yorkshire, and of earlier, more disturbing experiences too.

Then, in the 1930s, Moore's work began to change. His sculptures began to embrace what, for him, were new forms. Modernist criticism has always tended to place an exclusive emphasis on the development of formal and technical means and to neglect consideration of the ends to which formal innovations are put. Whether or not Barbara Hepworth realised a pierced form before Moore, as her protagonists like to claim, the fact remains that plenty of punctured figures had already been produced on the Continent by Archipenko, Picasso, Vantongerloo, Lipchitz, *et al*, long before. In fact, Charles Harrison is right in one respect when

he writes: 'Moore was not himself responsible for a single, substantial technical advance which could be seen as such in the context of modern sculpture as a whole.'[21]

Moore was not interested in the idea of avant-garde innovation as an end in itself; rather, formal devices were, for him, simply a way of bringing about such transformations and metamorphoses of natural form as might enable him to intensify the emotive content of his work. This content was often quite different from that pursued by the continental innovators. 'My sculpture,' Moore himself said in 1937, 'is becoming less representational, less an outward visual copy, and so what some people would call more abstract.' But, he added, this was 'only because I believe that in this way I can present the human psychological content of my work with greatest directness and intensity.'[22]

Take, for example, the *Mother and Child* (cat. 30) of 1936, in Ancaster stone: it has sometimes been said that, in works like this, Moore was 'following the lead' of that biomorphism which Arp was pursuing in France. This may, or may not, have been the case, but it hardly seems to matter, for in this small work Moore achieved something Arp never did; this *Mother and Child* represents a radical re-working of the infant–mother theme as a subject for sculpture. It is quite different from, say, the nineteenth-century sculptor Dalou's treatment of the nursing couple as a sight or object of a third party's gaze; work which, today, we tend to regard as 'sentimental', or as evoking emotions which are not fully earned, or worked through in the forms themselves. Nor is this *Mother and Child* like Moore's borrowings from, say, the art of the Aztecs of ten years earlier. In this piece, Moore endeavoured to depict the relationship between child and mother from the inside: he has expressed that sense of mergence or fusion with the other which is an essential part

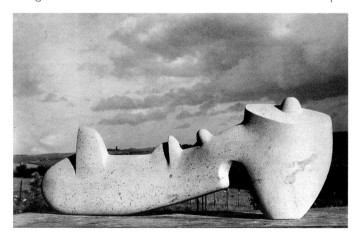

Fig. 23. *Reclining Figure*, 1937, L. 33 in., Hopton-wood stone, permanent loan to the Fogg Art Museum, University of Harvard. Photograph taken in Kent by the artist, *c*. 1937.

of the experience of infancy, but which cannot be seen from the outside. The sculpture gives plastic expression to the child's point of view, or way of feeling.

It must be admitted, however, that not everything Moore made in the 1930s can be seen in this way: works like the upright *Mother and Child* of 1936 (cat. 29), or, judging by the photographs, the *Reclining Figure* of 1937 (LH 178, fig. 23), have about them a now out-dated chic. They seem to want to declare, first and foremost, that they are *modern* sculptures although their novel forms do not reveal any new content. This was, I think, especially true of the stringed figures Moore made in the late thirties: Moore himself later came to criticise their divorce from what he called, 'fundamental human experience'; they are examples of the way in which the impact of modernism could deflect Moore from his true course.

In the late 1930s Moore also used what were for him new formal means through which he infused the great theme of the reclining figure with fresh meaning. Nowhere is this more clear than in the great reclining figures – three in elmwood (including cat. 25), and one, the Tate Gallery's *Recumbent Figure* (cat. 34), in Hornton stone – which Moore produced in those years. The idea of an identity between subject and object, woman and ground, which (as we have seen) had once been expressed through archaic (or, in Ledward's case, conventional) imagery and 'truth to materials' is now realised through forms themselves. By any account, the Tate's *Recumbent Figure* must be reckoned among Moore's greatest masterpieces.

Moore explained that the device of the hole enabled him to make a space and a three-dimensional form within a single object. As he pointed out, sculpture in air thus became possible: the hole itself can be the 'intended and considered form'.[23] But as the psychological force of this new formal device may have stemmed from the fact that the hole blurs the boundary between the object and its environment, the punctured figure can no longer be said to be contained by a limiting membrane, or skin, separating inside from outside: the image of the 'Earth Mother' is expressed not through the trappings of anachronistic myth, but rather through the language of sculptural form itself.

Transformation is at the centre of Moore's art; and it is this quality which differentiates him on the one hand from the Victorian sculptors, and on the other from the 'avant-gardists': indeed, this idea of 'transformation' links Moore to that other, great stylistic eclectic, Picasso. 'Only Picasso,' the painter Graham Sutherland once remarked, 'seemed to have the true idea of metamorphosis whereby things found a new form through feeling.'[24] But 'transformation', in this sense, was a romantic rather than a modernist idea; and Sutherland

admitted that what he admired in Picasso was a quality he had already encountered in Samuel Palmer, whose landscapes were also *transformed* by imagination and feeling.

I believe that the liberating force on Moore in the late 1930s was not his encounter with the modern movement but rather that great resurgence of English romanticism, about which we are slowly beginning to understand more and more. As the clouds of war began to gather, the Continental avant-garde artists who had sought refuge in London left Britain, mostly for America. There was then a turning inwards on the part of British artists and a welling up of interest in the imaginative and romantic traditions of Britain's past, and a new sense of interest in her architecture, her landscape, even her reformed religion. The critic who perhaps understood all this best was, of course, that great opponent of modernism, Kenneth Clark, who became a patron of the work of Moore, Piper and Sutherland. Moore's reclining figures of the late 1930s, at once injured and fractured, and yet vividly expressing a new sense of wholeness and unity, arose out of, and reached beyond, the fears and hopes of those troubled times. Freed of the inhibiting restraints of modernity, and yet nourished by its formal and technical innovations, Moore was able to begin to achieve his full stature. He benefited from what Robin Ironside called, 'a return to a freedom of attitude more easily accessible to the temper of our culture, a freedom of attitude that might acquiesce in the inconsistencies of Ruskin but could not flourish under the system of Fry.'[25] For, as Ironside put it, 'the best British art relied upon a stimulus that might be ethical, poetic or philosophic, but was not simply plastic.'[26]

Soon after the outbreak of war, Moore stopped making sculptures altogether. He did not, however, stop working creatively; indeed, he made his well-known Shelter drawings of people sleeping on the platforms of London's tube stations during air raids. The imagery was of such a kind as was bound to move Moore; mothers and children lay swathed and swaddled in rugs and blankets in long tunnels which stretched into the distance like the bowels of the earth itself. The scene was tinged with menace, and a sense of potential destruction; and yet, equally, it was suffused with a feeling of maternal intimacy. The wrappings and blankets which intertwine among the figures suddenly seem like shrouds; yet these suggestions of death are overcome, and, in the drawings, the final impression can be best described as one of stoic harmony.

These remarkable drawings are, I believe, among the finest ever produced in Britain: Moore made use of both his acute perceptual observation, and his powers of intense, imaginative transformation. Yet here we should emphasise that, in

'avant-gardist' terms, they are almost a step backwards from the work Moore was doing in the late 1930s. These drawings do *not* function primarily through the metaphors of form: Moore reveals himself confident enough to have reached back into the reservoir of classical convention which was anathema to the modern movement. Erich Neumann, the Jungian psychoanalyst who made a study of Moore's work, rightly argued that, in these drawings, the motif of intertwining drapery has 'the same formal role of uniting mother and child that the stone once had'.[27] The folding drapery in which Moore swathed his figures evokes the ghostly world of Victorian classicism: stylistically, these works have strong affinities with, for example, the drawings of Frederick Leighton. If the comparison sounds strained, compare the draped studies Leighton made for his *Fatidica* with *Shelter Scene: Two Swathed Figures* (cat. 152), 1941[28], or with *Woman Seated in the Underground* (HMF 1828) of the same year.

There is, however, a vacuity and a blandness about Leighton's 'art for art's sake' classicism, while Moore's work is charged with a depth of feeling at once deeply personal, and national. Moore's return to sculpture in 1943 was marked by his Northampton Madonna (cat. 102), a work which in its magnificent aloofness recalls the hieratic serenity of the English Romanesque; the hopeful dignity that Moore had managed to find even amidst the barbarity of global war contrasts strongly with the vision of a sick and mutant humanity expressed through Francis Bacon's *Three Studies for the Base of a Crucifixion* (belonging to the Tate Gallery), made at almost exactly the same time.

In a book on Moore, Herbert Read wrote:

The sculptor is essentially a public artist. He cannot confine himself to the bibelots which are all that fall within the capacity of the individual patron of our time. The sculptor is driven into the open, into the church and the market-place, and his work must rise majestically above the agora, the assembled people. But the people must be worthy of the sculpture.[29]

He complained that there was a long distance to be travelled before there existed between art and the people 'that spontaneous give-and-take of inspiration and appreciation which is the fundamental factor in a great period of art.' Genius, Read added, 'can never reach a final scope until sensibility is awake in the people'.[30] By the time the second edition of this book was published in 1949, these words had been excised. They had become obsolete. Moore's work entered a new and very public phase: there was a response to his sculpture from the agora, and beyond. This was a time when there was tremendous interest in British art, and in that peculiarly British cultural achievement which had its roots in the neo-romantic revival of the 1930s and 1940s.

Fig. 24. Stages in the carving of *Reclining Figure*, Elmwood.

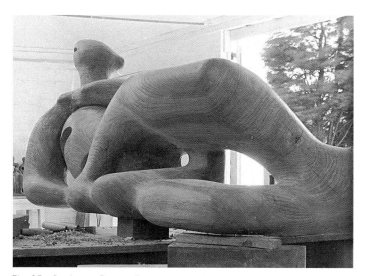

Fig. 25. *Reclining Figure*, Elmwood, L. 75 in.

Like the nineteenth-century romantics, Moore was revealing a growing obsession with classicism: in fact, it might be said that he was one of the last great artists whose imagination was structured in terms of this romantic-classical opposition; just as the PreRaphaelite revolution of the 1850s issued forth in a Victorian High Renaissance, so Moore's 'primitivism' of the 1920s developed into his classicism of the 1950s. His immediate post-war sculptures, like the great stone *Memorial Figure* (LH 262) in the gardens of Dartington Hall, Devon (fig. 1), and the extraordinary elmwood *Reclining Figure* (LH 263) of 1945–6 incorporating an explosive armoured head *within* an undulating female figure (fig. 25), or the ambitious family groups, such as cat. 107, all exhibit a poise and an equilibrium for which the work 'classical' seems appropriate; this association became explicit after Moore's trip to Greece in 1951, which resulted in works like the overtly Hellenic *Draped Reclining Figure* of 1952–3 (cat. 127).

Predictably, this change in Moore's work was associated with a change in his conception of the sculptor's role in the world, and also with a profound change in his working practices. Moore benefited greatly from the foresight and patronage of agencies like the British Council and the Arts Council of Great Britain, who successfully promoted his work and his reputation throughout the Western world. He, in his turn, saw it as his duty to serve upon those committees and public bodies dedicated to the advancement of art, especially of sculpture, in the modern world: he began to resemble those nineteenth-century classical artists, like Eastlake and Leighton, who also played a large part in public life.

Interestingly, Moore also began to return to those working practices which he had begun his life by rebelling against. Bronze became his favoured material; he often modelled pieces on a very small scale and his works were subsequently enlarged into working models and full-blown sculptures by assistants and craftsmen. The importance of 'truth to materials', he explained, had been exaggerated; the very idea of truth to a metal as versatile as bronze was without meaning. What mattered most was the imagination of the artist and his heroic aspiration to embody his imaginings in matter.

This phase of Moore's work ended with his gigantic UNESCO *Reclining Figure* (LH 416) which, exceptionally for this stage in his career, Moore *carved* for the organisation's headquarters in Paris during 1957–8 (see fig. 12); the completion of this sculpture, in Alan Bowness's words, marked a 'watershed' in Moore's development.[31] No other piece Moore had made had been conceived on such a gigantic scale: in front of this work, one realises what Kenneth Clark meant when he argued that, 'in Moore's work there is always at the back of his mind the memory of Michelangelo and the Greeks.'[32] Moore, Clark

believed, was driven by an 'urge to create an almost classical ideal of noble, placid female beauty', but, within a few years, his work was once again to be convulsed by a new, invigorating and transforming tide of romanticism.

Moore had now severed himself from the modern movement, and the assaults upon him, from a modernist stance, were not long in coming. Few were more vociferous in their condemnation of Moore than Clement Greenberg, a protagonist of abstract painting in America, who accused Moore of tastefulness and 'attachment to the past';[33] the final effect of a Moore sculpture, Greenberg wrote, 'somehow discounts the actual presence of modernist calligraphy and detail, to leave one with the impression, hard to define but nevertheless definite, of something not too far from classical statuary.'[34] Needless to say, for Greenberg, this was a singular fault. Truly new and modern sculpture, Greenberg insisted, 'has almost no historical associations whatsoever – at least not with our own civilization's past – which endows it with a virginity that compels the artist's boldness and invites him to tell everything without fear of censorship by tradition. All he need remember of the past is cubist painting, all he need avoid is naturalism.'[35] Greenberg announced that he could even agree with the opponents of modernism: 'I have had my fill of Henry Moore and artists like him.'[36] Thomas Hess was even more outspoken: he attributed the 'inflation' of Henry Moore's reputation to 'the achievement of British intellectuals, who, at the end of the last war, needed *chefs-d'école* who would be: native, yet Continental in style; metaphysical for metaphors, yet natural (i.e. connected with a country garden of the soul); verbally Socialist in human sympathies, yet aristocratic in stance.'[37]

The remark about 'a country garden of the soul' reflects back on the man, and the culture, from which it emanated; but this American view of sculpture was channelled back to England by one of Moore's erstwhile assistants, Anthony Caro, who was as dismissive of Moore's imagery, style and working practices, as he was of his stance. 'My generation,' Caro wrote in 1960, 'abhors the idea of a father-figure, and [Moore's] work is bitterly attacked by artists and critics under forty when it fails to measure up to the outsize scale it has been given.'[38] Under the direct influence of Greenberg, and of American abstract painting, Caro went on to advocate and to produce an urban, synthetic, constructed, and radically abstract sculpture, made out of brightly painted industrial components – usually steel. Caro's sculptures, wrote Michael Fried, one of the artist's American critical protagonists, 'reject almost everything Moore's stand for'.[39] As is well known, Caro himself quickly became the father figure of successive waves of fashionable sculpture in Britain, united in

little except their repudiation of Moore; indeed, as Moore's stature grew and grew in the world at large, the art world came to pay less and less attention to him, and he was largely ignored by those in a position to be influenced by him.

Much has been made of the 'innovatory', even revolutionary, qualities of British sculpture in the 1960s; but there is no doubt in my mind that the truly great and original work of this era was in fact made by Henry Moore. In 1959, Moore endeavoured to sum up thirty years of exploration of the reclining female figure as both a nurturing and consoling body and a landscape. He did so in another elmwood *Reclining Figure* (LH 452) which he worked on over a five year period; this work is, in effect, a drawing together of all that Moore felt about this theme. The quiet strength of the piece contrasts with the fact that while he was working on it his conception of the figure was undergoing fundamental change.

In other sculptures he made around this time, his epic female figures began fragmenting, splitting, and cleaving into their several parts. The great rocks and cliff faces of breasts, torso and mountainously raised knees were severing and drifting apart, as if some strange geological convulsion was erupting from the lower strata of Moore's imagination itself. Moore described the process in a characteristically matter-of-fact way; 'I realised what an advantage a separated two-piece composition could have in relating figures to landscape. Knees and breasts are mountains. Once these two parts become separated you don't expect it to be a naturalistic figure: therefore you can justifiably make it like a landscape or a rock.'[40] Even so, these changes led to some of the strangest of Moore's sculptures based on the female body, sculptures which seemed menaced by a constant threat of disintegration. It was not just chance which led to the awesome immensity of *Nuclear Energy* (LH 526, fig. 13) of 1964. The terrifying 'skull' of this work seems to resemble that helmeted head which lay explosively, yet silently, within the elmwood reclining figure of 1945–6 . . . It was as if Moore was exploring, and, in formal terms, somehow containing, the cataclysmic forces which threatened the world.

Elsewhere, I have tried to analyse the two great themes of the Mother and Child, and the reclining figure, in Moore's work in terms of the ideas of one of his contemporaries, the psychoanalyst, D.W. Winnicott.[41] Winnicott argued that in the infant's emotional experience, the child tends to split the mother into two. He distinguished between the 'object mother', who is the specific object of the infant's affections and excited, instinctual needs and the 'environment mother', whose holding, sustaining and providing constitute the ground of what Winnicott called the infant's 'going on being', before he becomes a separate and independent person.

These two poles of infantile experience can be related to the two extremes of adult aesthetic experience: that is, to the sort of defined, limited and formal experiences we describe as 'beautiful' (in the classical sense); and to the engulfing, suffusing, or oceanic kinds of experience which have traditionally been given the label 'sublime'. The sense of the beautiful, I would suggest, has something to do with the 'object mother' and the sense of the sublime has something to do with the 'environment mother', the mother as landscape.

The sublime, with its sensations of engulfment, is always tinged about with terror, as Edmund Burke recognised: it involves a threat of the annihilation of the self, of being subsumed into another; even, in its extreme forms, of the disintegration of the sustaining environment itself. The greatest art, it seems, touches upon such terrible areas of experience, but brings about a new sense of equilibrium, through form. Before Henry Moore, the experience of the sublime was possible only in, for example, cathedrals, or in the experience of actual landscapes, such as mountain ranges, or in certain kinds of landscape and abstract painting, such as those of Turner. Sculpture had been confined to the more superficial experiences of the beautiful. As John Read has put it, 'This blending of human and natural form, this ability to see the figures in the landscape, and a landscape in the figures, is Moore's greatest contribution to sculpture.'[42]

At its best, Moore's work offers much more than a new kind of aesthetic experience, or a new view of woman; for his great reclining figures seem to speak of the sustaining environment of nature, and indeed perhaps even of culture itself. If we look back over Moore's work we cannot help but notice that he eschewed the whole range of mechanical and technological imagery. He revived and replenished an indigenous romantic tradition, but he did so in a way which was at once fully sculptural, and yet new to sculpture.

Like all great art, the best of Moore's sculptures cannot be tied down to a single interpretation; and yet one of their many meanings may be that they offer us an aesthetic of ecological harmony. Moore often spoke of a love of organic form, which is self-evident in the works themselves, of 'the growth of branches from the trunk each finding its individual airspace, the texture and variety of grasses, the shape of shells, of pebbles.'[43] Such concerns were Ruskinian rather than modernist; indeed Moore even retained an 'organic' view of human culture itself. 'Culture,' he once said, 'as the word implies, is an organic process. There is no such thing as a synthetic culture, or if there is it is a false and impermanent culture.'[44] Moore's reclining figures are perhaps the closest things to the great Gothic cathedrals (which Ruskin so dearly loved) that a secular age, like our own, can hope to produce.

N O T E S
F O R T H E
E S S A Y S

NOTES FOR 'AN ART OF THE OPEN AIR'

1. *Henry Moore. Drie staande motieven. Ter gelegenheid van de onthulling op 10 April 1965 in het Nationale Park de Hoge Veluwe*, Otterlo, Rijksmuseum Kröller-Müller 1965. Reprinted in *Henry Moore on Sculpture*, P. James, ed., London, 1966, revised ed., 1968, p. 257.
2. *Sculpture and drawings by Henry Moore. Catalogue of an exhibition. May 2nd–July 29th, at the Tate Gallery*, London, 1951, intro. by D. Sylvester. Reprinted ibid, p. 97.
3. For a detailed account of the opposition which led to Moore's resignation, see R. Berthoud, *The Life of Henry Moore*, London, 1987, pp. 107–9.
4. H. Moore, *The sculptor in modern society*. Paper read at UNESCO's International Congress of Artists, Venice, 22–28 September 1952, and published in *Art News*, November 1952.
5. ibid.
6. H. Moore, *Henry Moore Wood Sculpture*, photographs by G. Levine, London 1983, p. 54. Moore's first invitation to make a carving occurred four years before, in 1913, when he incised the lettering in a school notice-board for the newly-formed Scott Society.
7. J. and V. Russell, 'Conversations with Henry Moore', *The Sunday Times*, 17 and 24 December 1961.
8. ibid.
9. The other sculptors were Eric Aumonier, A.H. Gerrard, Sam Rabin (then called Rabinovitch) and Allan Wyon. For a comprehensive account of the Underground Railway Headquarters and its sculpture, see R. Cork, *Art Beyond The Gallery in Early 20th-Century England*, New Haven and London 1985, chapter six.
10. H. Moore, *Sculpture in the open air. A talk by Henry Moore on his sculpture and its placing in open-air sites*. London, British Council, 1955.
11. H. Moore, interview with the author, 1 December 1980.
12. Holden had been responsible for commissioning Epstein's sequence of statues for the new headquarters of the British Medical Association in The Strand, and he afterwards helped Epstein with the *Tomb of Oscar Wilde*.
13. C. Holden to the *Manchester Guardian*, 3 August 1929.
14. A facsimile edition of the *Sketchbook 1928. The West Wind Relief*, A. Wilkinson, ed., was published by Raymond Spencer Company, Much Hadham in 1982.
15. H. Moore, interview with the author, 1 December 1980.
16. The *Morning Post* wrote of the contributions by Moore and Gerrard (both art-school teachers) that 'it is almost unbelievable that men occupying positions of this high responsibility should execute such figures as serious works of art.' (13 April 1929.)
17. C. Barman, *The Man Who Built London Transport. A Biography of Frank Pick*, London, 1979, p. 131.
18. H. Moore, *Sculpture in the open air*, op. cit.
19. ibid.
20. Even the great *Reclining Figure* of 1929 had to wait until 1941 before it found a home at the Leeds City Art Gallery.
21. H. Moore, *Sculpture in the open air*, op. cit.
22. ibid.
23. The threat of world war prompted Chermayeff to return the *Reclining Figure* to Moore after only six months, and the architect left for America at the beginning of 1940. At Kenneth Clark's behest, it was purchased by the Contemporary Art Society in 1939 and presented to the Tate Gallery.
24. H. Moore, *Sculpture in the open air*, op. cit.
25. *Circle* was edited jointly by Naum Gabo, J.L. Martin and Ben Nicholson, and Chermayeff was represented in it by his new offices in Camden Town (1937) and a hotel project for Southsea (with Erich Mendelsohn).
26. H. Moore, 'Quotations', *Circle. International Survey of Constructive Art*, London, 1937, p. 118.
27. N. Bullock, *Circle: constructive art in Britain 1934–40*, ed., J. Lewison, catalogue of an exhibition held at Kettle's Yard Gallery, Cambridge, 1982, p. 84.
28. R. Berthoud, *The Life of Henry Moore*, op. cit., p. 159.
29. H. Moore, interview with the author, 26 May 1981.
30. W. Hussey, *Patron of Art*, London 1985, p. 33.
31. 'This sculpture may be great art without beauty', declared an anonymous correspondent in the *Northampton Chronicle and Echo*, 'or it may be beautiful in the eyes of an initiated few, but it warps a mental picture of an ideal which has remained unchanged for 2,000 years'. (Quoted by Hussey, op. cit., p. 45.)
32. On a blue-green sheet of studies for the Underground Railway *West Wind* carving, Moore wrote of the need for 'Big form. (Remember Massaccio [*sic*] in Nat. Art. Col. Fund)'. The *Virgin and Child* from the Pisa Polyptych was acquired by the National Gallery in 1916 with substantial help from the National Art-Collections Fund.
33. W. Hussey, interview with R. Berthoud, December 1982, *The Life of Henry Moore*, op. cit., p. 188.
34. 'We stood it as far away from the wall as possible', wrote Moore, 'but one can only see it from a limited number of views, one cannot get those sudden revelations that occur when one comes upon a sculpture from an unexpected angle' (*Sculpture in the open air*, op. cit.).
35. This *Reclining Figure* is now in the J.B. Speed Art Museum, Louisville.
36. H. Moore, interview with J. Heilpern, *The Observer* magazine, 30 April 1972.
37. H. Moore, *Sculpture in the open air*, op. cit.

38. ibid.

39. ibid.

40. Commissioning letter, 24 May 1949, Arts Council archives.

41. Several members of the younger generation of British sculptors were represented in the Festival of Britain, as Moore would have realised beforehand. They included Lynn Chadwick and Eduardo Paolozzi.

42. H. Moore, 'Some notes on space and form in sculpture', Felix H. Man, *Eight European Artists*, London 1954. Reprinted in *Henry Moore on Sculpture*, op. cit., p.118.

43. H. Moore, *Sculpture in the open air*, op. cit.

44. ibid.

45. ibid.

46. Each relief would have been twelve feet square, and installed in a well-lit recess referred to as a 'hallowing place'.

47. Eventually, Ralph Beyer was commissioned to incise appropriate Biblical texts instead.

48. H. Moore, interview with the author, 26 May 1981.

49. The wall is twenty-eight feet high and sixty-three feet wide.

50. Gabo's Bijenkorf sculpture was commissioned in 1954 and finally unveiled three years later.

51. See R. Berthoud, op. cit., p. 251–2.

52. H. Moore, *Sculpture in the open air*, op. cit.

53. Moore had received this commission from the newly-formed Harlow Arts Trust, and the Hadene stone group was unveiled in May 1956. It was later restored after being severely vandalised.

54. H. Moore, in E. Roditi, *Dialogues on art*, London 1960. Moore's interview was also published in *The Observer*, 10 April 1960.

55. H. Moore, *Architectural Association Journal*, May 1930.

56. J. Epstein to J. Quinn, March 1912, B. L. Reid, *The Man from New York: John Quinn and His Friends*, Oxford, 1968, p. 130.

57. H. Gaudier-Brzeska, 'Vortex. Gaudier Brzeska', *Blast No. I*, London, 1914, p. 155.

58. J. Russell, *Henry Moore*, London 1968, revised ed. 1973, p. 19.

59. Seurat's *Le Bec du Hoc, Grandcamp*, 1885, now in the Tate Gallery, formerly belonged to Kenneth Clark, in whose house Moore often saw it; and Monet's *Cliff at Etretat*, 1883, is owned by the Metropolitan Museum of Art, New York.

60. *Daily Sketch*, 6 March 1960. Moore's view was not shared by Gabo, whose *Torsion* Fountain was unveiled at St Thomas's Hospital, London, in 1977.

61. See R. Berthoud, op. cit., p. 258.

62. ibid., p. 361.

63. The full title of the enlargement became *Three Way Piece No 2: Archer*. Moore had originally been introduced to Revell by the architectural critic and historian J.M. Richards.

64. D. Finn and H. Moore, *Sculpture and Environment*, London 1977, p. 100.

65. J. Carter Brown, memo on visit to Moore, 23 June 1975 (archives of National Gallery of Art, Washington).

66. Although Moore thought that Pei's Dallas building was 'great, bold, magnificent', he insisted that his sculpture should offer a contrast – just as *Recumbent Figure* had done near Chermayeff's house as far back as 1938.

67. The original lead figure is in the collection of the Museum of Modern Art, New York.

68. Sir Denis Hamilton to Berthoud, quoted by Berthoud, op. cit., p. 413. Hamilton undertook to propose the invitation to Moore on behalf of the Dean of St Paul's, Dr Alan Webster.

69. *Henry Moore on Sculpture*, op. cit., p. 220.

70. The elmwood *Mother and Child* is now owned by the Museum of Modern Art, New York.

NOTES FOR 'DRAWING AND SCULPTURE'

Throughout this text the catalogue numbers are intended to refer the reader to the reproductions and the Catalogue Notes, which will expand the information given in this text.

1. The woodcut cover inscribed 'Narayana and Bhataryan, a play by Harry Spencer Moore' is reproduced by Roger Berthoud, who also quotes the prologue, R. Berthoud, *The Life of Henry Moore*, London, Faber and Faber, 1987, pp. 52–3. The play was performed at Castleford Grammar School in 1920 and again at The Royal College of Art at the Easter social in 1922.

2. Moore's first one-man exhibition was held at the Warren Gallery, February 1928, where buyers included Epstein, Henry Lamb and Augustus John; his second, at the Leicester Galleries, March 1931 had a short catalogue introduction by Epstein.

3. When Alan Wilkinson studied the drawings for his PhD thesis, Moore talked with him on many occasions and revealing quotations are published in Wilkinson's catalogue, *The Drawings of Henry Moore*, London, Tate Gallery Publications, 1977; this quotation Wilkinson, 1977, p. 12.

4. Roger Fry, *Vision and Design*, a collection of essays on art written over twenty years, first published December 1920.

5. H. Moore, 'Contemporary English Sculptors', *Architectural Association Journal*, Vol. XLV, no. 519, p. 408.

6. R. H. Wilenski, 'Ruminations on Sculpture and the work of Henry Moore', *Apollo*, Vol. XII, no. 12, Dec. 1930.

7. A. Ozenfant, trans. J. Rodker, *Foundations of Modern Art*, London, 1931.

8. A. Ozenfant, trans. J. Rodker, *Foundations of Modern Art*, 1931 edition, (reprinted and augmented) New York, Dover, 1952, p. 222 (this passage was in the 1931 edition).

9. According to Roger Berthoud, Raymond Coxon had moved to Chelsea School of Art and proposed that Moore be invited to start a sculpture school; Moore's resignation from the RCA was accepted on 14 January 1931. His replacement at the RCA took up his post in the autumn of 1932.

10. Wilkinson, op. cit., 1977, p. 24.

11. R. H. Wilenski, *The Meaning of Modern Sculpture*, London, Faber and Faber, 1932, p. 164.

12. H. Read, ed., *Unit I, The Modern Movement in English Architecture, Painting and Sculpture*, London, Cassell, 1934, pp. 29–30.

13. There are photographs of 11a Parkhill Road, off Haverstock Hill, in the illustrated chronology prepared by D. Mitchinson, in *Henry Moore*, Otterlo Rijkmuseum Kröller-Müller; Rotterdam, Museum Boymans-Van Beuningen, 1968, under the year 1933.

14. H. Read, *The Meaning of Art*, London, Faber, 1931.

15. H. Read, *Art Now*, London, Faber, 1933.

16. H. Read, *Henry Moore, Sculptor*, London, Zwemmer, 1934.

17. One double sheet of Picasso's *Une Anatomie*, from *Minotaure No. I*, 1933, is reproduced in D. Sylvester, *Henry Moore*, The Arts Council of Great Britain, 1968, fig.157; a second sheet is to be found in D. Ades, *Dada and Surrealism Reviewed*, London, The Arts Council of Great Britain, 1978, p. 284; the third is reproduced in A. G. Wilkinson, *The Moore Collection in the Art Gallery of Ontario*, Toronto, 1979, p. 60.

18. P. Nash, *The Listener*, 5 July 1933, this quotation from C. Harrison, 'Unit One', *Unit I*, based on the 1934 Unit I exhibition held at the Mayor Gallery, Portsmouth City Museum and Art Gallery, 1978, p. 2.

19. P. Nash, *The Listener*, 29 April 1931, cited from D. Ades, op, cit., 1978, p. 365.

20. H. Read, M. Fordham, G. Adler, eds, *C. J. Jung, The Collected Works*, trans. R. F. C. Hull, London, Routledge and Kegan Paul, 18 vols with separate titles and publication dates.

21. H. Read, ed., *Henry Moore, Sculpture and Drawings*, London, Lund Humphries, 1944.

22. H. Moore, 'The Sculptor Speaks', *The Listener*, 18 August 1937, reprinted in D. Sylvester, ed., *Henry Moore, Sculpture and Drawings*, London, Lund Humphries, 1969, pp. xxxiii–xxxv, from which this and subsequent quotations are cited.

23. A. Breton, *What is Surrealism?*, London, Faber and Faber, 1936. Dawn Ades records Breton's anger because the book was cut without his consent (Ades, 1978, op. cit., p. 348). As both Moore and Breton served on the Organising Committee for the International Surrealist Exhibition (New Burlington Galleries, 11 June– 4 July 1936) no doubt Moore's attention had been drawn to the book.

24. see note 22 above; this extract, p.xxxv.

25. ibid.

26. ibid.

27. See the chronology by N. Lee and S. Nash in *Naum Gabo, Sixty Years of Constructivism*, Munich, Prestel, 1985, p. 65.

28. J. L. Martin, Ben Nicholson, N. Gabo, eds, *Circle, International Survey of Constructive Art*, London, Faber, 1937. Text: H. Moore, 'Quotations', p. 118, photographs of sculpture, pls 9–11, following p. 75 and pl.4, following p. 123.

29. For example, Ben Nicholson, *Relief*, reproduced Martin, Nicholson, Gabo, eds, op. cit., 1937, pl.7a following p. 123.

30. see note 22 above; this extract, p.xxxv.

31. ibid.

32. see note 18 above.

33. C. Jung, *Two Essays on Analytical Psychology*, trans. H. G. and C. F. Baynes, London, Bailliere, Tindall and Cox, 1928, p. 165.

34. *Page 37 from Sketchbook B*, includes a sketch of a Malanggan figure, see A. G. Wilkinson, *Henry Moore Remembered, The Collection at the Art Gallery of Ontario in Toronto*, Art Gallery of Ontario and Key Porter Books, p. 139, see also D. Ades, op. cit., 1978, nos 12.192, 3, p. 329.

35. A. Gardner, *A Handbook of English Medieval Sculpture*, Cambridge University Press, 1935.

36. H. Read, 'What is Revolutionary Art?' in B. Rea, ed., *Five on Revolutionary Art*, London, Artists International Association, 1935, partially reprinted in F. Frascina, C. Harrison, eds, *Modern Art and Modernism: A Critical Anthology*, London, Harper and Row with The Open University, 1982.

37. This quotation from F. Frascina, C. Harrison, eds, 1982, p. 123.

38. see note 22 above; this extract, p.xxxv.

39. Wilkinson, 1977, op. cit., p. 36.

40. Moore had declined Clark's invitation to become an Official War Artist early in 1940, but in 1941 Clark recommended the purchase of shelter drawings to the Committee, which subsequently offered him a commission for 'a series of drawings of Civil Defence subjects'; Moore showed the committee eight to ten drawings at a time of which they chose four or five, leaving him the rest, see A. Ross, *Colours of War, War Art 1939–45*, London, Cape, 1983, pp. 38–9.

41. An account of the War Artists' Advisory Committee and its work is given in Ross, 1983, op. cit., Chapter 1. Subject categories were portraits, figures in action (front and home), landscape, sea, shipping, sky, aeroplanes, towns, factory exteriors, factory interiors, battleship equipment, and general, see ibid., p. 25.

42. Wilkinson, 1977, op. cit., p. 37.

43. 'Sculptural energy is the mountain' is a phrase coined by Gaudier-Brzeska and first published in his article 'Vortex Gaudier-Brzeska' in the Vorticist periodical edited by Wyndham Lewis, *Blast No. 1*, London, 1914, p. 155. Moore read Ezra Pound, *Gaudier-Brezska, A Memoir*, London, John Lane, Bodley Head, 1916, with its illustrations of the work of this French sculptor who had worked in London from 1911–14 but was killed in the trenches in 1915 at the age of only twenty-four.

44. see B. F. Cook, *The Elgin Marbles*, London, British Museum Publications, 1984; the book was published with a grant from the Henry Moore Foundation.

45. E. Sackville-West, *The Rescue*, London, Secker and Warburg, 1945, p. 12.

46. R. Melville, *Henry Moore, Sculpture and Drawings*, London, Thames and Hudson and New York, Abrams, 1970.

47. Sackville-West, 1945, op. cit., p. 12.

48. British Council, Zappeion Gallery, Athens, 1951; 53 sculptures and 44 drawings were exhibited and Moore was taken on an official tour of the classical sites.

49. Angelos Procopion, quoted by Will Grohmann, trans. M. Bullock, *The Art of Henry Moore*, London, Thames and Hudson, 1960, p. 103.

50. Goethe, trans. André Gide, *Prométhée*, Paris. Nicaise, 1950, lithographs printed by Mourlot.

51. P. Cramer, A. Grant, D. Mitchinson, eds, *Henry Moore, Catalogue of Graphic Work*, 4.vols., Geneva, Cramer, 1973–86. The author is grateful to D. Mitchinson for clarifying the confusion over titles.

52. E. Neumann, *The Archetypal World of Henry Moore*, Bollingen Series LXVIII, New York, Pantheon Books, 1959.

53. Huw Wheldon, *Monitor. An anthology*, London, Macdonald, 1962.

54. *Jackson Pollock*, London, Whitechapel Art Gallery, Nov–Dec 1958.

55. Henry Moore, *Heads, Figures & Ideas*, London, Rainbird, 1958; the following quotations are taken from the book which is unpaginated.

56. Henry Moore, *Shelter Sketchbook*, London, Editions Poetry, 1945; eighty-two pages drawn from the first and second Shelter sketchbooks were reproduced in this publication.

57. see note 8 above.

58. see note 55 above.

59. Caro worked part-time as Moore's assistant from 1951–3; he showed welded steel sculpture in his one-man exhibition at the Whitechapel Art Gallery, September–October 1963. In 1969 the critic M. Fried wrote, 'Caro's sculptures reject almost everything that Moore's stand for. But that rejection does not in itself imply a judgement of Moore's art, only of the validity for Caro of its basic conventions.' M. Fried, 'Introduction', *Anthony Caro*, London, The Arts Council of Great Britain, 1969, p. 16.

60. P. King, 'Phillip King talks about his sculpture', *Studio International* 175, 901, June 1968, p. 300, cited by C. Harrison, 'Sculpture's Recent Past', in Terry A. Neff, ed., *A Quiet Revolution, British Sculpture Since 1965*, London, Thames and Hudson, 1987, p. 15.

61. W. Tucker, ed., 'Statement', *First 2*, a magazine published in 1961 by sculpture students at St Martin's School of Art, cited by C. Harrison, 1987, op. cit., p. 15. Harrison gives a full account of the history of the New Generation in this article.

62. P. James ed., *Henry Moore on Sculpture*, London, Macdonald and New York, Viking, 1966.

63. J. Hedgecoe, *Henry Moore*, London, Nelson and New York, Simon and Schuster, 1968.

64. P. James ed., *Henry Moore on Sculpture*, London, Macdonald, 1968.

65. D. Sylvester, *Henry Moore*, London, The Arts Council of Great Britain, 1968.

66. P. Gilmour, *Henry Moore, Graphics in the Making*, London, The Tate Gallery, 1975, p. 16.

67. The drawing is reproduced in Neff, 1987, op. cit., p. 23, fig. 12.

68. see note 43 above.

69. Donald Hall records that Moore read Tolstoy, Dostoevsky, Hardy and Stendhal, but that 'one of his strongest admirations was for D. H. Lawrence', D. Hall, *Henry Moore, The Life and Work of a Great Sculptor*, London, Gollancz, 1966, p. 43.

70. D. H. Lawrence, *Women in Love*, London, Secker, 1921; quotation from Penguin Books edition, 1960, p. 348.

NOTES FOR 'AN ENGLISH ROMANTIC'

1. C. Harrison, *English Art and Modernism, 1900–1939*, London, Allen Lane and Bloomington, Ind., Indiana University Press, 1981, p. 331.

2. Quoted in D. Mitchinson, ed., *Henry Moore Sculpture*, London, Macmillan, 1981, p. 50.

3. N. Pevsner, *Pioneers of Modern Design*, 2nd ed., New York, 1949, p. 135.

4. J. Rothenstein, *Modern English Painters vol. II: Lewis to Moore*, 2nd ed., London, Macdonald, 1976, p. 320.

5. ibid, p. 314.

6. Henry Moore told the present writer that his father had introduced him to the writings of Ruskin.

7. H. Gaudier-Brzeska, 'Vortex. Gaudier Brzeksa', *Blast* No. 1, London, 1914, p. 155.

8. E. Silber, *The Sculpture of Epstein*, Oxford, Phaidon, 1986.

9. Rothenstein, op. cit., p. 325.

10. P. James, ed., *Henry Moore on Sculpture*, London, Macdonald, 1966, p. 33.

11. R. Fry, *Vision and Design*, Harmondsworth, Penguin Books edition, 1937, pp. 88–9.

12. James, op. cit., p. 172.

13. ibid, p. 73.

14. T. Friedman, ''Epsteinism'', *Jacob Epstein Sculpture and Drawings*, Leeds City Art Galleries; London, Whitechapel Art Gallery, 1987.

15. H. Read, *Henry Moore, Sculptor*, London, Zwemmer, 1934, p. 7.

16. repr., C. Neave, *Leon Underwood*, London, Thames and Hudson, 1974, plate 63.

17. Quoted in *Sculpture: 1850 and 1950*, London, London County Council, 1957, n.p.

18. J. Ruskin, *Modern Painters Vol. I* in *The Works of John Ruskin*, E. T. Cook and A. Wedderburn, eds, Vol. III, p. 427.

19. L. Underwood, *Art for Heaven's Sake*, London, Faber and Faber, 1934.

20. Read, op. cit., p. 12.
21. Harrison, op. cit., p. 331.
22. James, op. cit., p. 68.
23. Mitchinson, op. cit., p. 46.
24. Quoted in *Sutherland: the Early Years*, exhibition catalogue, London, 1986, p. 31.
25. R. Ironside, *Painting Since 1939*, London, Longmans Green (for the British Council), 1947, p. 25.
26. ibid, p. 10.
27. E. Neumann, *The Archetypal World of Henry Moore*, London, Routledge and Kegan Paul, 1959, pp. 63–4.
28. both repr., *Modern Painters*, A Quarterly Journal of the Fine Arts, Vol. 1, No. 1, Spring 1988, p. 93.
29. H. Read, *Henry Moore, Sculpture and Drawings*, London, Lund Humphries, 1944, p. xxxvi.
30. ibid.
31. A, Bowness, ed., *Henry Moore: Complete Sculpture, Vol. IV*, London, Lund Humphries, 1977, p. 8.
32. K. Clark, *Henry Moore, Drawings*, London, Thames and Hudson, 1974, p. 200.
33. C. Greenberg, *The Collected Essays and Criticism, Vol. 2. Arrogant Purpose, 1945–1949*, Chicago, The University of Chicago Press, 1986, pp. 126–7.
34. ibid.
35. ibid, p. 318.
36. Quoted in Henry Seldis, *Henry Moore in America*, New York, LACMA, Praeger; Oxford, Phaidon, 1973, p. 136.
37. ibid, p. 135.
38. Quoted in Roger Berthoud, *The Life of Henry Moore*, London, Faber and Faber, 1987, p. 289.
39. M. Fried, 'Introduction', *Anthony Caro*, London, The Arts Council, Hayward Gallery, 1969, p. 16.
40. James, op. cit., p. 266.
41. P. Fuller, 'Mother and Child in Henry Moore and Winnicott', *Winnicott Studies, The Journal of the Squiggle Foundation*, No. 2, 1987.
42. John Read, *Henry Moore: Portrait of an Artist*, London, Whizzard (Deutsch); New York, Hacker, 1979, p. 82.
43. Mitchinson, op. cit., p. 246.
44. James, op. cit., p. 90.

THE PLATES

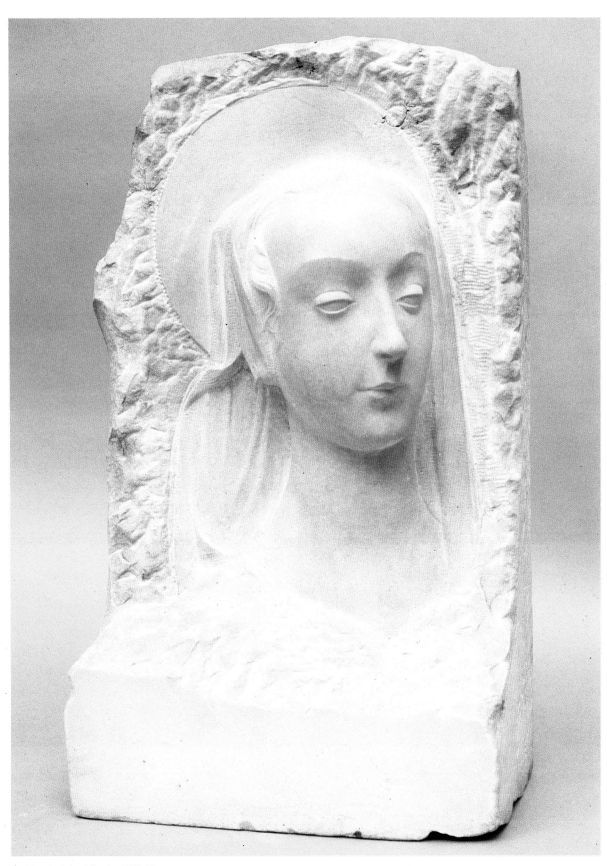

1　Head of the Virgin 1922–3

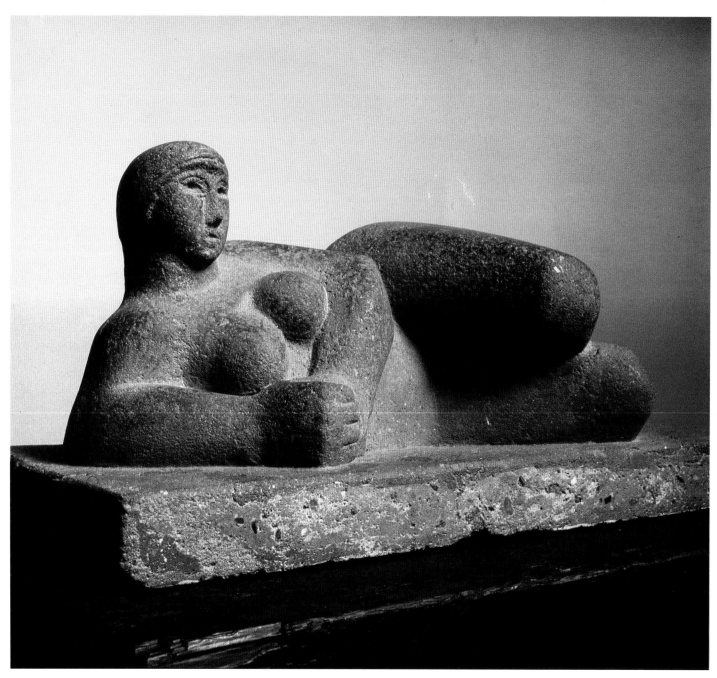

2 Reclining Woman 1927

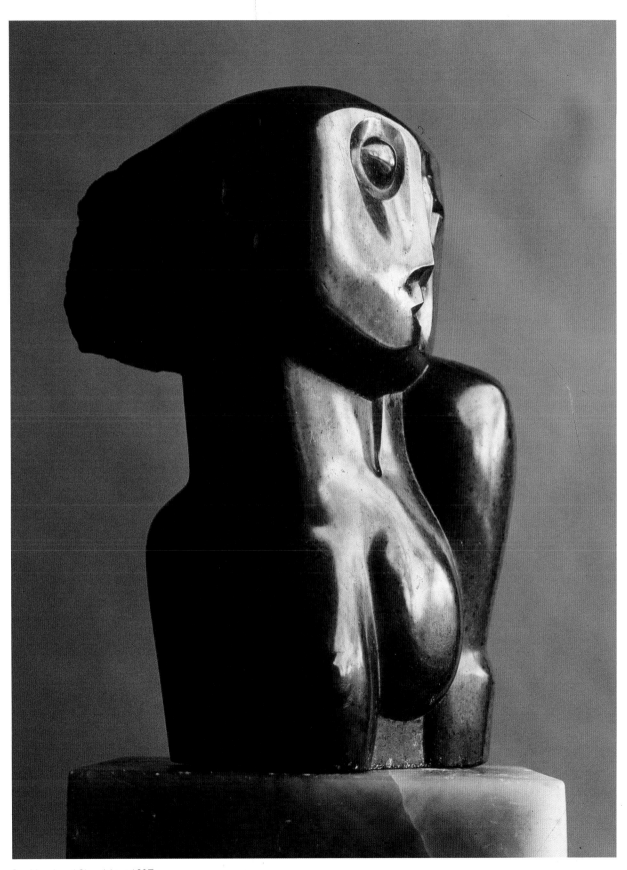

3 Head and Shoulders 1927

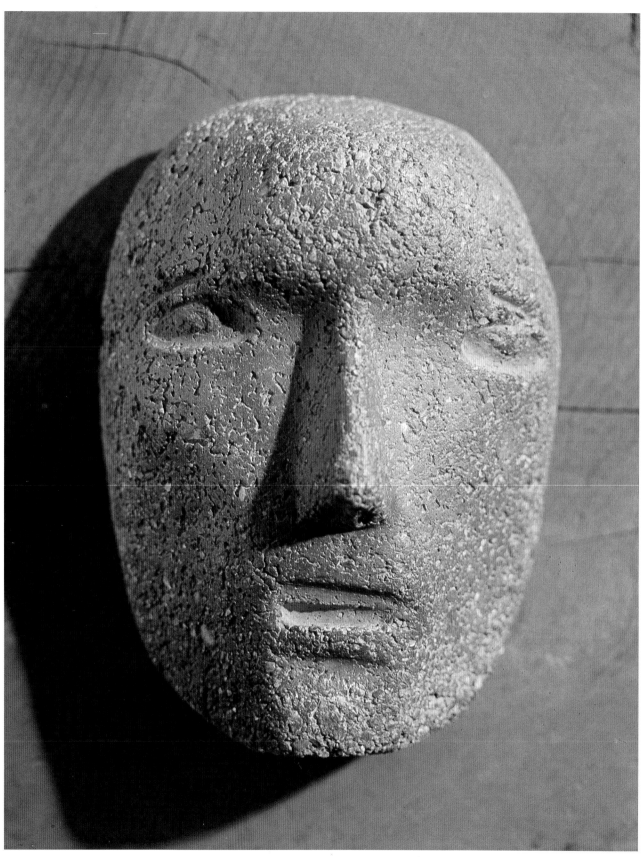

7 Mask 1929

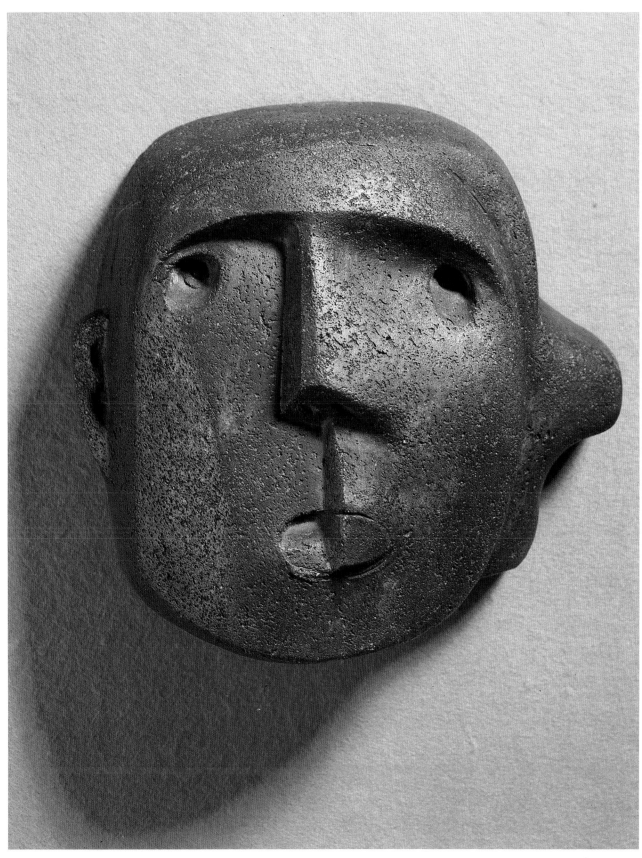

6 Mask 1929

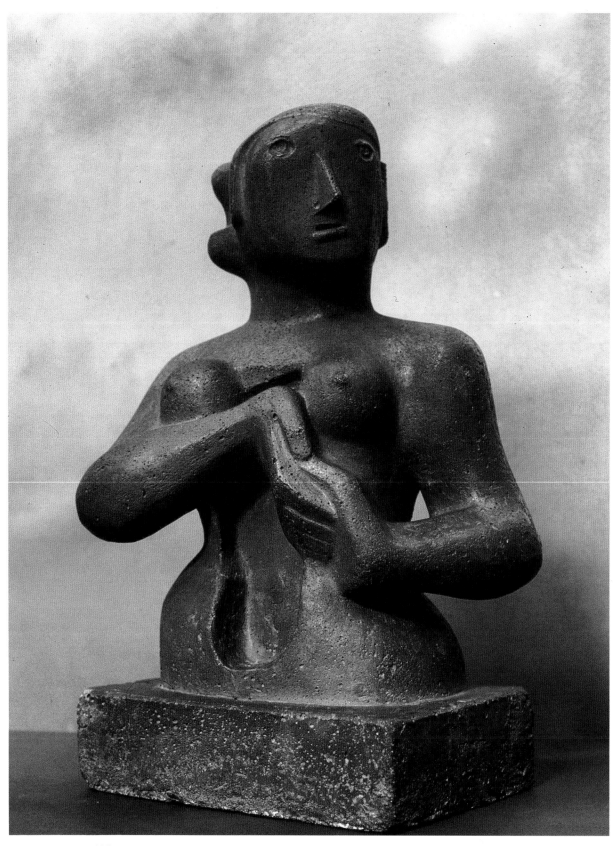

10 Half-Figure 1929

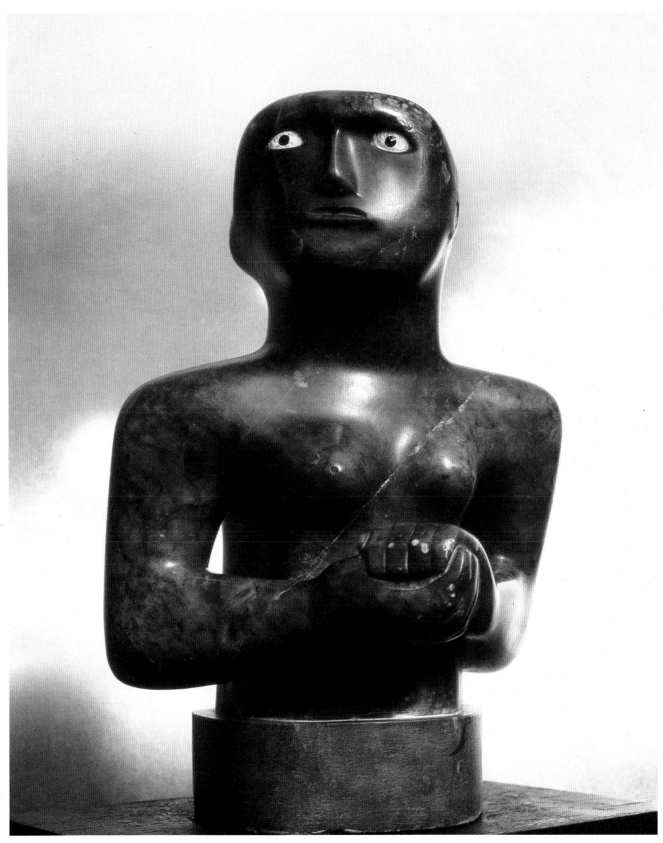

12 Girl with Clasped Hands 1930

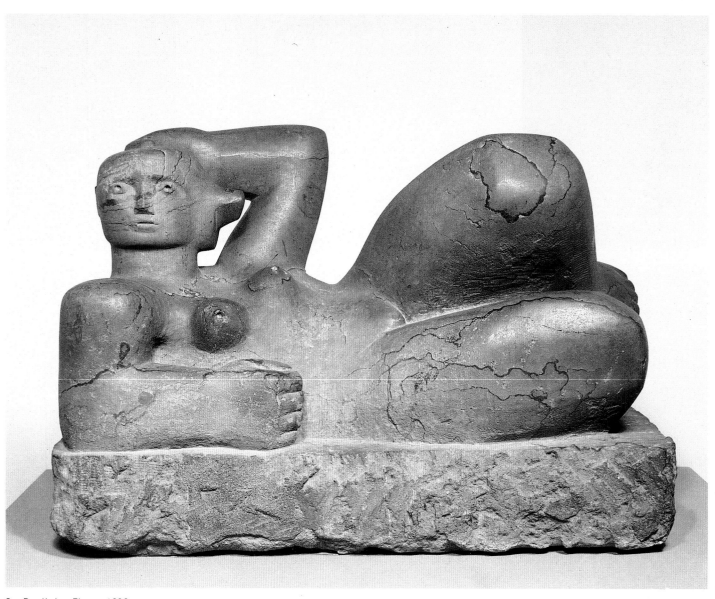

9 Reclining Figure 1929

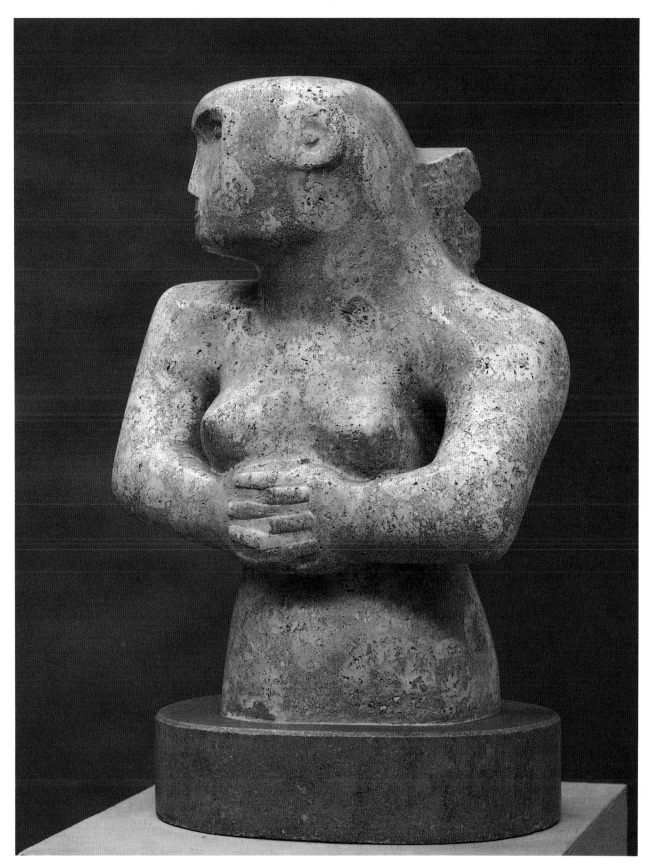

8 Figure with Clasped Hands 1929

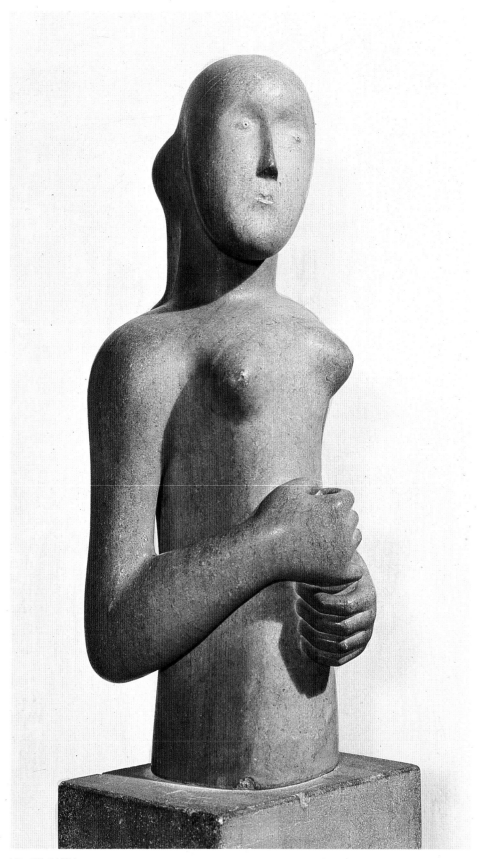

17 Girl 1931

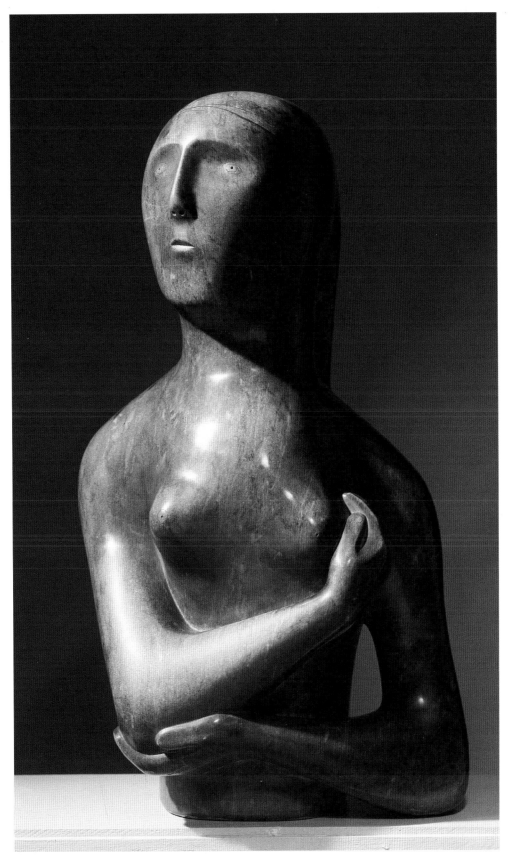

18 Half-Figure 1932

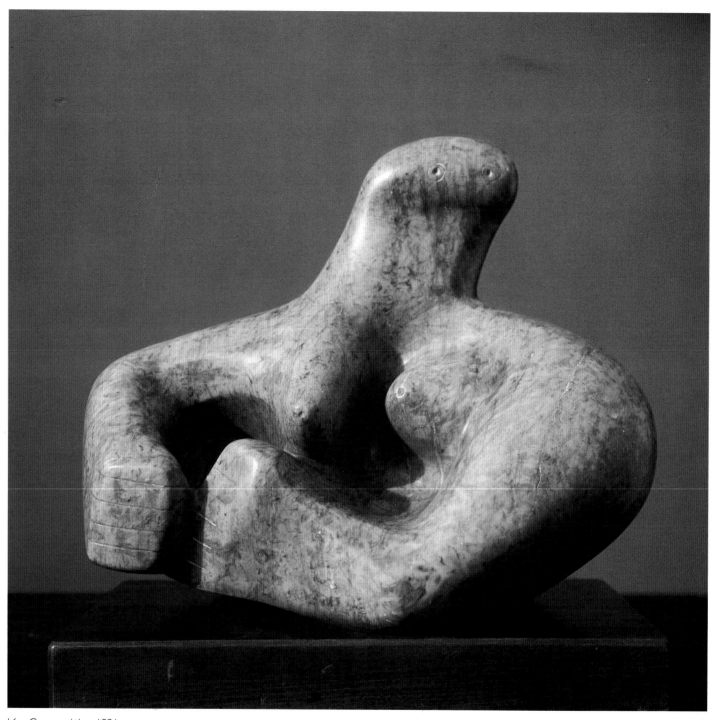

16 Composition 1931

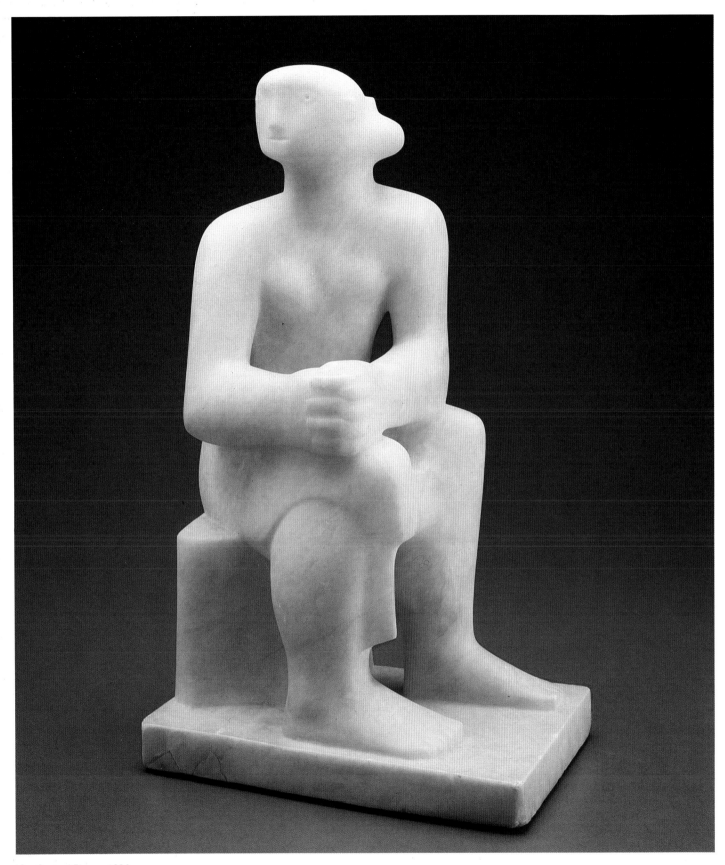

13 Seated Figure 1930

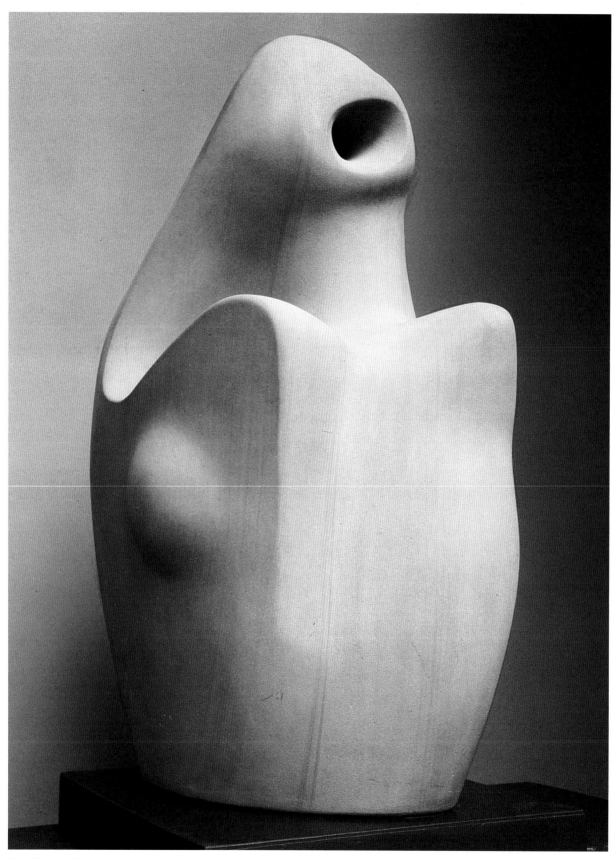

19 Figure 1933–4

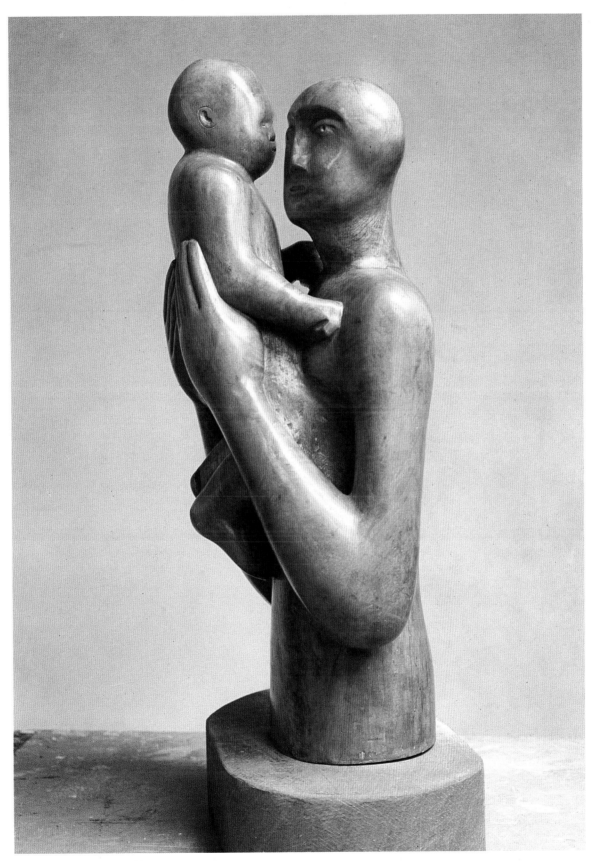

14 Mother and Child 1931

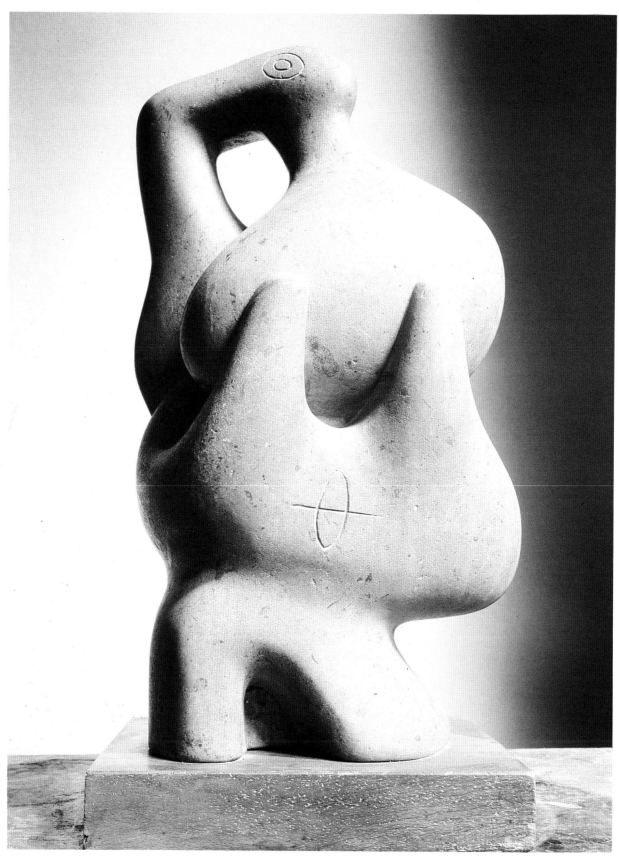

15 Composition 1931

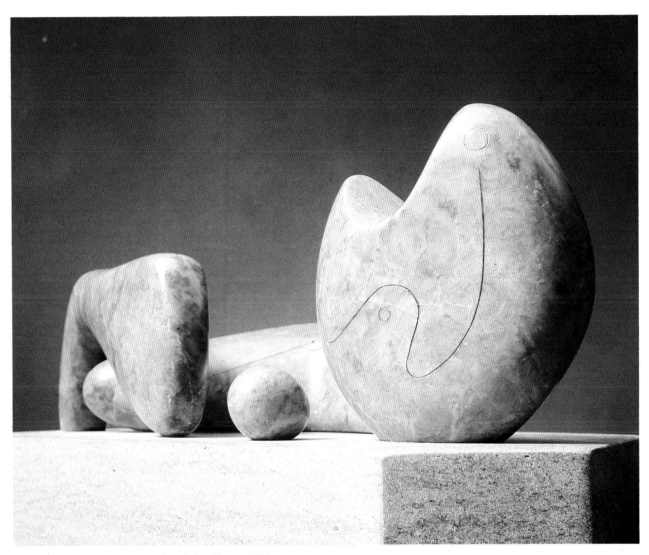

20 Four-Piece Composition: Reclining Figure 1934

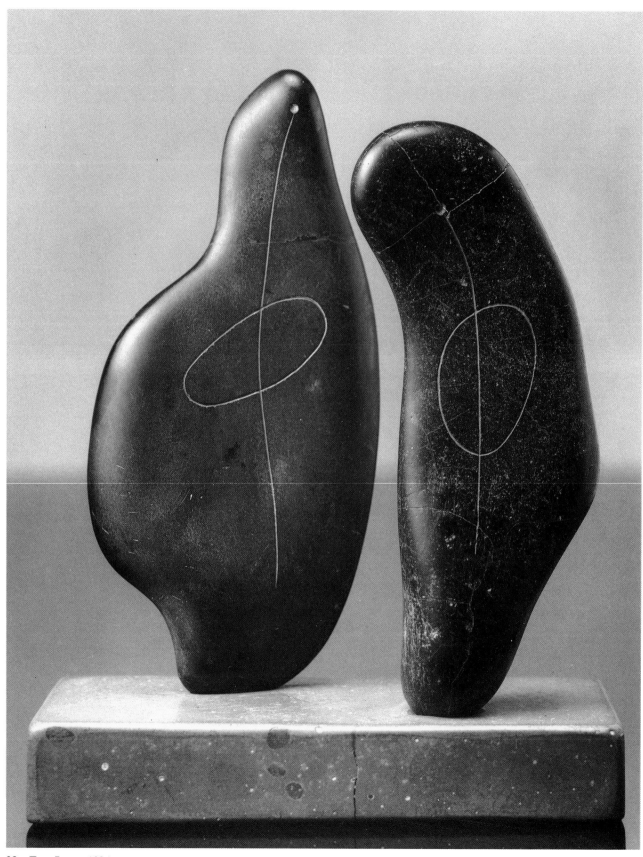

23 Two Forms 1934

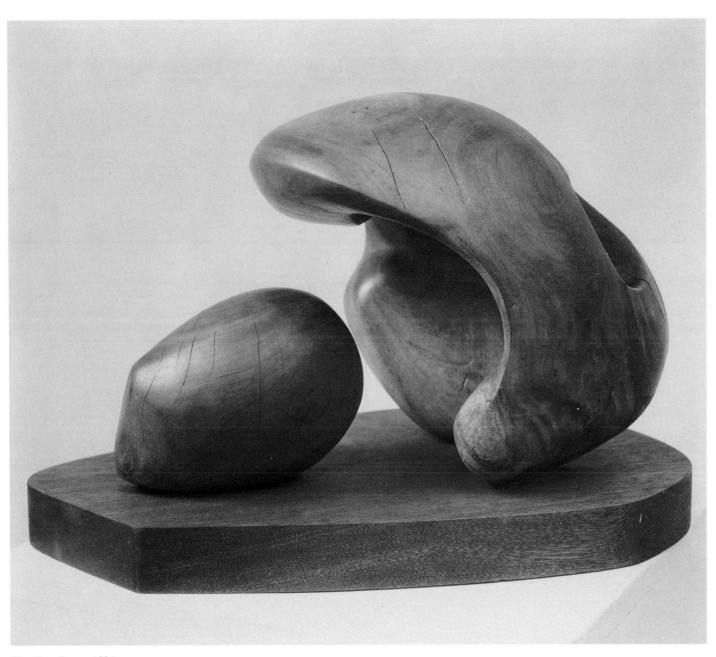

22　Two Forms 1934

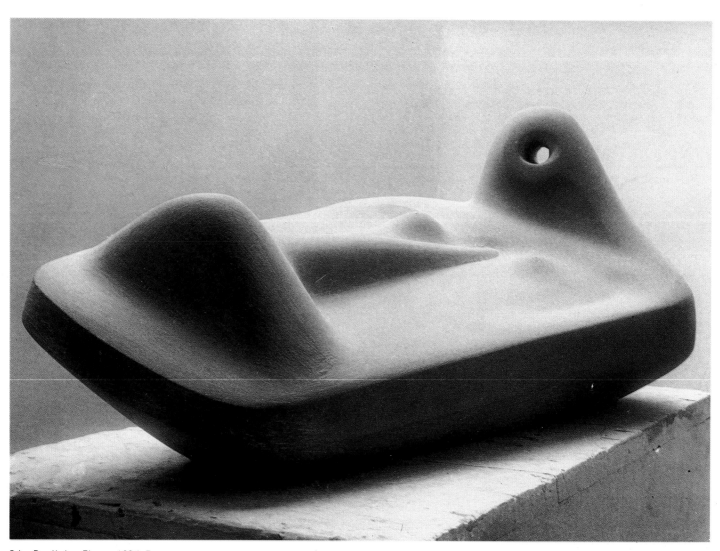

24 Reclining Figure 1934–5

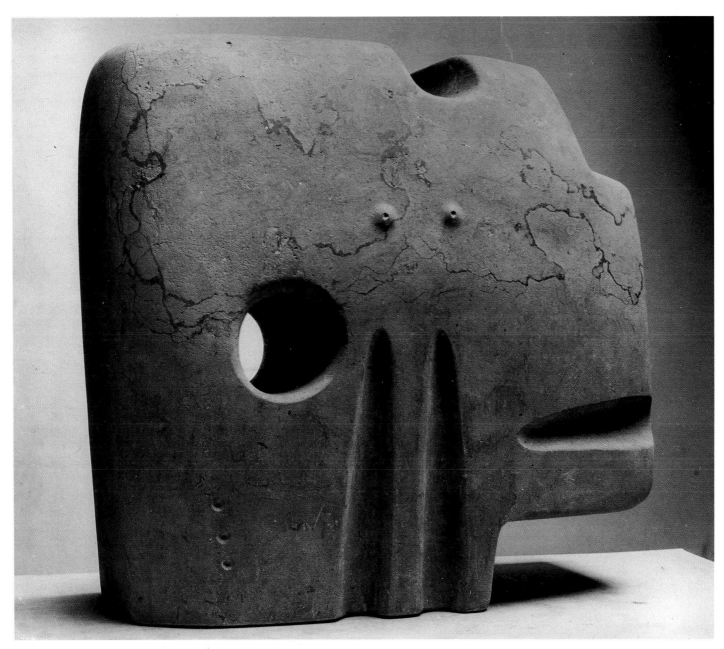

27 Square Form 1936

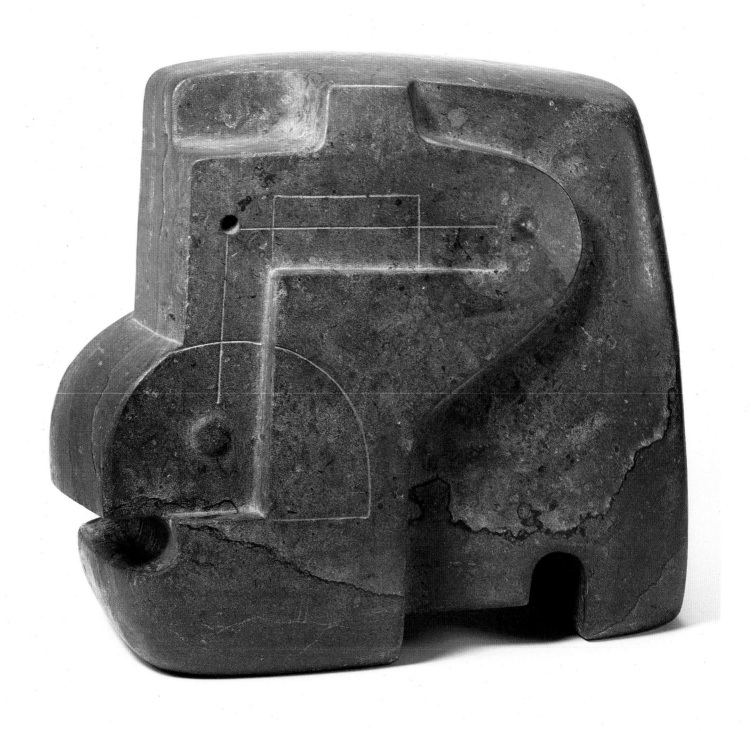

26 Square Form 1936

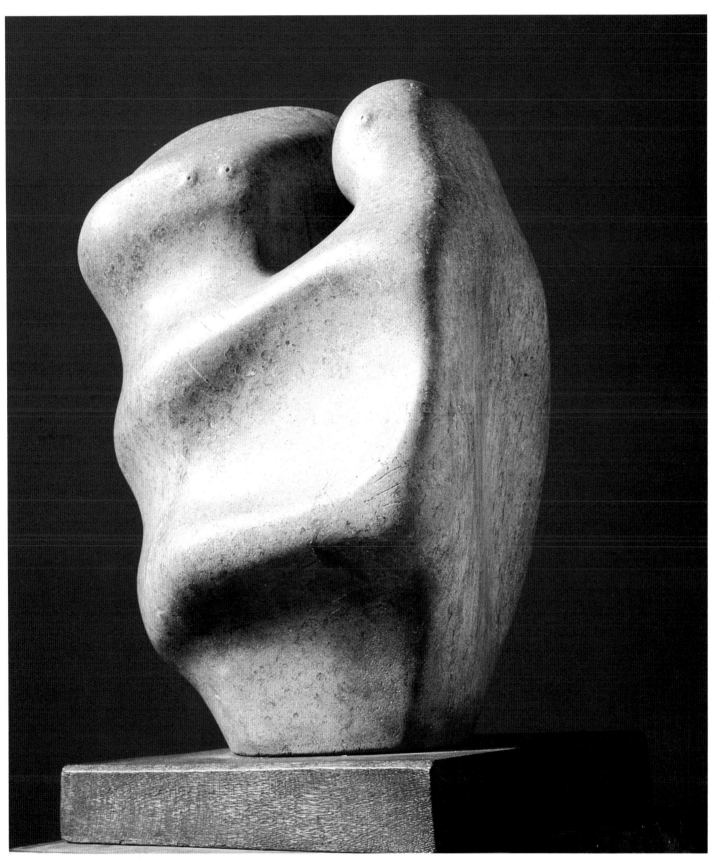

30 Mother and Child 1936

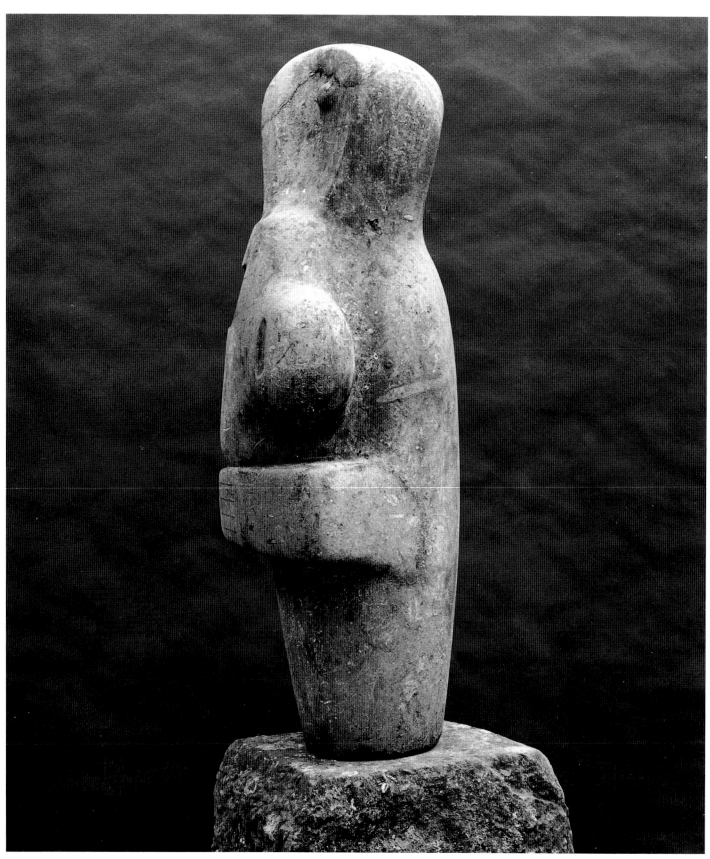

29 Mother and Child 1936

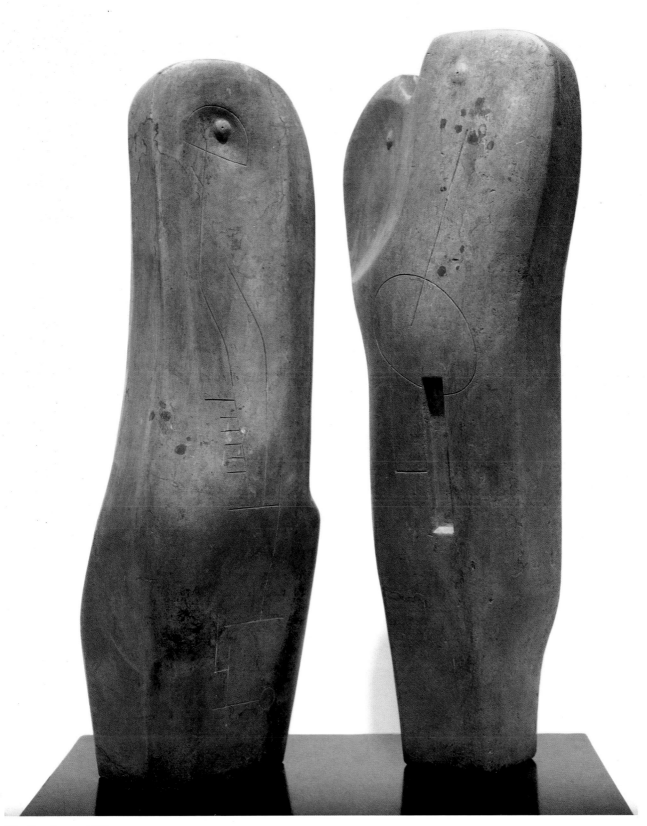

28 Two Forms 1936

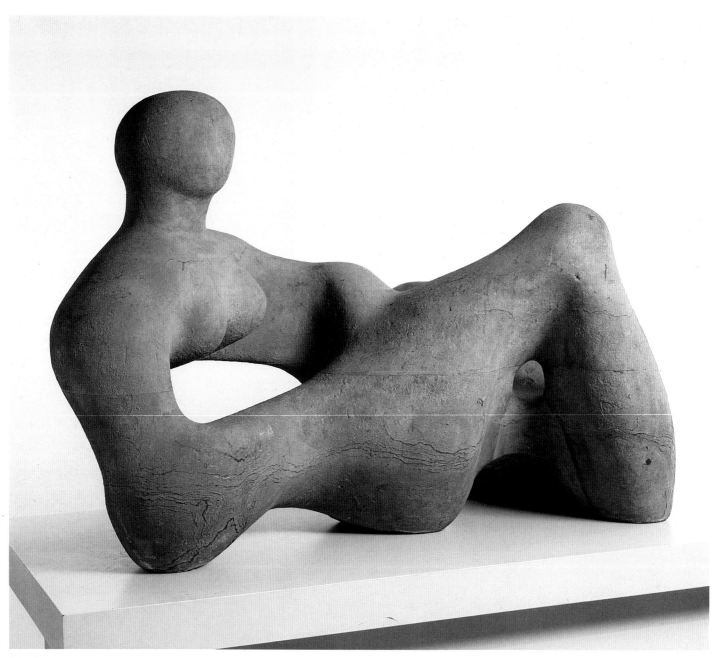

34 Recumbent Figure 1938

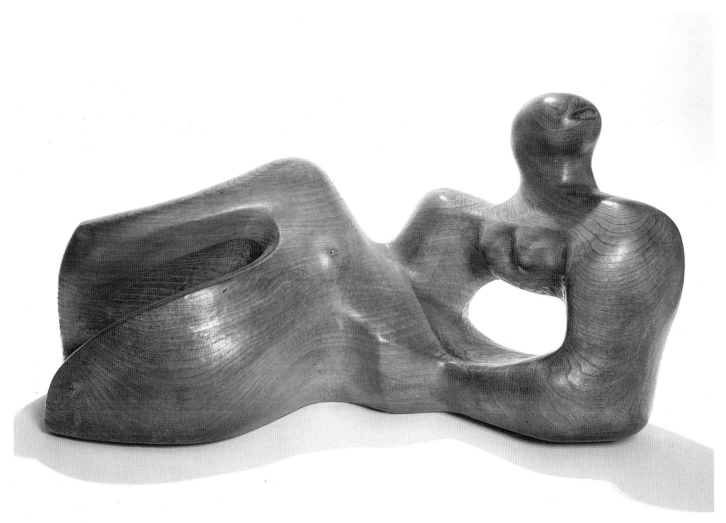

25 Reclining Figure 1935–6

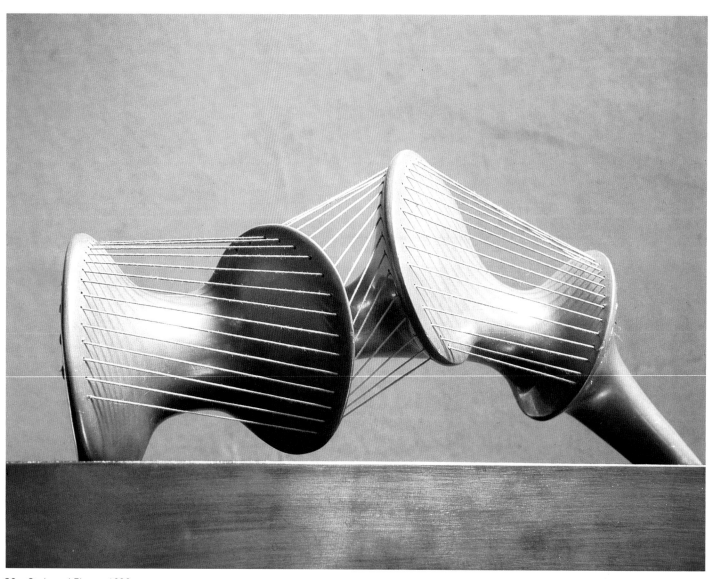

38 Stringed Figure 1939

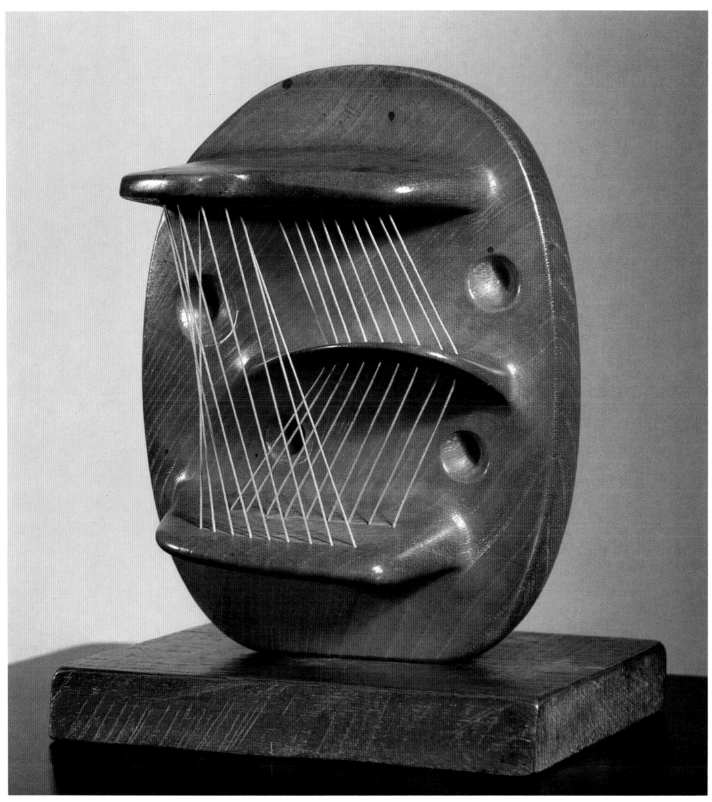

33 Head 1938

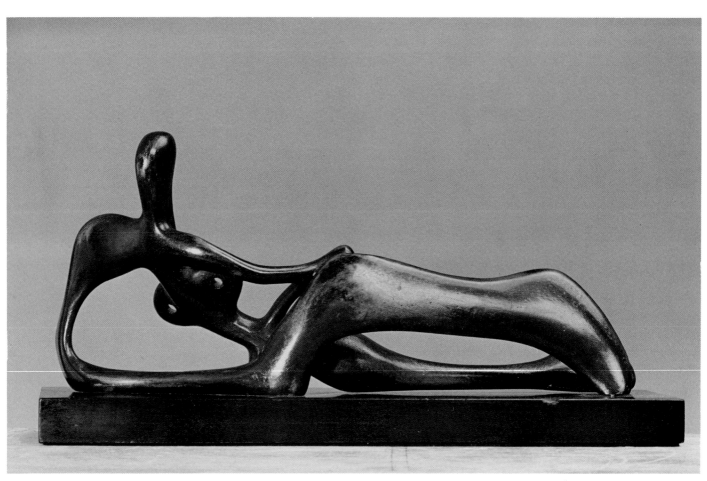

39 Reclining Figure: Snake 1939–40

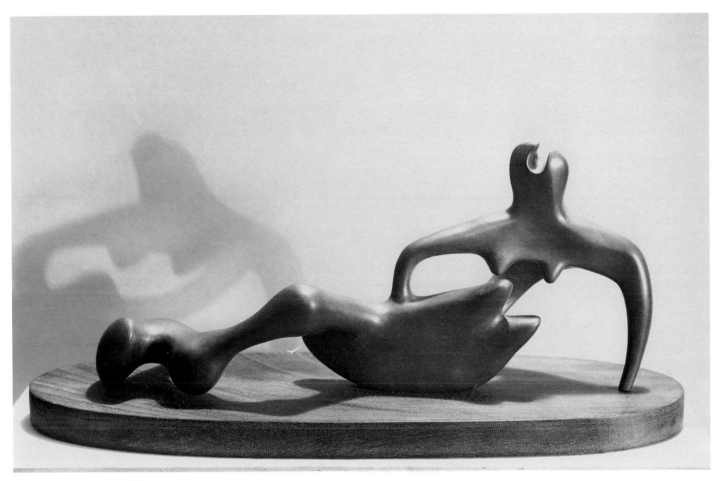

36 Reclining Figure 1938

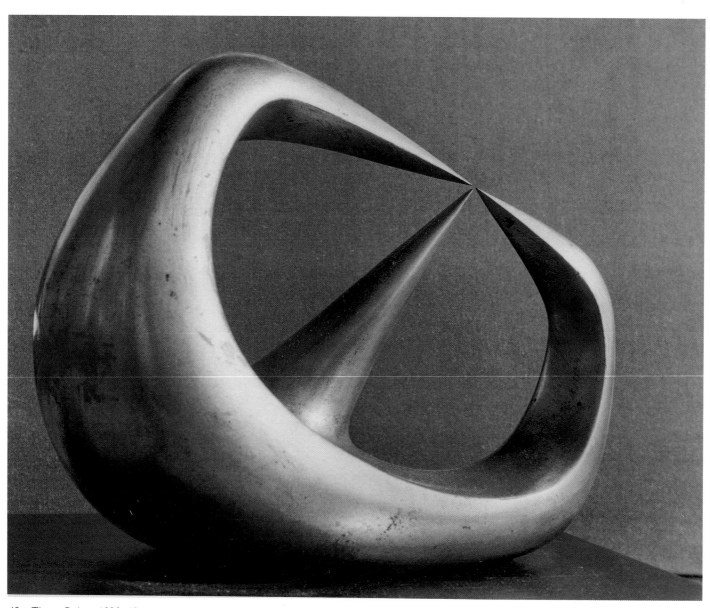

40 Three Points 1939–40

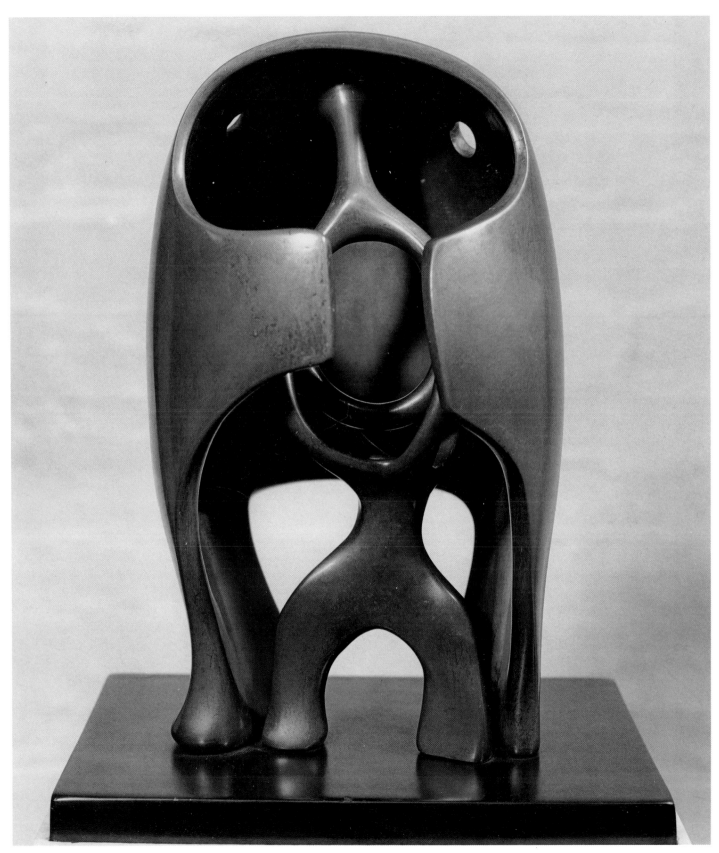

41 The Helmet 1939–40

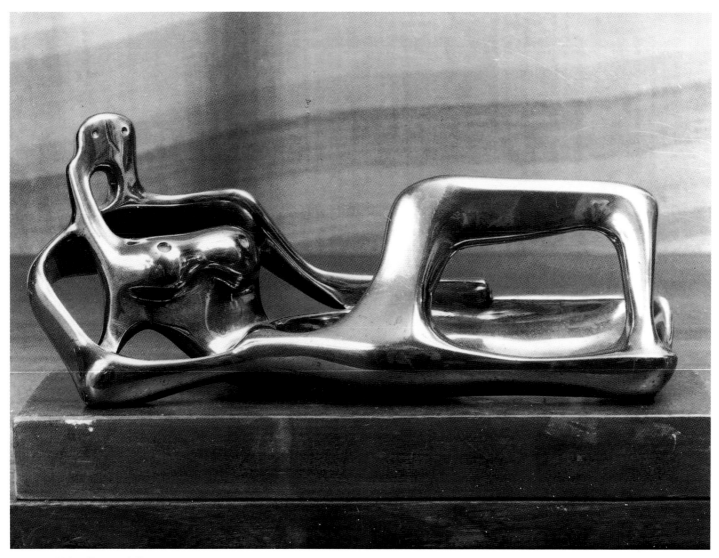

106 Reclining Figure 1945

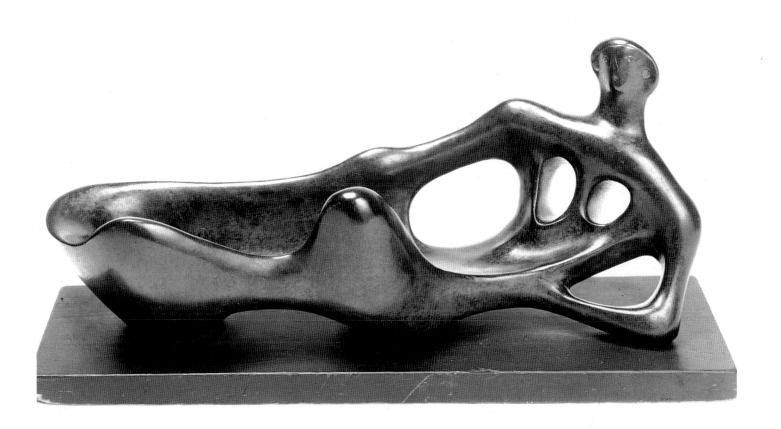

105 Reclining Figure 1945

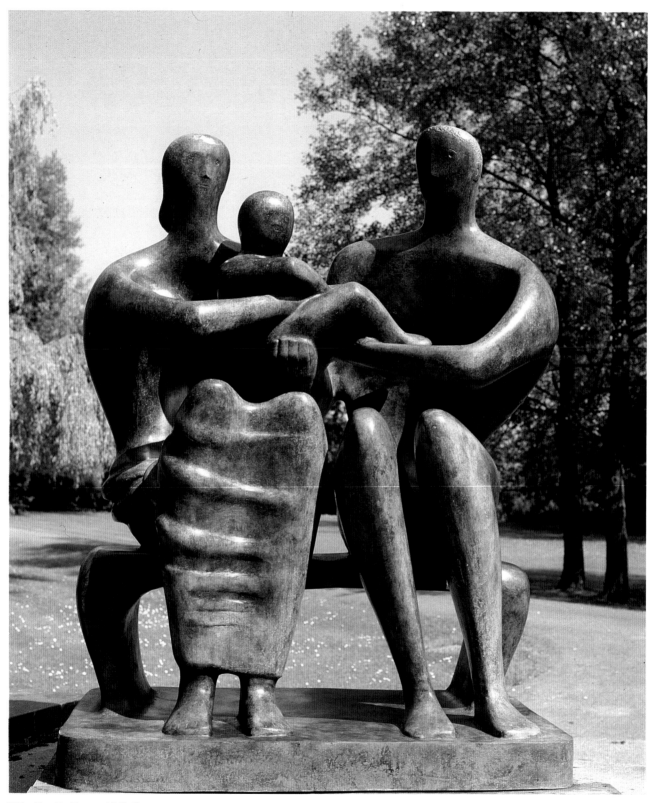

107 Family Group 1948–9

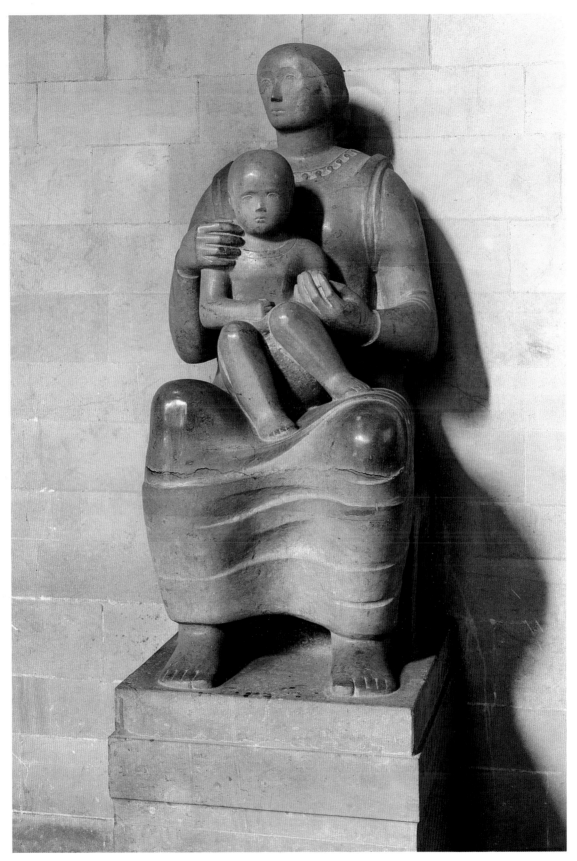

102 Madonna and Child 1943–4

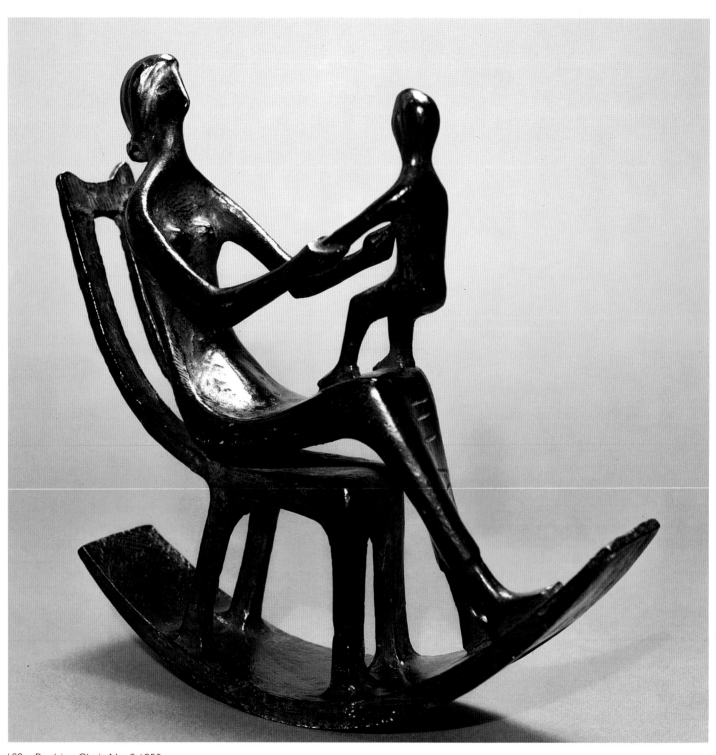

109 Rocking Chair No. 2 1950

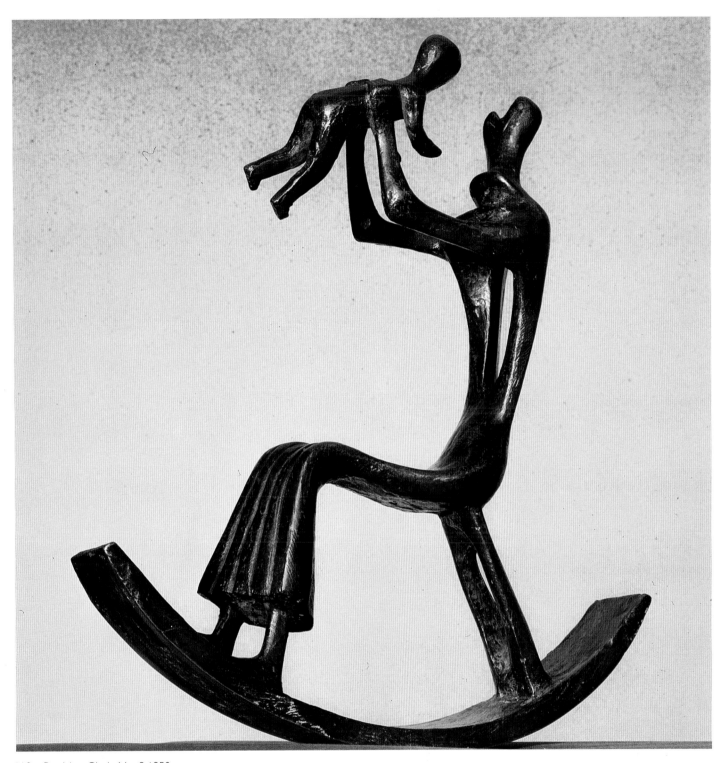

110 Rocking Chair No. 3 1950

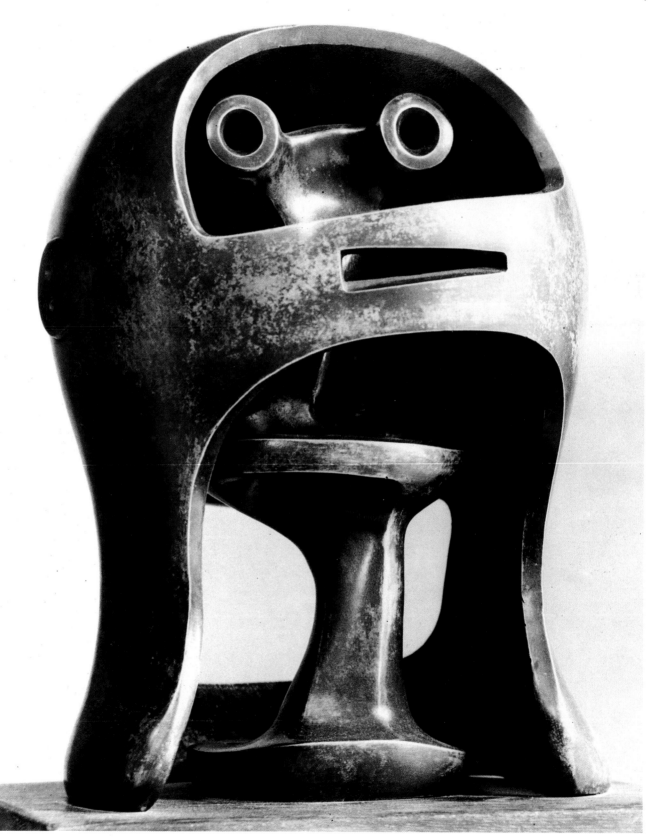

115 Helmet Head No. 2 1950

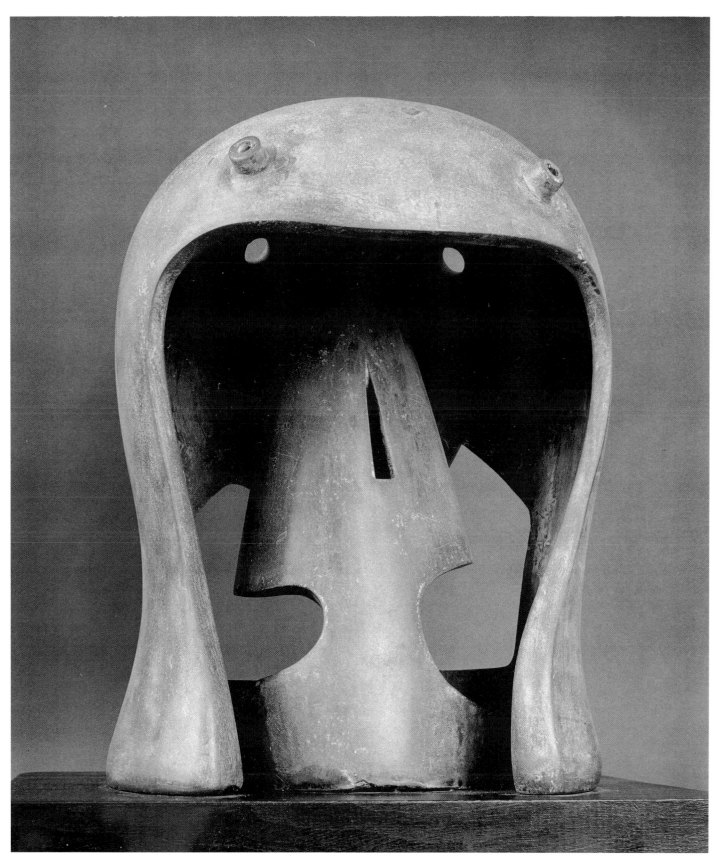

114 Helmet Head No. 1 1950

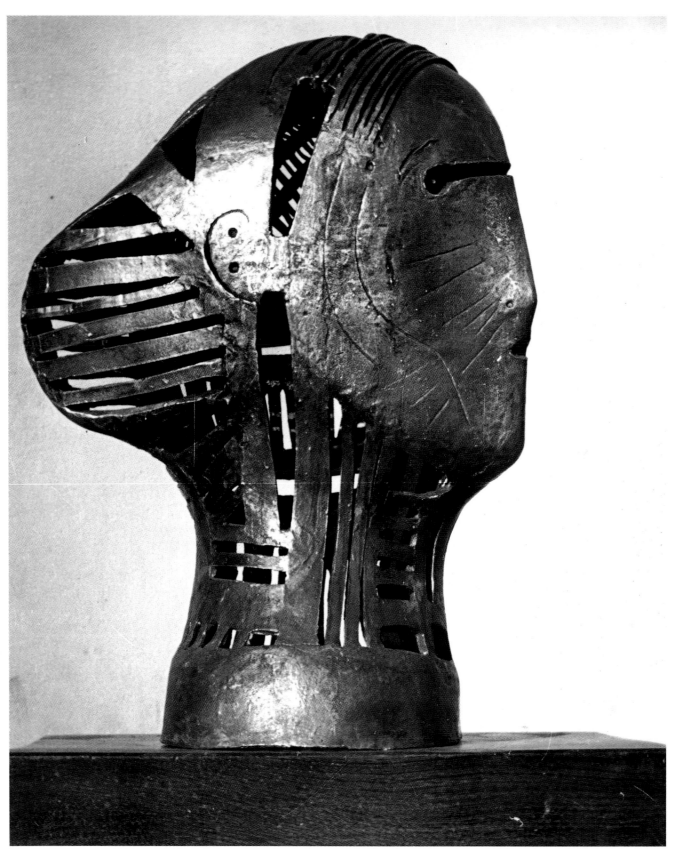

117 Openwork Head No.2 1950

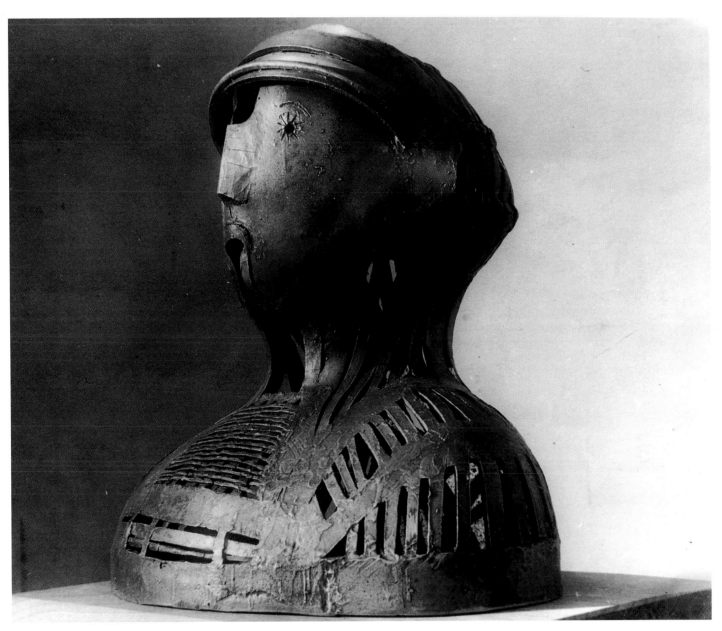

116 Openwork Head and Shoulders 1950

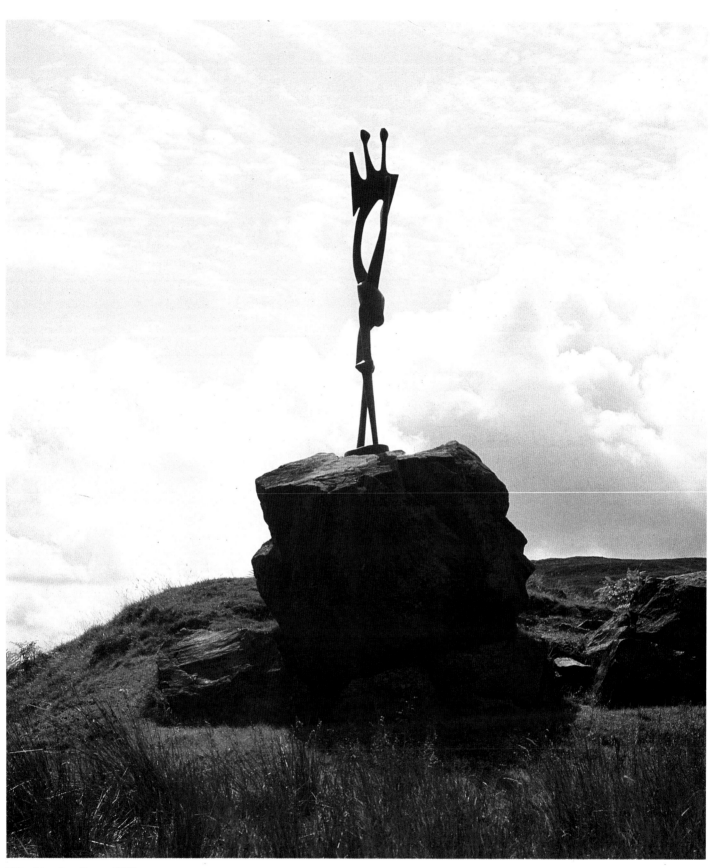

122 Standing Figure 1950

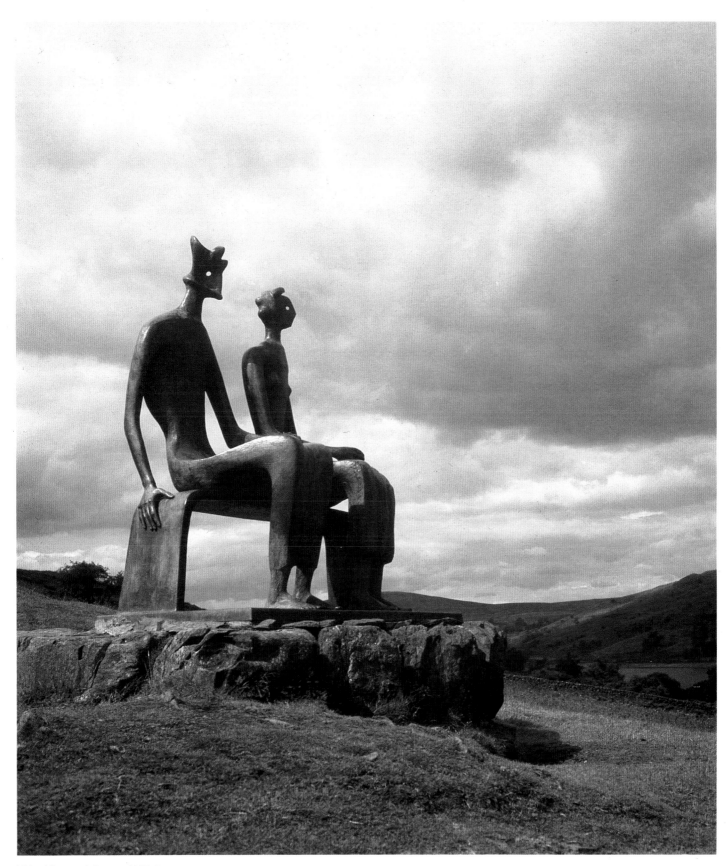

126 King and Queen 1952–3

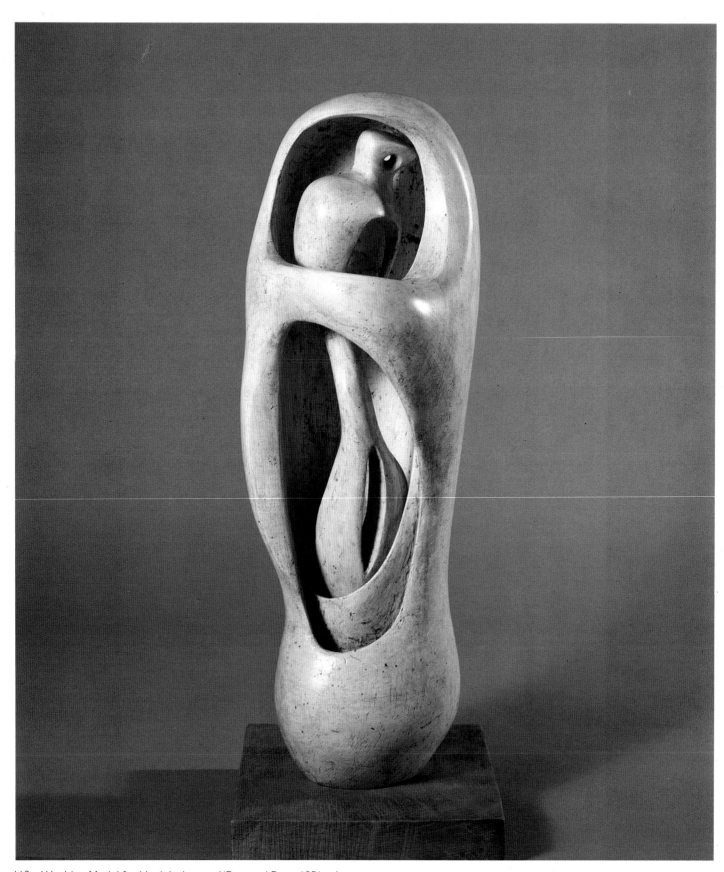

118 Working Model for Upright Internal/External Form 1951, plaster

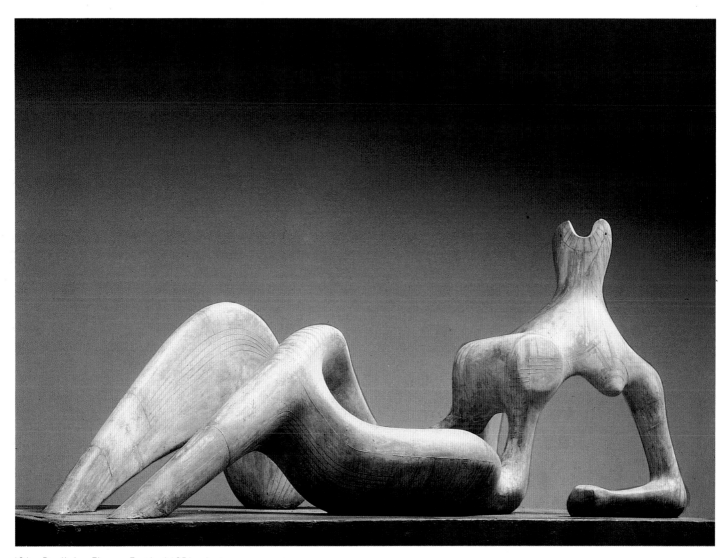

121 Reclining Figure: Festival 1951, plaster

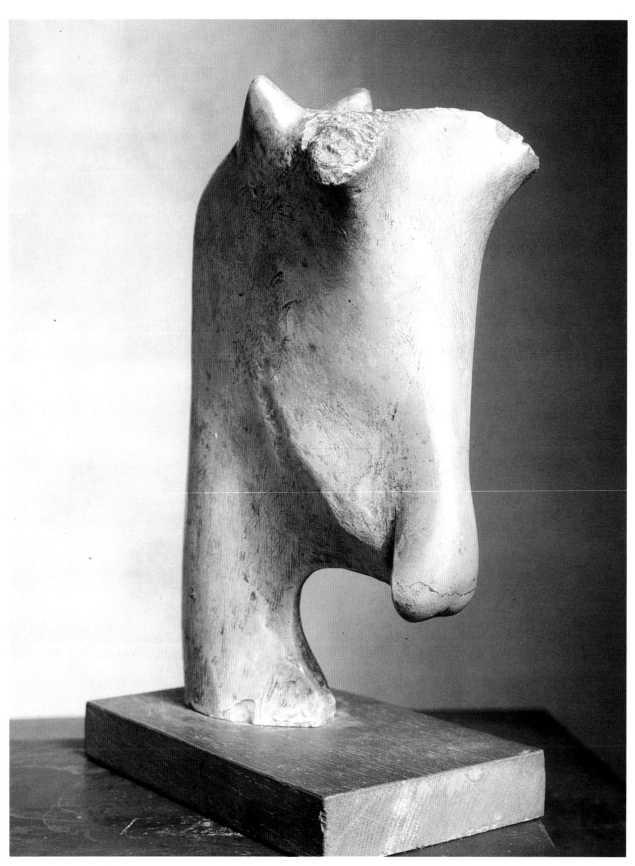

120 Goat's Head 1952, plaster

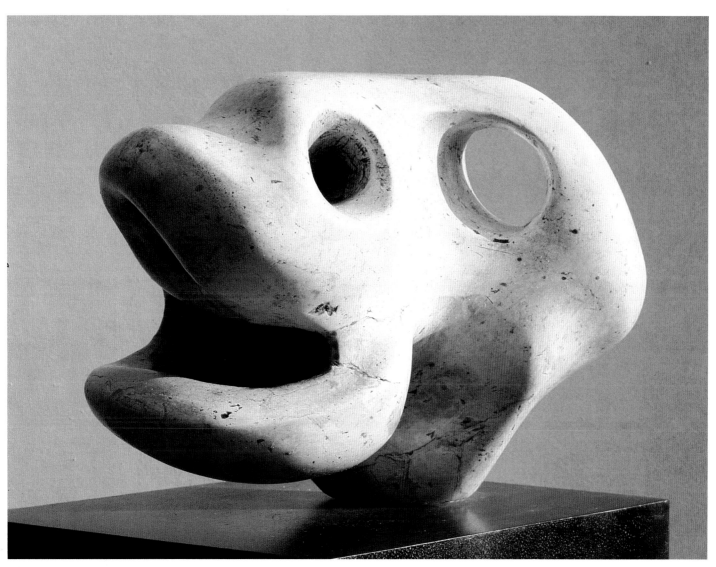

119 Animal Head 1951, plaster

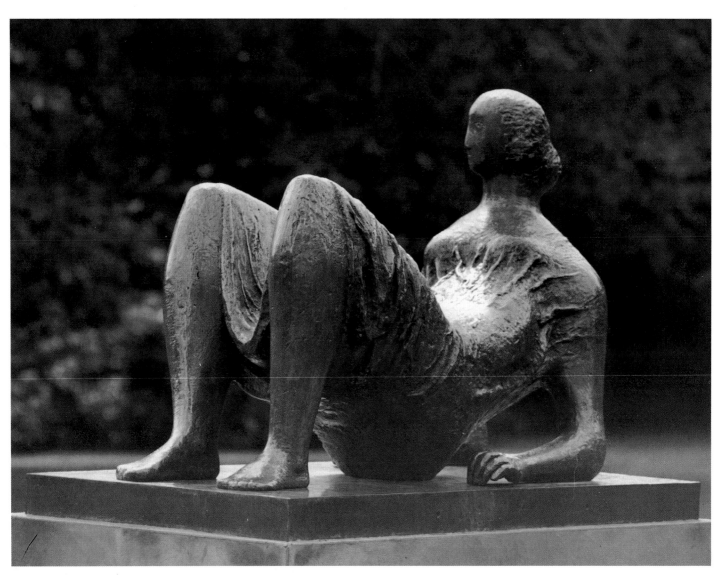

127 Draped Reclining Figure 1952–3

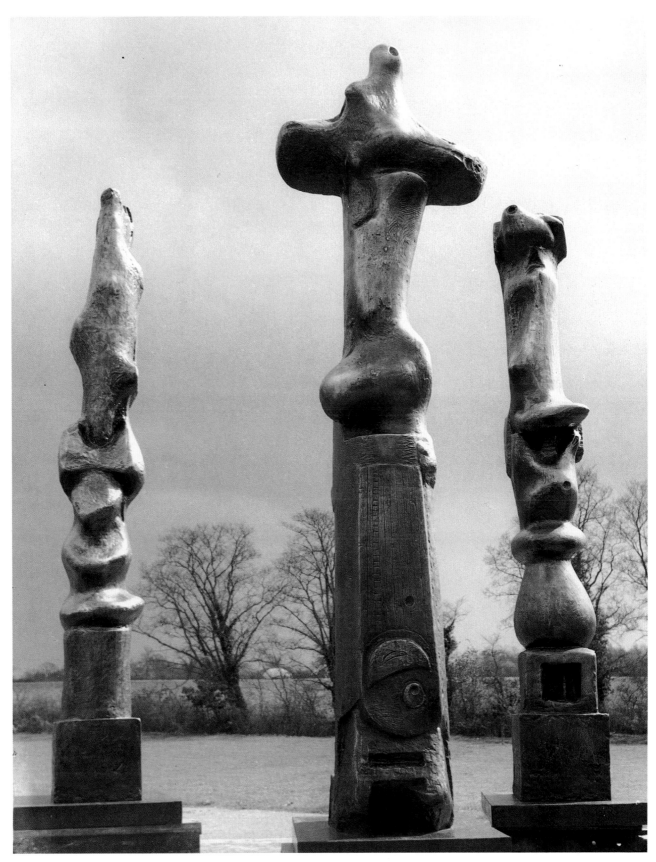

134–6 Upright Motives Nos. 7, 1, 2 1955–6

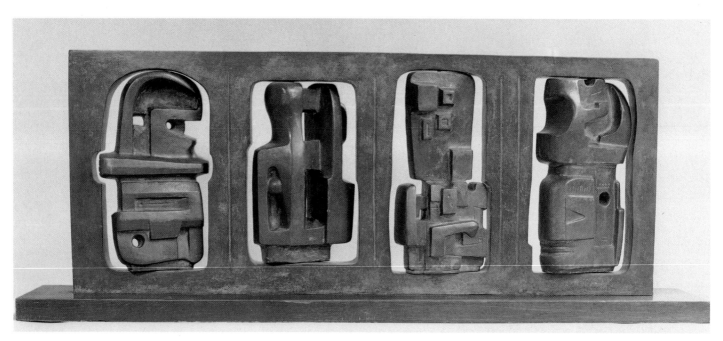

125 Working Model for Time-Life Screen 1952

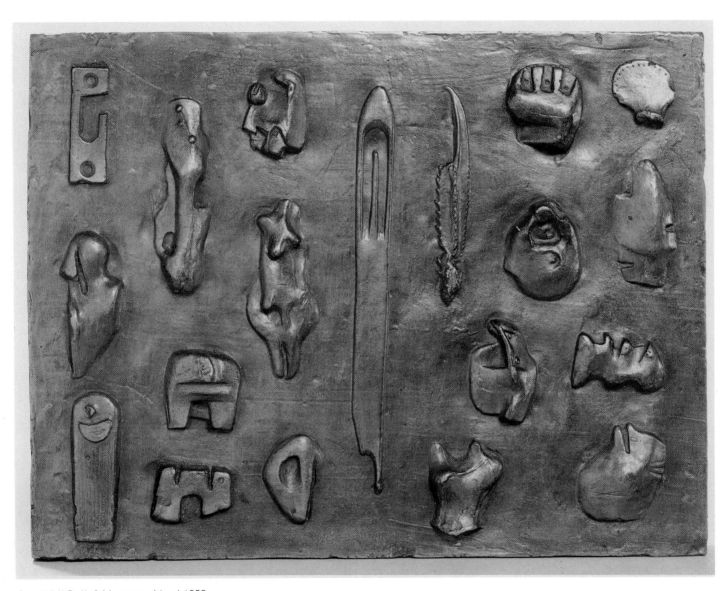

131 Wall Relief: Maquette No. 6 1955

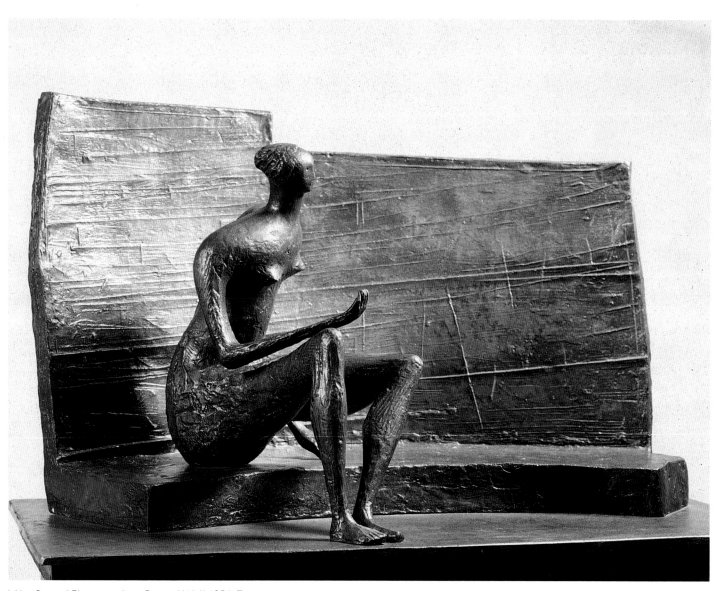

141 Seated Figure against Curved Wall 1956–7

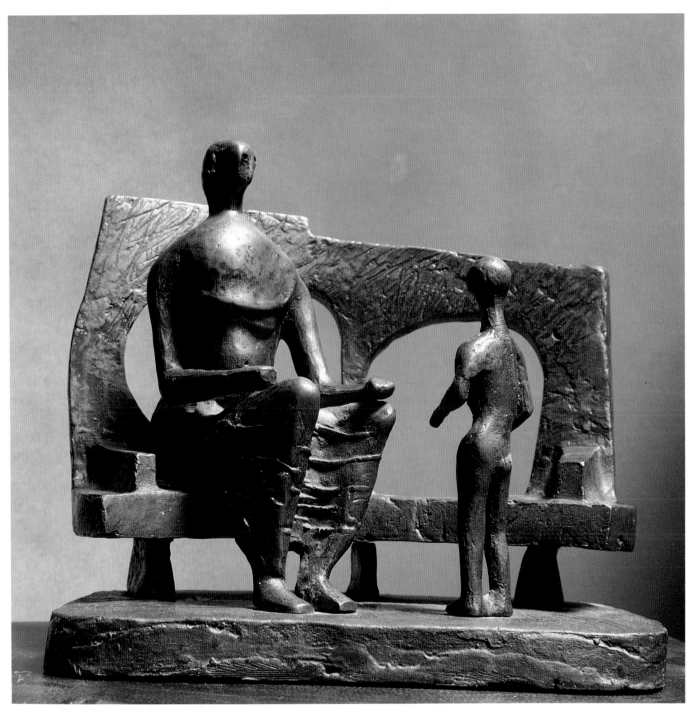

140 Mother and Child against Open Wall 1956

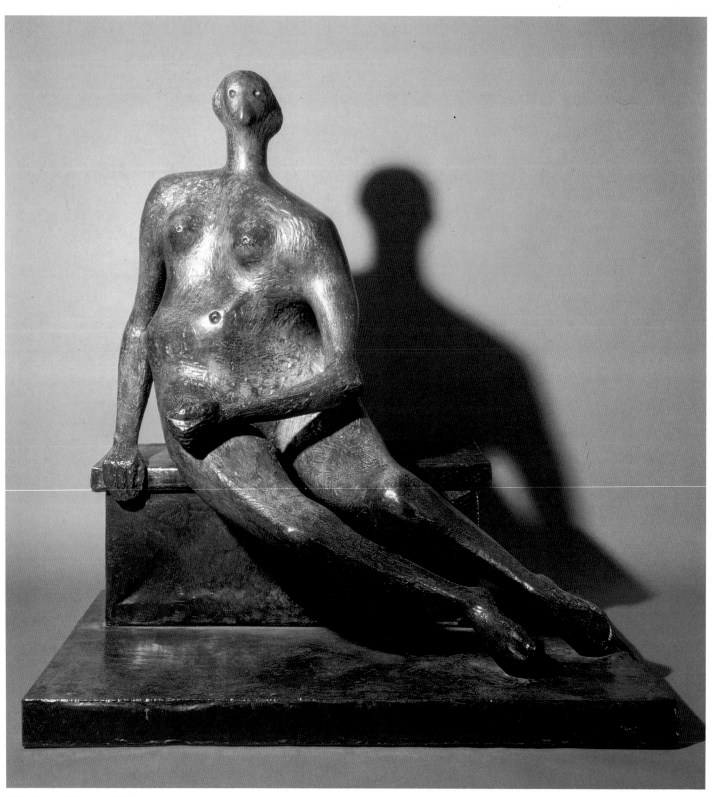

145 Seated Woman 1957

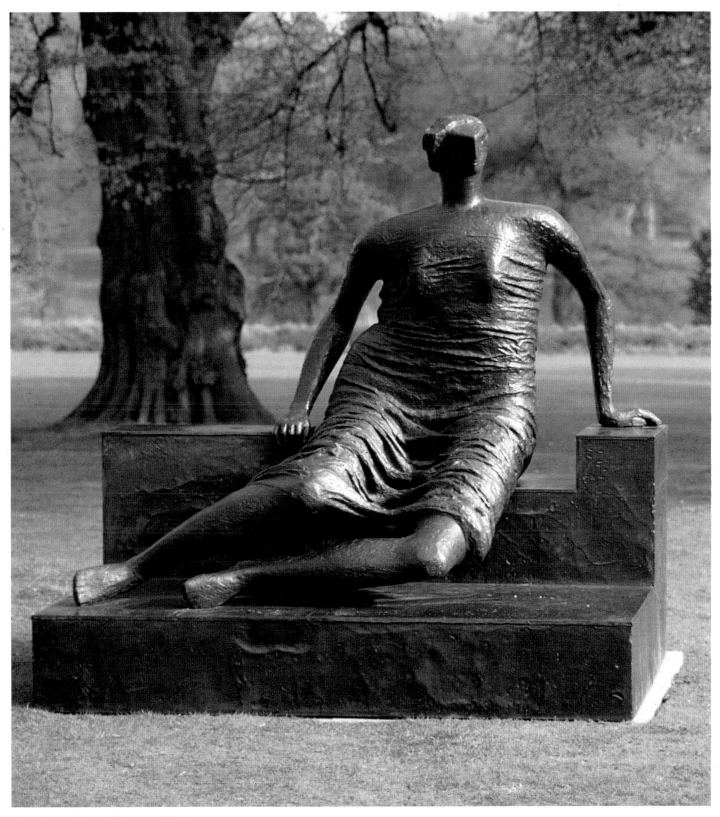

146　Draped Seated Woman 1957–8

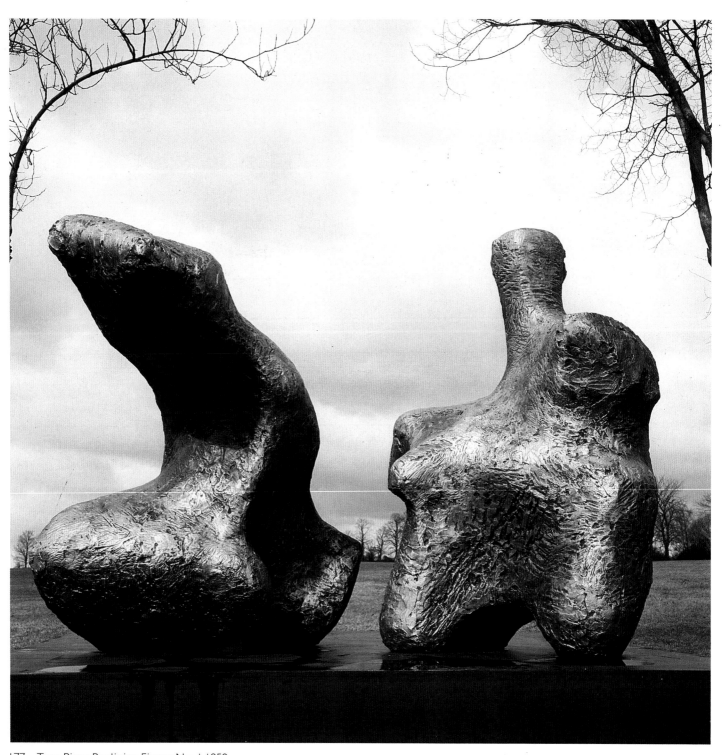

177　Two-Piece Reclining Figure No. 1 1959

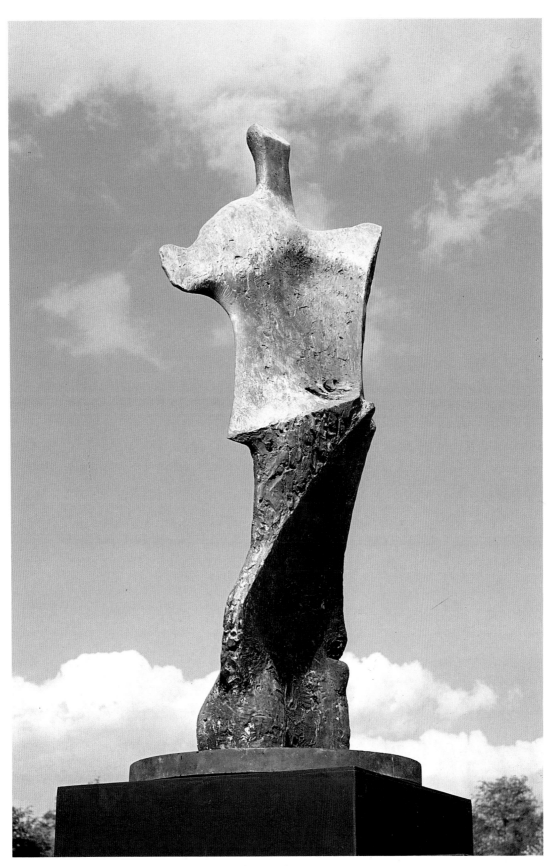

179 Working Model for Standing Figure: Knife Edge 1961

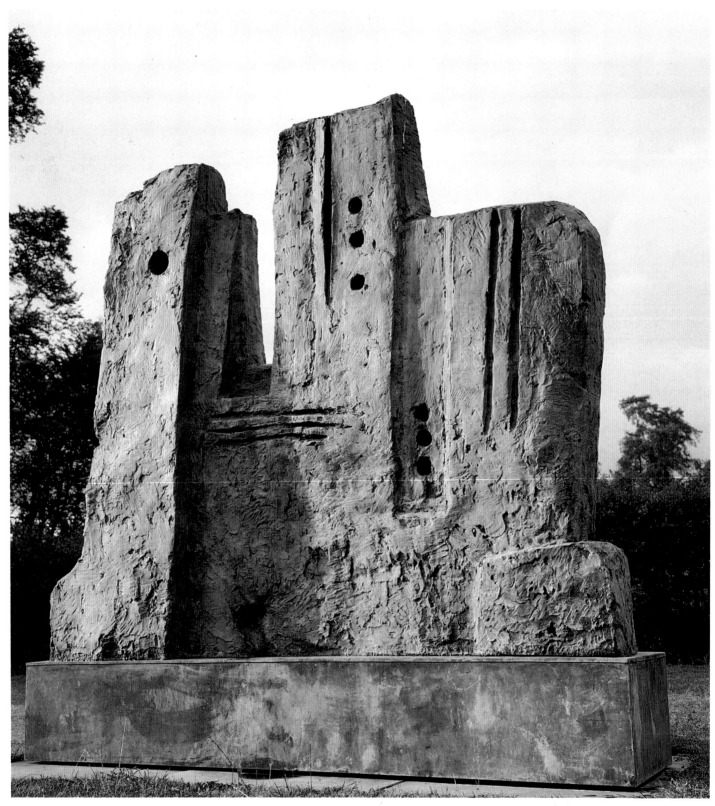

181 The Wall: Background for Sculpture 1962

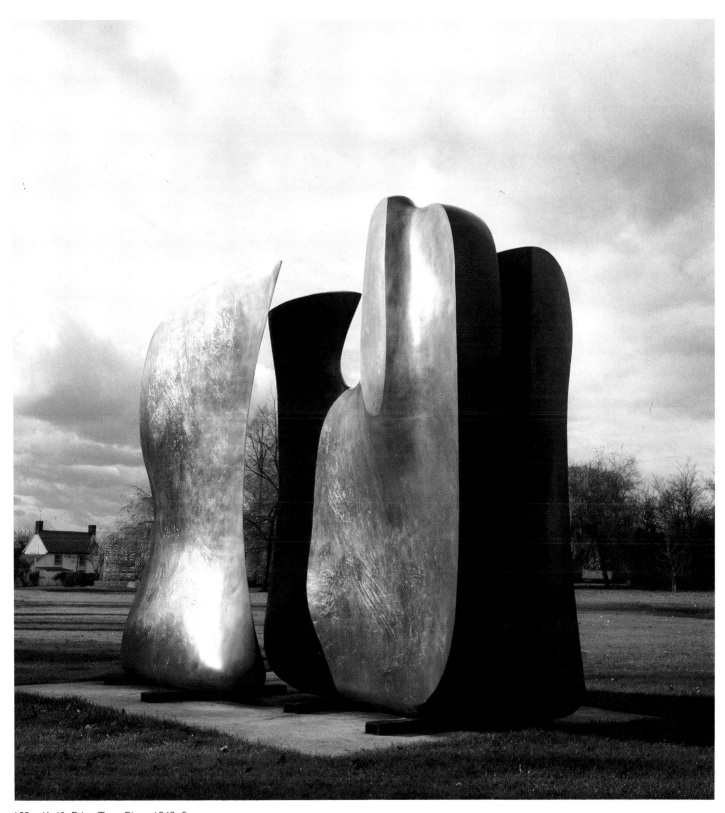

182 Knife Edge Two-Piece 1962–5

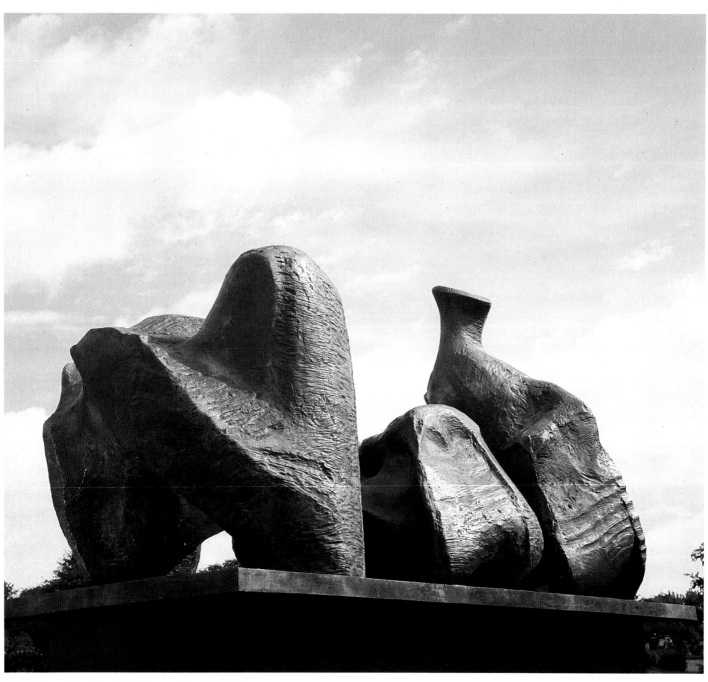

180 Three-Piece Reclining Figure No. 1 1961–2

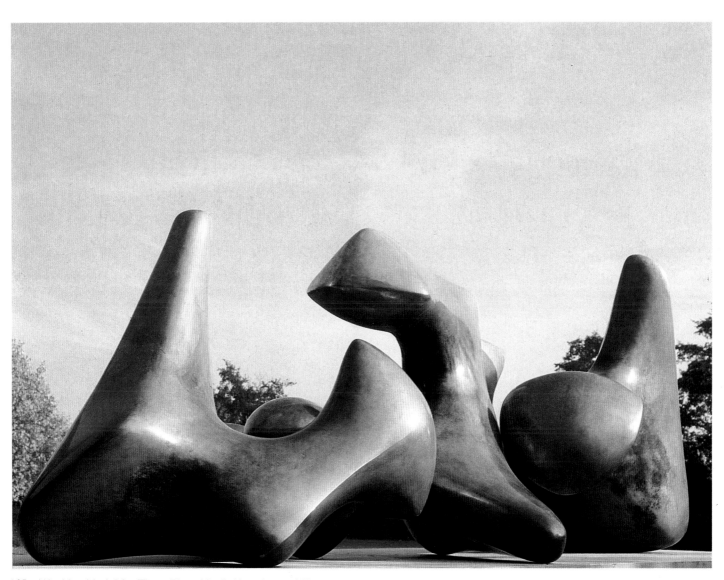

185 Working Model for Three Piece No. 3: Vertebrae 1968

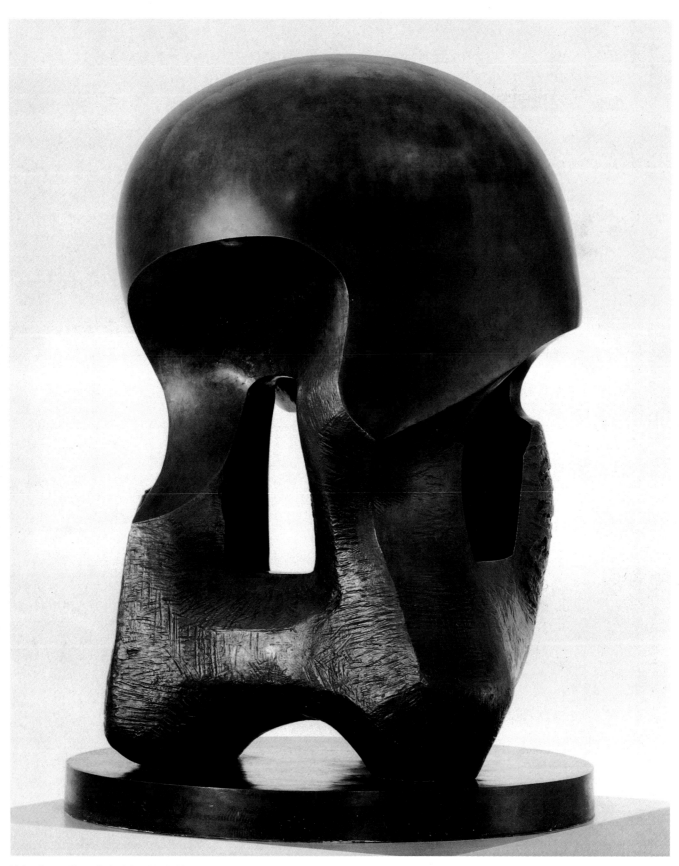

184 Atom Piece (Working Model for Nuclear Energy) 1964–5

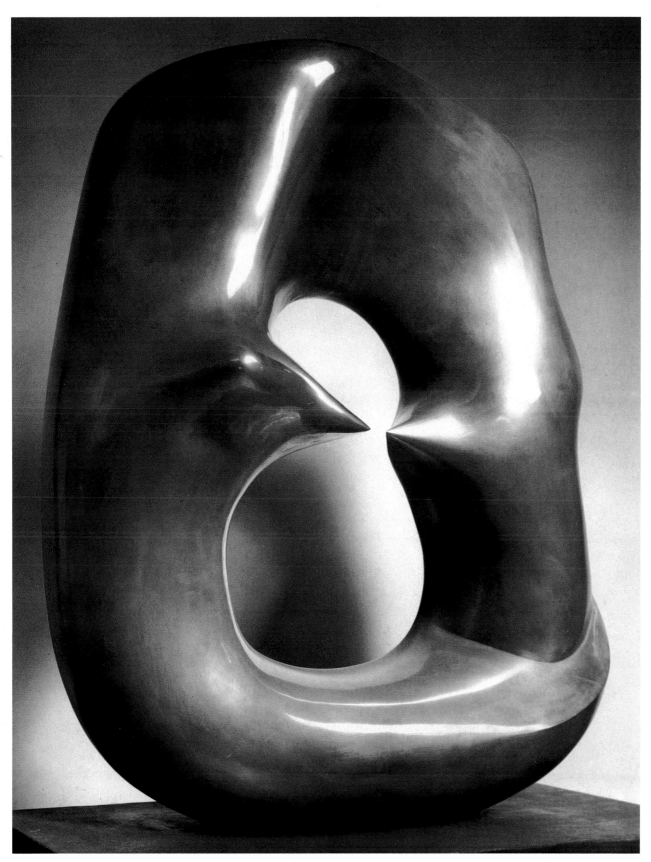

186 Working Model for Oval with Points 1968–9

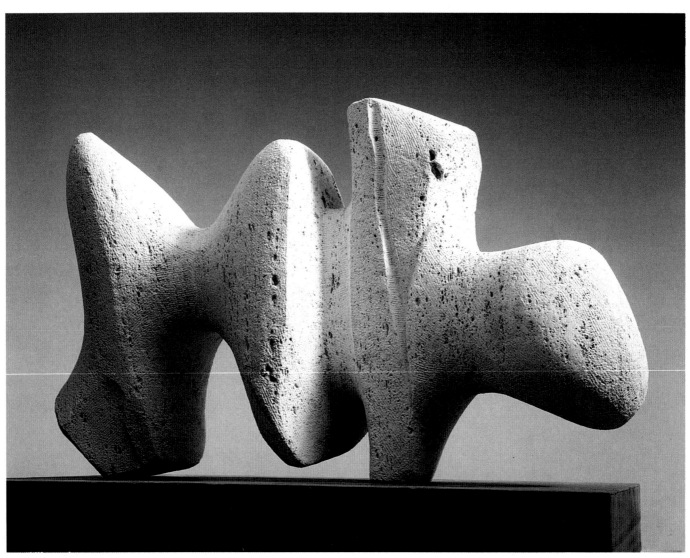

187 Animal Form 1969

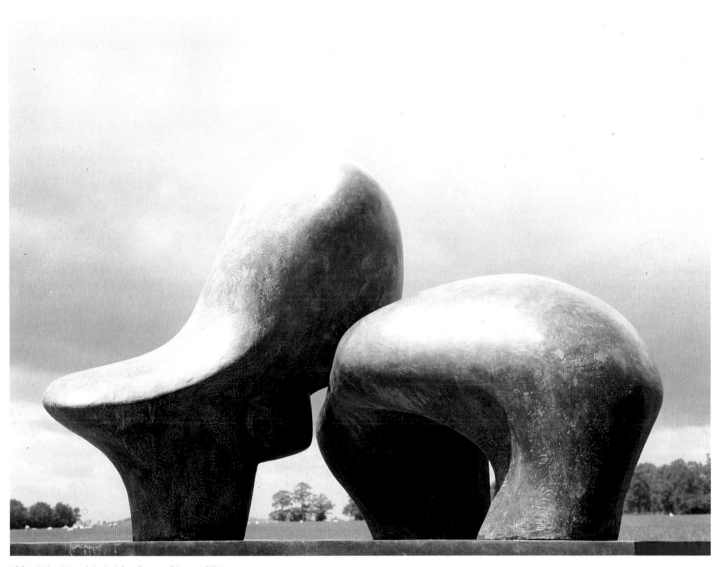

188 Working Model for Sheep Piece 1971

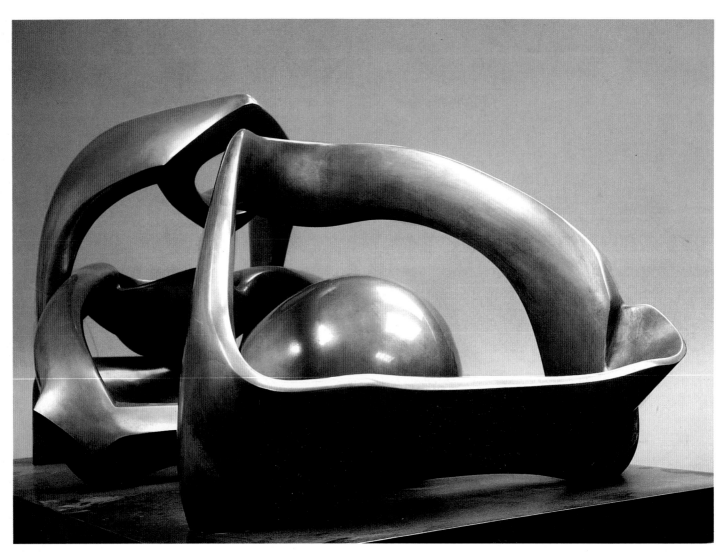

189 Working Model for Hill Arches 1972

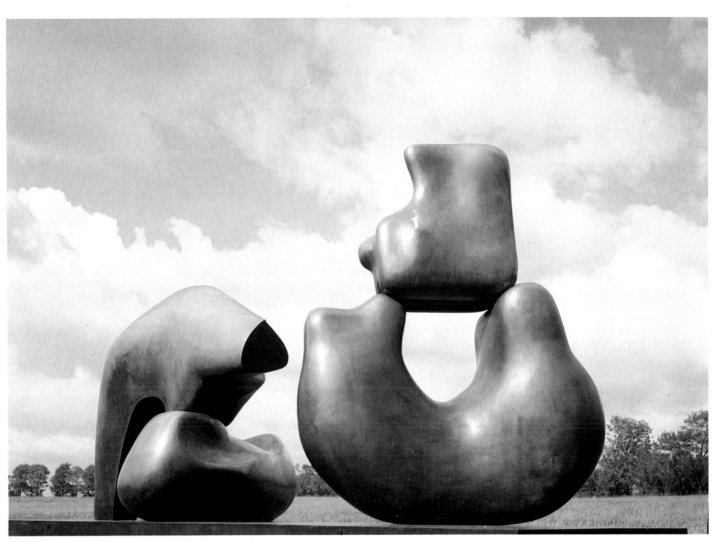

190 Large Four-Piece Reclining Figure 1972–3

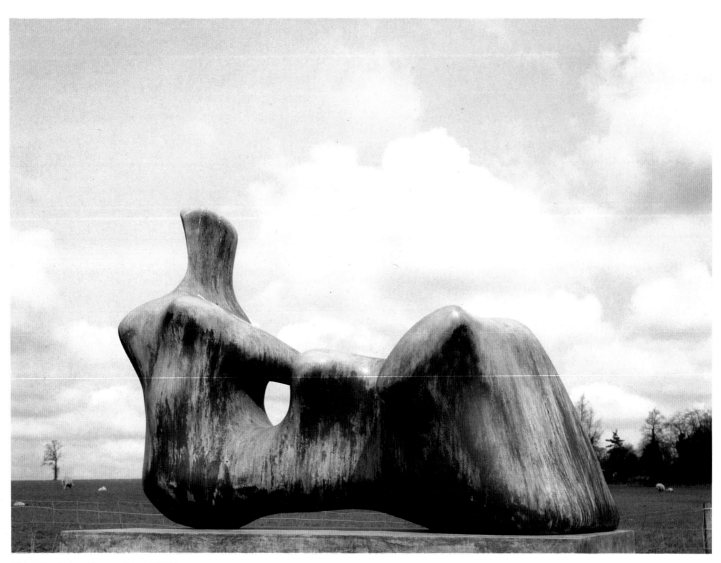

197 Reclining Figure: Hand 1979

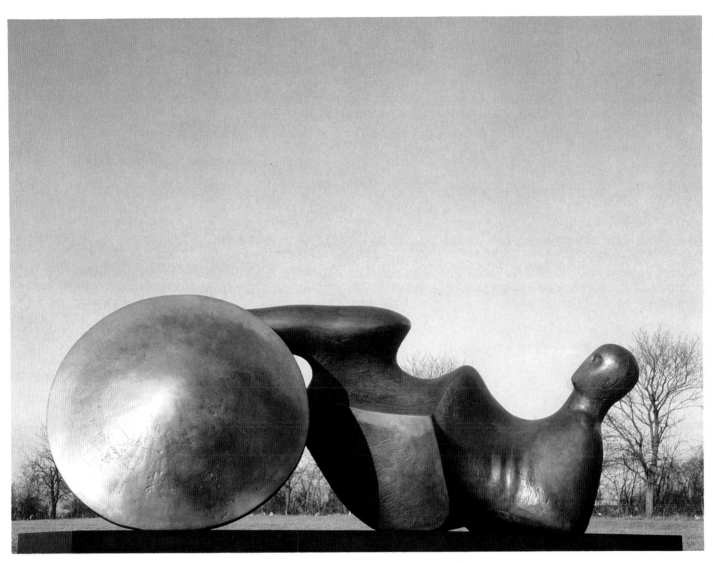

191 Goslar Warrior 1973–4

47 Nude Study of Seated Girl c.1924

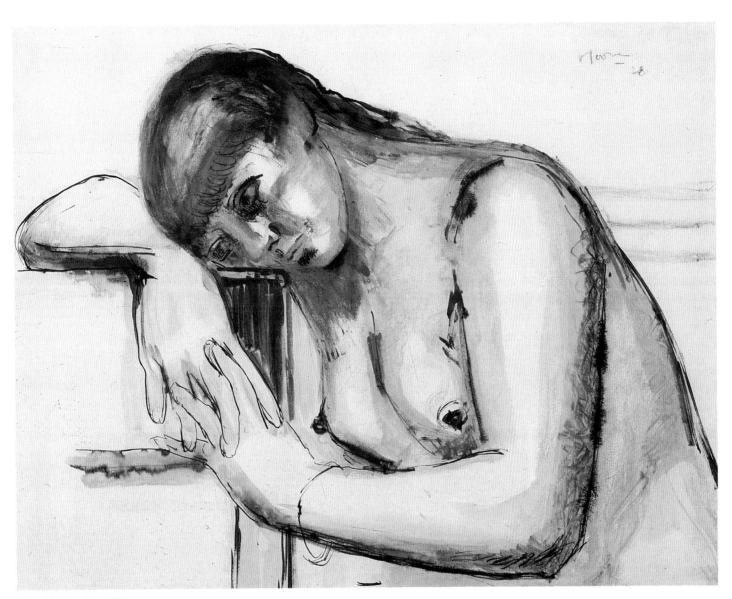

58 Girl Resting 1928

54 Woman Seated Reading (The Artist's Sister) 1925

55 The Artist's Mother 1927

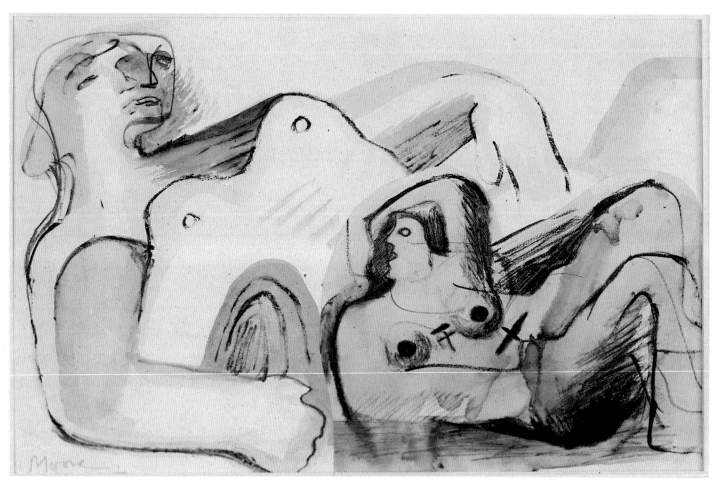

63 Two Recumbent Nudes 1928

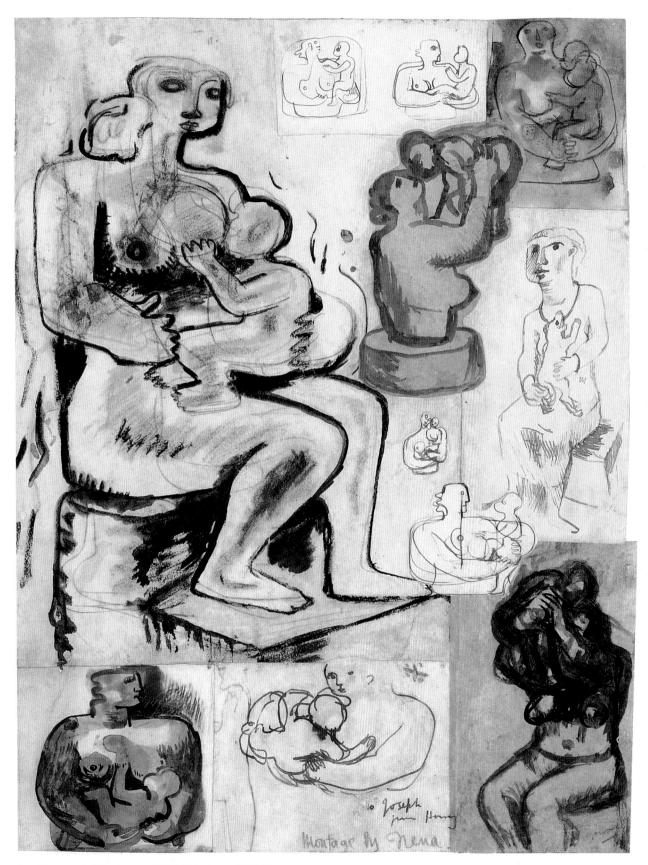

64 Montage of Mother and Child Studies c. 1929–30

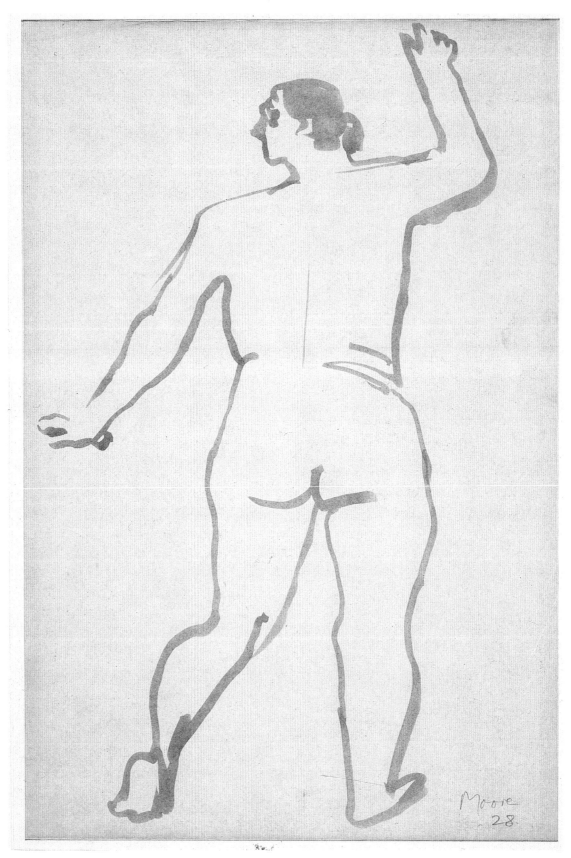

56 Standing Female Figure 1928

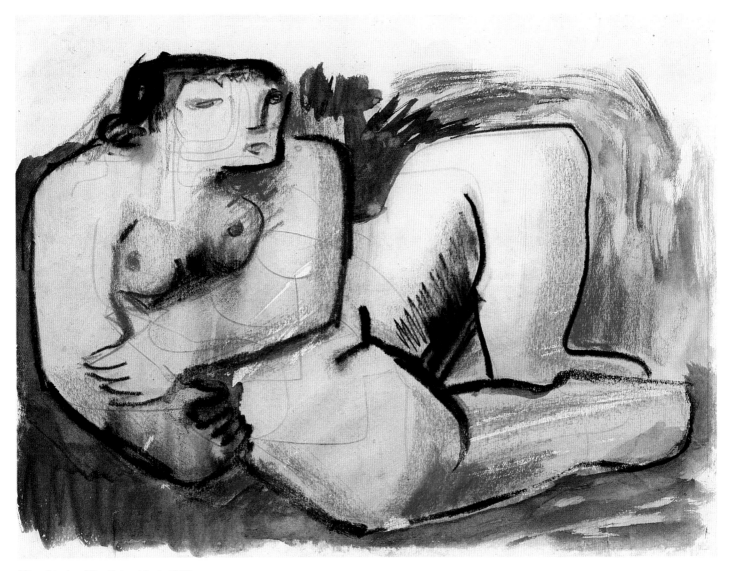

68b Study of Reclining Nude 1930

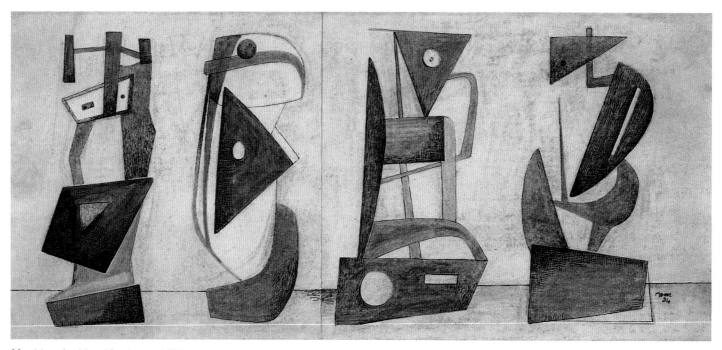

80 Ideas for Metal Sculpture 1934

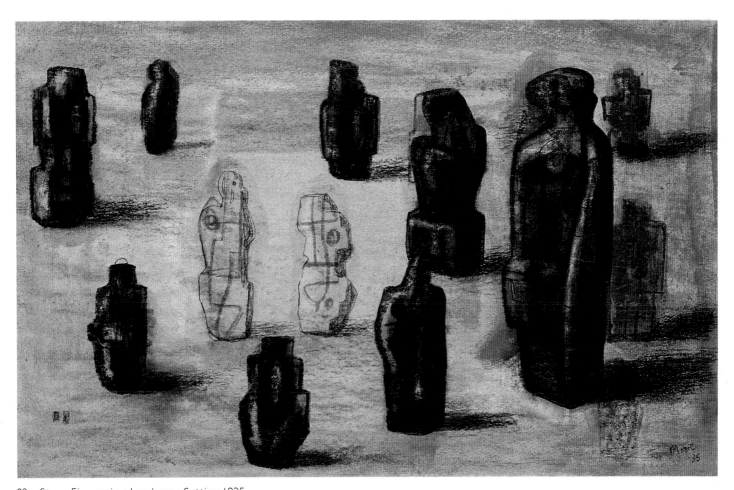

82 Stone Figures in a Landscape Setting 1935

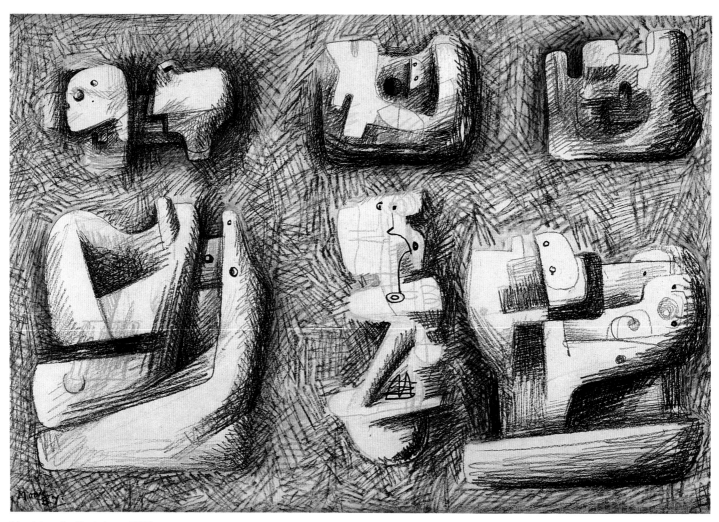

86 Ideas for Sculpture 1937

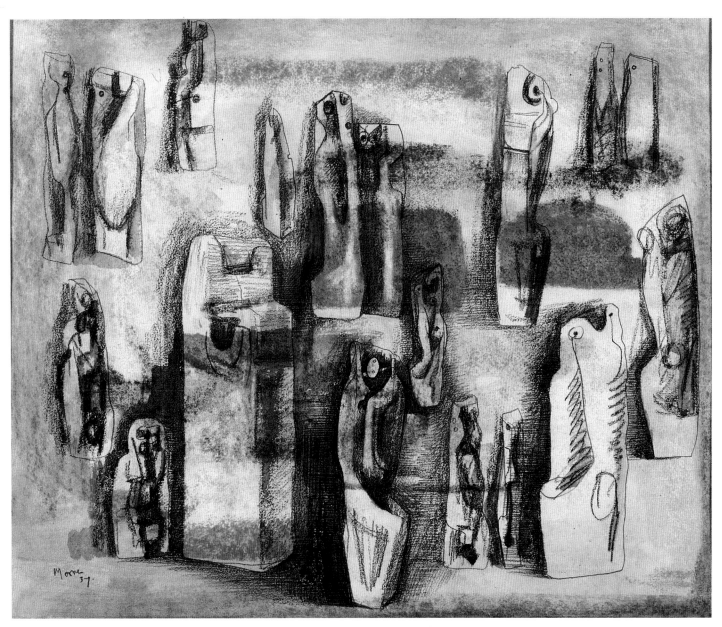

87 Drawings for Stone Sculpture 1937

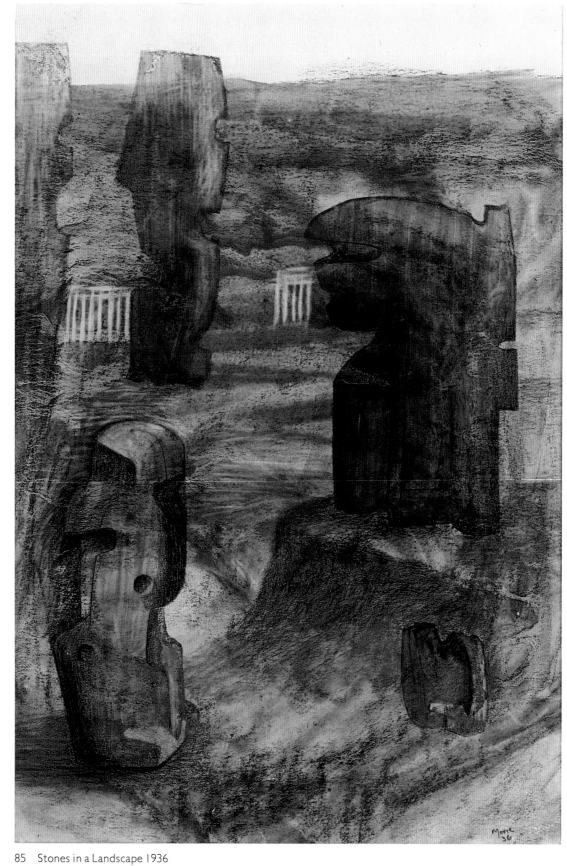

85 Stones in a Landscape 1936

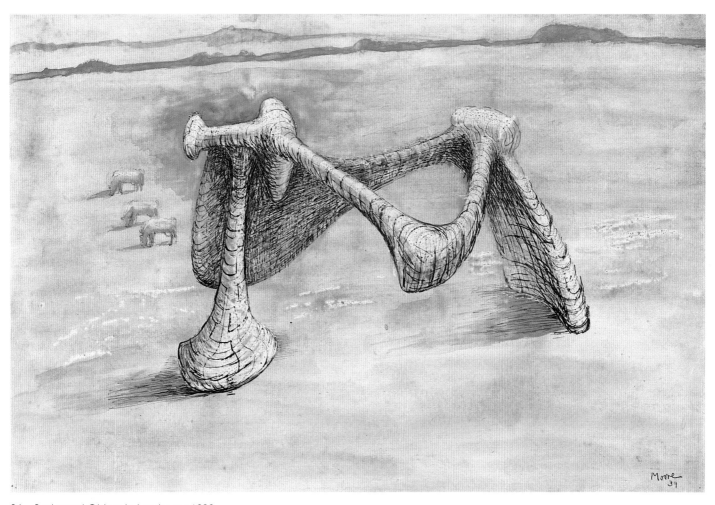

96 Sculptural Object in Landscape 1939

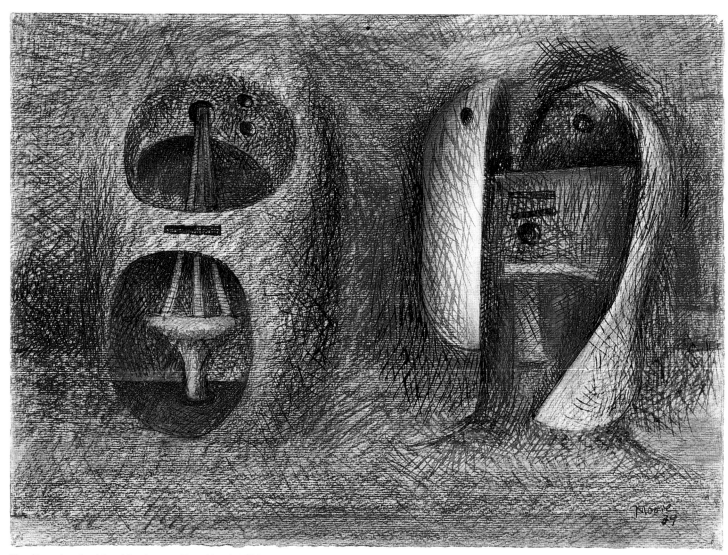

93 Drawing for Metal Sculpture: Two Heads 1939

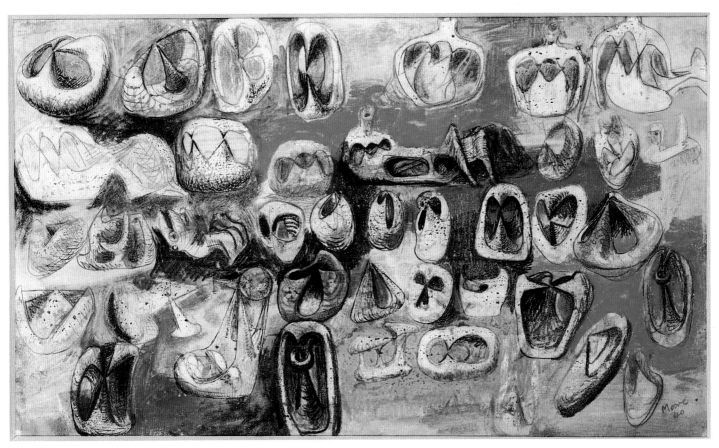

101 Pointed Forms 1940

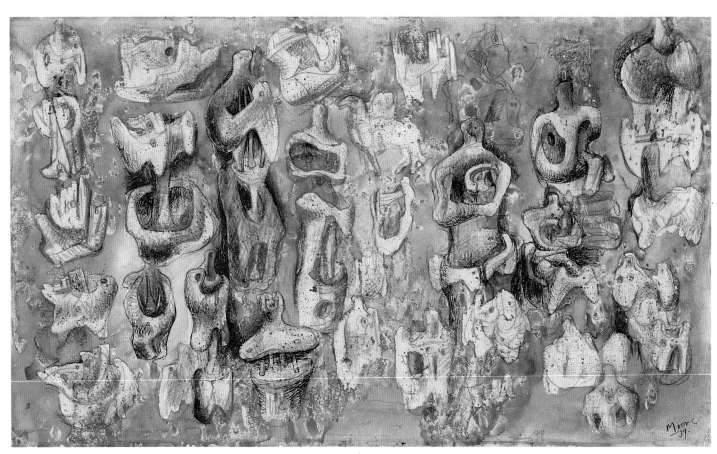

98 Studies for Sculpture in Various Materials 1939

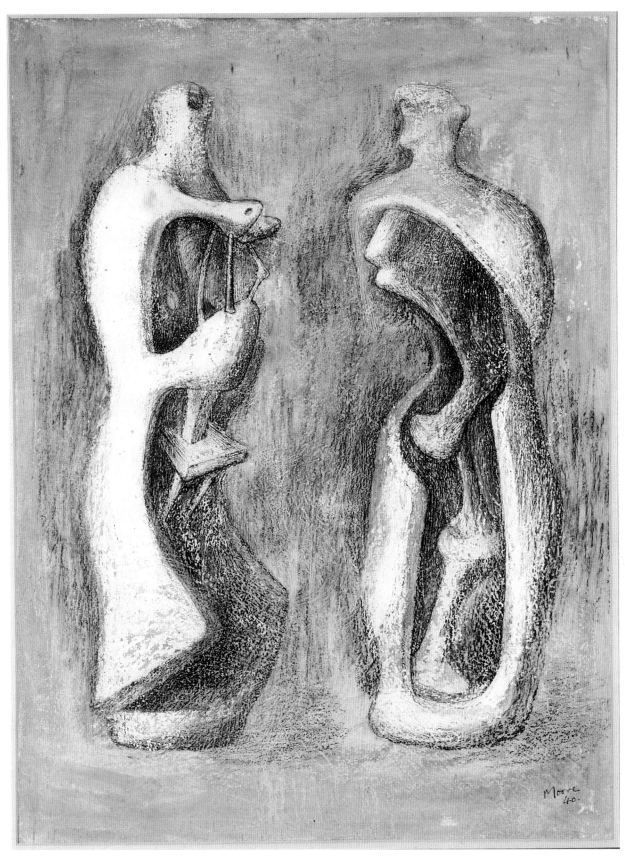

100 Two Standing Figures 1940

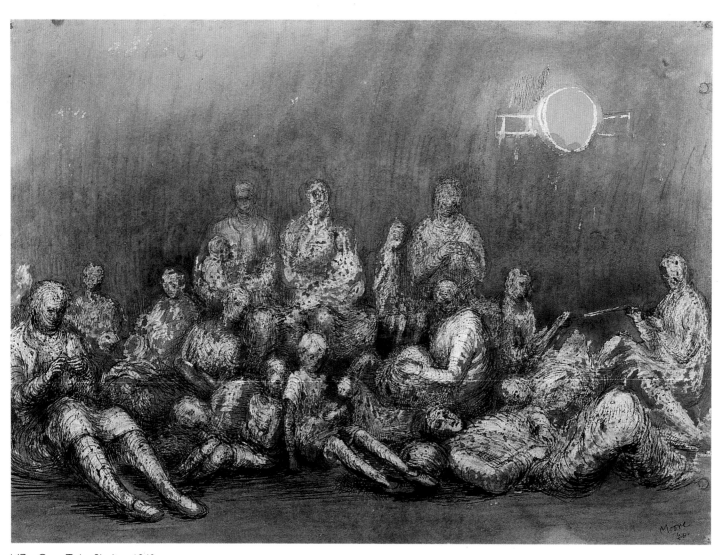

147 Grey Tube Shelter 1940

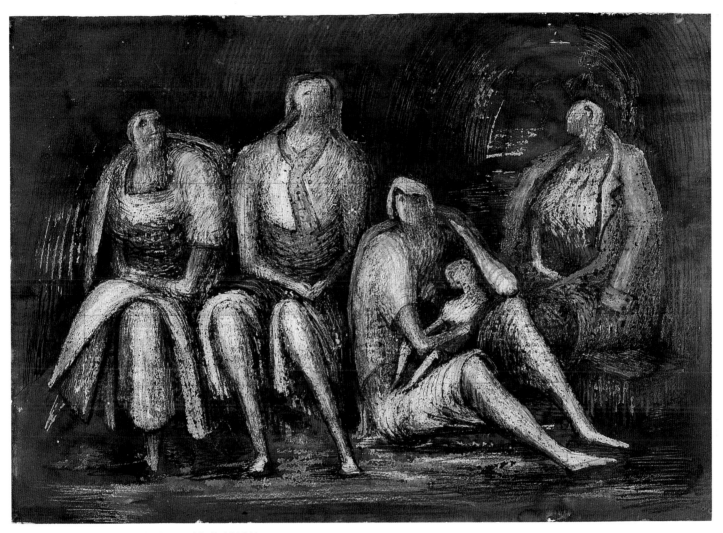

151 Group of Shelterers during an Air Raid 1941

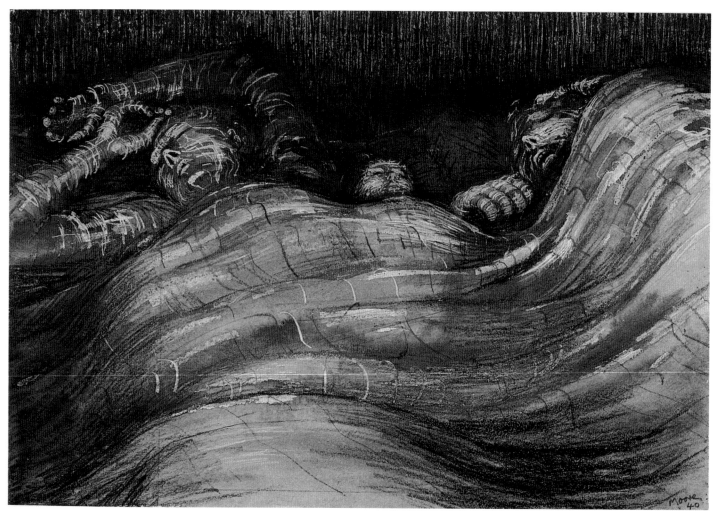

148 Sleeping Shelterers: Two Women and a Child 1941

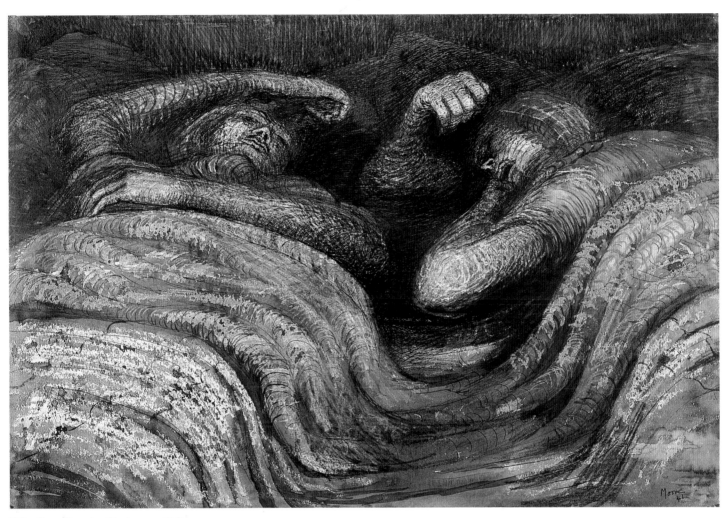

153 Two Sleeping Shelterers 1941

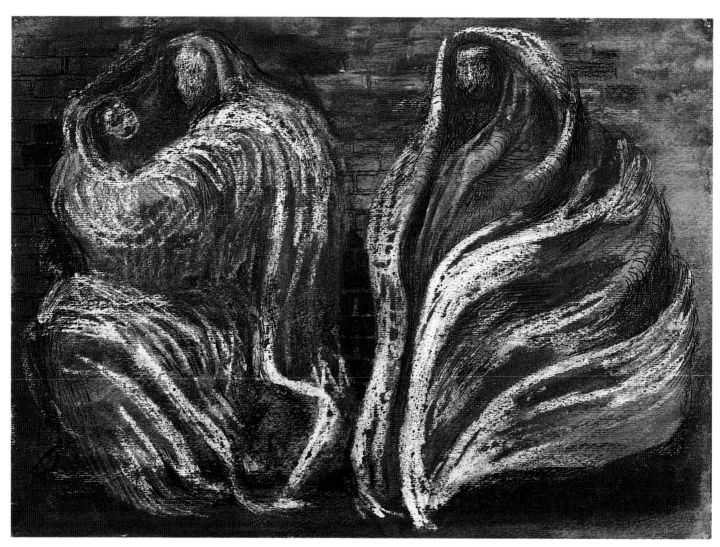

152 Shelter Scene: Two Swathed Figures 1941

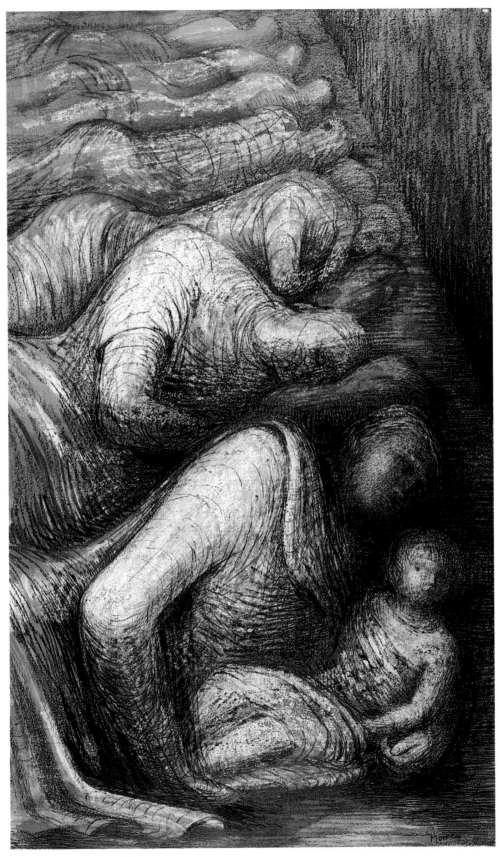

150 Row of Sleepers 1941

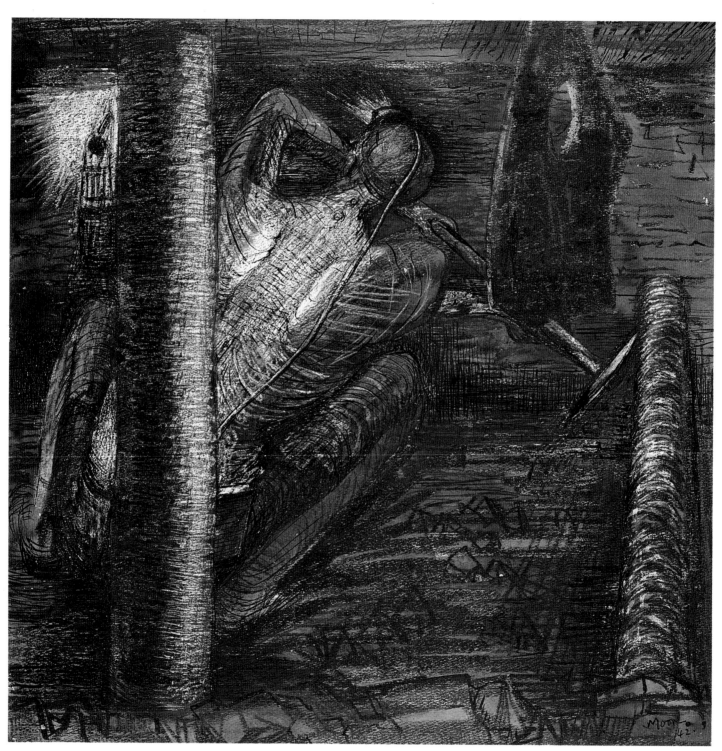

158 Miner at Work 1942

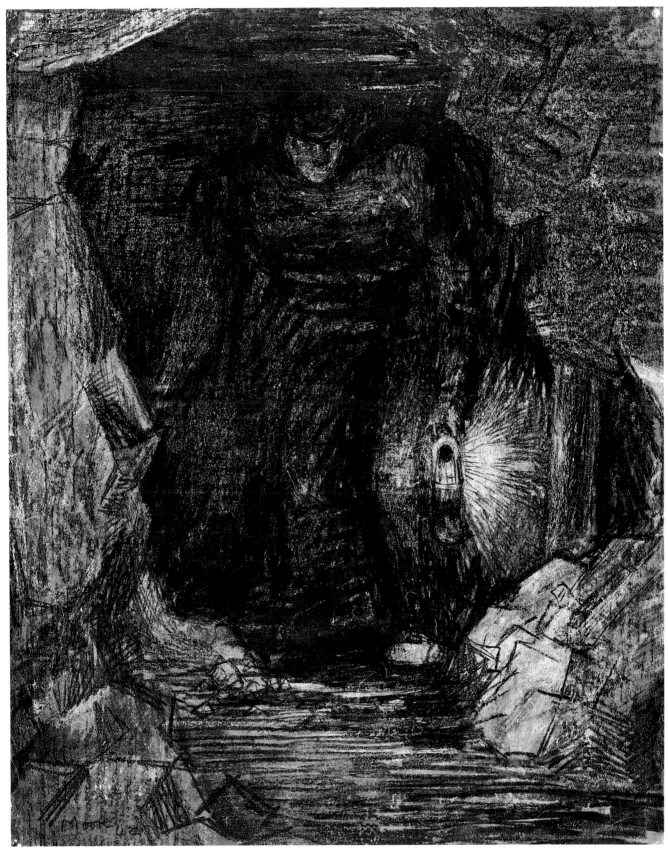

157 Coal-Miner Carrying Lamp 1942

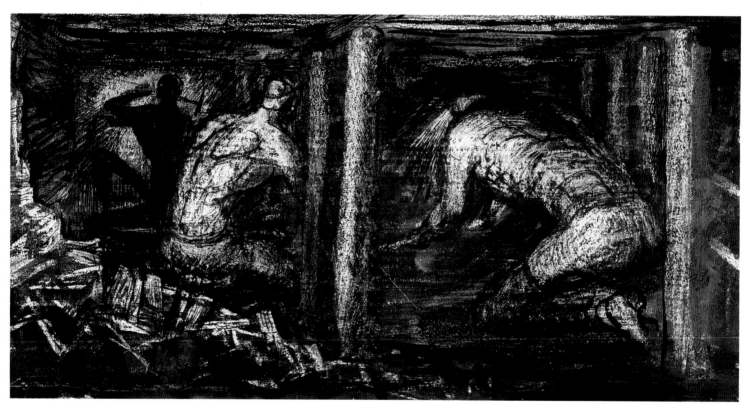

156 At the Coal-face 1942

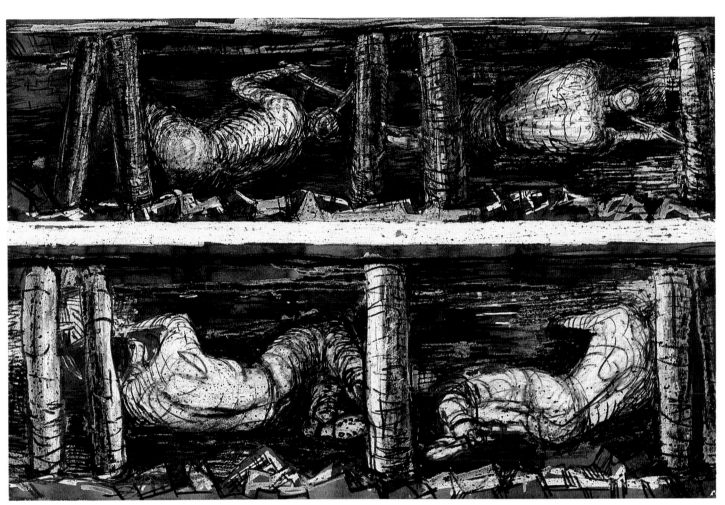

159 Four Studies of Miners at the Coal-Face 1942

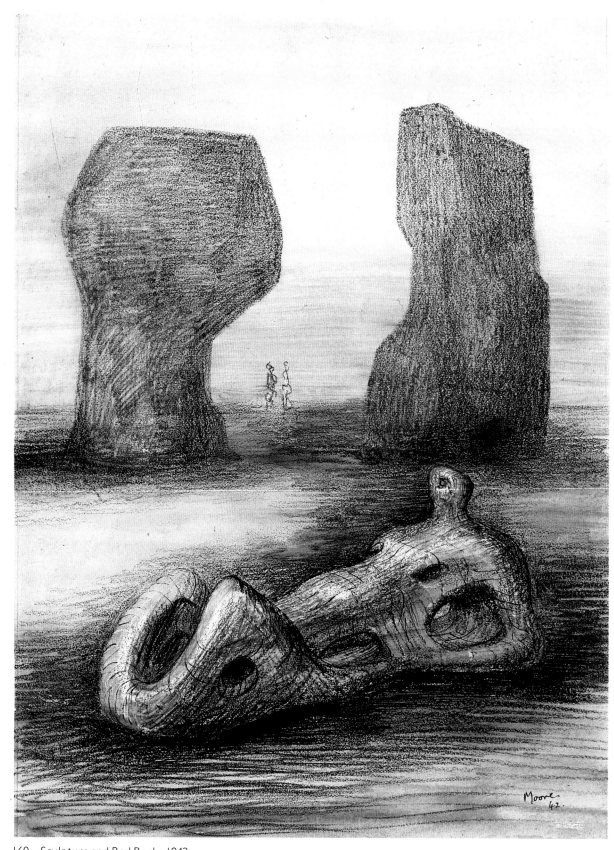

160 Sculpture and Red Rocks 1942

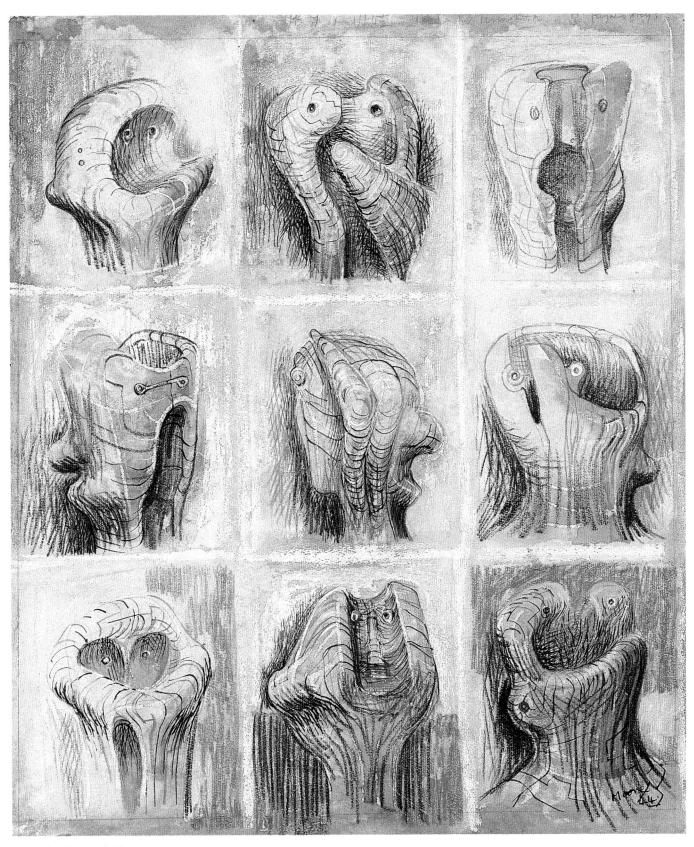

162 Nine Heads 1944

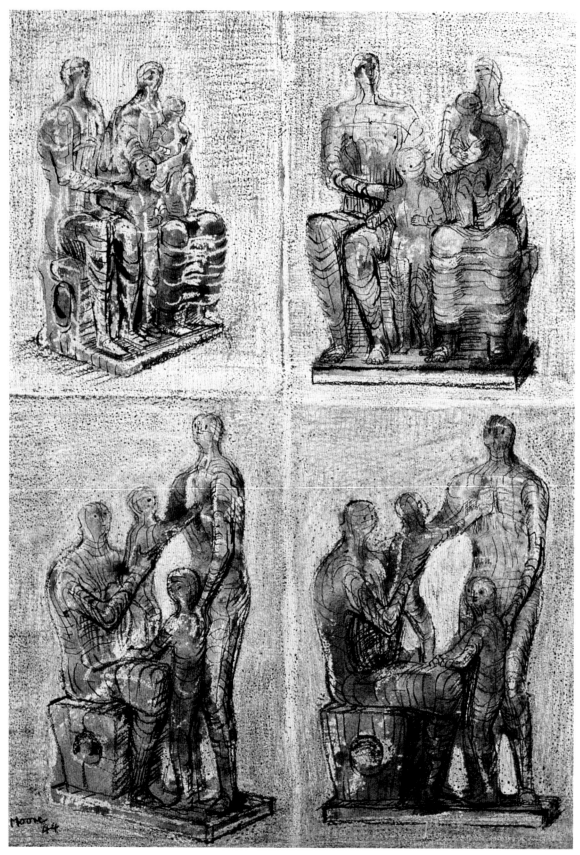

165 Family Groups 1944

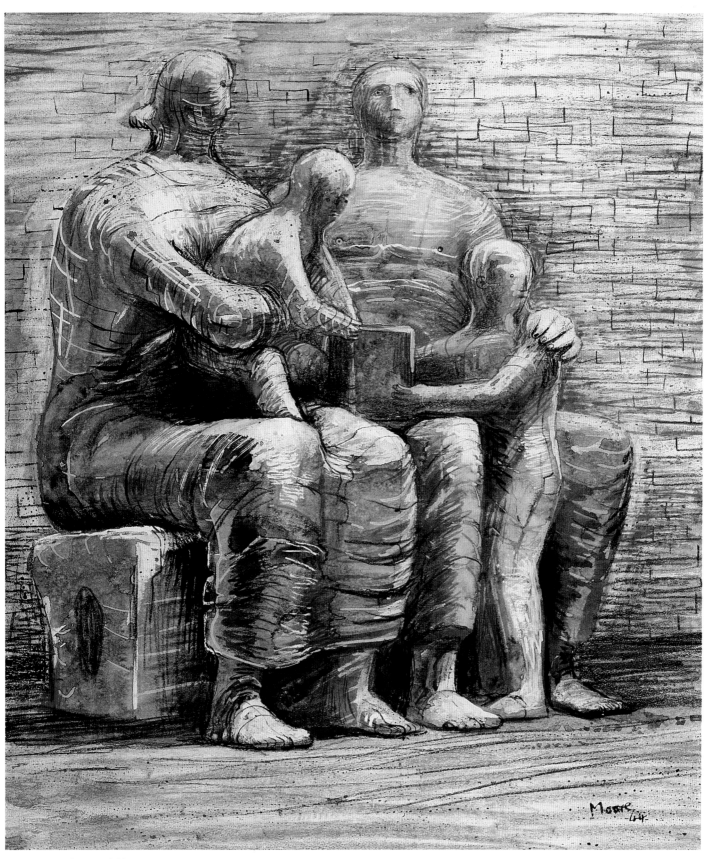

166 Family Group 1944

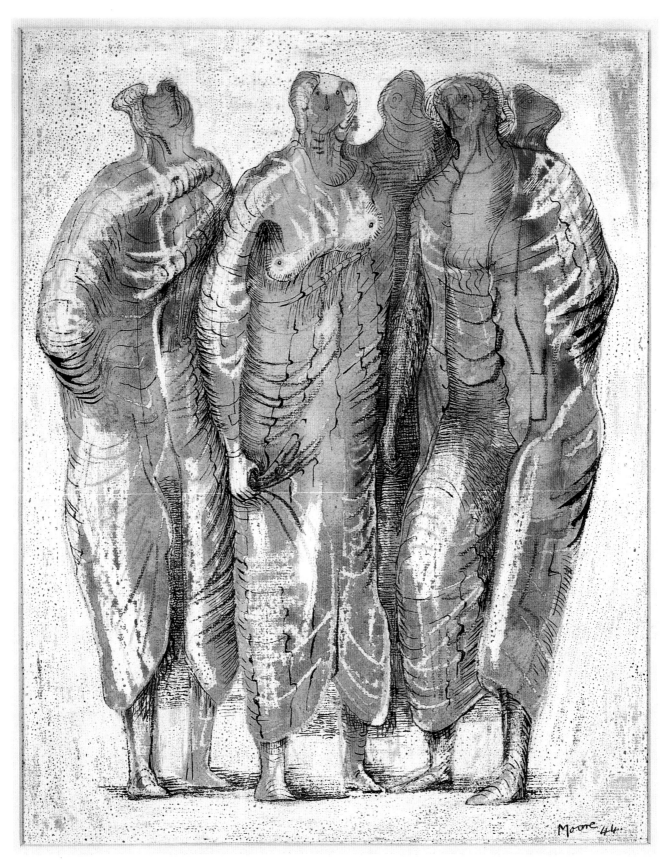

163 Draped Standing Figures in Red 1944

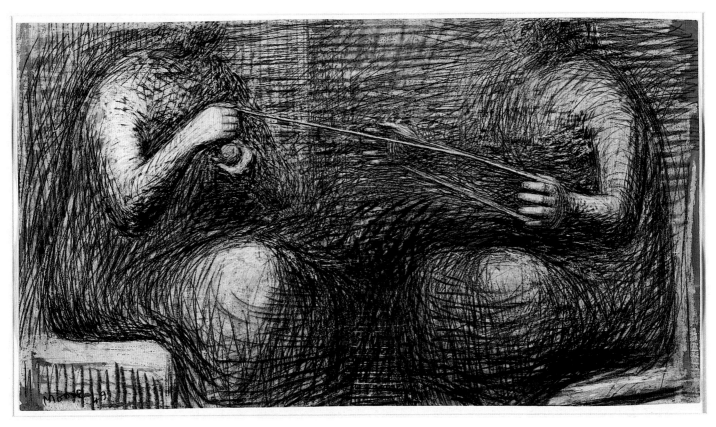

171 Women Winding Wool 1949

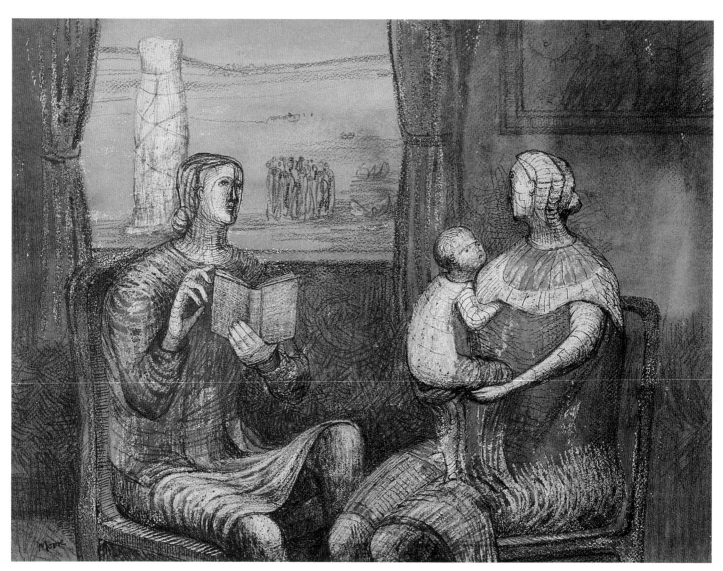

167 Girl Reading to a Woman and Child c.1946

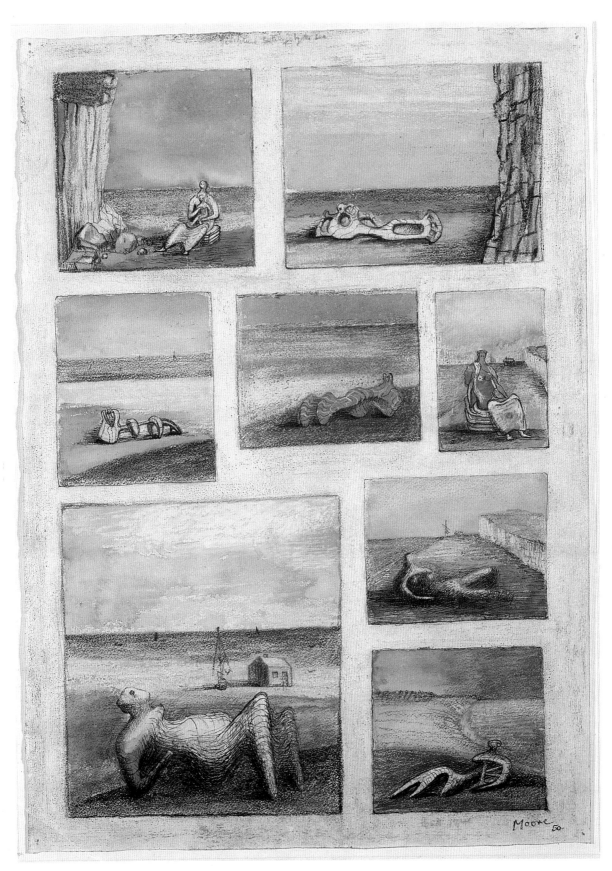

172 Sculpture Settings by the Sea 1950

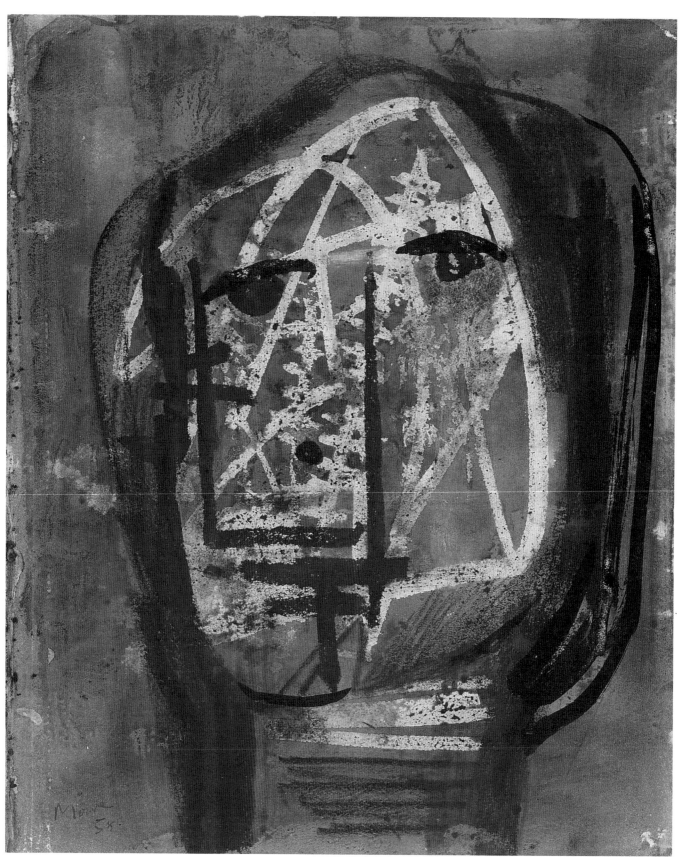

174 Page from Sketchbook: Head 1958

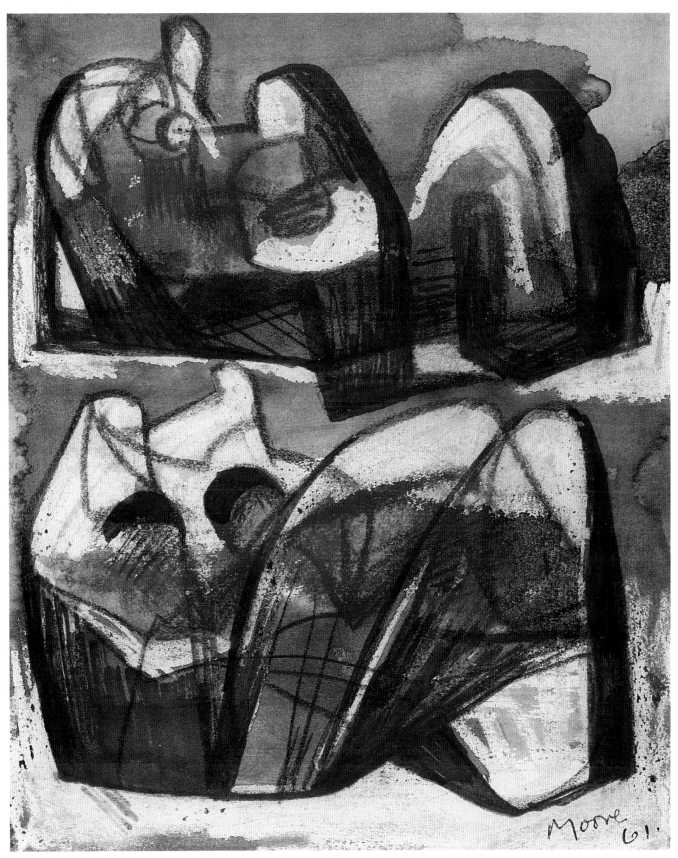

176 Page from Sketchbook 1961–6: Two Reclining Figures 1961

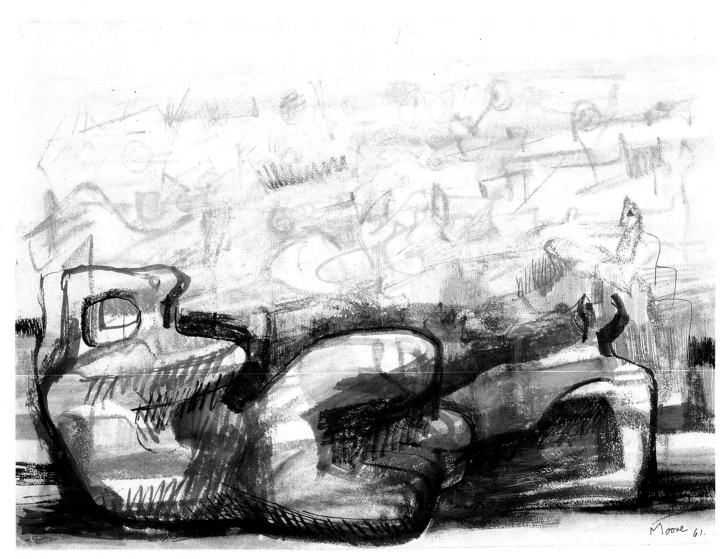

175 Reclining Figure: Bunched 1961

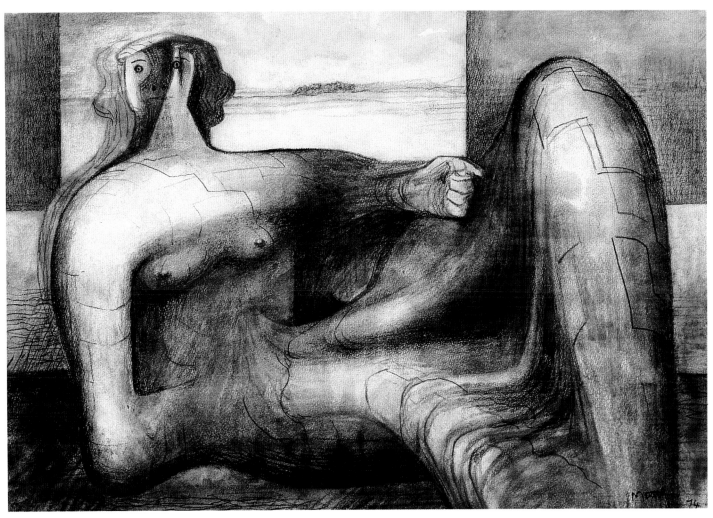

209 Reclining Woman in a Setting 1974

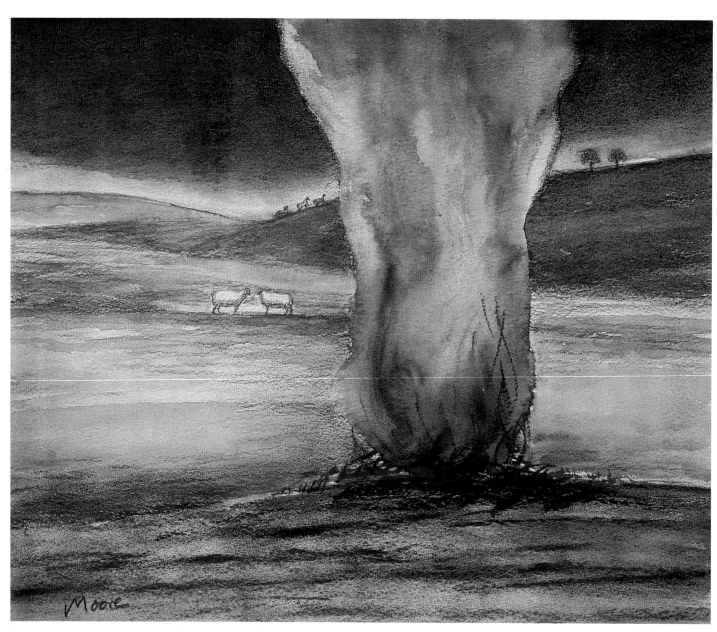

210 Landscape with Bonfire IX 1975

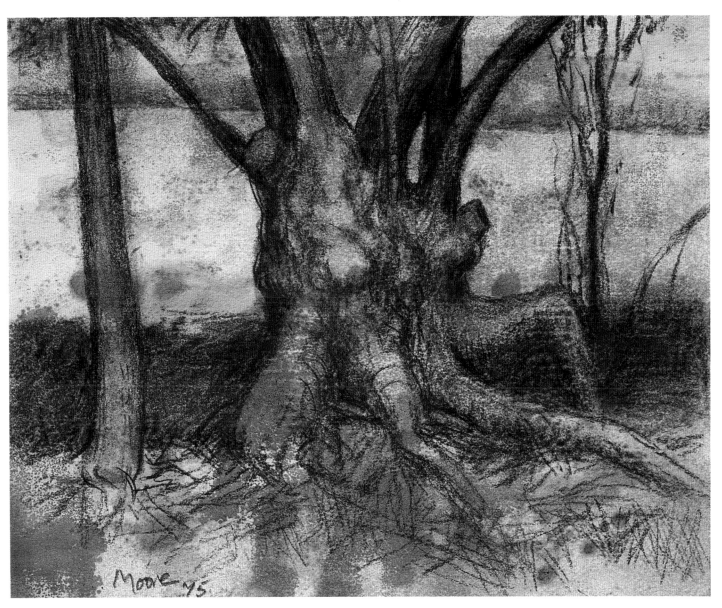

211 Trees VII 1975

230 Mountains and Sky 1982

231 Clouds in Sky 1982

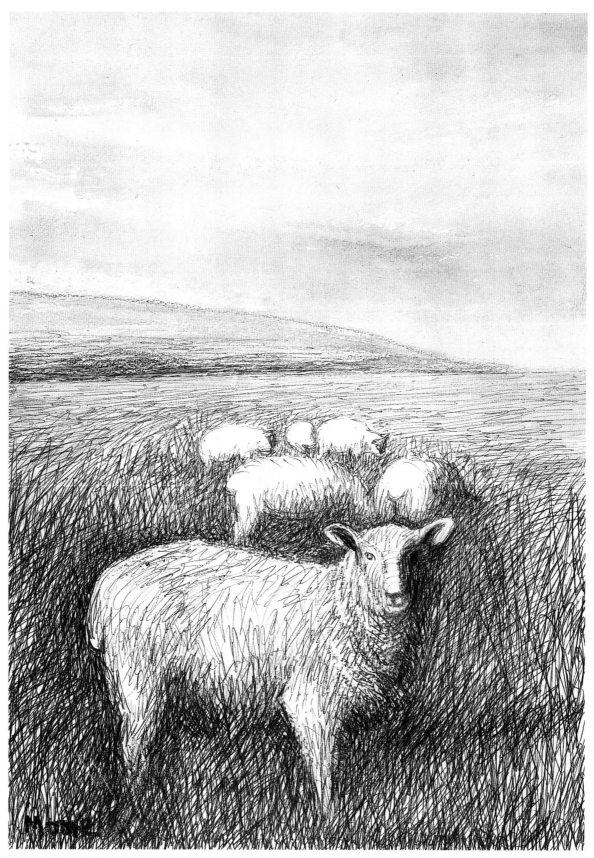

225 Sheep Grazing in Long Grass (No. 1) 1981

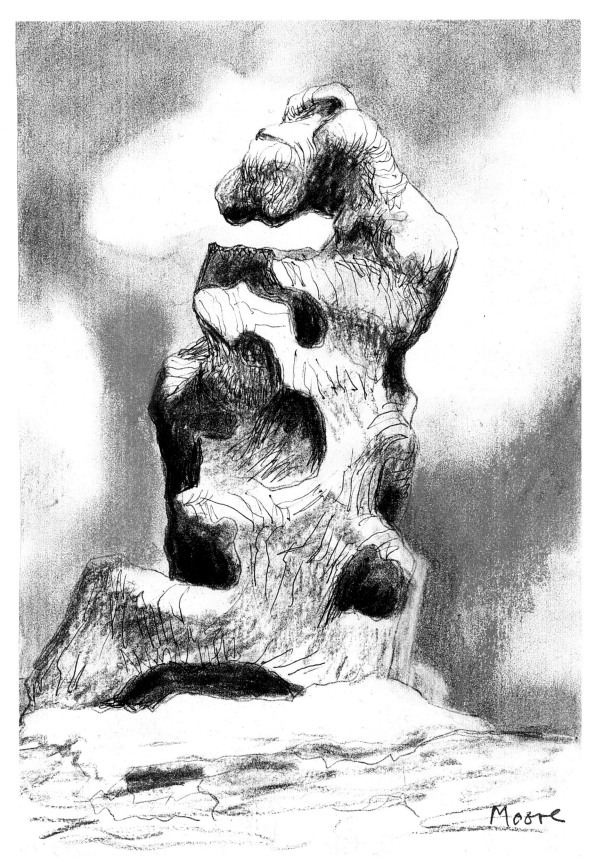

229 Rock in Landscape 1982

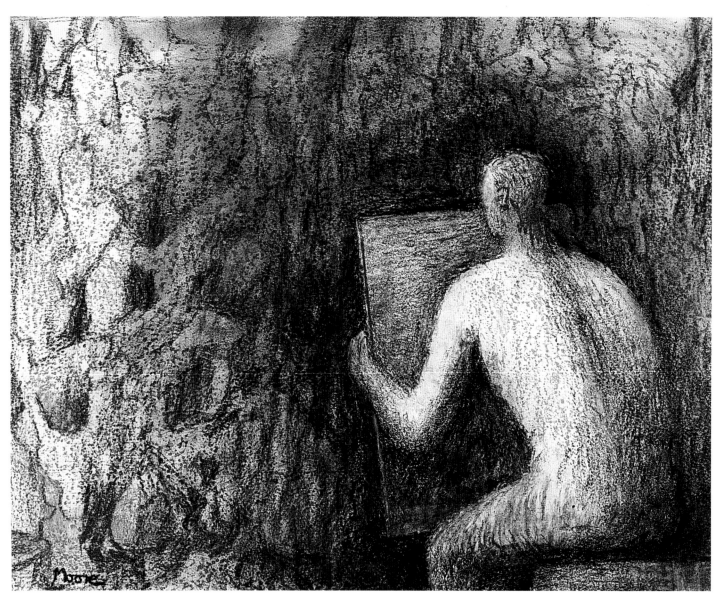

234 Man Drawing Rock Formation 1982

THE CATALOGUE

CATALOGUE NOTES

LH and HMF numbers are preceded by the catalogue number where the work is included in this exhibition.

Measurements are expressed in inches and centimetres for sculpture, and inches and millimetres for drawings. They are indicated by the greater dimension for sculpture with height or length abbreviated to H. and L. When the sculpture is rectangular (for example, panels for a wall relief) two measurements are given as they are for drawings, with height preceding width. All drawings are on paper unless otherwise specified.

Where possible, each sculpture illustrated in the Plates section is represented by an alternative view in the Catalogue; occasionally it has been necessary to show another cast.

Published sources referred to throughout the Catalogue notes have been abbreviated as follows:

BERTHOUD, 1987 R. Berthoud, *The Life of Henry Moore*, London, Faber and Faber, 1987

CLARK, 1984 K. Clark, *Henry Moore Drawings*, London, Thames and Hudson, 1974

HALL, 1966 D. Hall, *Henry Moore, The Life and Work of a Great Sculptor*, London, Gollancz, 1966

HEDGECOE, 1968 H. Moore and J. Hedgecoe, *Henry Moore*, London, Thomas Nelson, 1968

HENRY MOORE DRAWINGS, 1979 *Henry Moore Drawings, 1969–79*, New York, Wildenstein, 1979

JAMES, 1966 Philip James, ed., *Henry Moore on Sculpture*, London, Macdonald, 1966

MOORE, 1981 H. Moore, *Henry Moore at the British Museum*, London, British Museum Publications, 1981

RUSSELL, 1973 J. Russell, *Henry Moore*, Harmondsworth, Penguin Books, revised edition 1973

SYLVESTER, 1968 A.D.B. Sylvester, *Henry Moore*, London, The Arts Council of Great Britain, 1968

WILKINSON, 1977 A.G. Wilkinson, *The Drawings of Henry Moore*, London, Tate Gallery Publications, 1977

WILKINSON, 1979 A.G. Wilkinson, *The Moore Collection in the Art Gallery of Ontario*, Toronto, 1979

SCULPTURE
1922–1940

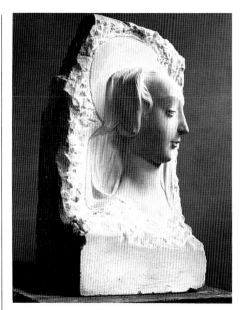

I Another view reproduced on p.51

1 | HEAD OF THE VIRGIN
1922–3
Marble
H.21 in; 53.2 cm
The Henry Moore Foundation
LH 6

The earliest sculpture in this exhibition was carved by the artist in a studio at the Royal College of Art in London while he was a student there. His professor required him to copy a Renaissance model and he chose an Italian marble in the collection of the Victoria and Albert Museum, the *Virgin and Child with Three Cherub Heads* by Domenico Rosselli. He was told to make a 'model in clay and transfer the clay into stone by mechanical means'. (Hall, 1966, p.52.) This meant using a pointing machine, which Donald Hall succinctly describes as 'a framework which is attached firmly to the clay model and to the block of stone. The carver measures exact distances from the outside of the frame to the model, and transfers this exact distance by boring a little hole into the stone, to a depth equal to the point in the clay model. The executed carving has tiny pores in it, which reveal that a pointing

machine has been used.' (Hall, 1966, p.52.) Moore wanted to carve the marble direct and his technical instructor allowed him to try; he fooled the professor by adding pores so that it looked as though he had used the pointing machine. This makes the sculpture a unique record of the beginning of his creed of 'truth to material' which thereafter prevented him from carving stone to look like flesh. The artist has described the painful conflict between his new interest in primitive sculpture, which he studied in the British Museum, and the academic teaching he received at the College, which he partly resolved by carving according to his own instincts in the vacations. This is the only surviving carving in Renaissance style by Moore, as well as one of his earliest known finished pieces. It was no doubt preserved because he gave it as a wedding present to his friend, the sculptor Raymond Coxon, on his marriage to another student, Edna Ginesi, in 1926.

2 | RECLINING WOMAN 1927
Cast concrete
L.25 in; 63.5 cm
The Moore Danowski Trust
LH 43

The genesis of this figure comes from a sketch in a notebook dating from 1921–2, where a reclining figure is suckling a baby seated on her lower leg (repr., Wilkinson, 1977, p.73). During the twenties Moore carved several half-length mothers with children, but here, in his first major reclining figure, he has tautened the pose and dispensed with the baby. Cast concrete was a new material, chosen as an experiment by the artist who thought that he might one day want to connect a sculpture with a concrete building. In the event, the following year he was commissioned to make a relief for the new headquarters of the London Underground Rail-

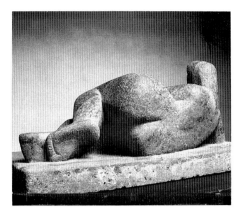

2 Another view reproduced on p.52

way at 55 Broadway (St James's Park Underground Station, fig.2, LH 58). However, the commission was for a carving in Portland stone so his experiments in working in concrete were not directly useful. The material allowed a certain fluidity of outline which matched his admiration for the paintings of Fernand Léger at the time; but it was also an altogether tougher material than the traditional clay or plaster used for modelling. In order to attain permanence, those materials would have to be cast into bronze, but concrete sets so hard that naturally it becomes like stone. Indeed, Moore sometimes experimented with colouring the concrete to make it look like natural stone.

3 | HEAD AND SHOULDERS 1927
 | Verde di Prato
 | H.18 in; 45.7 cm
 | The Roland Collection
 | LH 48

This *Head and Shoulders* is among the more cubistic works that Moore made in the twenties. Seen full face from the right the face resembles those paintings by Picasso with a profile joined to a frontal view. These are surprisingly rare in the decade but Moore must have been fascinated by the idea because he also used it in a drawing of 1928 (cat.61, HMF 604), though the pencil head of the

drawing from life is more rational than this carved one, with its single full eye and the second one in almost the same plane but barely defined. The sculptor has shaped a block of hard Verde di Prato into a wide face and seemingly overlarge head which is firmly joined to the shoulders in a twisted pose. The raised left shoulder is drawn forward and touches the chin in such a way that the block of stone remains more intact. He has also used the device naturalistically to constrict and push the left breast towards the right and forward, thus producing a distortion which looks cubistic but is realistic enough to seem anatomically acceptable to the viewer. The total effect is related to the work of Jacques Lipchitz or even the paintings of Fernand Léger. However, Moore does not seem to have found the style satisfying enough to develop it further, and he turned again to primitive art for inspiration in the next few years.

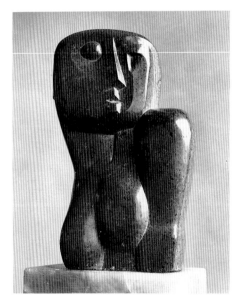

3 Another view reproduced on p.53

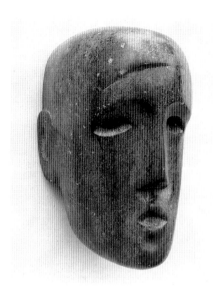

4

4 | MASK 1927
 | Stone
 | H.8¼ in; 21 cm
 | Private Collection
 | LH 46

In the late twenties Moore made a number of masks, but, unlike several later ones, this is carved in stone rather than cast in concrete (see cat.6, 7, LH 62, 64). The term 'mask' may suggest the theatre or perhaps a carnival, but although Moore had written and performed in his own play, put on first at Castleford Grammar School and then at the Royal College of Art in London, this carving is more like the type of head that adorned Norman and Gothic church architecture. By reducing the depth and creating a mask rather than a fully three-dimensional head, Moore was able to avoid the particularity of his early carving of the *Head of the Virgin* derived from a Renaissance model (see cat.1, LH 6). In the first half of 1925 he had spent some six months on a travelling scholarship in Italy where he was impressed by the proto-Renaissance work of the sculptor Giovanni Pisano and of the painters Masaccio and Piero

della Francesca. This *Mask* captures some of the generalisations of those severe and expressive models, although he has kept a north European approach which is a reminder of sculpted heads on Yorkshire churches.

5 | MASK 1929
Stone
H.5 in; 12.7 cm
Private Collection
LH 61

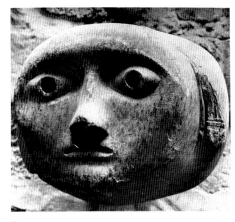

5

Like a mask of two years before (cat.4, LH 46) this one is carved in stone, though it is smaller than life size. A more primitive feeling is conveyed by the unnaturally rounded face and its exaggerated flatness, though these also give a timeless quality to the piece. It seems, none the less, to have been based on a drawing of the *Head of a Girl* of 1927 (repr., Mitchinson, 1968, under 1927), but with the lifelike details of the eyes and hair removed and generalised. Moore explained his avowed intention to give the eyes in this mask 'tremendous penetration and to make them stare, because it is the eyes which most easily express human emotion.' (Hedgecoe, 1986, p.62.)

The critic R. H. Wilenski reviewed an exhibition of Moore's work in 1930 and went on to discuss problems of modern sculpture with him in preparation for a series of lectures (Berthoud, p.106). These led to a book in which Wilenski expressed his concern about the emphasis that Europeans had traditionally placed on facial features in art; he felt that modern sculptors should pay more attention to the whole body. It is notable that Moore rarely depicted detailed facial features after the publication of Wilenski's book.

REFERENCES: D. Mitchinson, 'Seventy Years of Henry Moore', *Henry Moore*, Rijksmuseum Kröller-Müller, Otterlo Museum Boymans-Van Beuningen, Rotterdam, 1968; R. H. Wilenski, *The Meaning of Modern Sculpture*, London, Faber and Faber, 1932.

6 | MASK 1929
Cast concrete
H.8½ in; 21.6 cm
Leeds City Art Galleries
LH 62

In common with the other masks that Moore made at the time, this one is designed to be attached to a wall. It is also one of the most primitive of those of 1929 when he was experimenting with the technique of working in concrete. Moreover, its smoothness, together with the precision of the curves of the brow and planes of the nose and mouth, suggest that it was indeed cast rather than built up on an armature, the method described under cat.7 (LH 64). It is amongst the works by Moore which reveal cubist connections, particularly with the sculpture of Jacques Lipchitz. The head is almost a Janus-head with a male left-hand side embedded with a female right, an idea close to some of Picasso's paintings from the twenties. But it also has a very strong primitive feel, which links it to the contemporary

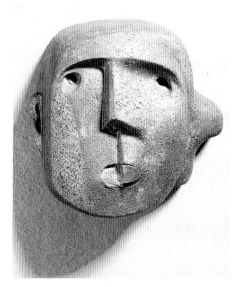

6 Also reproduced on p.55

Reclining Figure (cat.9, LH 59). Moore had become fascinated by Mexican sculpture and this mask invokes the nobility of Aztec pieces.

7 | MASK 1929
Cast concrete
H.8 in; 20.3 cm
The Moore Danowski Trust
LH 64

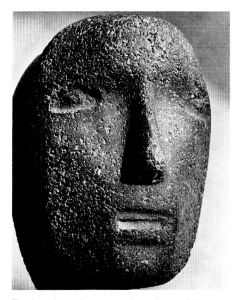

7 Another view reproduced on p.54

In the late twenties, Moore decided that he would experiment with reinforced concrete as a material for sculpture. Later on he explained the two methods that he tried, and this mask was made by the second method, by casting the material. He had rejected the first, which consisted in building the concrete up on an armaturè – an underlying metal structure – and rubbing it down after it had set, because he soon found that the cement with its gritty aggregate was difficult to shape, since once it was set the concrete was so hard that it wore his tools out very quickly. In this case, the use of rough aggregate produced a head with unresolved features, which would have accorded well with modern architecture.

8 | FIGURE WITH CLASPED HANDS
1929
Travertine marble
H.19½ in; 49.5 cm
The Tel Aviv Museum of Art
LH 60

In later years Moore used travertine marble for several large figures, particularly the UNESCO *Reclining Figure* (LH 416, see cat.139, LH 414). However, the choice is rare among his early works, when he was eager to explore the potential of stone indigenous to the British Isles. Travertine marble, in contrast, is quarried in Italy near Tivoli and one must presume that the artist had acquired a piece of the stone, like the block of Armenian marble that he used in 1932 (see cat.18, LH 117). The advantage to Moore of using travertine was no doubt the open texture of this hard material (which is not really a marble at all, but a crystalline stone whose geological character is formed by deposits of calcium carbonate accruing near hot springs). In some ways, therefore, its texture was related to what he could

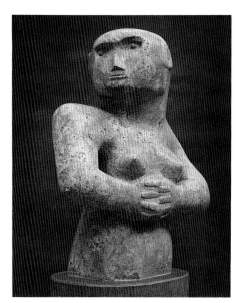

8 Another view reproduced on p.59

achieve artifically by using cast concrete; however, instead of the problems that he encountered with that mainly additive method (see cat.7, LH 64) he could concentrate on direct carving from a given size of block. The novelty of this technique in Britain in the twenties has been explained under cat.1 (LH 6). Moore said later that he had found the vitality that he needed in Mexican art: 'I began to find my own direction, and one thing that helped, I think, was the fact that Mexican sculpture had more excitement for me than negro sculpture. As most of the other sculptors had been more moved by negro sculpture this gave me a feeling that I was striking out on my own.' (Russell, 1973, pp.28–9.)

9 | RECLINING FIGURE 1929
Brown Hornton stone
L.33 in; 83.8 cm
Leeds City Art Galleries
LH 59

Though surprisingly small, Moore's first *Reclining Figure* carved from a single block of stone is monumental in its

grandeur. It has become traditional to compare it to a Toltec-Maya *Chacmool* – a rain god from the eleventh or twelfth century AD, in the collection of the Museo National de Antropologia, Mexico City. However, the transformation of the source (known to the artist by a photograph as well as a cast in Paris) is as radical as the borrowing: the drawing, cat.62 (HMF 684), makes this very clear. Not only has Moore changed the figure from male to female, but he has turned the body so that his figure reclines on its side rather than raising itself from its back. (The Mexican devotional piece would have held an offering bowl on its navel.) Furthermore, he has taken the left arm and raised it up over the head, thus creating a natural opening in the solid stone and showing that he had overcome his fear of weakening the stone, which, he admitted, had prevented his opening the block in the 1925 *Mother and Child* (LH 26). The figure also makes an interesting comparison with the reclining figure of two years before (cat.2, LH 43) which he had cast in concrete. By using the strength of the stone, he has been able to raise the position of the legs almost to the same height as the lifted arm. This gives tension to the figure as well as retaining the original shape of the block of stone, giving renewed force to the current idea of 'truth to material'. In 1930 Moore explained the new basis from which the modern sculptor worked,

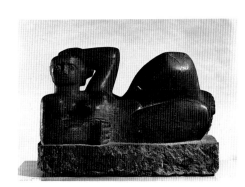

9 Another view reproduced on p.58

describing the 'removal of the Greek spectacles' from his eyes which

'freed him to recognise again the importance of the material in which he works, to think and create in his material by carving direct, understanding and being in sympathy with his material so that he does not force it beyond its natural constructive build, producing weakness; to know that sculpture in stone should look honestly like stone, that to make it look like flesh and blood, hair and dimples is coming down to the level of the stage conjurer.' (Moore, 1930, p.408.)

REFERENCE: H. Moore, 'Contemporary English Sculptors', *The Architectural Association Journal*, May 1930.

10	HALF-FIGURE 1929
	Cast concrete
	H.14½in; 36.8 cm
	The British Council
	LH 67

By 1929 Moore had largely perfected his method of using concrete for sculpture, which, he said later, he had developed in order to be able to associate sculpture with the material of modern architecture. The technique also allowed him to form a hollow in the body, a forerunner of the cavities and penetrations that characterise his mature carved figures. The head has an affinity with contemporary masks (for instance, cat.7, LH 64) and clearly owes allegiance to the Mexican prototypes that Moore admired so much at the time. However, when the artist reviewed a book on Mesopotamian sculpture for *The Listener* in 1935 (pp.944–6), three of the five illustrations reproduced were of figures with clasped hands, a pose which apparently fascinated him when he made this figure and others related to it. He has exploited the position of the right arm to emphasise the fullness of the breast, yet he has reduced the sensuality of the gesture by

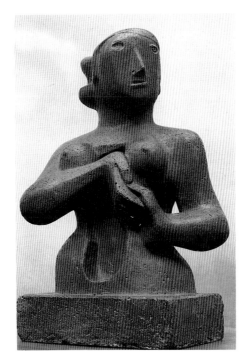

10 Another view reproduced on p.56

the impassive and impersonal expression of the face. Although owing so much to non-European models, the asymmetry of the pose is surprisingly typical of Italian Mannerist art.

REFERENCE: H. Moore, 'Mesopotamian Art' (a review of *L'Art de la Mésopotamie* by C. Zervos, Cahiers d'Art, and Zwemmer) *The Listener*, 5 June, London, 1935.

11	HEAD 1930
	Slate
	H.10 in; 25.4 cm
	Private Collection
	LH 89

From this dense material Moore has carved a powerful head and neck, as it were completing the idea of the partial head which had proved such an inspiration in the masks. Indeed, this head with its sharp profile is related to one of them (cat.4, LH 46) which the artist

sometimes exhibited with eyes fixed in with plasticine or sometimes without. The problem of eyes concerned him in other sculptures made at the same time, such as cat.12 (LH 93) where they are exaggerated or cat.6 (LH 62) of the year before where they are stylised depressions in the concrete. In this slate head he has both solved the problem and broken new sculptural ground by creating a hole right through the carving. In his study of Moore, Will Grohmann pointed out that the artist saw the head not as a portrait but as a theme (Grohmann, 1960, p.30); one of the primary discoveries for realising that important change in concept was the hole. Later, Moore himself remembered the struggle to achieve it: 'for me the hole is not just a round hole, it is the penetration through from the front of the block to the back. This was for me a revelation, a great mental effort.' (Hedgecoe, 1968, p.67.)

REFERENCE: W. Grohmann, trans. M. Bullock, *The Art of Henry Moore*, London, Thames and Hudson, 1960.

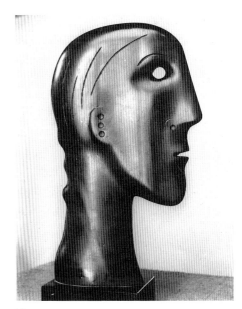

11

12 | GIRL WITH CLASPED HANDS
1930
Cumberland alabaster
H.15 in; 38 cm
The British Council
LH 93

This stern head with staring, coloured eyes like those of some antique mask, crowns a carving that denies the seductive quality usually connected with alabaster. Moore has penetrated the solid stone with beautifully worked holes between the arms and torso, anticipating his later freedom in carving. In addition, the clasped hands, asymmetry and stocky neck are all characteristic of work of the young sculptor whose early exhibitions caused such dispute among critics. Moore's carving makes a strong contrast to current work by older British sculptors such as Jacob Epstein, Frank Dobson and Eric Gill; the sculptor of similar age and experience with whom the young Moore's name could be bracketed (and was by sculpture students in the thirties) was Barbara Hepworth, like himself from Yorkshire.

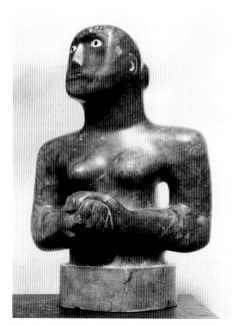

12 Another view reproduced on p.57

There is an affinity between their early work, for both were seeking to find a modern style by a creative use of primitive art; furthermore, both moved towards a more abstract style under the influence of European art in the early thirties.

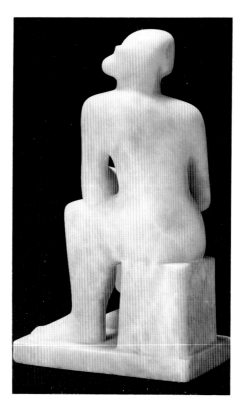

13 Another view reproduced on p.63

13 | SEATED FIGURE 1930
Alabaster
H.18½ in; 47 cm
Art Gallery of Ontario, Purchase 1976
LH 92

Using a block of alabaster, Moore carved this seated figure giving it a monumentality that belies its small size. In spite of the massive limbs which add weight to the apparently delicate material, the pose of the figure generates internal movement. The feet face forwards on the base but the shoulders are twisted and the head turned

sideways so that the viewer's eye is led to explore right round the figure. This Mannerist approach, perhaps derived from Michelangelo, is surprising in view of the conflicting influence of primitive art. For the figure is also related to the Reclining Figure of 1929 (cat.9, LH 59) based on Pre-Columbian Mexican art, though Moore himself connected the Seated Figure with a Cycladic Lyre Player in the National Museum in Athens which he much admired, and, presumably, knew from a photograph (repr., Lund Humphries, vol.1, 1969 reprint, p.x). Alabaster was a material that he used for a number of carvings in the twenties and thirties (see cat.16, 20, LH 102, 154) though he later abandoned it because he felt that its intrinsic beauty interfered with the appreciation of the carved form.

14 | MOTHER AND CHILD 1931
Sycamore wood
H.30 in; 76.2 cm
Private Collection
LH 106

This is one of the most forceful carvings of a subject which was close to the artist's heart. Pairing the female torso with a child gave him the opportunity to extend the range of emotion conveyed by his sculpture, as well as varying the pose and rhythm. In other stone carvings he showed the child in a variety of positions, feeding from the breast (LH 100), held against the mother (LH 83), or even emerging from between her legs (LH 3, fig. 20). Such variations show that Moore was aware of the psychology of a relationship which also represented a sculptural challenge. Thus Moore inscribed the preliminary drawing for a child atop its mother's shoulders (cat.49, HMF 139) 'poising of weights', showing how he envisaged the technical problem of relating the two figures. The

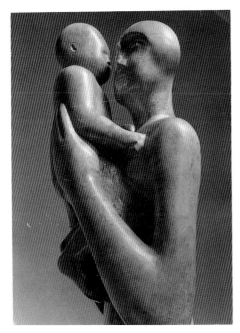

14 Another view reproduced on p.65

relationship is made more interesting because of the great difference in size of a mother and child, though in a stone carving there is less freedom to open a gap between the two bodies than is possible when carving wood.

By raising the child in this sycamore sculpture, Moore has been able to reveal the contrast between the small size of its head and the larger one of the mother. The pose also allowed him to emphasise the difference in scale of the torsos and establish a rhythm between the upward movement of the mother's forearms and hands and the downward thrust of the child's arms and fists. Although he has kept a distance between the heads he has indicated the all-important eye contact which is so characteristic of the relationship of a mother and baby.

15 | COMPOSITION 1931
Green Hornton stone
H.19 in; 48.3 cm
The Moore Danowski Trust
LH 99

The innovation marked by this *Composition* is of such an extreme kind that it would have been difficult to predict, for it seems to mark so radical a change from Moore's preceding work that little connection can be established. There is, however, a drawing on a sketchbook page (cat.70, HMF 832) made the year before, which reveals that the underlying idea was related to a woman with upturned breasts. Several writers have noted the influence of Picasso, especially Herbert Read and David Sylvester, who both compare the carving to Picasso's sculpture *Metamorphosis* of 1928, reproduced in the Parisian journal *Les Cahiers d'Art* almost immediately (Année 3, no.7; repr. Sylvester 1968, p.162).

However, while heralding a decade when Moore was sufficiently interested in Surrealism to sit on the Committee which organised the International Surrealist exhibition in London in 1936, the underlying idea also demonstrates his continuing interest in a primitive, non-

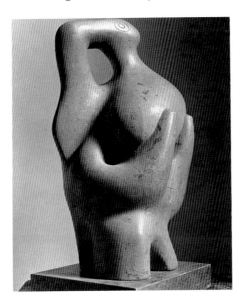

15 Another view reproduced on p.66

western tradition. It was not until 1957 that Moore made a double page of drawings of Etruscan pottery and 'Women from pots' (Moore, 1958); however, it seems not unreasonable to imagine that as early as 1931 he had become fascinated by the metamorphosis of figure and pot, suggested by ancient forms invented by more primitive people for their sculpture-like pottery. Furthermore, by carving in stone Moore removes his invention from any possibility of confusion with such a source, for the viewer receives a totally different tactile experience from its polished surface than would be given by fired clay. Perhaps coincidentally, Paul Nash was working at this time on the illustrations for Sir Thomas Browne's *Urne Buriall*, an investigation into sepulchral urns found in Norfolk.

REFERENCES: H. Read, *A Concise History of Modern Sculpture*, London, Thames and Hudson, 1964; H. Moore, *Heads, Figures & Ideas, with a comment by G. Grigson*, London, Rainbird, and Greenwich, Conn., New York Graphic Society, 1958; Sir Thomas Browne, ed. J. Carter, *Urne Buriall and The Garden of Cyrus*, London, Cassell, 1932.

16 | COMPOSITION 1931
Cumberland alabaster
L.16½ in; 41.9 cm
The Henry Moore Foundation
LH 102

In contrast to the half-length figures (cat.17 and 18, LH 109, 117) this torso may serve as a bridge to the far less representational Square Forms (cat.26, 27, LH 167, 168) of the mid-thirties. This is not to prejudice its remarkable originality, for by forsaking the features usually expected in a head, Moore returns his sculpture to an era when vitality was prized above naturalism. He

probably found his inspiration in ancient Egyptian fertility goddesses, tiny figurines modelled in clay with similar snake-like heads, to be seen in the collection of the British Museum. However, Moore's firmly rendered arms, pressed in primitive embrace, together with his way of twisting the head and shoulders to force the viewer to take in all possible view points, reveal the inventive power by which he transformed his source into a carving which conveys monumentality. His growing awareness of and interest in Surrealism also gives this *Composition* its contemporary character.

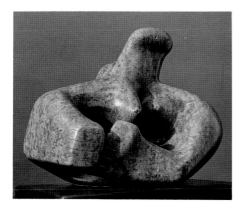

16 Another view reproduced on p.62

17 | *GIRL 1931*
Ancaster stone
H.29 in; 73.7 cm
The Trustees of the Tate Gallery
LH 109

After the almost fierce quality of those of 1929–30 (cat.8, 10, 12, LH 60, 67, 93), Moore carved two larger half-length figures which have a surprising quality of near gentleness (see cat.18, LH 117). He achieved the change by altering his approach to the head and hair, but he also rounded the shoulders to give a more feminine appearance. For although the slightly earlier figures have breasts, the masculinity of the heads gives them the strength of Amazons

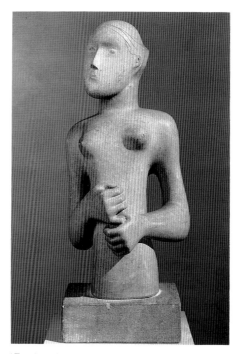

17 Another view reproduced on p.60

rather than the allure of Venuses. No doubt this was because the artist wished to avoid the clichés of a post-Renaissance sculptural tradition, so he turned for guidance to the least emotional non-European sources, in particular Aztec sculpture with its chunky heads. *Girl* has a flattened, mask-like face but with quite sharply defined features, owing a debt to the sculpture which Moore avidly studied both in the British Museum and in photographs. His fascination for ancient half-length sculptures with arms crossed and hands together is clear from the reproductions printed with a review he wrote for *The Listener* in 1935. The hands of this *Girl* owe more to those of a male figure (A Governor of Lagash, c.2400 BC. British Museum) of which he reproduced a detail (Moore, 1935, p.945) than to a more refined sculpture of a Sumerian woman, also reproduced in his article. Yet Moore's figure is thoroughly original and the long hair and pubescent breasts convey some of the awkwardness of girlhood.

REFERENCE: H. Moore, 'Mesopotamian Art' (a review of *L'Art de la Mésopotamie* by C. Zervos, Cahiers d'Art, and Zwemmer), *The Listener*, 5 June, London 1935.

18 | *HALF-FIGURE 1932*
Armenian marble
H.27 in; 68.6 cm
The Trustees of the Tate Gallery
LH 117

In his early years Moore practised direct stone carving, that is, cutting the stone without making a preliminary model. This, combined with his belief in the prevailing dogma of 'truth to material' meant that he avoided making stone look like flesh. None the less, compared with the earlier half-figures, this almost life-size carving is lifelike. Yet it would be a mistake to read it as a portrait, for the features, though explicit enough for recognition, are not a likeness. This *Half-Figure* is, however, one of the most

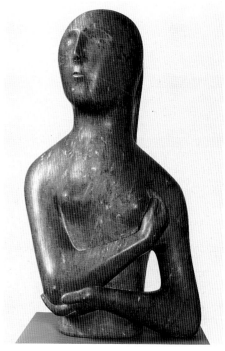

18 Another view reproduced on p.61

detailed pieces of carving attempted by Moore since the fully realised *Head of the Virgin* (cat.1, LH 6), which he had made while a student at the Royal College of Art. This is particularly true of the folded arms which are much thinner than those even of the *Girl* (cat.17, LH 109) carved the year before, to which this sculpture makes a pendant.

In his book on the collections of non-Western art in the British Museum written towards the end of his life, Moore included photographs of a number of seated figures from ancient Egypt which he had always enjoyed. He particularly admired a limestone statuette of *Tetisheri, Grandmother of Amosis, first king of the eighteenth dynasty*, whose head-dress is 'freed from the body so that you can look through its arches to the delicate neck inside.' (Moore, 1981, p.28.) He has achieved a similar feel in this sculpture by the separation of the hair from the back of the neck, but he has retained a solemn facial expression which helps to avoid any sentimentality that detail might have entailed.

19 | **FIGURE 1933–4**
 | *Corsehill stone*
 | *H.30 in; 76.2 cm*
 | **Private Collection**
 | *LH 138*

In his study of twentieth-century sculpture Herbert Read explained the change from representation to substitution as the intention of revolutionary artists 'to find symbols to symbolize their inner feelings, which feelings they shared with mankind everywhere.' (Read, 1964, p.57.) Thus Cubist artists had searched the history of primitive art to find symbols that might still be usable in the present. When he wrote this in the sixties, Read was extrapolating from the work of such a sculptor as Moore,

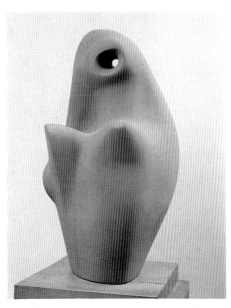

19 Another view reproduced on p.64

who in the twenties had already found his own archetypal symbols in the female figure with its overtones of the Mother Goddess and of fruitfulness.

In this metamorphic *Figure*, he owes less to Cubism and primitive art and more to Surrealism and poetic metaphor. Thus it would be tempting to draw an analogy with the *concrétions humains* that Jean Arp was making, especially as Moore's friend Barbara Hepworth had visited Arp's studio in 1932 and had been greatly inspired by what she saw there. However, Moore has exploited the unusual soft pink of the Corsehill stone to make the analogy with a human form more precise than it is in Arp's contemporary inventions. Moreover Moore had already carved a small beechwood *Figure* (LH 111) in 1931 which anticipates this one to a remarkable degree; less than ten inches high, it serves as a bridge between his work of the twenties and thirties. The head is less abstract than here, and it retains the shoulders of a more cubistic carving in Verde di Prato (cat.3, LH 48) of 1927; Moore has discarded such anatomical references in the present limbless *Figure*.

REFERENCE: H. Read, *A Concise History of Modern Sculpture*, London, Thames and Hudson, 1964.

20 | **FOUR-PIECE COMPOSITION: RECLINING FIGURE 1934**
 | *Cumberland alabaster*
 | *L.18 in; 45.7 cm*
 | **The Trustees of the Tate Gallery**
 | *LH 154*

Moore has described the elements in this sculpture as made up of head, body and legs, with the small egg-like shape as an umbilicus, which he saw as making the connection between the parts. The four-piece sculpture anticipates the complexity of the over-life-size two-piece reclining figures that he made twenty-five years later, but this earlier sculpture seems more surreal, with only the barest resemblance to what we think of as a figure. Its antecedents must lie in the freely placed distortions that Picasso invented, mainly in two dimensions. Moore was anxious to retain the underlying concept of a human figure and he said that this consideration accounted for his not using more than four pieces. By dismembering the figure, he intended to intensify the viewer's awareness of the positions in space occupied by each part of the body; these positions have an analogy with the way branches and other natural forms find their own space (Hedgecoe, 1968, p.120). Only one side of the sculpture is incised, and Moore thought of the figure as facing in that direction. He told the compiler of the Tate catalogue that he used the incisions to make 'a free use of human attributes' (*The Tate Gallery*, 1979, p.121) and prevent the work becoming merely a kind of form-exercise. He intended the tallest part to represent both the head and the top of the body including the arms; he described it as 'nearly a body in itself'

(ibid, p.120). The boomerang-shaped element at the back serves as a combination of body and leg, with the leg resting on the ground and bent at the knee – the part at the very back.

REFERENCE: *The Tate Gallery 1976–8, Illustrated Catalogue of Acquisitions*, London, Tate Gallery Publications, 1979.

21 | COMPOSITION 1934
Reinforced concrete
L.17½in; 44.5cm
The Henry Moore Foundation
LH 140

Although apparently more abstract than the *Four-Piece Composition, Reclining Figure* in alabaster of the same year (cat.20, LH 154), Moore spoke of the organic elements of this *Composition*, describing them as a head and torso, related to the base. Being cast in concrete and not carved from stone, the forms are fluid and almost menacing in the erect and angular disposition of the parts. The sculpture has been compared with the beach scenes which Picasso had made from 1928 to 1932 (John Russell reproduced Picasso's painting of a *Head* from 1929, Russell, 1973, p.55, fig.19, but there are many other relevant paintings and drawings). Despite any dependence on Picasso, Moore's sculpture remains entirely original, for, translated into three dimensions, the relationship of one part to another becomes crucial. What Moore called the 'form-elements' have to be encompassed by the viewer's tactile sense, the mind has visually to explore the disparity of forms without losing touch with the whole. This is one of Moore's most extreme inventions of the thirties, when he was in close contact with British artists like Paul Nash, who was particularly aware of connections with European art, especially with Surrealism.

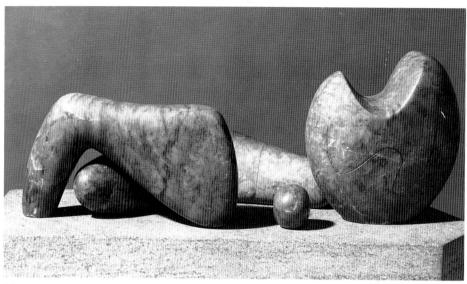

20 Another view reproduced on p.67

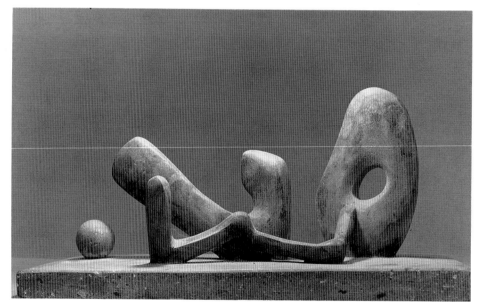

21

22 | *TWO FORMS 1934*
Pynkado wood
H.11, L.17¾in; 27.9, 45.1 cm
on irregular oak base,
L.21, W.12½in; 53.3, 31.7 cm
The Museum of Modern Art, New York, Sir Michael Sadler Fund, 1937
LH 153

Unlike the more tortured forms of other multi-part works of 1934 (cat.20, 21, LH 154, 140), these *Two Forms* retain comforting allusions to a more usual experience of nature. Indeed, Moore later said that the work could perhaps be thought of as a Mother and Child, because 'the bigger form has a kind of pelvic shape in it and the smaller form is like the big head of a child.' (Hedgecoe, 1968, p.76.) Although this description seems almost too literal, it gives to the piece an extraordinary physical association with birth. But it also retains a multiplicity of allusions, for instance, to the protection of a mother for her baby as she nurses it. The forms are organic, but they have wider, metamorphic associations, such as the shelter that a cave or overhanging rock may afford. Though carved in a dark wood, the forms seem also to relate to those of the beach stones, rounded by the relentless pounding of the sea, which Moore collected from 1931 onwards, on holidays and visits to the seashore.

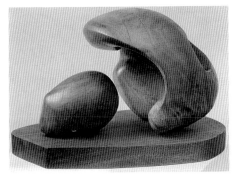

22 Also reproduced on p.69

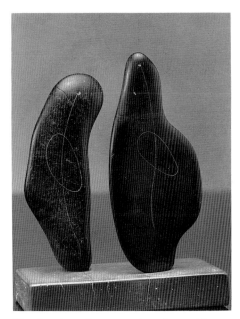

23 Another view reproduced on p.68

23 | *TWO FORMS 1934*
Ironstone
H.7¼in; 18.4 cm
J. S. Cook and D. M. Skinner
LH 146

In the thirties 'truth to material' was a credo for the leading young British sculptors, Moore and Hepworth. As early as 1931 Moore had collected pebbles on the beach at Happisburgh in Norfolk, where he and his wife were guests in the summer at a farm rented by Barbara Hepworth. The shapes of naturally weathered stones had an immense attraction for both sculptors, and formed the basis of many works exhibited by Hepworth in the next year or two. They were discussed by the critic Adrian Stokes in his review for *The Spectator* of her exhibition at the Lefevre Galleries in 1933. Some of his words seem equally applicable to Moore's *Two Forms*:

What are the essential shapes of stone? Pebbles are such shapes since in accordance with their structures they have responded to the carving of the elements. They are nearly always beautiful when

smooth, when they show an equal light, when that light and the texture it illumines convey the sense of all the vagaries of centuries as one smooth object.... As pebbles by natural forces, so forms by the true carver are rubbed: though it is sufficient for him to rub the stone in the final process only. (Hepworth, 1985, p.29.)

Stokes also picked out the qualities which, he felt without detriment, distinguished Hepworth's sculpture as the product of a woman. He felt that her Mother and Child forms were exemplary: 'Nothing, it would appear, should be attempted for a time on the mountain and mother-and-child themes in view of what Miss Hepworth has here accomplished.... Miss Hepworth's stone is a mother, her huge pebble its child. A man would have made the group more pointed ...'. Without disparaging the work of either sculptor, it seems with hindsight that this work by Moore is a response to that challenge. Later on it was cast in bronze (because the ironstone had unfortunately cracked); the bronze casts naturally have a rather different resonance.

REFERENCE: A. Stokes, 'Miss Hepworth's Carving', *The Spectator*, 3 November, 1933, reproduced in *Barbara Hepworth, A Pictorial Autobiography*, London, Tate Gallery Publications, revised edition, 1985.

24 | *RECLINING FIGURE 1934–5*
Corsehill stone
L.24½in; 62.2 cm
The Moore Danowski Trust
LH 155

By creating a single surface the artist emphasised the wholeness of this mysterious figure in contrast to the way he had divided the body in the multi-part sculptures of the previous year (cat.20, 21, LH 154, 140). In his book devoted to Moore's drawings, his friend Kenneth

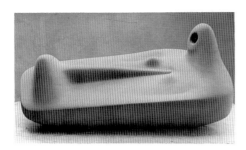

24 Another view reproduced on p.70

Clark described the piece as 'the reclining figure that seems to have become part of its own bath'. (Clark, 1974, p.78) However, on the same page he reproduced a pencil drawing of a reclining figure with only the head and torso differentiated, not from a bath, but from an unmarked rectangular block of stone. The flat plane of stone from which the breasts and knees of the carved woman protrude might be equated with bath water which establishes just such a level and had fascinated Pierre Bonnard in a series of paintings of his wife in the bathtub. Despite this Moore's sculpture may equally have been inspired by a marriage of two ancient Egyptians forms, sculptures where the head protrudes from a block of limestone and the inner coffin of a mummified figure, both represented by magnificent examples in the collection of the British Museum (for example, James and Davies, 1983, p.53, fig.49).

REFERENCE: T. G. H. James and W. V. Davies, *Egyptian Sculpture*, London, British Museum Publications, 1983.

25 | RECLINING FIGURE 1935–6
Elmwood
L.36¾in; 93.3 cm
Albright-Knox Art Gallery, Buffalo, NY, Room of Contemporary Art, 1939
LH 162

Moore carved three wooden reclining figures in the thirties and this was the first. In later life he recalled that it was made from a rectangular block of elmwood about three feet long by two feet square. Not only was elmwood available in large balks, but he found it a good choice for horizontal figures because the wood has a rather wide grain which he used to emphasise the pose. The block of wood was heavy enough for him to be able to work with saws and an axe. This, he said, 'changed my attitude to wood-carving since in the smaller carvings I had sometimes felt the process of production was almost like a mouse nibbling to make a hole.' (Mitchinson, 1982, p.34.) Like the *Reclining Figure* in Hornton stone of 1929 (cat.9, LH 59), the figure leans on an elbow and the head seems to face across the shoulder. However, the conception is less representational; the umbilicus, regarded by Moore as the kernel of the body and given its own element in the *Four-Piece Composition* (cat.20, LH 154), here seems to double as the 'Mount of Venus'; the tunnel-like leg cavity is streamlined, lacking the disruption of feet. Finally, the radical invention of the hollow

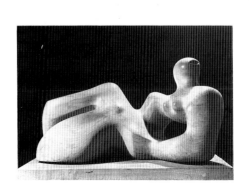

25 Another view reproduced on p.77

thorax straddled by the shoulder arch, replaces the natural hole formed in the earlier sculpture by the raised arm and hand holding the head. Whereas the earlier monumental figure is based on an ancient man-made prototype – an Aztec god – the wooden figure is more closely related to the mountains which Moore, following Gaudier-Brzeska, equated with sculptural energy (Moore, 1930, p.408).

REFERENCES: D. Mitchinson, 'Henry Moore, 1930–1940', *Henry Moore, Early Carvings 1920–1940*, Leeds City Art Galleries, 1982; Gaudier, *Manifesto* in Blast, No.1, London, June 1914; H. Moore, 'Contemporary English Sculptors', *The Architectural Association Journal*, May 1930.

26 | SQUARE FORM 1936
Green Hornton stone
L.15 in; 38.1 cm
Robert and Lisa Sainsbury Collection, University of East Anglia
LH 167

This is one of a series of stone carvings that the artist made after 1934. In that year he was able to buy a small house at Burcroft in Kent with five acres of meadowland attached. He bought stones in Derbyshire and set them out in the landscape: 'seeing them daily gave me fresh ideas for sculpture'. It was the first time that he worked with a three or four mile view of the countryside to which he could relate his sculpture: 'The space, the distance and the landscape became very important to me as a background and as an environment for my sculpture.' (Hedgecoe, 1968, p.93.) Although the title gives no clue to the subject-matter, like all of Moore's work this carving relates to the human form. He said: 'Stone for me has a blunt squareness, a squareness where you

round off the corners. This seems a natural form for a stone, and in fact I have called some of my sculptures "Square Form". On other occasions I have deliberately worked against the square idea, trying to eliminate the squareness of the original block.' (Hedgecoe, 1968, p.86.)

David Sylvester has seen a likeness between this *Square Form* and images of animals and birds, such as the Toltec macaw, and he also pointed to a possible inspiration from the incised lines on Ben Nicholson's contemporary white reliefs (Sylvester, 1968, p.63). There may have been a common source for Nicholson and Moore, for in the book *Circle*, published in 1937, photographs of one of Nicholson's incised reliefs and a *Stone-carving from Tiahuanaco (Peru)* are reproduced on the same page (Martin et al, 1937, pls 7a, 7b, following p.123).

REFERENCE: J. L. Martin, B. Nicholson, N. Gabo, eds, *Circle, International Survey of Constructive Art*, London, Faber and Faber, 1937.

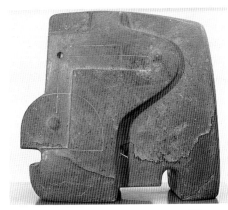

26 Another view reproduced on p.72

27 | SQUARE FORM 1936
Brown Hornton stone
L.21 ¼ in; 54 cm
Private Collection
LH 168

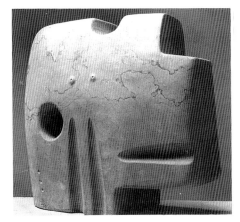

27 Another view reproduced on p.71

When works such as this were shown in Athens in 1951, a Greek critic was reminded of an ancient legend, which tells how Deucalion and Pyrrha were instructed by a goddess to cast behind them the bones of their first ancestor. They veiled their heads and walked across the plain, throwing over their shoulders stones torn from the earth — for they were descendants of Gaea, the earth, and the rocks were her bones; the stones which Deucalion threw were changed into men, those thrown by Pyrrha, into women (Larousse, 1959, p.100). On seeing Moore's carvings, the critic — Angelos Procopion — wrote: 'Can one depict the shapes a great block of stone will assume when it suddenly becomes warm, takes on life, begins to move, and here and there to swell? Moore's sculptural works are realizations of such a mythological vision.' (Grohmann, 1960, p.103.)

Mythology is unlikely to have served as an inspiration for Moore when he made pieces such as this and cat.26 (LH 167) in the thirties; it seems more likely that lines of poetry by T. S. Eliot would

have moved him at that time. Particularly appropriate are words from 'The Hollow Men', Stanza III: 'This is the dead land/This is cactus land/Here the stone images/Are raised, here they receive/The supplication of a dead man's hand/Under the twinkle of a fading star.'

REFERENCES: *Larousse Encyclopedia of Mythology*, London, Hamlyn, 1959; W. Grohmann, trans. M. Bullock, *The Art of Henry Moore*, London, Thames and Hudson, 1960; T. S. Eliot, *Collected Poems 1909–1935*, London, Faber and Faber, 1936.

28 | TWO FORMS 1936
Hornton stone
H.41 ½ in; 105.4 cm
Philadelphia Museum of Art, Gift of Mrs H. Gates Lloyd
LH 170

Like the tiny pair of forms in ironstone carved two years earlier (cat.23, LH 146), Moore here gave two standing forms parity, and arranged them in proximity so that they convey a close relationship. Again, in these *Two Forms* the Hornton stone is carved into such simple elements that they keep their strong reference to blocks of uncut stone, as the earlier pair had continued to resemble ironstone pebbles. The larger scale was no doubt facilitated by Moore's acquisition of a small property in Kent where he set up a number of uncut stones ready for carving (see cat.26, LH 167). Perhaps there is also a connection with the standing stones to be found in various sites in Britain. In the mid-thirties Avebury had caught the imagination of Moore's friend, Paul Nash, who incorporated the mysterious forms of these prehistoric landmarks in his landscapes, but Moore has given a metamorphic twist to his carvings. They

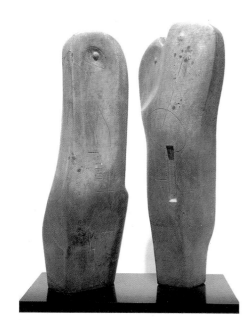

28 Another view reproduced on p.75

take on an analogy with standing figures, whether male and female is not clear, for only the eyes are indicated; curiously, they can also double as nipples, in which case the forms are headless. As well as being remarkably defined by carving, each block is engraved with incised lines. Though abstract, these lines are closely related to the marks with which the Spanish painter, Joan Miró, had embellished his classic paintings of the twenties (such as *Maternité*, Scottish National Gallery of Modern Art); or those painted on dummy-like figures by Giorgio de Chirico. Moore commented later on the impact on Nash of an exhibition of work by this Italian inventor of *Pittura Metafisica*, held in London at Tooth's Gallery in 1928 (Harrison, 1981, pp.200, 366, n.30). In conversation with Charles Harrison, Moore apparently did not disclose his own interest, which, however, from the evidence of his work, cannot be denied. Firsthand knowledge of the work of Surrealist painters also became possible in London in the thirties with exhibitions of Max Ernst and Miró held

at the Mayor Gallery in summer 1933; Salvador Dalí's work was shown at Lefevre in 1934.

REFERENCE: C. Harrison, *English Art and Modernism 1900–1930*, London, Allen Lane, and Bloomington, Indiana University Press, 1981.

29 | MOTHER AND CHILD 1936
Green Hornton stone
H.45 in; 114.3 cm
Leeds City Art Galleries
LH 171

One of the largest in the group of carved stones that Moore made during the thirties, this *Mother and Child* was bought by the English Surrealist, Roland Penrose, from the artist early in 1938. Penrose set it up in his front garden in Downshire Hill, Hampstead on the

roughcut stone which Moore had chosen as a base. The neighbours' complaints provoked comment in the London *Evening Standard*: they would have preferred the 'modernist statue, said to represent a mother and child' to have been placed unobtrusively in the back garden (Packer, 1985, p.109).

Early photographs taken when the sculpture was moved to Sussex, show the profiles to have been far sharper then than they are today after nearly fifty years of weathering. Although the faces were never precisely delineated, today the biomorphic shapes still convey the closeness of the relationship of a mother to her child.

REFERENCE: W. Packer, *Henry Moore, an Illustrated Biography*, London, Weidenfeld and Nicolson, 1985.

30 | MOTHER AND CHILD 1936
Ancaster stone
H.20 in; 51 cm
The British Council
LH 165

The bond that links mother and child had formed an essential subject of Moore's sculpture since the early twenties. This primal relationship carries within itself the potential for a full range of human emotions, and enabled the artist to convey a drama without telling a story. The love that a mother has for her child and it for her includes tenderness, suffering, compliance, frustration, affection, revulsion, a feeling of unity, jealousy. All these manifestations have been explored by psychologists in the twentieth century; one British writer who revealed much of the underlying contradictions of maternity in the thirties was D. J. Winnicott. Peter Fuller has elsewhere made a fascinating analysis of the, no doubt, unconscious way that Moore's approach

29 Also reproduced on p.74

to the mother and child may be used to illustrate Winnicott's theories (Fuller, 1987, pp.72–86). However, this sculpture was no doubt inspired by Surrealism, a movement which encouraged artists to reach and bring to the surface material from the unconscious. Surrealist artists sometimes used extreme techniques (for instance, Joan Miró practised starvation to produce hallucinations); they did this in order better to suppress the conscious mind, which they felt interfered with creation stemming from a deeper level. Moore was never a Surrealist in this extreme sense and, however original his imagery, he kept a firm footing in the 'real' world. As a result, an image like this *Mother and Child* can work on the viewer's consciousness at many levels.

REFERENCE: P. Fuller, 'Mother and Child in Henry Moore and Winnicott', *Winnicott Studies, The Journal of the Squiggle Foundation*, No.2, 1987.

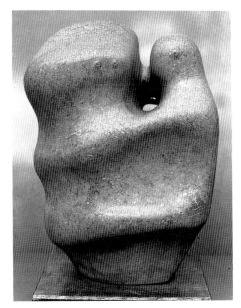

30 Another view reproduced on p.73

31 | MOTHER AND CHILD 1938
Lead and string
H.5 in; 12.7 cm
James Kirkman, London
LH 186

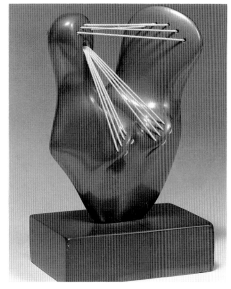

31

For many years this tiny sculpture was thought to be lost; indeed, in the catalogue raisonné of Moore's sculpture it is represented only by a photograph of the plaster maquette. However, it reappeared in 1985, when bronze casts were taken and an enlargement made (LH 186h); at the same time the lead was polished and re-threaded with yellow strings. Although so tiny, the sculpture retains remarkable purity of invention on Moore's much loved theme of the Mother and Child, whose amorphous form contrasts with the tautness of the strings.

Largely from knowledge of Moore's related sculptural inventions, such as cat.30 (LH 165), the upper protrusions from the vase-like torso are interpreted as two heads; their conjunction is reinforced by string, which embody the empathy by which a mother instinctively understands the needs of her child. In a more voracious mood, the

orifice which stands for the baby's mouth is joined by further strings to the two elements which naturally seem to be the mother's breasts. These strings seem metaphorically to issue from the hole in the sounding board of a musical instrument, so they provide a poignant reminder of sound – not the harmonies of a mandolin or guitar, but the despairing cry of a hungry child.

32 | STRINGED FIGURE 1937
Cherry wood and string
H.20 in; 50.8 cm
The Moore Danowski Trust
LH 183

The artist described the inspiration for his stringed figures as having come from visits to the Science Museum, where there is a fine collection of mathematical models, 'hyperbolic paraboloids and groins and so on, developed by Lagrange in Paris, that have geometric figures at the end with coloured threads from one to the other to show what the form between would be. I saw the sculptural possibilities of them and did some.' (Hedgecoe, 1968, p.105.) Moore transformed the didactic intention of these originals, by using string to create new planes that would delineate organic, rather than geometric forms. Thus this *Stringed Figure* can be related to a half-length figure: the strings define internal spaces.

Moore's later comment that 'Others, like Gabo and Barbara Hepworth have gone on doing it' is a reminder that he was not the only sculptor to investigate geometric forms and the importance of Gabo's ideas published in *Circle: International Survey of Constructive Art* of 1937 is set out under cat.38 (LH 206). Moore contributed statements and photographs of his work to this book in which the relationship of art and science was discussed by Professor J. D. Bernal.

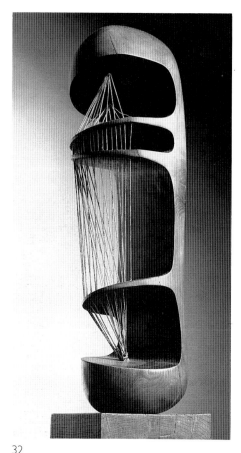

32

Bernal's essay may have acted as a trigger for Moore's interest in mathematical models in the same year.

REFERENCE: J. L. Martin, Ben Nicholson, N. Gabo, eds, *Circle, International Survey of Constructive Art*, London, Faber and Faber, 1937.

33 | HEAD 1938
Elmwood and string
H.8 in; 20.3 cm
Ursula Goldfinger and Family
LH 188

This evocative and mysterious object features in several contemporary drawings, whether made in advance or after the sculpture (cat.89, HMF 1379). In 1946 it was reproduced with the title *Stringed Figure (No. 2)* in the catalogue of the retrospective exhibition held at the Museum of Modern Art in New York,

but the more evocative title *Head* allows it to be seen as an extension of the masks that Moore had made in the twenties, especially cat.7 (LH 64). However, the pronounced though simplified features of that flattened head have given way to a poetic interpretation. Recognition now depends on identification from basics, including size, curved outline and depressions for eyes and nostrils. The concept of a mask is no longer derived from primitive sources but from Surrealism, to the extent that it relies on the name to create resonances in the viewer's mind. None the less the sculpture shares characteristics with contemporary abstract art for, without the strings, the circles and smooth surfaces are related to Ben Nicholson's contemporary reliefs. Moore's vital new ingredient, the strings borrowed from mathematical models, increases the connections with contemporary abstract art, particularly with Naum Gabo's writings on sculpture (see cat.38, LH 206). In the thirties in London Gabo promulgated the idea that opened-up sculptural mass is as important as traditional closed forms. By using strings Moore was able to create new

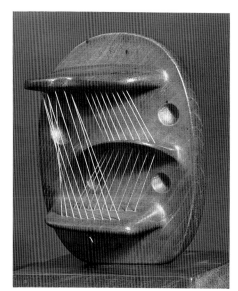

33 Another view reproduced on p.79

sculptural space, at the same time visible and enclosed.

REFERENCE: J. Johnson Sweeney, *Henry Moore*, New York, The Museum of Modern Art, 1946.

34 | RECUMBENT FIGURE 1938
Green Hornton stone
L.52¼in; 132.7 cm
The Trustees of the Tate Gallery
LH 191

The invitation to make this reclining figure came from the emigré Russian architect, Serge Chermayeff, who wanted a sculpture for the intersection of his terrace and garden at a new house he was building for himself at Halland in Sussex. Moore decided that a horizontal figure would suit the long, low-lying building with its view of the South Downs. The folds in the chalk downs were echoed by the undulations in the carving which follow the natural sediments in the green Hornton stone. Unlike the heads in some of the maquettes for figures of 1938 (cat.36, 39, LH 192, 208a) or even the wooden figures that had preceded it (such as cat.25, LH 162), the head is here more naturalistically defined, as though to draw attention to the distinction between the human form and the hills. Moore 'became aware of the necessity of giving outdoor sculpture a far-seeing gaze. My figure looked out across a great sweep of the Downs and her gaze gathered in the horizon.' (James, 1966, p.99.)

The next year, however, Chermayeff moved to the United States, selling the *Recumbent Figure* to the Contemporary Art Society, which presented it to the Tate Gallery. It was then lent to a Trade Fair in New York and spent the years of the Second World War in the courtyard of the Museum of Modern Art in New York, where the extreme conditions of

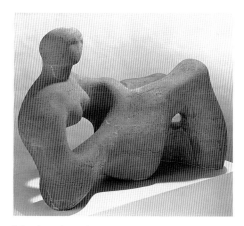

34 Another view reproduced on p.76

hot and cold and the salt-laden wind resulted in weathering of the stone.

The *Recumbent Figure* seems to have been in the mind of the archaeologist and poet, Jacquetta Hawkes, when she wrote in 1949: [Henry Moore's] 'curves follow life back into the stone, grope round the contours of the woman he feels there, pull her out with the accumulating layers of time, the impressions of detailed life, marking the flesh of her universal existence.' (Hawkes, 1951, p.142.)

REFERENCE: J. Hawkes, *A Land*, London, Cresset Press, 1951, with 2 illustrations by H. Moore.

35 | MAQUETTE FOR RECLINING FIGURE 1938
Bronze
L.8½ in; 21.6 cm
The Henry Moore Foundation
LH 185

This small maquette was made for the largest carving that Moore had attempted up to that time, namely the elmwood figure now in the Detroit Institute of Arts (LH 210). It was originally proposed by Berthold Lubetkin, a Russian-born architect like Chermayeff, who had commissioned the stone *Recumbent Figure* (cat.34, LH 191). Lubetkin told Moore's biographer, Roger Berthoud,

that Moore had brought him a maquette (presumably the one from which this bronze cast was made) as Lubetkin had suggested that he 'should create something special for an alcove, without apparently providing much information about the site', which was a shelf about eight feet from the ground in Lubetkin's own London penthouse at High Point, the block of modern flats he had built in Highgate. This was, of course, a very different setting from the outdoor site for which Moore was making the stone figure for Chermayeff, and Lubetkin realised that the 'figure proposed by Moore would be both too large and sited too high to be seen to advantage'. (Berthoud, 1987, p.159.) Moore himself had told an earlier biographer that he had refused to look at the offer as a commission; according to Donald Hall: 'He was doing it for himself; if Lubetkin liked it he could have it.' (Hall, 1966, p.97.) No doubt there is truth in both accounts but its conception for an indoor site helps to account for the freedom with which Moore opened up the figure. Its cave-like body provides its own vistas rather than relating to the hollows and protuberances of a natural landscape, or, put another way, it brings the characteristics of nature into an interior setting. Mysteriously, a breast doubles as the head of a serpent.

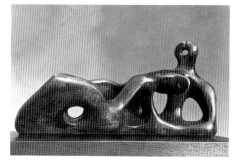

35

36 | RECLINING FIGURE 1938
Lead
H.5¾ in; L.13 in; 14.6, 33 cm
The Museum of Modern Art, New York, Purchase 1939
LH 192

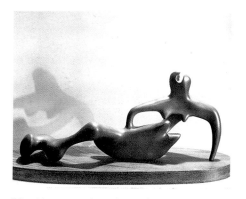

36 Also reproduced on p.81

During the same year that Moore cast this sculpture he was working on large reclining figures carved respectively in Green Hornton stone (cat.34, LH 191) and elmwood (see cat.35, LH 185). In both of these figures he pushed direct carving to new limits, opening up the stone and wood with daring freedom, for as well as providing a new sensibility for the viewer, holes naturally weaken these materials and one false step in the carving could break the delicate archways that survive. By making a maquette and then casting in lead, Moore could forget those technical problems, though he faced different ones, especially the free flow of metal into the furthest ends of the mould. The result is a different approach to the human figure, relying more on the tenuous links between parts than on the cavities which can be opened in a carving. Rather than an analogy with such natural formations as caves, there is a direct reliance on bone formations: the legs have been replaced by a single bone-like element. This gives tension as well as tautness to the resulting form; the sensitive viewer is made newly

aware of the dependence of the human frame on the skeleton.

In 1983, when technical problems had been solved by the use of polystyrene instead of plaster for preparing an enlargement, this figure was used for a bronze version thirty-five feet long to stand in front of the headquarters of the Overseas Chinese Banking Corporation in Singapore (designed by the artist's friend, the architect I. M. Pei).

37	STRINGED RECLINING FIGURE 1939
	Terracotta and string
	L.11¼ in; 28.6 cm
	Private Collection
	LH 197

This terracotta was used to make casts, first in lead and later in bronze. The metamorphic form might easily be confused with some primitive stringed musical instrument were it not for the title identifying it with a reclining fig-

ure. It thus serves as a link between the stringed figure sculptures that Moore had made since 1937 and the opened out Reclining Figures (such as cat.39, LH 208a) of the same year. Here the initial inspiration may have been a piece of flint or even bone (as the body-parts are reduced to such thin surfaces). The spaces are made more complex by the addition of wedge-shaped elements, the central one being rather like the bridge of a guitar, a violin or 'cello. However, this analogy, which had intrigued cubist sculptors earlier in the century, is negated because the strings pass through holes in the form instead of being stretched over incisions as they would be on a musical instrument.

The arrangement of the strings links the sculpture to mathematical models which Moore admired in the Science Museum. He later spoke of his fascination for the shapes which mathematicians described by the use of string, particularly of the planes interposed through the middle. But he continued:

'It wasn't the scientific study of these models but the ability to look through the strings as with a bird cage and to see one form within another which excited me.' (Hedgecoe, 1968, p.105.) As in other stringed figures, the forms are organic rather than scientific and the analogy is visceral rather than mathematical.

38	STRINGED FIGURE 1939
	Lead and string
	L.10 in; 25.4 cm
	The Henry Moore Foundation
	LH 206

The facility of invention represented by Moore's variations on the stringed figure is astonishing. Beginning from the simple idea of a mathematical model, developed in the nineteenth century to teach students about geometrical surfaces, he transformed the rather barren originals into complexities undreamt of by scientists. The nearest equivalents are the later inventions of the emigré Russian artist, Naum Gabo, who first visited London in 1935 and then settled in Hampstead in 1936. Like Moore, Gabo exhibited in Oxford at 'Abstract and Concrete' in Spring 1936; he was the initiator of the book *Circle*, which included four photographs of Moore's sculptures and a statement by him. In his own article 'Sculpture' (subtitled 'Carving and Construction in Space') Gabo set out the difference between carving and construction and pointed out that sculptors had usually preferred to treat volume as a solid entity and had paid very little attention to space as one of its components. He felt sure that artists would understand him when he said:

'We experience this sense as a reality, both internal and external. Our task is to penetrate deeper into its substance and bring it closer to our consciousness; so that the sensation of space will become for us a

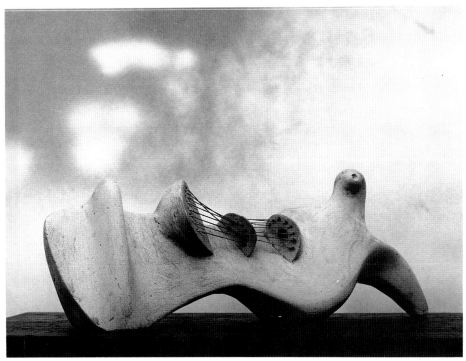

37

more elementary and everyday emotion the same as the sensation of light or the sensation of sound.' (Gabo, 1937, p.107.)

The works by Moore reproduced in *Circle* were solid carvings and he appears to have embraced the idea of space as volume in sculpture after the publication of the book. But, whereas Gabo was at that time interested in making an equivalent of the structure of a crystal (his *Construction in Space, Crystal* was exhibited at the London Gallery and reproduced in *The Listener*, 21 July 1937, p.131), Moore was basing his own constructions on invented organic forms, in this instance a bone-like structure.

Although this sculpture appears to be one of Moore's least representational creations, it is less difficult to interpret than the multi-part figures of 1934 (cat. 20, 21, LH 154, 140). A clue to reading it as the reclining Figure of the title is the sharp end-piece, angled to the ground, which continued in Moore's repertoire of forms to stand for the leg piece as late as 1975 (see cat.193, LH 656).

REFERENCE: J. L. Martin, Ben Nicholson, N. Gabo, eds, *Circle, International Survey of Constructive Art*, London, Faber and Faber, 1937.

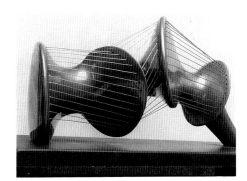
38 Another view reproduced on p.78

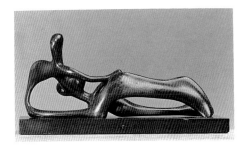
39 Also reproduced on p.80

39 | RECLINING FIGURE: SNAKE
1939–40
Bronze
L.11$\frac{3}{8}$in; 28.9 cm
The Henry Moore Foundation
LH 208a

In recent years when a catalogue raisonné of Moore's sculpture has been compiled and revised, the large number of small-scale figures has invited the invention of descriptive names. Thus this piece has attracted the designation 'Snake' to distinguish it from others. Indeed, the female form has here been drawn out in such convoluted curves that such an analogy is not unreasonable, and the upstanding head resembles that of a snake. However, it is less likely to have been invoked by the serpent which tempted Eve in the Garden of Eden, than by the inspiration of heads on tiny Egyptian fertility figures to be found in the collections of the British Museum. Such terracotta figurines also have prominent breasts, which in Moore's figure seem almost to double as the wings on a key for a clockwork motor. On a more serious note, the surrounding ring-like structure owes its origin to bone formations which already fascinated the artist as early as 1932, when he drew a sheet of *Studies of Transformation of Bones* (cat.72, HMF 941). Although on such a small scale, the sculpture anticipates Moore's fascination for internal and external forms that reached an apogee in 1951 (see cat.118, LH 295).

40 | THREE POINTS 1939–40
Cast Iron
L.7$\frac{1}{2}$in; 19 cm
The Henry Moore Foundation
LH 211

The original version of this sculpture was the lead, first shown at the Leicester Galleries in February 1940. The cast-iron version was the second, and finally it was cast in bronze. *Three Points* is also found in the drawing, *Pointed Forms* (cat.101, HMF 1496). Moore has written about the piece: 'In 1940 I made a sculpture with three points, because this pointing has an emotional or physical action in it where things are just about to touch but don't.' He cited Michelangelo's use of the device in *The Creation of Adam* fresco on the ceiling of the Sistine chapel and also used a modern analogy, 'It is also like the points in the sparking plug of a car, where the spark has to jump across the gap between the points.' (Levine, 1978, p.28.) Moore told the compiler of the Tate Gallery catalogue in 1980 that it was important that the points in the sculpture should not touch (in some bronzes, due to a fault in the casting, the points actually meet) because he wanted the work to convey a sense of anticipation and anxiety. He used the analogy of the sparking plug to illustrate this idea (*The Tate Gallery*, 1981, p.117). In addition,

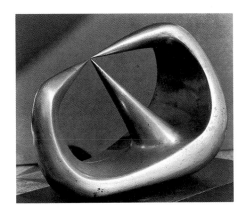
40 Another view reproduced on p.82

he drew attention to the early French painting, from the School of Fontainebleau, of Gabrielle d'Estrées with her sister in the bath, 'where one sister is just about to touch the nipple of the other'. A more modern source may have been provided by the open mouth of the braying horse with its sharply pointed tongue in Picasso's painting *Guernica*, which Moore saw in the studio on a visit to Paris in 1937 (Berthoud, 1987, p.162). Later, Moore said that there was no single source for the imagery.

REFERENCES: G. Levine, *With Henry Moore, The Artist at Work*, London, Sidgwick and Jackson, 1978; *The Tate Gallery, Illustrated Catalogue of Acquisitions 1978–80*, London, Tate Gallery Publications, 1981.

41 | THE HELMET 1939–40
 | Lead
 | H.12⅓in; 31.5 cm
 | Private Collection
 | LH 212

The artist intended this sculpture to be sinister, 'like a face peering out from inside a prison.' (Hedgecoe, 1968, p.185.) This interpretation connects it with the drawing of a *Spanish Prisoner* (cat.94, HMF 1464) from 1938, though *The Helmet* is both more generalised and more awe inspiring. Alan Wilkinson has noticed a connection with another drawing which Moore made in 1937 of helmet-like prehistoric Greek utensils or implements whose usage is unknown (Wilkinson, 1977, p.144, with reproductions). The artist had firsthand experience of helmets for he had seen active service as a very young man in the First World War. However, that proves irrelevant, for only the title of this sculpture is related to the 'real' world. Furthermore, the shape of the enclosing sheath is closer to a head than a helmet,

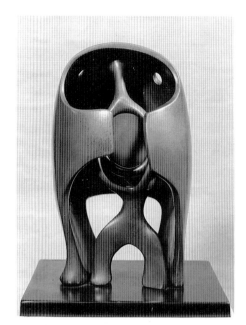

41 Also reproduced on p.83

an analogy made more real by the pinpoint holes at the back which seem to double as eyes. There is a sense in which the sculpture can be seen as an embodiment of the ideas of psycho-analysis, of the emerging psyche contained or even constrained by the persona. This idea (discussed further in the essay, 'Drawing and Sculpture' q.v.) also seems to underlie the related upright internal and external forms which Moore developed ten years later (see cat.118, LH 295). He later described the helmet as an obsessive theme: 'One form inside another, so you get the mystery of not entirely knowing the form inside . . . it's rather like armour which protects – the outer shell protecting the softer inside – which is what shells do in animals too.' (Gilmour, 1975, p.43.) The freestanding figure-like element inside the helmet is additionally related to others in this exhibition (see cat.113, LH 282).

REFERENCE: P. Gilmour, *Graphics in the Making*, London, The Tate Gallery, 1975.

DRAWINGS 1921–1940

42 | *PORTRAIT OF MRS RAYMOND COXON 1921*
Pencil
6¼ x 4½ in; 165 x 114 mm
From the Collection of the late W. A. Evill
HMF 0

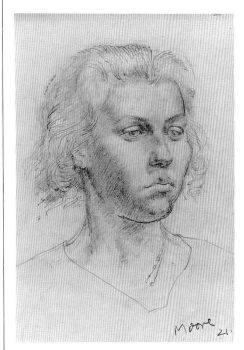

42

This early drawing is a rare example of a portrait likeness of which few examples survive; apart from this, they are mainly of the artist's family (see cat.54–5, HMF 470, 488). It would be more correct if the title were 'Portrait of Edna Ginesi' for, in 1921, she was a fellow student at Leeds School of Art. She lived locally, at Horsforth, and after the evening drawing class, which lasted from seven o'clock until nine, she used to walk to Leeds railway station with Moore and their friend Raymond Coxon. Roger Berthoud tells of her Italian ancestry (she had an Italian great-grandfather) and, 'Since she hated the name Edna, she was always known as Gin.' (Berthoud, 1987, p.51.) From Leeds College of Art she gained admission to the Royal College of Art in 1921 together with Moore

and Coxon. The following year she became unofficially engaged to Raymond Coxon, Moore's best friend, with whom he shared first a room and later a flat. Then in 1925, when Moore arrived in Florence on the travelling scholarship that he had won from the Royal College, he found Gin there and made a number of drawings of her. He had naturally seen a good deal of her in London, but in March in Florence he professed his love and Gin rebuffed him, for 'she wanted to go back to Raymond a better person than when she started the journey.' (Berthoud, 1987, p.79.) Moore wrote to Raymond hoping the episode would not spoil the friendship of the three; Gin told Roger Berthoud, 'The wonderful thing was that we did stay together.' (Berthoud, 1987, p.80.) Moore gave his two friends a sculpture as a wedding present (cat.1, LH 6), and he and his own wife remained friends with the Coxons.

43 | *HEAD OF AN OLD MAN 1921*
Pencil
6 x 6¼ in; 152 x 158 mm
Art Gallery of Ontario, Gift of Henry Moore, 1974
HMF 1

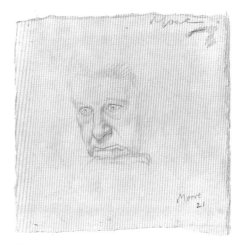

43

This is one of five known sheets of drawings of an old man, made in the modelling class in the Sculpture School at the Royal College of Art during Moore's first term there in the Autumn of 1921. Moore told Alan Wilkinson that on some days they did portraits, on others life drawing; he also described this pencil study as, 'portrait drawing of the purely academic type' (Wilkinson, 1979, p.13). His competence in this style is also shown by a small *Portrait Bust* (LH 1), now destroyed, made from the same model.

44 | SEATED WOMAN 1921
Pencil, pen and ink, wash
22 x 16 in; 559 x 406 mm
The Trustees of the British Museum
HMF 22

Like cat.43 (HMF 1) this study of a seated nude dates from Moore's first term at the Royal College of Art. However, his technique had already begun to change; instead of the meticulous pencil shading, he first made a rougher pencil sketch and then added wash as well as

boldly applied pen and ink details to give a broader and livelier treatment. Although he concentrated on the torso, forgoing detail in the lower arms and legs, he has caught the essence of his model's face. It is, however, the areas of the neck and buttocks that concerned him most and these are the 'weak' spots when carving stone direct, without the aid of a preliminary clay model or the use of a pointing machine. Moore was determined to carve direct even though the academic teaching methods at the College made practising the technique difficult (see cat.1, LH 6).

45

45 | RECLINING NUDE AND FIVE STUDIES OF AN ARM 1922
Pencil, crayon, watercolour
$17\frac{1}{4}$ x $14\frac{1}{4}$ in; 437 x 362 mm
The Henry Moore Foundation
HMF 81

This sheet, with a reclining nude seen from below, records the traditional style of drawing that Moore had to practise in his first years as a student. From his earliest days he wanted to become proficient in drawing and in later years he maintained that all sculp-

tors should be able to draw well in a conventional way. He told Alan Wilkinson, 'If you are going to train a sculptor to know about the human figure, make him do more drawing to begin with than modelling'. (Wilkinson, 1977, p.12.) The diagram at the top of the sheet is a schematised rendering of the structure of the arm and Moore has redrawn it several times on the lower half of the paper.

46 | STANDING WOMAN 1923
Crayon, charcoal (rubbed), ink wash, pencil
19 x $13\frac{3}{16}$ in; 483 x 335 mm
The Henry Moore Foundation
HMF 180

The variations in size of the sheets of paper that Moore used for his early life drawings suggest that he may afterwards have trimmed some of them down. This is most likely with the tall and narrow sheets on which there are upright figures. On this comparatively

46

44

192

large sheet, it is not certain whether he concentrated on the torso of his model and ran out of space for her head and left arm and toes, or whether he cut the paper down because he was dissatisfied with those areas. After the academic style of his first drawings made at the Royal College of Art, he has here begun to think in terms of using more boldly realised modelling to shape the form more sketchily. The arms are less important to him than the legs, and he has preferred the stockier figure of a woman to that of a girl.

47 | NUDE STUDY OF A SEATED GIRL c.1924
Chalk, watercolour
$16\frac{3}{4}$ x $13\frac{3}{4}$ in; 425 x 350 mm
Whitworth Art Gallery, University of Manchester
HMF 256

47 Reproduced in colour on p.122

Very few studies of the nude model made by Moore in the twenties are as sensuous as this sketch. It is surprisingly spontaneous with sweeping outlines barely modified by more definitive curves in black chalk. Much later he described it to Alan Wilkinson as

'Renoiresque', rather surprisingly admitting that Renoir had had a considerable impact on his early career (Wilkinson, 1977, p.14). The colours that Moore chose to emphasise the modelling are the greens and browns that resemble the colour of bronze, a reminder that he was intent on being a sculptor not a painter. There is an unusually lifelike detail in the cut of the girl's hair, which looks as though it has been bobbed, a style new to women in the twenties.

48

48 | STANDING FIGURE: BACK VIEW c.1924
Pen and ink, chalk, wash
$17\frac{3}{4}$ x 11 in; 451 x 279 mm
The Henry Moore Foundation
HMF 228

The artist admitted that round about 1923 he 'began to like bulky models, sturdy wide figures rather than thin ones' (Wilkinson, 1977, p.51). His dictum, 'Outline should be the outcome of

the inside form, the edge of form not the silhouette' (James, 1966, p.115), is well illustrated here, where the bold and broad outline encloses the scratched pen lines which convey the broad masses of this figure. For a sculptor, no one view of a model can ever be definitive since he will expect eventually to realise his figure in three dimensions.

49 | PAGE 155 FROM NO. 3 NOTEBOOK: STUDY FOR MANCHESTER 'MOTHER AND CHILD' 1924
Pencil, pen and ink, brush and ink
$6\frac{9}{16}$ x $6\frac{13}{16}$ in; 166 x 173 mm
Art Gallery of Ontario, Gift of Henry Moore, 1974
HMF 139

This sheet includes the definitive study for one of Moore's early sculptures, *Mother and Child* (LH 26); about one and a half inches has been cut from the top of the paper. An inscription on the drawing reveals that the artist was interested in the proportions: '$(2\frac{1}{2})/5×3×3$', and more significantly, the relationship of the mother and child which he describes as 'poising/ of weights'. By placing a child on her shoulders Moore has given reason for the mother's arms to be raised to form a more complicated composition than a simple torso would have done. The drawing also shows that Moore first conceived the figure as slightly more than half length, finishing with an oval plinth. He later admitted his fear at the time of weakening the stone by cutting away too much, which accounts for some of the changes from this squared-up drawing and the sculpture as executed. (Related drawings repr. Wilkinson, 1979, pp.18–19.) Altogether there are six known sheets of studies dating from 1924–5 and in view of the artist's love of the theme of Mother and Child it is strange that his first idea was for a 'Man carrying child'.

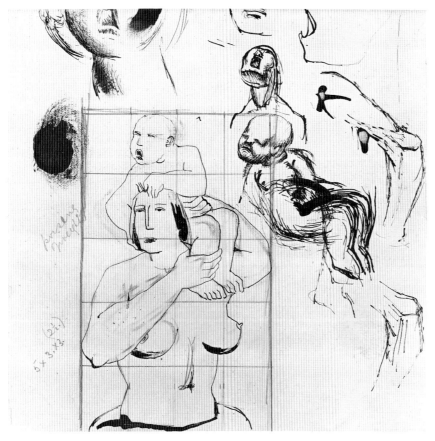

49

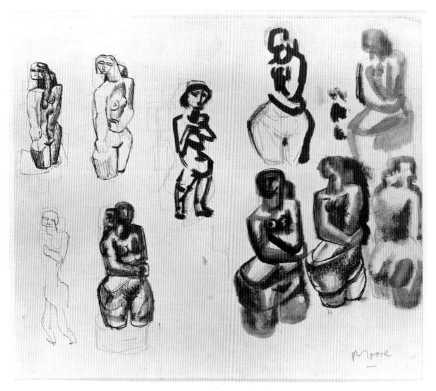

50

This was reproduced by Wilkinson (ibid, fig.6), who, in a revised publication, notes that the artist recently trimmed away the sketch, so that it survives only as a photograph (Wilkinson, 1987, p.267, 'Drawings and Sculpture' n.1).

REFERENCE: A. G. Wilkinson, *Henry Moore Remembered, The Collection at the Art Gallery of Ontario in Toronto,* Art Gallery of Ontario and Key Porter Books, 1987.

| 50 | IDEAS FOR SCULPTURE: STUDY FOR 'TORSO' c.1925 |

Pencil, pen and ink, brush and ink

$9\frac{15}{16}$ x $11\frac{9}{16}$ in; 249 x 294 mm

Art Gallery of Ontario, Gift of Henry Moore, 1974

HMF 360

Moore identified the figure at top left as the definitive sketch for the sculpture *Torso* (LH 37), although it varies considerably from the drawing, particularly in its cubistic origins. The more completely rendered figure in this drawing seems either to carry an infant, whose arm hangs over her shoulder, or to have a long plait of hair, which provides a third vertical element. Moreover the head in this drawing has a closer link with primitive sculpture and the artist truncated the head in the sculpture. The final sculpture is unusual in being a torso: in later sculptures he concentrated on the half-length figure (cat.10, LH 67). Moore evidently considered the possibilities of using several other figures on this sheet as the basis for sculptures as there are notations for a base, or other ideas for how the figure might be enabled to stand when carved. Most of the figures in this drawing seem to be based on non-western prototypes.

51 | *TWO SEATED FIGURES 1924*
Pen and Indian ink
9 1/2 x 12 7/8 in; 242 x 327 mm
The Henry Moore Foundation
HMF 263

This apparently spontaneous outline drawing was based on a page of studies from No.3 Notebook (HMF 965). Perhaps surprisingly, this includes a squared up, shaded drawing, done, the artist told Alan Wilkinson, after a visit in 1922 to see the paintings by Paul Cézanne in the Pellerin Collection in Paris (Wilkinson, 1979, p.22). However, on this sheet, the artist has redrawn his own figures in a style closer to that of Picasso or Matisse, who both made outline drawings in the twenties. Moore later explained:

Pure outline drawing is a shorthand method of drawing, to be arrived at later in an artist's career. Matisse and Picasso often used this method, but they began their careers with . . . highly finished three-dimensional drawing using light and shade, and then later simplified their styles. This is the real way to understand form and drawing (Wilkinson, 1977 p.13.)

As well as changing the style of drawing he has made the facial features much harsher. If he used a model to make the transformation, it seems likely that it served for both figures; the one on the right being the front view of the girl on the left.

52 | *THE TWO THIEVES, ST JOHN AND ROMAN SOLDIERS 1925*
Pen and ink
8 x 9 5/8 in; 207 x 245 mm
Art Gallery of Ontario, Gift of Henry Moore, 1974
HMF 354

In his later years the artist told Alan Wilkinson that although he was primarily a sculptor he had never different-

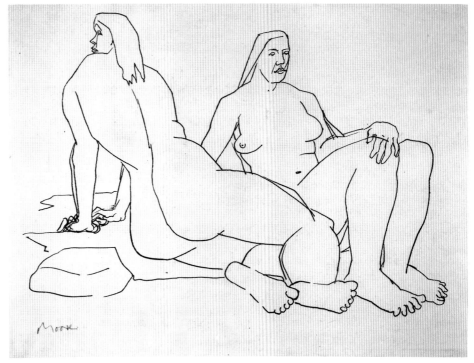

51

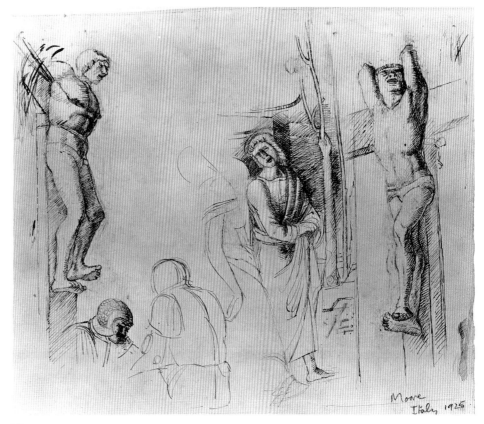

52

iated his appreciation of painting from that of sculpture and that on his travelling scholarship he had probably looked at painting as much as at sculpture (Wilkinson, 1984, p.11). Moore had won a travelling scholarship to Italy when he graduated from the Royal College of Art and had attempted to get the destination changed as he felt uninspired at the idea of studying Renaissance works of art. However, early in 1925 he set off via Paris and spent time in Genoa, Pisa, Rome, Florence and Venice, making several copies of works that particularly caught his eye. The source of the figures on this sheet has not yet been identified though Moore has chosen a surprisingly emotive source. The use of firm, parallel lines of shading, is a reminder of the academic technique that Moore had been taught at Leeds College of Art.

REFERENCE: A. G. Wilkinson, 'Reminiscences and Continuing Themes', *Henry Moore Drawings from the Henry Moore Foundation 1979–1983*, London, Marlborough Fine Art, 1984.

53

53	COPIES OF FIGURES FROM 'THE VISITATION', ANONYMOUS EARLY 15TH-CENTURY DRAWING, UFFIZI, FLORENCE 1925
	Pencil, pen and ink, wash
	$13\frac{1}{4}$ x $9\frac{5}{8}$ in; 338 x 245 mm
	Art Gallery of Ontario, Gift of Henry Moore, 1974
	HMF 355

On his travelling scholarship to Italy Moore made copies of figures that he admired (see cat.52, HMF 354). On this sheet, no doubt drawn in Florence, he copied some of the women from *The Visitation*, an anonymous early fifteenth-century drawing in the Uffizi (repr., Wilkinson, 1977, p.69). In the foreground are two studies of the head of a younger woman, so far not identified. Moore has not shown interest in the composition of *The Visitation*, for he has rearranged the row of austere figures, giving prominence to one who, in the original, is on the left edge of a row of four women. They are watching Mary greeting Elizabeth in the centre, but Moore has barely defined the older woman, Elizabeth, and placed her on the extreme left of his drawing; he has taken the figure of a bystander from the original and increased her importance. In his last years Moore returned to the subject in a very different style in the print *Visitation* (CGM 629).

54	WOMAN SEATED READING (THE ARTIST'S SISTER) 1925
	Ink, wash, watercolour, chalk
	$17\frac{1}{2}$ x 13 in; 445 x 335 mm
	The British Council
	HMF 470

The subject is the artist's sister, Betty, four years older than himself and a schoolteacher, like so many of his six surviving brothers and sisters. In 1925 she was already married and living at Mulbarton in Norfolk, and Moore spent part of the summer holidays staying at her home there (Berthoud, 1987, pp.82–4), after returning from five months in Italy on his travelling scholarship (see cat.52, HMF 354). He had written to the principal of the Royal College: 'In Italy the early wall paintings – the work of Giotto, Orcagna, Lorenzetti, Taddeo Gaddi, the paintings leading up to and including Masaccio's are what have so far interested me most.' (Letter dated 12 March, Rothenstein, 1984, pp.241–2.) As late as 1974 Moore named Masaccio as an important influence: 'I've got as much substance, inspiration and nourishment out of Masaccio as I've got from any sculptor's work.' (Wilkinson, 1984, p.11.) This drawing, with the figure in its long dress, has something of the gravity of the work of that fifteenth-century master.

REFERENCES: J. Rothenstein, *Modern English Painters: Lewis to Moore*, London, Eyre and Spottiswood, 1984; A. G. Wilkinson, 'Reminiscences and

54 Reproduced in colour on p.124

Continuing Themes', *Henry Moore Drawings 1979–83 from the Henry Moore Foundation*, London, Marlborough Fine Art, 1984.

55 Reproduced in colour on p.125

55 | THE ARTIST'S MOTHER 1927
Pencil, pen and ink with finger rub and scraping
$10\frac{15}{16}$ x $7\frac{9}{16}$ in; 277 x 191 mm
The Henry Moore Foundation
HMF 488

Jack Clarkson, who began studying at the Royal College of Art in 1927, told Moore's biographer Roger Berthoud of the artist's way of teaching: 'He taught me to see the human figure not as an outline but in masses.' (Berthoud, 1987, p.87.) Although this description was of modelling rather than drawing, the ample form depicted here shows that the teacher put his own advice into practice. Moore's mother was described by one of her grandchildren as 'a very handsome woman. She stood very straight, and she wore black all the time, and always clothes with a high

neck. She had the kind of dignity that Henry's figures have.' (Berthoud, 1987, p.21.) By 1927 she was living with her daughter in Norfolk (having left Yorkshire in 1922), but Moore's later memories of her centred on his childhood years in Castleford. He told Donald Hall that she was 'absolutely feminine, womanly, motherly', and admitted that he probably had a mother complex (Hall, 1966, p.30). This majestic record of his mother conveys the strong but affectionate character which she passed on to her artist son.

56 | STANDING FEMALE FIGURE 1928
Brush and watercolour
$17\frac{1}{4}$ x $11\frac{1}{2}$ in; 438 x 293 mm
Private Collection
HMF 535

From 1922 Moore visited Paris once or twice a year until 1932–3. There, usually in the company of Raymond Coxon or another friend, he would attend sub-

56 Reproduced in colour on p.128

scription life classes, either at the Académie de la Grande Chaumière, or at Colarossi's, where there were long poses in the afternoons or short poses in the evenings. Indeed, as the day wore on, the poses became shorter and shorter, ending with ones of a minute each. Although Moore never followed Rodin's practice of drawing a model in movement, the swiftly brushed, terracotta lines by which this figure is conveyed were clearly made quickly and spontaneously. Unlike many other more fully realised poses, it gives the feeling of a model poised between movements. Drawings such as this reveal Moore's inventive skill as a draughtsman, wholly independent of ideas for sculpture.

57

57 | STANDING NUDE 1928
Pen and ink, chalk, wash
27 x 20 in; 686 x 508 mm
The Trustees of the British Museum
HMF 557

The contrast of the highlights and areas of wash and chalk on this drawing is unusual, with the strong 'sectional' line used to emphasise the way the light falls

197

on the model rather than to define her structure. Alan Wilkinson has compared the use of wash both on and around the figure to late drawings by Rodin (Wilkinson, 1977, p.57). However, in spite of the well defined breast and nipple, Moore's drawing entirely lacks the sensuality of Rodin's work. Indeed, Moore uses the awkward position of the model with one foot raised on a block to investigate her massive form in a detached and architectural way; he seems only to be interested in the structure of the body, in no way does he intimate desire. As a sculptor, Rodin's preferred method of working was to model the figure in imitation of flesh. Moore rejected the seductive qualities of clay modelling in favour of truth to material; in his drawing eroticism is replaced by formal analysis.

58 Reproduced in colour on p.123

58	GIRL RESTING 1928
	Pen and ink, chalk, wash
	15¼ x 19½ in; 387 x 495 mm
	Private Collection
	HMF 563

A number of Moore's finished life drawings are coloured with green wash, which is used here to great effect to express the modelling of the forms. The position of the model is unusual, for by leaning her face on the back of a chair the head and torso are formed into a sculptural block, interrupted only by the right forearm. The face is also in shadow and conveys an element of serenity, as well as a hint of sadness. Emotion is rarely an ingredient of these studies from life and it gives a special quality to this drawing.

59	IDEAS FOR 'WEST WIND' RELIEF 1928
	Pen and ink, brush and ink, watercolour
	14 x 8⅞ in; 356 x 225 mm
	Art Gallery of Ontario, Gift of Henry Moore, 1974
	HMF 647

This drawing includes the study at lower left for the definitive pose which Moore used for his relief sculpture (LH 58) on the headquarters of the London Underground Railway (at St James's Park Underground Station). Confusion has arisen in the intervening years because the sculpture has been referred to as the North Wind, an error corrected by Dennis Farr (1978, pp.251–2, n. 1, cited with additional evidence by Wilkinson, 1979, p.38); the four winds were the subject of eight reliefs of which Eric Gill made three, and five other sculptors each did one. Moore had been reluctant to accept the invitation given him by the architect Charles Holden. However, to be invited to work on a project of which the older Jacob Epstein was the principal sculptor, must have given Moore encouragement, particularly as Epstein had bought a piece at Moore's first one man show at the Leicester Galleries in January 1928. The existence of a complete sketchbook devoted to the project as well as individual drawings such as this one shows how seriously Moore devoted himself to his first public task, which is also described in the notes for cat.60 (HMF 529). As a result of a misunderstanding, in the revised version of the catalogue of

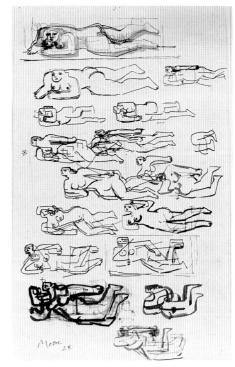

59

the Moore Collection in Toronto, this drawing is named *Ideas for North Wind Sculpture* and none of the corrections established by Alan Wilkinson in 1979 are noted (Wilkinson, 1987, p.64–5).

REFERENCES: D. Farr, *English Art 1870–1940*, Oxford University Press, 1978; A. G. Wilkinson, *Henry Moore Remembered, The Collection at the Art Gallery of Ontario in Toronto*, Art Gallery of Ontario and Key Porter Books, 1987.

60	IDEAS FOR RELIEF 'WEST WIND' FOR ST JAMES'S UNDERGROUND STATION (1928)
	Pen and wash
	14¾ x 10½ in; 375 x 267 mm
	Arts Council of Great Britain
	HMF 529

In the catalogue of the Arts Council Collection this drawing is entitled 'Ideas for Relief "North Wind" ...' and dated 1927. Recent research has revealed that Charles Holden, the architect of the

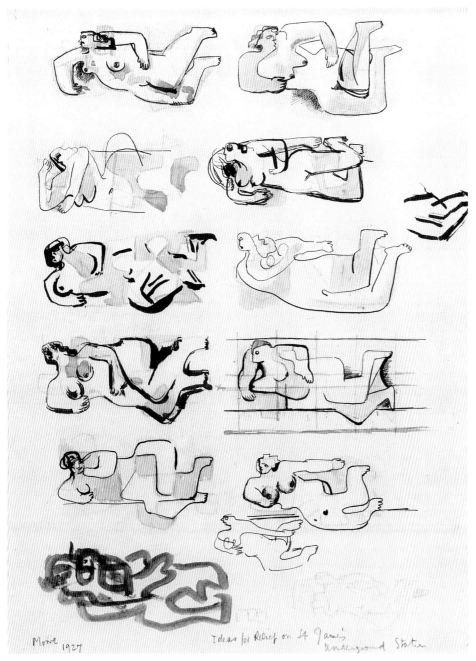

Moore 1927

Ideas for Relief on St James's Underground Station

60

Headquarters of the London Underground Railway, approached Moore in 1928 to invite him to make a sculpture of the West Wind for the north wall of the new building. Perhaps because the sculpture is on the north wall, it became erroneously named 'North Wind', in spite of the fact that a photograph of the relief was published in the Manchester Guardian (on 27 July 1929) with the caption 'West Wind by Henry Moore' (Wilkinson, 1979, p.38). From 1928 there remains a sketchbook devoted to the project; a facsimile was published in 1982 in a limited edition. The brochure published on the same occasion includes a preface by Moore himself 'on the origin of the West Wind Relief'. 'They planned to have a tower to the building, an idea inspired by the "Tower of the Winds" in Athens, Eric Gill would do two of the stone reliefs high up on the tower.' He told of his misgivings about the commission: 'At that stage in my career I did not (and still do not) like sculpture that represents actual physical movement – sculpture that appears to be jumping off its pedestal. I was also prejudiced against relief sculpture itself as being too much akin to painting, and also because relief sculpture figured too prominently in art schools' teaching.' He finally resolved his feelings and his description admirably fits this drawing:

Slowly I realised that I might be wrong to give the title West Wind *to a static figure and then I hit on the idea of a figure suggesting a floating movement, thinking of the character of the four chief winds – North being cold and hard – a male wind; South – a warm female wind; East – a hard, cutting wind and West, a rainier and softer wind – I made drawings, trying to express something of this character. (Wilkinson, 1982.)*

REFERENCE: A. G. Wilkinson, *Henry Moore Sketchbook 1928, The West Wind Relief*, Much Hadham, Raymond Spencer Company, 1982.

61 | **SEATED WOMAN 1928**
Brush and ink, ink wash
$22 \times 14\frac{3}{8}$*in; 559 x 373 mm*
Private Collection
HMF 604

This is one of several drawings that Moore made at this time of a model wearing a necklace; it is one of his strongest nudes as well as one of the most sculptural of the life drawings. The head is seen both in profile and full face in a manner derived from contemporary work by Braque and Picasso. However the structural lines added over the body are Moore's own invention which he later termed 'sectional lines'; he

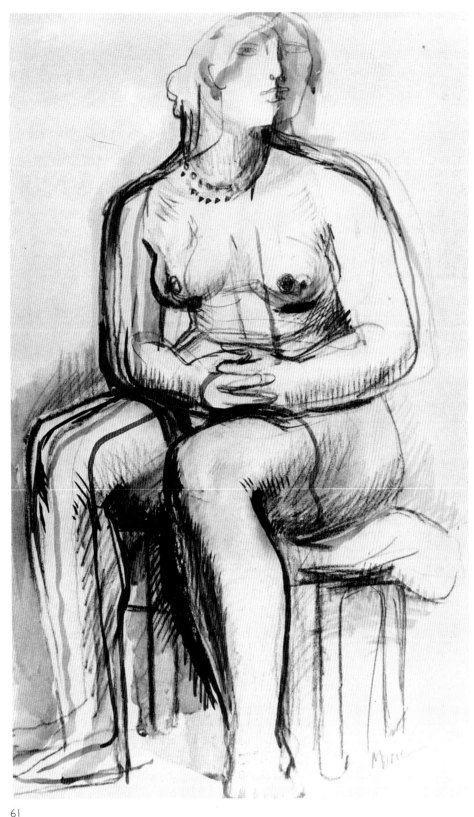

61

drew these lines down the figure and round it in order better to imagine the form in three dimensions. By turning the head at right angles to the shoulders Moore has increased the asymmetry of the figure; this is characteristic of his preoccupations at the time and can be seen in a sculpture such as the *Seated Figure* (cat.13, LH 92) from 1930 now in the Art Gallery of Ontario.

62 | STUDY FOR LEEDS 'RECLINING FIGURE' 1928
Pencil
$4\frac{3}{4}$ x $7\frac{1}{8}$ in; 121 x 181 mm
Art Gallery of Ontario, Gift of Henry Moore, 1974
HMF 684

This pencil figure has been cut and mounted on its own sheet of paper and thus given the special attention it deserves as the definitive drawing for the Hornton stone *Reclining Figure* (cat.9, LH 59). It betrays its connections both with the Aztec rain god on which Moore admitted that he based the sculpture and with the figure of the West Wind (LH 58) that he carved for Holden's building at 55 Broadway in the same year (see cat.59, HMF 647 and fig.2). Interestingly, the changes that he made to the Mexican prototype are very well documented by this drawing. Firstly, he added a raised arm instead of the one that does not show in the photograph of the original in the Museo Nacional de Antropologia, Mexico, and it looks positively grotesque in this drawing. Secondly, he added breasts to transform it into a female figure – these are schematically shown here. But the most important change, the turning of the lower half of the figure on edge is clearly derived from his own *West Wind*. Moore had not wanted to make a relief and although this drawing still does not seem fully in the round, in the sculpture

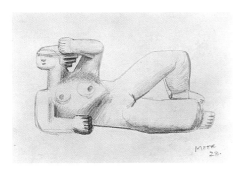

62

made from it, he exulted in exploring three dimensions.

63 | TWO RECUMBENT NUDES 1928
Charcoal, wash, collage
9 x 14 in; 228 x 355 mm
Private Collection
HMF 688

This unusual composition is made up of two separate, contemporary drawings of reclining figures, the smaller cut out and pasted onto the larger, which, however, may never have been more complete. Alan Wilkinson has connected this large torso with the *Reclining Woman* (LH 84) in the National Gallery of Canada in Ottawa, for which, he pointed out, no drawing is known (Wilkinson, 1977, p.80); he also links the head to that of the drawing from life (cat.61, HMF 604). However, it seems to the present writer that the two positions of the present figure's head may simply be pentimenti, rather than a cubistic use of two viewpoints deriving

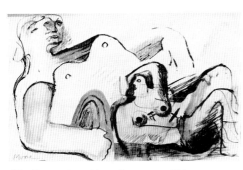

63 Reproduced in colour on p.126

from the work of Picasso. The smaller figure is related to the *Reclining Figure* (cat.9, LH 59) and is far less transitional than the study (cat.62, HMF 684).

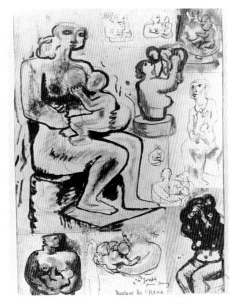

64 Reproduced in colour on p.127

64 | MONTAGE OF MOTHER AND
CHILD STUDIES c.1929–30
Pencil, pen and ink, brush and ink,
chalk, coloured washes
19 x 14$\frac{11}{16}$ in; 482 x 373 mm
Art Gallery of Ontario, Purchase,
1976
HMF 731

Many of Moore's carvings from the twenties are of a mother and child and in the first two years of his marriage he made twelve carvings of the theme, to which some of these drawings are related. For instance, Alan Wilkinson has noted that the large seated mother and child included here is connected with the Hornton stone *Mother and Child* of 1932 (LH 121, Wilkinson, 1979, p.43). It is the only figure that was not cut from a notebook by Moore's young wife who had herself been a student of painting at the Royal College of Art. She made this montage by cutting out the drawings and then pasting them onto cardboard.

The result is not without humour, for on the right a wide-eyed woman holds a puppy rather than a baby! In an inscription in her hand, the Russian-born Irina has spelled her name 'Irena', a more usual transliteration from her native Russian. Moore later admitted that he had discovered that when drawing he 'could turn every little scribble, blot or smudge into a Mother and Child'. (Hedgecoe, 1968, p.61.)

65 | SEATED WOMAN 1929
Chalk, wash
27 x 20 in; 686 x 508 mm
The Trustees of the British
Museum
HMF 694

Very few of Moore's models are shown in architectural surroundings; this drawing however depicts not a model in

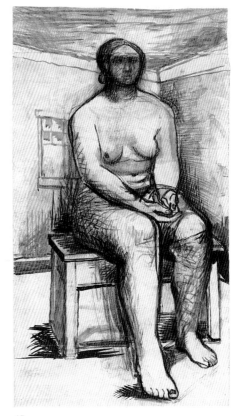

65

201

the life room at the Royal College, but the artist's wife, Irina Radetsky, who had studied painting there. They were married in July 1929 and subsequently moved into a flat at Parkhill Road, Hampstead. There is a drawing of Irina standing in the studio with sculpture round about her from 1930 (cat.66, HMF 760), but the later drawings from the life show her seated in or on an armchair, generally with no reference to the room (for instance cat.78, HMF 1067). In this case Moore has paid more than usual attention to the head; as Alan Wilkinson has pointed out, both the unusually low viewpoint and the heavily worked legs remained characteristic of his life drawings of his wife (Wilkinson, 1977, p.61).

66	STANDING FIGURE c. 1929
	Black chalk or charcoal, watercolour base
	20 1/8 x 15 3/4 in; 513 x 397 mm
	The Board of Trustees of the Victoria and Albert Museum
	HMF 760

This is the only known life drawing to include sculpture; behind the commanding draped figure of Irina, the artist's wife, is a mask resembling cat.6 (LH 62). Below it, on a shelf, is an unidentified tiny figure, while behind a table to the left, is the stone *Standing Woman* (LH 33) made in 1926 and later destroyed. The artist has picked up an affinity between the sinuous form of his model's arm and the profile of the sculptured figure; furthermore, by placing her fingers on the edge of the table he has introduced an element of asymmetry, which balances the position of the head of the sculpture. This, in turn, contrasts with the severe frontality of both the living head and the mask. By restricting his use of colour Moore has reduced the distinction between woman and sculpture, though the flowers convey domestic life.

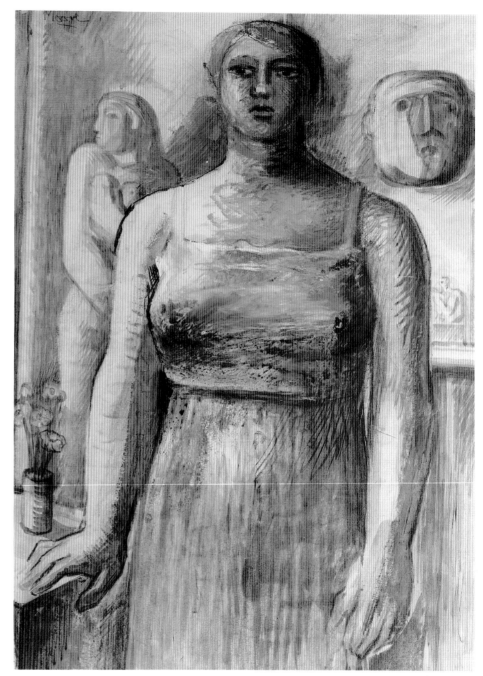

66

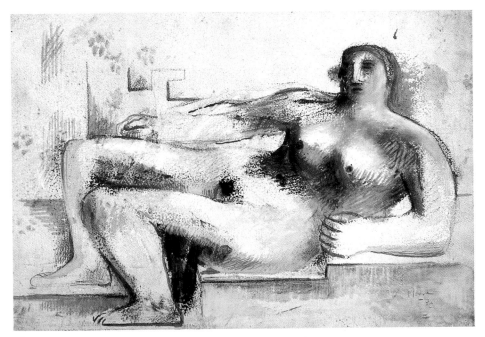

67

St James's Park Station). It is especially
clear from (b) that he had carved the
Reclining Figure (cat.9, LH 59) in the
intervening year, for the 'Sectional
lines', super-imposed in brown crayon,
form a totally independent, three-
dimensional pattern. The third drawing
(c) is of an equally bulky figure but with
a surprisingly delicate and feminine
head. In all three Moore has used his
favoured green for modelling, which
links the drawings with bronze.

REFERENCE: *Henry Moore Sketchbook 1928,
The West Wind Relief*, Much Hadham,
Raymond Spencer Company, 1982.

68(a)

67	FIGURE ON STEPS 1930

Chalk, wash, watercolour, oil
$14\frac{5}{8} \times 21\frac{5}{8}$ in; 372 x 549 mm
The Henry Moore Foundation
HMF 784

Encapsulating the monumentality that
Moore had explored in a sculpture the
year before (cat.9, LH 59), this nude
confidently straddles a flight of steps. In
a drawing the device provides architec-
tural nuances, but considered in sculp-
tural terms, it provides the figure with
the base that traditionally separates the
space occupied by a carving from that of
the viewer. There is also enough back-
ground to suggest that Moore was re-
considering the problem of relief sculp-
ture that had exercised him in 1928
when he was working on the *West Wind*
relief (LH 58, see cat.59, HMF 647).
However, although these connections
are present, Moore has removed some
of the sculptural associations in this
drawing by applying washes of grey,
green and white, which serve to flatten
the image and make it more pictorial.
Two or three marks towards the top left
corner are chance marks from a cat's

paw, according to the compiler of
cataloguing data of drawings belonging
to the Henry Moore Foundation.

68	THREE STUDIES OF RECLINING NUDES 1930

Wash, chalk, watercolour
(a) $5\frac{3}{16} \times 8\frac{1}{2}$ in; 136 x 216 mm
(b) $6\frac{11}{16} \times 8\frac{13}{16}$ in; 170 x 225 mm
(c) $6\frac{1}{4} \times 8\frac{7}{8}$ in; 159 x 226 mm
The British Council
HMF 786, 787, 788

These three separate drawings have
been framed together with a single
British Council inventory number (P69)
since their purchase in 1948. Taken
together they resemble a type which
Moore used in a Sketchbook of 1928
entitled *The West Wind Relief*, in which
five pages show three reclining figures,
one above another; in addition, two of
three overlays of sheets of blue paper
are similar in composition. Here the
figures are more lifelike as well as more
massive than the relief that Moore had
carved in 1928 for the new headquarters
of the London Underground Railway (at

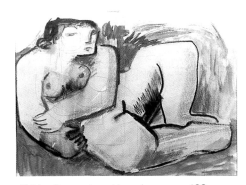

68(b) Reproduced in colour on p.129

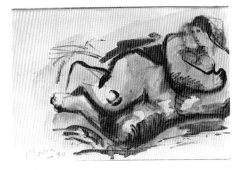

68(c)

69 | TRANSFORMATION DRAWING:
IDEAS FOR SCULPTURE 1930

Pencil, brush and ink

$7\frac{7}{8} \times 9\frac{3}{8}$ in; 200 x 238 mm

*Art Gallery of Ontario, Gift of
Henry Moore, 1974*

HMF 808

The four studies on the right of this
sheet are directly related to the Cum-
berland alabaster *Composition* (cat.16,
LH 102) of 1931, executed as a head and
shoulders only, but here thought of in
terms both of a half-length and a reclin-
ing figure. It is particularly revealing to
find these studies with the even more
obvious transformations from bones
which occupy the left side. Alan Wilkin-
son records that the first notation that
Moore made of natural forms is an
inscription inside the cover of No. 6
Notebook of 1926: 'remember pebbles
on beach' and that at the Natural His-
tory Museum (which is next door to the
Sculpture School of the Royal College of
Art in London) Moore often made
sketches of bones and shells (Wilkinson,
1979, p.45). Here he has begun deriving
figures from bones by a process of
metamorphosis that became a hallmark
of his invention; it is especially clear in
the figure on the left.

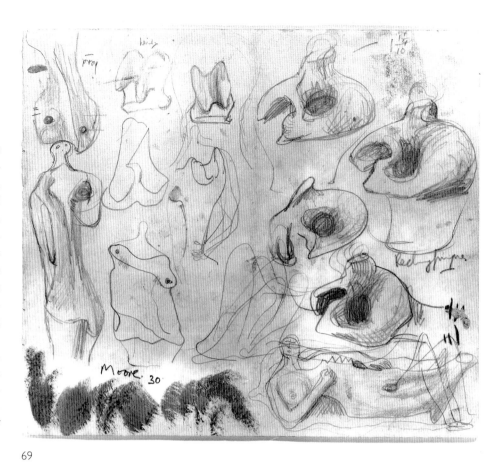

69

70 | PAGE FROM NO. 1 DRAWING
BOOK 1930–33: IDEAS FOR
'COMPOSITION' IN GREEN
HORNTON STONE 1930

Pencil

$6\frac{3}{8} \times 8$ in; 162 x 203 mm

The Henry Moore Foundation

HMF 832

This page includes the definitive study
for the remarkable sculpture, simply
named *Composition* (cat.15, LH 99), and
also notations connected with the *Suck-
ling Child* (LH 96) of the same year. The
various stages of invention were discus-
sed in considerable detail by Alan Wil-

kinson in 1977 (Wilkinson, 1977,
p.83–4). In the notes on *Composition* it
has been suggested here that primitive
pottery may have served as an underly-
ing inspiration for the work, and in this
drawing, the bird-like head which
seems to double as a handle, reinforces
the notion. The latter idea came to
fruition in the early sixties with the
drawing, *Reclining Figure Bunched*

70

(cat.175, HMF 3025) and the maquette
from which it was drawn (LH 489). By
turning this page (easily done with a
reproduction) the other pencil sketches
take on sinister connotations, resem-
bling a foetus or even the ungainly form
of a young bird or bat, with a breast in
one case doubling as an egg.

71 | STUDIES OF SHELLS AND
PEBBLES 1932

Pencil, crayon, Indian ink

$9\frac{3}{4} \times 6\frac{11}{16}$ in; 248 x 171 mm

Arts Council of Great Britain

HMF 946

Two of the shapes on this page are
indicated as 'limestone pebble facetted
in curiously windblown sand'. How-
ever, early in the thirties Moore began
not simply to record the external ap-

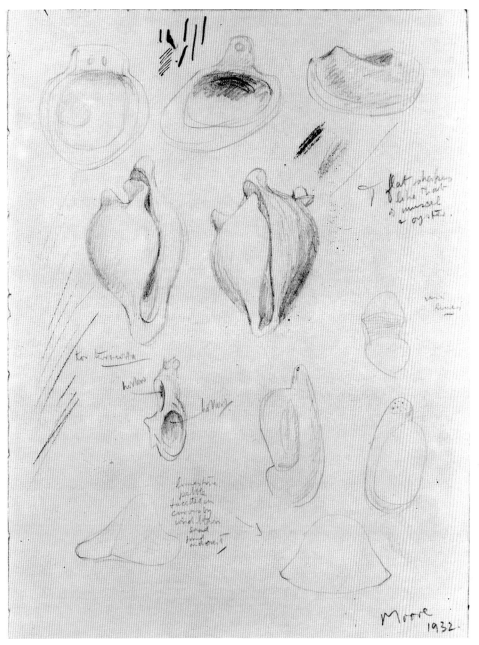

71

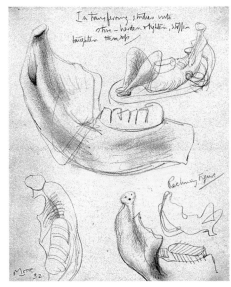

72

72 | IDEAS FOR SCULPTURE:
TRANSFORMATION OF BONES
1932

Pencil, finger washed and rubbed
$9\frac{1}{4}$ x $7\frac{11}{16}$ in; 236 x 195 mm
The Henry Moore Foundation
HMF 941

The artist's inscription at the top of this sheet reads: 'In Transferring studies into stone – harden & tighten, stiffen, toughen them up'. He has also named the sketch at bottom right, 'Reclining Figure', though another, apparently more finished though less sculptural, figure is to be seen at top right, reclining on an oval pedestal. Both are next to drawings of the jawbone of some animal with the teeth clearly visible. Of these, the upper one appears to have arms, and the one bottom right, a head, so Moore was considering the metamorphosis of these natural forms into figures. At the time, he was aware of the ways that Surrealists were attempting to renew the basis of art by using devices previously unconnected with fine art; his own process may seem startling, but because bones are the underlying structure of the human body the transformation seems not altogether unnatural.

pearance of pebbles and shells, but to use them as the starting point for transformation into sculptural ideas. Thus the top central form conveys the dual association of a hollowed-out pebble and a human torso, the perimeter of the stone forming shoulders and arms to which Moore has added a schematic head, itself pierced by a small hole to echo natural formations. Lower down, he has added the word 'hollow' to a worn shell in an upright position, to remind himself that the shaded holes pierce the shell. Above it he has written 'For terracotta', a medium that he used later in the thirties when he began casting regularly in lead. Most telling is the clearly defined shell, seen in two upright views in the centre: its edges are sufficiently curved to reveal the mysterious hollow inside; it suggests a hooded, draped figure.

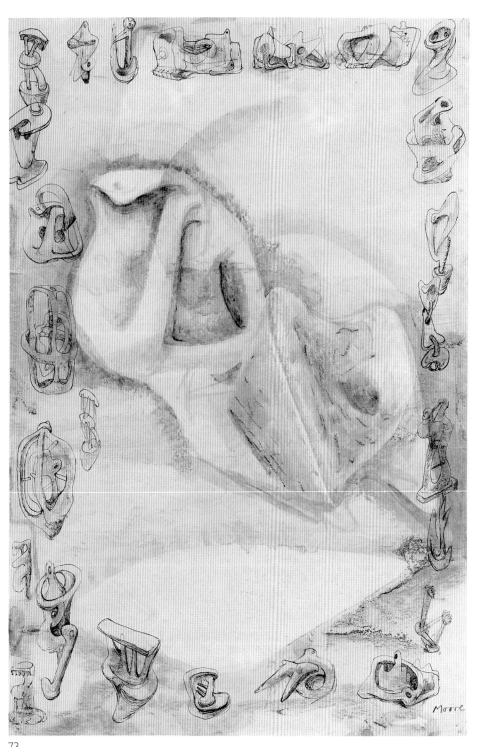

73

twenty-three inventions, certainly owing allegiance to Picasso's fantasies, the series of small drawings, *Une Anatomie*, published in the first issue of the surrealist journal, *Minotaure* in 1933 (No. 1, pp.33–7). Moore made no secret of knowing Picasso's drawings, but they seem rather like an alphabet, laid out in a regular series, in contrast with Moore's inventions, seen in a variety of perspectives, and of many different sizes. Nor are Moore's ideas all connected with the human figure: one that is above the left corner is clearly a snake-like creature, while nearly opposite, above the right corner, is a plant form. Some of Picasso's figures are composed from alien elements – a chair or a ladder become torsos, part of a cog-wheel replaces a thigh; Moore's drawings have structures derived from nature. The shapes are those of bones or shells, of plants or seaweeds, which he has metamorphosed into numerous reminders of parts of human bodies. Picasso's forms are indeed sinister but Moore's seem all the more convincing for being distortions based on organic forms.

74 | IDEAS FOR TWO-PIECE COMPOSITION 1934

Pen and ink, chalk and wash, watercolour

$14\frac{9}{16}$ x $21\frac{11}{16}$ in; 370 x 550 mm

Rijksmuseum Kröller-Müller, Otterlo

HMF 1085

Some of the ideas explored here in two dimensions are related to the sculpture *Two Forms* (cat.28, LH 170) carved in the same year. However, the smaller form of that wooden sculpture has an altogether more symmetrical appearance than the stone-like shapes depicted here. Each, however, is conceived as a sculpture, for the forms rest on suitably shaped bases; in the middle row these are contiguous and thus may create a surprising association with a jigsaw

73 | RECLINING FIGURE AND IDEAS FOR SCULPTURE 1933

Pencil, watercolour or diluted ink wash, pen and ink, crayon

$21\frac{15}{16}$ x $14\frac{7}{8}$ in; 558 x 378 mm

The Moore Danowski Trust

HMF 996

The pale tones and subdued modelling of this multi-part drawing should not mislead the viewer, for the folded forms of the central reclining figure convey a mysterious personage, at the same time human and monstrous. It is framed by

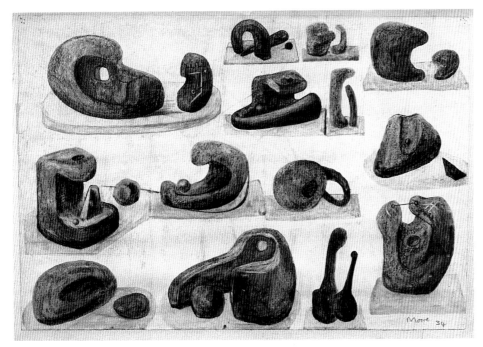

74

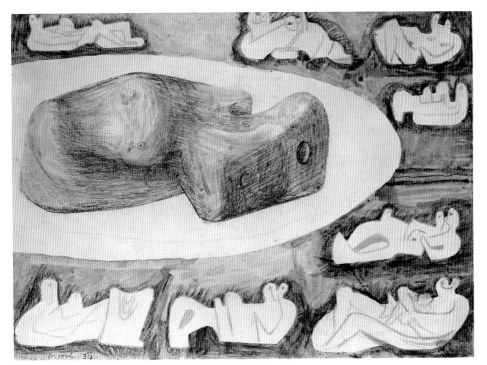

75

puzzle. In later life Moore suggested that his carved *Two Forms* bore a resemblance to a mother and child; it is not unreasonable to consider the relationship of smaller to larger forms on this sheet as based on a similar idea. This is particularly appropriate with the centre group on the bottom row, where the hollowed out enclosing shape may be read as the mother reaching out with her arms towards the child's ball-like head. Yet such a literal interpretation is not appropriate, for the essence of Moore's approach in the mid-thirties was poetic metaphor. That does not exclude human feelings and in this drawing the larger form may menace the smaller, as in the centre left, or may even be attached, as in the lower right corner, where a string forms a physical attachment between the eyes. This may be an early indication of the stringed figure sculptures which Moore made from 1937 to 1939.

75 | *STUDY FOR RECUMBENT FIGURE 1934*

Chalk, brush and ink, wash

$10\frac{7}{8}$ x $15\frac{1}{4}$ in; 277 x 387 mm

Art Gallery of Ontario, Gift from the Junior Women's Committee Fund, 1961

HMF 1089

Unexpectedly asymmetrical, the veiled central image reposing in an egg-like space is here surrounded on only three sides by more readable figures. Several have two heads and it is not certain whether they are couples, or intended, like the figure in the bottom right corner, to be holding children. The central form itself, wrapped like some ancient mummy or burial figure, reveals its gender by its clearly defined nipples, pressing forward below a wrapped head and above a lap. The theme is not unlike that of a woodcut, *Figures Sculptures* (CGM 1, fig.16), which Moore had made

in 1931, though the arrangement there is far more decorative. Here the lower part of the central form is halfway to a carving, hewn from a solid material and lacking the attributes of humanity visible in the smaller figures. Paradoxically, although this central image gives the title and already looks like a drawing from a carving, it is the freer, less defined, outer figures that provided the starting point for later sculptures. The various forms of divided head became particularly important in later works, for instance cat. 36, LH 192.

76 | SEATED FIGURE 1933
Pencil, pen and brush and ink and watercolour
23 x 15½ in; 584 x 394 mm
Private Collection, Toronto
HMF 1042

In his extensive studies of Moore's drawings, Alan Wilkinson has drawn attention to fourteen life drawings made by the artist between 1932 and

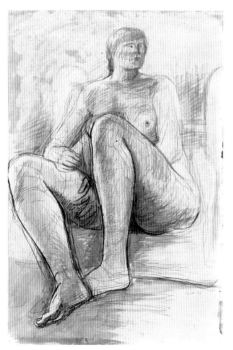

76

1935. The model was his wife, in all but three seated in or on the arm of a chair. Wilkinson has quoted Moore's admission that 'In the small room in which his wife posed, ... he was unable to draw from any great distance, and his model seemed to loom up in front of him as he worked.' (Wilkinson, 1977, p. 63.) In this drawing the way the feet overlap and the right foot turns ninety degrees to display the full width of the calf, adds a Michelangelesque detail to the otherwise static pose.

As in two other drawings (cat.77, 78, HMF 1067, 1047), the junction of the legs with the pelvis receives the most attention and the artist later on suggested that the depth created by the legs projecting forward allows one to read the composition in terms of landscape. The *Reclining Woman* (LH 84) today in the collection of the National Gallery of Canada in Ottawa had recently been reproduced by Wilenski with the title 'Mountains' (Wilenski, 1932, plate 24).

REFERENCE: R. H. Wilenski, *The Meaning of Modern Sculpture*, London, Faber and Faber, 1932.

77

77 | RECLINING WOMAN c.1934
Ink, wash
14⅞ x 21¾ in; 378 x 552 mm
The Board of Trustees of the Victoria and Albert Museum
HMF 1067

Although in his sculpture of the thirties Moore moved further away from a naturalistic rendering of the human body, he continued to draw from the life until 1935. The model was his wife, seen here holding a rather awkward pose, with one foot higher than the other, which allows more of the left leg to be seen. Although the support looks like an armchair, the semi-reclining pose is a reminder of the more stylised figure from 1930 (cat.67, HMF 784), shown on steps. While the torso and face are here drawn with detachment, there is a vigour about the working of the thigh area which conveys a more sculptural effect even than the coarser limbs of that earlier nude. The alert stance and the distant gaze look forward to those of the *Recumbent Figure* of 1938 (cat.34 LH 191).

78 | *SEATED FIGURE: LIFE DRAWING 1934*
Pencil and wash
21 ⅞ x 15 in; 555 x 381 mm
Arts Council of Great Britain
HMF 1047

In order to draw from the low view-point that the artist favoured, he has posed his model on the arm of a chair with her feet on its seat. As with other life drawings from the thirties, the model was his wife and the setting their sitting-room with the frame of a picture providing an architectural element in the background. There are only a few sculptures made from life in this decade and by 1934 Moore was already explor-ing non-representational equivalents to the human body in multi-part sculp-tures such as cat.20 (LH 154). A sculp-tural transcription of this life drawing might have occurred when the artist was invited to provide relief sculptures for Charles Holden's University of Lon-don Senate House building; Moore made several trial drawings and one dating from 1938, of seated figures (cat.95, HMF 1424), includes a pose in the centre of the top row with legs closely related to this study. These life drawings from the mid-thirties are the equivalents to Moore's drawings of shells, pebbles and bones (such as cat.71, HMF 946). Both types of drawing are accurate renderings which triggered the transformations that became so characteristic of his sculpture. Writing about these later life drawings, Alan Wilkinson invoked Moore's admiration for the Archaic Greek life-size seated figures in the British Museum, quoting the artist's description of them as '... seated in easy, still naturalness, grand and full like Handel's music'. (Wilkin-son, 1977, p.64.)

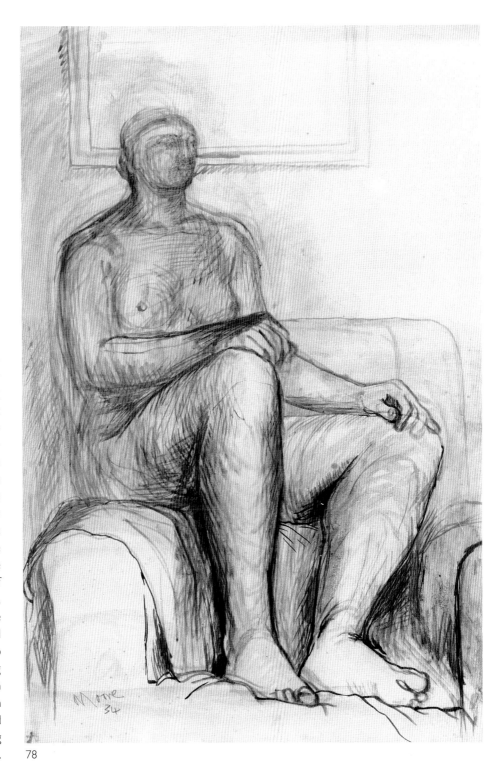

78

79

79 | PAGE FROM SHINY NOTEBOOK
1933–5: IDEAS FOR RELIEFS
c.1934
Pen and ink
9½ x 7⅛ in; 241 x 181 mm
Art Gallery of Ontario, Gift of
Henry Moore, 1974
HMF 1066

This page of drawings, in an unusual style for Moore, is the only known sheet separated from a notebook at the Henry Moore Foundation; this includes a second page of line and dot drawings, also used for *Ideas for Relief Sculpture* (HMF 1109). Alan Wilkinson has pointed out the derivation of the 'line and dot' from Picasso's pen and ink drawings for Balzac's *Le Chef d'Oeuvre inconnu* (1924) and he included a comparative photograph in his text (Wilkinson, 1979, p.59). Nevertheless, there is a marked difference between Moore's decisive irregular lines, freely positioned in relation to dots, by no means invariably joining one point to another, and Picasso's orderly arrangements of regular curves, parts of circles, ellipses, single straight lines, parts of triangles and rectangles. Picasso's idea may have sprung from drawing books with pages

of dots and numbers beside them which children join up so that their lines produce an image. In contrast, Moore's inventions resemble the more freely positioned linear invention of Joan Miró, which interested Ben Nicholson for a brief period (for example, Nicholson's *Composition in Black and White*, 1933, Borough of Thamesdown, Swindon Art Collection).

80 | IDEAS FOR METAL SCULPTURE
1934
Pen and ink, chalks
11 x 24¾ in; 279 x 630 mm
Art Gallery of Ontario, Gift of
Henry Moore, 1974
HMF 1098

The drawings on these two sheets together with related *Ideas for Metal Sculpture* (HMF 1100, repr. Wilkinson, 1979, p.61, fig.50) indicate that in the thirties Moore was considering the possibility of making sculpture by welding pieces of metal together rather than casting. The technique was used in the same decade by Picasso, who learned it from his compatriot, the sculptor Julio González. The sections of Moore's imaginary 'figures' include geometric shapes, especially triangles; these played an important role in his later transformation of figures into metal

sculpture. This is particularly clear in the 1950 *Standing Figure* (cat.122, LH 290), even though it was made from an armature and then cast in bronze and not welded from individual shapes. The figures in this drawing have been connected with those in Picasso's *Une Anatomie* of 1933 (repr. in the Surrealist journal *Minotaure* No. 1, 1933, pp.33–7). However, they seem to the present author to be more like the 'transparencies' which Mikhail Larionov had imagined as puppets for the theatre. Some of them were published as pochoirs in 1919 in Paris, in *L'Art Décoratif Théâtrale Moderne*, and were quite well known in London, though a connection with Moore can only be surmised.

REFERENCE: V. Parnack, *L'Art Décoratif Théâtrale Moderne*, Paris, 1919.

81 | DRAWING FOR SCULPTURE:
HEAD 1934
Charcoal, pen and Indian ink,
crayon
10¾ x 14 11⁄16 in; 273 x 374 mm
The Moore Danowski Trust
HMF 1096

In later life Moore no longer derived sculpture from his drawings but from maquettes which he could hold in his hand. This allowed him to experience

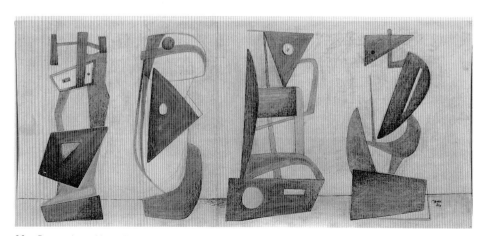

80 Reproduced in colour on p.130

his creation in three dimensions from the smallest beginnings. It is clear from this drawing how even in 1934 he felt that the two-dimensional medium allowed only a partial view of a sculpture and left a great deal to be imagined. He has begun to overcome the problem by differentiating the separate planes so it is possible to see one behind another. Moreover, although the base on which the head is to stand is seen from the front elevation, with a plane rising directly from it, he has made a tilted up 'ground plan' of what lies behind, to show the spaces he has imagined inside the head, which thus prefigures the helmet sculptures (see cat.41, LH 212). Even so, except for the tiny eyes, it is very difficult to imagine what a sculpture made from this drawing would have been like, although the different methods of shading suggest that Moore thought of constructing it from several materials.

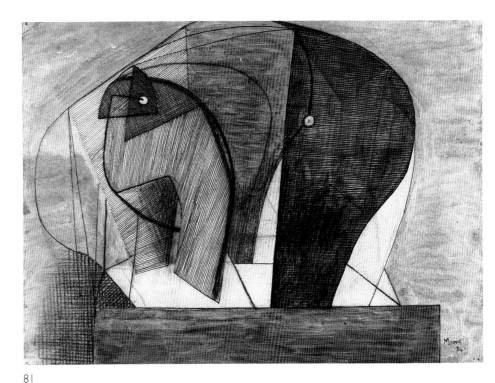

81

| 82 | *STONE FIGURES IN A LANDSCAPE SETTING 1935*
Charcoal, pastel (rubbed and washed) pencil, black chalk, pen and ink
$11\frac{1}{2} \times 18\frac{3}{8}$ in; 292 x 466 mm
The Henry Moore Foundation
HMF 1163 |

Photographs of the artist's newly acquired land in Kent show his arrangement of uncut stones waiting to be carved; this drawing mysteriously conveys the shapes that the artist imagined to be hidden within them. Surprisingly, Moore has chosen black for most of these standing forms even though the various types of British stones that he had assembled were of a light colour. Black may provide drama, but it also adds mystery because detail is obscured, suggesting potential rather than actual forms. Indeed, still shrouded in stone, details of heads and limbs can be discer-

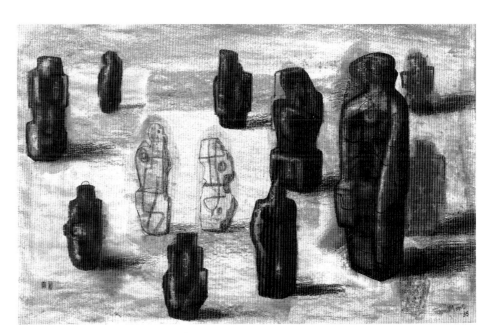

82 Reproduced in colour on p.131

ned, far more clearly than in related sculpture (for instance, cat.29, LH 171). Poetry is added by the shadows on the orange ground, which takes its colour from the sun setting in the west. In case the composition should seem too overbearing, the two green shapes are

more abstract: they are decorated with lines, rather freer than the ones incised on sculpture (such as cat.28, LH 170).

In his review of Moore's exhibition at the Leicester Galleries two years before, Adrian Stokes had written: '... contemporary sculptors have studied

the essential shapes of stone with reverence: indeed, only by this tutelage to stone might plastic conception be linked once more to the stern demands of materials, be thus renewed so that it may accomplish again a well-earned freedom.' (Gowing, 1978, p.312.)

REFERENCE: A. Stokes, 'Mr Moore's Sculpture', *The Spectator*, November 1933, reprinted in Lawrence Gowing, ed., *The Critical Writings of Adrian Stokes*, Vol.I, London, Thames and Hudson, 1978.

83

83 | SQUARE FORM RECLINING FIGURES 1936
Black chalk, ink wash
$21\frac{7}{8}$ x $15\frac{7}{16}$ in; 555 x 392 mm
The Henry Moore Foundation
HMF 1242

Though arranged in a less pictorial manner and lacking a coloured background, these forceful reclining figures are counterparts to the drawing of vertical *Stone Figures in a Landscape Setting* (cat.82,

84

HMF 1163) of the previous year. Moore seems here to have been considering the problems of carving a horizontal block of stone with the greatest possible respect for the material. In practice, it was only in vertical figures and square head-forms such as cat.26 and 29 (LH 167, 171), that he allowed the block to dominate the finished sculpture; in the thirties he used the reclining figure to explore opened-up forms. This may have been due in part to the fact that the major stone *Recumbent Figure* (cat.34, LH 191) of 1938 was commissioned for an outdoor site looking across to the rolling South Downs. It was not until Moore came to use bronze in the late fifties that he began to use massive horizontal squared forms related to the ones in this drawing.

84 | FIGURES IN A CAVE 1936
Black chalk, brush and water
15 x 22 in 381 x 559 mm
Private Collection
HMF 1260

This drawing is an evocation of those mysterious arched spaces marked by primitive man. Two years earlier, Irina and Henry Moore had taken a late summer holiday in Europe with their friends Edna and Raymond Coxon. They had driven down through France to see the cave paintings at Altamira and returned (after touring other places in Spain) via the Dordogne. There the paintings at Les Eyzies and Font de Gaume had made a special impression on Moore (Berthoud, 1987, pp.132–3). The four draped figures might prosaically represent the two couples on this visit, but their vaguely defined forms evoke the ancient cave dwellers who entered the mysterious darkness to perform their magic rites, which are thought to have been closely connected with the drawings they made on the walls. At this period too, Moore was

working on the earliest elmwood *Reclining Figure* (cat.25, LH 162) which he penetrated with the first of his large holes, forming the head and shoulders into an arched cave-like space. The forms became all the more cave-like in the following figures, particularly in the elmwood *Reclining Figure* (LH 186) of 1939 (see cat.35, LH 185).

85 | **STONES IN A LANDSCAPE 1936**
Charcoal with wash, crayon, pen and Indian ink
22 x 15 in; 559 x 381 mm
Private Collection
HMF 1259

85 Reproduced in colour on p.134

In 1936 Moore made drawings inspired not only by the stones ready for carving that he had set up in his field in Kent (see cat.82, HMF 1163), but by landscapes seen or imagined on the motoring holiday he had taken two years before in France and Spain. On that occasion he had been impressed by the deep valleys of the Dordogne and its prehistoric caves, a memory which contributed to

another wash drawing of 1936, *Figures in a Cave* (cat.84, HMF 1260). Thus, although the present composition has been interpreted as Moore's first usage of a Greek temple motif, the sets of vertical lines topped by horizontals merely evoke that analogy in the viewer's mind: they could equally be interpreted as grids, or as a presentiment of the strings and wires that Moore began to use in his sculptures the following year. The stones themselves blend with the landscape for Moore has here created an effect like an old and faded photograph, very different from the contrast of black and green forms on a terracotta background that he had used the previous year (cat.82). In the thirties Moore began to make use of photography to gain an idea of what small sculptures would look like if enlarged; there are black and white photographs of many of them seen against the open fields (fig.4).

86 | **IDEAS FOR SCULPTURE 1937**
Crayon, pen and Indian ink, waxy crayon
15 x 21 $\frac{15}{16}$ in; 381 x 558 mm
Private Collection
HMF 1306

The ideas on this sheet are related to the compact sculptures that Moore carved from stone in the thirties, such as cat.26 and 27 (LH 167, 168), though the forms in this drawing are generally of a greater complexity. Its most unusual feature, however, is the colouring, which seems to have gained in importance for the artist in 1937. Another drawing (cat.87, HMF 1320) of ideas for tall upright figures, arranged more freely on the page and less closely related to known carvings than this one, has several colours applied in irregularly shaped areas partially laid over the dark sculptural ideas. In contrast, the forms in this

86 Reproduced in colour on p.132

drawing stand out against a background of criss-crossed strokes of uniformly coloured crayon. A slightly waxy white crayon is apparent, and serves as a reminder that the artist experimented with quite simple materials such as the cheap wax crayons wrapped in paper generally sold for young children to use.

87 | **DRAWINGS FOR STONE SCULPTURE 1937**
Watercolour, pencil, crayon
16 x 21 in; 407 x 535 cm
Gerald Cramer, Geneva
HMF 1320

The crowded standing figures rendered in black and white with shading which cover the sheet of paper are in a variety of stages of resolution. Some remain block-like, others are much more hollowed out, even suggesting the beginnings of the internal and external forms that became so important later on (see

87 Reproduced in colour on p.133

cat.118, LH 295). What is most unusual about this drawing, however, is the use of colour: the margins of the paper are uniformly coloured as in another drawing of standing forms (cat.82, HMF 1163), though a browner tone replaces the brilliant orange. But there are also unexpectedly aggressive horizontal bands of red, blue, green and yellow crayon which bear little or no relationship to the forms. They add a surprising vitality to the drawing as well as revealing Moore as, potentially, an adventurous technician and colourist. It is interesting to speculate on the effect on the artist of some words of T. S. Eliot in stanza IX of his 'Choruses from "The Rock"' (first published in his *Collected Poems 1909–1935*): 'Out of the formless stone, when the artist united himself with stone,/Spring always new forms of life, from the soul of man that is joined to the soul of stone;/Out of the meaningless practical shapes of all that is living or lifeless/Joined with the artist's eye, new life, new form, new colour.' The drawing was the only example of such a use of colour until the early sixties when Moore used a similar idea for cat.175 (HMF 3025); the immediate development was in the pages of crowded forms with all-over colour (see cat.99, HMF 1495).

REFERENCE: T. S. Eliot, *Collected Poems 1909–1935*, London, Faber and Faber, 1936.

88 | FIVE FIGURES IN A SETTING 1937

Charcoal (rubbed), washed pastel, crayon

$14\frac{7}{8}$ x $21\frac{7}{8}$ in; 380 x 555 mm

The Moore Danowski Trust

HMF 1319

In 1937 Moore decried 'The violent quarrel between the abstractionists and the surrealists' as 'quite unecessary. All

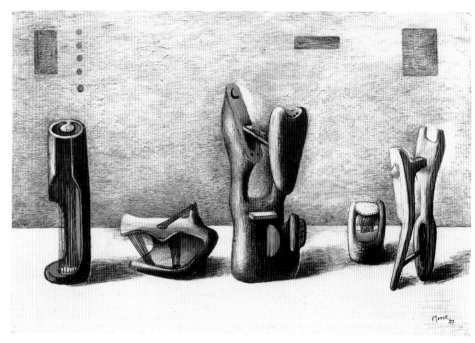

88

good art has contained both abstract and surrealist elements, just as it has contained both classical and romantic elements – order and surprise, intellect and imagination, conscious and unconscious. Both sides of the artist's personality must play their part.' (Sylvester, 1969, p.xxxv.) As if to illustrate the paradox, the figures in this drawing tend towards the fantastic, the Surreal and even the unconscious, whereas the formality of the design, and, above all, the geometric forms on the wall behind the stage-like setting, suggest the more rarefied world of Constructivism. Moore showed at 'Abstract and Concrete' and the Surrealist Exhibition in London in 1936 so the combination of apparently opposing forces in this drawing illustrates his midway position.

The centre one of the five 'figures' is related to the carving *The Family* (LH 157A); the idea for the stringed figure second from the left reappears in another drawing of 1939 (cat.90, HMF 1459) and became the sculpture LH 207. The markings on the background wall anticipate the similar treatment of the

front and back of the wall in a maquette of 1957, cat.142 (LH 424).

REFERENCE: H. Moore, 'The Sculptor Speaks', *The Listener*, 18 August, 1937, reprinted in D. Sylvester, ed., *Henry Moore, Sculpture and Drawings, 1921–48*, Vol.1, London, Lund Humphries, 1969.

89 | FOUR FORMS, DRAWING FOR SCULPTURE 1938

Ink, chalk, gouache

11 x 15 in; 279 x 381 mm

The Trustees of the Tate Gallery

HMF 1379

Second from the left is an idea which gave rise in the same year to the stringed *Head* (cat.33, LH 188), which appears to be a literal transcription of this drawing. In later life, Moore rather dismissed his stringed figure inventions, and in the other three forms depicted here he may have been attempting an alternative to the use of strings to define space. Sharing the same flat surface, he has invented partially hollowed out and rounded forms, the two larger ones

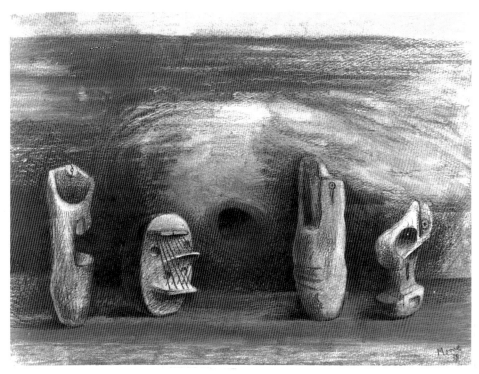

89

resembling headless torsos, related to the more complete forms in the *Drawing for Stone Sculpture* (cat.87, HMF 1320) from the previous year. Although like them they suggest that related figures would be carved and even gouged out from a solid, the three on this Tate drawing seem all the more convincing because they are more resolved, with dark holes and hollows penetrating their smooth surfaces. Except for the flattened disk threaded with string, these mysterious forms hover in a magical world which lies between the human form and a container. As well as incomplete pottery vessels, they could be imagined as partial mummy-cases and so are also embryonic ideas for the *Upright Internal/External Form* (see cat.118, LH 295) of 1952–3.

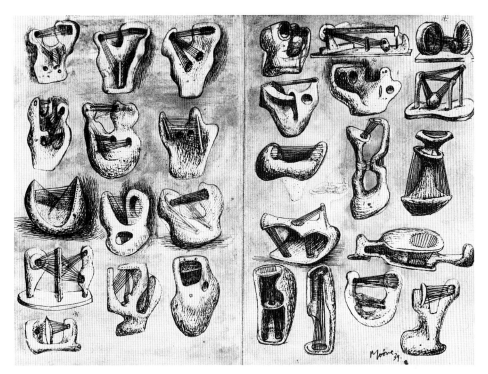

90

90 | *IDEAS FOR SCULPTURE IN METAL AND WIRE 1939*
Pencil, pen and ink, watercolour
$10\frac{7}{8}$ x $14\frac{3}{4}$ in; 275 x 375 mm
Private Collection, Courtesy of Thomas Gibson Fine Art
HMF 1459

The fully realised drawings for sculpture on this double sheet include several ideas for existing sculptures from 1939, not necessarily executed in metal and wire. For instance, on the left top row the ideas are related to the lead and string *Mother and Child* (cat.31, LH 186); the fourth down on the right sheet is close to the bronze *Stringed Figure* (LH 207), while the third row down on the left show designs connected with the *Bird Basket* (LH 205), made in wood and string. Immediately below is what looks like a 'demonstration' piece, with the plane formed by the point of intersection of the strings shown as a simple, rectangular form. This makes it more like the mathematical models in the Science Museum which, in later life Moore admitted had given him the idea

of using string in the first place. Yet, like all the rest, this idea is a strange conjunction of the geometric and the organic, the characteristic which gives Moore's stringed figures their originality and their emotive power.

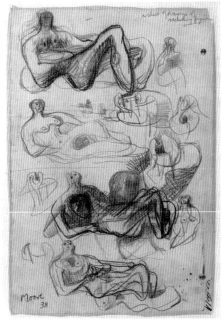

91

This small sheet reveals the fertility of Moore's ideas: as well as the definitive study for the *Recumbent Figure* (cat.34, LH 191) at top left, it includes three with greater representational possibilities. The main difference between the proposals is in the treatment of the arms, which are considered in a naturalistic way in the three lower sketches, whereas for the carving, Moore chose the bone-like formation of the upper figure, with its right arm joined into the pelvis and its line continuing into the thigh. None the less, Moore allowed the

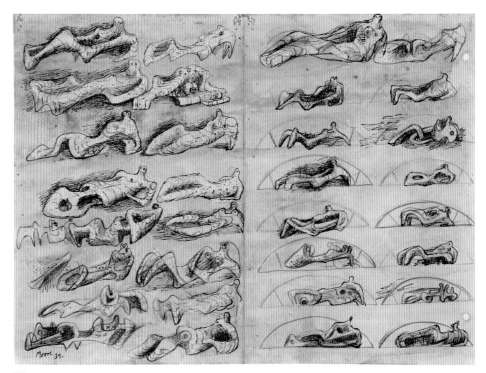

92

figure a relatively representational head and it is fascinating to see alternatives on the page; they include extremely abstracted ideas as well as the shaded pencil head resembling his wife, as seen, for example, in cat.78 (HMF 1047). Drawings, of course, show only one view and, as the sculpture had been commissioned, Moore followed the normal practice of making a maquette (LH 184) to show his client, Serge Chermayeff (see cat.34, LH 191).

In 1972 this sheet was entitled *Reclining Figures: drawings for lead sculptures* when reproduced in the catalogue for the retrospective in Florence (Carandente, 1972, p.266, no.222). On the left side the remarkably finished ideas

appear to be transformations inspired by bone and even rock formations, seen diagonally from a high enough viewpoint to show the perimeter. They are thus indeed related to the lead figures of the period and they also look forward to some from 1945. On the right, most of the figures are related to lunettes. The majority of these arched niches have their corners partitioned, or cut off by two diagonals with the figure contained within it. The viewpoint is from below and the reclining figure is usually shown in profile, sometimes leaning outwards so that more of the body is visible. The depth of the architectural feature is not indicated on the drawing, rather, depth is conveyed only by the figures themselves. In one or two instances the bodies are contained within the aperture and these provide a sense of the architectural space.

In 1939 Moore provided a maquette (cat.35, LH 185) of a sculpture to be set in an alcove in a penthouse at High Point, the home of the architect Berthold Lubetkin. The maquette was for

the elmwood *Reclining Figure* (LH 210) and although Lubetkin realised that the sculpture would be too large and sited too high, this drawing seems to reveal how Moore gave the matter considerable thought. It suggests that the cavities which are such a strong feature of the figure may originally have been intended to match the cave-like lunette as he imagined it.

REFERENCE: G. Carandente, *Henry Moore*, Florence, Il Bisonte and Enrico Vallecchi, 1972.

93 | DRAWING FOR METAL SCULPTURE: TWO HEADS 1939
Charcoal, wash, pen and coloured and Indian inks
$10\frac{13}{16}$ x 15 in; 276 x 381 mm
Private Collection
HMF 1462

Although it was not until much later that Moore owned a debt to Georges Seurat as a draughtsman (see cat.221, HMF 80(305)), the technique he has used for this drawing is not unlike that invented by the French Post-Impressionist in the 1880s. The overall texture is provided by the grain of the paper, on which Moore has criss-crossed fine lines with more or less density in order to model the forms. The two-part heads anticipate the first *Helmet* sculpture (cat.41, LH 212) of the same year. The head on the left, however, lies half way between that sculpture and the stringed figures that he had been making previously, for the element enclosed within the 'helmet' is more like strings than the solid forms that Moore used as 'interiors' for helmets (see cat.113, LH 282). In the second head on the right, the protective bone structure of the skull seems to have become unhinged, like the casing of a ripened nut, to reveal an inner core, which bears mysterious symbols. These are not unlike the mar-

93 Reproduced in colour on p.136

kings that Alberto Giacometti had placed on his rectangular relief entitled *Woman* of 1927–8 (cast in bronze in 1929, repr. in the catalogue of the Hirshhorn Museum and Sculpture Garden, p.247). Whatever the basis of Moore's sinister drawing, the interior has a fearsome quality that connects it with the mechanistic world which contrasts with the more reassuring, because more organic, lines of the exterior.

REFERENCE: *An Introduction to The Hirshhorn Museum and Sculpture Garden*, New York, Abrams, 1974.

94

94 | SPANISH PRISONER 1939
Charcoal, wax crayon, coloured chalks, watercolour wash
$14\frac{1}{2}$ x $12\frac{1}{4}$ in; 376 x 307 mm
The Moore Danowski Trust
HMF 1464

The eyes stare out from behind bars which form part of the skull, and strands of barbed wire running across the page additionally cage the head; both make this drawing the forerunner of the *Helmet* sculpture (cat.41, LH 212). However, technical problems and a political motive account for the simple colour scheme and clear imagery of *Spanish Prisoner*, which was made in 1939 for a lithograph of the same title (CGM 3). Only a few trial proofs were printed, though it was intended for sale to raise money for Republican soldiers who had been interned in the south of France after fleeing across the border. The artist and his wife had visited Spain in 1934 with their friends Raymond and Edna Coxon, two years before the outbreak of the Civil War, and, like most of their artist friends, they were deeply concerned about the suffering and struggle of the Republic. In an undated letter to Raymond Coxon, Moore wrote: 'Of course one would be moved in any case by the happenings in the Spanish revolution, but our trip there makes the picture of it twenty times as vivid.' (Berthoud, 1987, p.144.)

95 | PROJECTS FOR RELIEF SCULPTURES ON LONDON UNIVERSITY 1938
Pen and ink, chalk, wash
$14\frac{11}{16}$ x $10\frac{7}{8}$ in; 374 x 277 mm
Art Gallery of Ontario, Purchase 1975
HMF 1424

These drawings were made for the architect, Charles Holden, who had commissioned Moore's West Wind relief for the London Underground Rail-

217

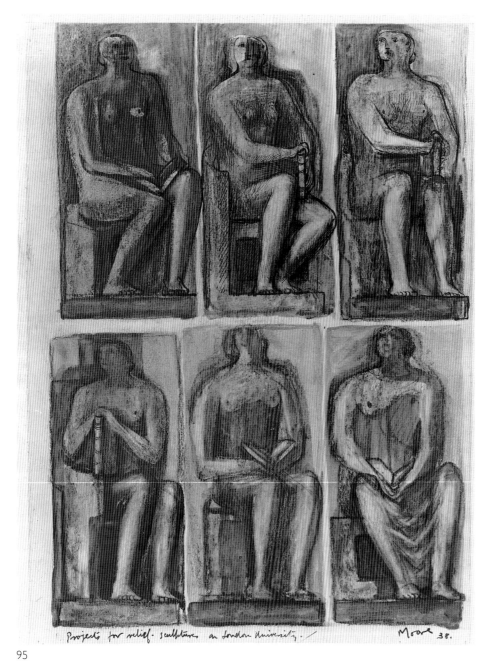

Projects for relief sculptures on London University. Moore 38.

95

enclosing and encouraging or havening youth'. (Wilkinson, 1979, p.71.) One of the present figures is closely related to an earlier life drawing, cat.78 (HMF 1047).

96 | *SCULPTURAL OBJECT IN LANDSCAPE 1939*
Pen and ink, coloured chalks, wax crayon, wash
14¾ x 21½ in; 375 x 546 mm
Robert and Lisa Sainsbury Collection, University of East Anglia
HMF 1441

The miniscule cows grazing in wide-open pastureland and the distant view of hills, make doubly incongruous the foreground apparition. This bone formation, no doubt derived from a fragment but masquerading as a complete skeleton, appears more real than nature's own forms. Such a juxtaposition is a reminder of the living tradition of British landscape painting which inspired Moore's friends Paul Nash and Graham Sutherland, under the influence of Surrealism in the thirties, to people their countryside with mysterious objects, often suggested by natural formations. However, Sutherland's exaggerated forms and Nash's stylised flints are incorporated in far more detailed views than this one drawn by Moore from his property in Kent. The sharp contrast between flattened landscape and three-dimensional form shows the sculptor's

way Headquarters (fig.2 see cat.59, HMF 647). In 1932 Holden began work on a new Senate House for the University of London and when it was completed in 1938, though uncertain about making relief sculpture, Moore made a number of sketches, of which this sheet is the most finished. Here he has given all the figures books (like Michelangelo's sibyls on the Sistine Ceiling) and only the final one is draped. It was not the initial idea, for Moore had considered a number of possibilities for subject-matter, including abstracts. However, most of the studies are figurative and the artist's notes on them explain his intentions. They include the idea of using a Mother and Child, with the University as mother and the child as the students; also, 'Figure with cloak,

96 Reproduced in colour on p.135

preference, for his metamorphic shape could quickly be transposed into three dimensions. Indeed, David Sylvester suggested a relationship with *Reclining Figure: Festival* of 1951 (cat.121, LH 293) by juxtaposing this drawing with the maquette in the catalogue he made in 1951 (*Sculpture and Drawings*, 1951, nos 40, 41).

REFERENCE: *Sculpture and Drawings by Henry Moore*, London, The Arts Council of Great Britain, 1951.

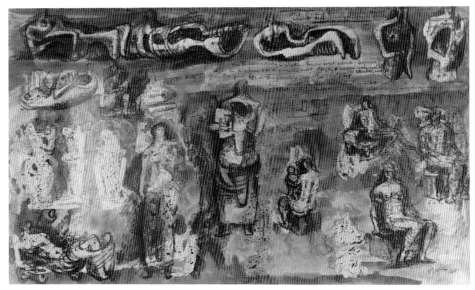

97

97	*DRAWING FOR SCULPTURE 1940*
	Pen and ink, chalk, watercolour, pencil
	9 15/16 x 17 in; 252 x 432 mm
	The Visitors of the Ashmolean Museum, Oxford
	HMF 1484

This drawing is from the same sketchbook as cat.98, 99, and 101 (HMF 1435, 1495 and 1496). However, it differs from them in showing a variety of poses and ways of drawing the figure, possibly to illustrate the words that Moore has written on the page. Along the top of the sheet he changed his mind, for there are two areas, here marked '...', which are erased and illegible: 'The human body is sculptural/but that is all the more reason ... for it to be a subject for /sculpture, it means that the sculptor cannot be a copyist,/but has to make changes and recreate it ...' Below the top row he has added: 'The human body is what we know most about, because/its [sic] ourselves: and so it moves us most strongly we can make complete/identity with it./We pick out from the past two or three painters, one or two sculptors/It is the integrity dynamic which counts, as though his intention was so/tremendously important to him that it comes ... shining through without being anywhere near achieved.' The text reveals the heart-

searching that Moore went through on account of the need he felt to devise a more humanist art. The realistic seated figures on the right and a group second from the left in the second row are close to the style that Moore developed for the first drawings that he made as an Official War Artist the following year.

98	*STUDIES FOR SCULPTURE IN VARIOUS MATERIALS 1939*
	Pencil, wax crayon, crayon, watercolour, pen and Indian ink
	10 x 17 in; 254 x 432 mm
	The Henry Moore Foundation
	HMF 1435

This ink drawing with colour washes in complementary harmonies of turquoise, orange and purple is exceptionally painterly in Moore's oeuvre. It belongs with several more from the same sketchbook in which the artist explored a gamut of forms, packing them on the sheet with little attempt to make a traditional composition (for instance, cat.99, HMF 1495). Here the ideas are so dense that the page has an affinity with the *frottages* of Max Ernst, who had visited Moore in his studio in 1938

(Packer, 1985, p.109). Ernst had invented *frottage* in 1925 as a technique of generating 'automatic' images by placing a paper on the floor and rubbing it with pencil – like brass rubbing without a 'given' image – stimulated by Leonardo's admonition that images suggested by spots, smouldering coals or drifting clouds should be taken seriously. Moore was again intrigued by the technique in his late years (see *Man Drawing Rock Formation*, cat.234, HMF 82 (437)), though he then used lithography to give a background of *frottage*. In this drawing he made use of the discovery that the cheap wax crayons used by his young niece could serve as a resist. He said he 'found, of course, that the water-colour did not "take" on the wax, but only on the background. ... If

98 Reproduced in colour on p.138

219

the waxed surface is too greasy for the India ink to register it can be scraped down with a knife.' (James, 1966, p.218).

REFERENCE: W. Packer, *Henry Moore, an Illustrated Biography*, London, Weidenfeld and Nicolson, 1985.

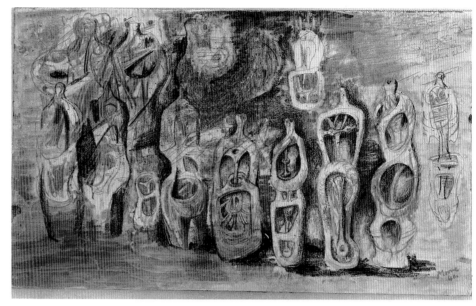

99

99 | STANDING FIGURES 1940

Pencil, wax crayon, pastel, coloured crayons, watercolour wash, pen and ink

$10\frac{1}{8}$ x $17\frac{3}{8}$ in; 256 x 440 mm

The Moore Danowski Trust

HMF 1495

On this closely worked sheet, Moore has explored possibilities for upright sculptures, placing his ideas one beside the other and even one above another until the sheet is almost entirely covered. (Partly erased and illegible is a letter, signed but not headed.) He has used colour in a different way from his earlier drawings, filling in the spaces between the figures, so emphasising the silhouettes which vary as much as the internal treatment. Evidently, Moore was searching for a new method of approaching upright figure sculptures, somewhat akin to the one that he had already developed for reclining figures, for instance cat.36 (LH 192). For much of the previous decade he had concentrated on compact stone sculptures; the largest upright that he had made was the *Mother and Child* (cat.29, LH 171), conceived as a solid form. The upright stringed figures were in some cases related to human forms and surprisingly visceral in effect. However, although the straight lines included in this drawing are reminiscent of string, the artist has begun to investigate skeletal forms which would convey the underlying structure of the human figure in a more organic way than was possible with string. He has placed these inside a containing exterior, large enough to

keep the figure upright even when cast in metal. It would appear that such figures contribute to the internal/external form idea that came to fruition in 1951 (see cat.118, LH 295).

100 | TWO STANDING FIGURES 1940

Pen and ink, black and coloured chalks, wax crayon, watercolour

$20\frac{1}{2}$ x $14\frac{3}{4}$ in; 520 x 375 mm

The Visitors of the Ashmolean Museum, Oxford

HMF 1517

The artist has here exploited a technique of using ordinary wax crayons (originally borrowed from his young niece) as a resist: their shiny surface on the paper creates a barrier for the watercolour applied afterwards and this gives added texture to the surface. The magisterial standing figures are a development from *Square Forms* (HMF 1243) of 1936 – evidently conceived as upright stone sculptures, through the 1939 *Drawing for Sculpture Combining Wood and Metal*, named *Two Women* (HMF 1445) (both repr. in colour by Clark, 1974, plates V, VIII). How to resolve the upright figure seems to have

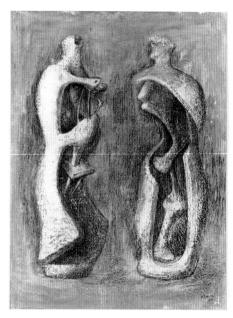

100 Reproduced in colour on p.139

preoccupied Moore during 1940; it was a technical problem which he had already solved in the reclining figure, where, provided it is self-supporting, the perimeter can rest on the base, whether the figure be carved in wood or cast in metal. For an upright, the proportion of the whole that can support the rest is very small; the weight of a solid figure becomes enormous and a

hollowed-out form quickly becomes unstable. Furthermore, the artist was intrigued by the structure; he had devised a method of articulating the figure by using strings, now he evidently wanted to make an equivalent of the skeleton underlying the external form. The figure on the right anticipates the sculptural solution, which Moore arrived at at the end of the decade, namely the *Upright Internal/External Form* of 1951 (see cat.118, LH 295). There the head is enclosed by the shell-like exterior and the figure itself has replaced its skeleton.

101 | POINTED FORMS 1940
Pencil, chalk, pen and watercolour
10 x 17 in; 254 x 432 mm
Graphische Sammlung Albertina, Vienna
HMF 1496

This drawing comes from a sketchbook with other crowded, coloured pages begun before the outbreak of the Second World War. Others are cat.97, 98 and 99 (HMF 1484, 1435, 1495). Taken together, these four sheets can be seen as a guide to Moore's current sculptural form ideas, for they include upright, reclining and seated figures, or in the case of this drawing, ideas based on the torso. It includes a number of ideas that were realised in three dimensions: second from left in the top row is *Three Points* (cat.40, LH 211) and Moore's connection with the School of Fontainebleau painting of Gabrielle d'Estrées and her sister in the bath (repr. Sylvester, 1968, fig. 159) is made the more poignant by the proximity of three views of a female torso with stylised breasts. The same torso had already been used in the *Reclining Figure* (cat.36, LH 192) of 1938 and here the artist seems to have been rethinking such a figure. Especially changed are the lower limbs, which, in the sculpture, are reduced to a single bone-like structure: an alternative is suggested on the second line of this sheet. Some of the drawings are also related to the *Helmet* (cat.41, LH 212), more clearly prefigured in cat.93, HMF 1462; above the bottom left corner is a drawing related to the *Bird Basket* (LH 205), a sculpture made in 1939. But references to individual works, though interesting, fail to convey the richness provided by the crowding of ideas and the unity produced by the colour washes.

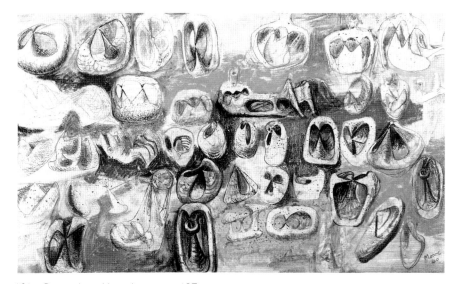

101 Reproduced in colour on p.137

SCULPTURE
1943–1961

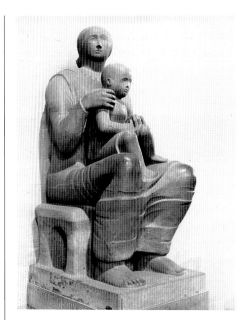

102 Another view reproduced on p.87

102	*MADONNA AND CHILD 1943–4*
	Brown Hornton stone
	H.59 in; 149.9 cm
	St Matthew's Church,
	Northampton, Gift of Canon J.
	Rowden Hussey
	LH 226

In 1942 the artist was invited to carve a Madonna and Child to celebrate the fiftieth anniversary in 1943 of the parish church of St Matthew's, Northampton. The commission was given in the darkest days of the Second World War, by the Revd John Walter Atherton Hussey, who in 1937 had succeeded his father, John Rowden Hussey, as the second rector of St Matthew's; he also invited Benjamin Britten to compose a cantata and, later, Graham Sutherland to paint a Crucifixion.

Although admitting that the Mother and Child theme was for him a 'fundamental obsession', Moore realised that a 'Madonna and Child' was different from her secular counterpart. It was the first time he had carved a full-length mother and child and also the first sculpture that he had had the opportunity to make after the period spent drawing as an Official War Artist. He began with sketches (see cat.161, HMF 2174) and then made preparatory clay models; nine are reproduced in *The Architectural Review*, 1944, p.189. Several of the latter are based on an idea that he had already carried out at half-length, of the child facing the mother. The pose, so poignantly realised in cat.14 (LH 106), is typical of the twentieth-century recognition of the exclusive relationship of mother and child, written about by child psychologists in the thirties, and explored by Moore in a more abstract carving (see cat.30, LH 165). The same intimacy was not appropriate here, for, as the critic Eric Newton wrote, 'the Madonna and Divine Child theme is one that has gripped the imagination of centuries. The statue is both a descendant of and a challenge to a thousand enthroned Madonnas of the past, including Donatello's and Michelangelo's.' (Newton, 1944, p.189.) No doubt Moore was fully aware of the challenge and he arrived at a pose much more in line with Renaissance prototypes. As Norbert Lynton has described so vividly, from his earliest days Moore's ambition was to 'make sculpture that would stand beside the great sculpture of past ages and masters He saw no point in anything less . . .'. (Lynton, 1987, pp.12–13.)

Nearly half a century later, Eric Newton's verdict on Moore's *Madonna and Child* remains true: 'She is not part of an art-revival but a stage in art-evolution. Therefore, a century hence, whatever may have happened to Christianity, she will have lost none of her potency. She will be seen as an example not of Henry Moore's sculpture but of a deep seriousness somehow inherent in the mid-twentieth century.' (Newton, 1944, p.190.)

REFERENCES: H. Moore, E. Newton et al., 'Henry Moore's Madonna and Child',

London, *The Architectural Review*, vol.xcv, May 1944; N. Lynton, 'Henry Moore', *Henry Moore, Sculptures, drawings and graphics 1922 to 1984*, (catalogue for an exhibition in New Delhi), London, The British Council and the Henry Moore Foundation, 1987.

103 | RECLINING FIGURE 1945
Terracotta
L.5½ in; 14 cm
Private Collection
LH 243

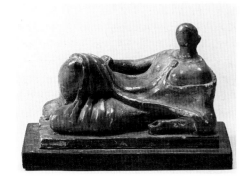

103

This is one of several maquettes made in preparation for a nearly life-size brown Hornton stone figure (LH 262) which stands in the landscaped grounds of Dartington Hall, Devon, as a memorial to Christopher Martin. Moore was a friend of the young man who had been Arts Director at Dartington Hall, where under him, at various times, he had the Joos Ballet (a refugee from Germany); the Chekhov Drama (run by a nephew of the dramatist); the pottery, run by Bernard Leach, and later, a Music School. In addition there were various resident artists, including the American, Mark Tobey, and the German Hein Hekroth.

The sculpture was commissioned by Dorothy and Leonard Elmhirst and Moore made this preliminary maquette – a normal procedure for a commission, when the client needs to have some idea

of what the sculpture is going to look like. In style, the figure seems naturally to relate to the Northampton *Madonna and Child* of 1943–4 (cat.102, LH 226) and, indeed, this maquette is more like the Madonna than the finished sculpture, where the turned head has the primitive look of the *Reclining Figure* of 1929 (cat.9, LH 59).

The secret of enlarging from a maquette lies in subtle changes which are needed particularly in the case of a stone carving, because the block of stone has striations which are not apparent before carving is begun.

104 | RECLINING FIGURE 1945
Terracotta
L.6 in; 15.2 cm
The Henry Moore Foundation
LH 247

This is one of three known terracotta models for the large elmwood *Reclining Figure* (LH 263), which Moore began to carve at the end of the Second World War. A layman cannot but marvel that such a monumental sculpture could have been enlarged from such a small beginning, but, as the artist has said, he could hold such a model in his hand, and, unlike a drawing, see all sides of the piece at once. At this date there was no intervening working model, the intermediate enlargement that Moore adop-

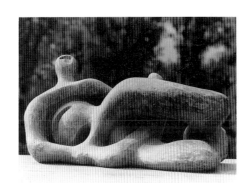

104

ted a few years later, so from this maquette the largest of his reclining figures to date was roughed out on the huge piece of elmwood and then carved. (Photographs of the stages are reproduced as fig.24.)

105 | RECLINING FIGURE 1945
Bronze
L.17 in; 43.2 cm
San Francisco Museum of Modern Art, Gift of Charlotte Mack
LH 257

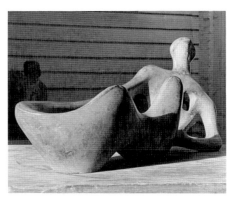

105 Another view reproduced on p.85

During the Second World War Moore restricted himself almost entirely to drawing and when he resumed sculpting a flood of invention resulted. His direct experience of the reclining figure had been enriched by observation in the London Underground which had served as a ready-made air raid shelter for thousands of families. This had led to drawings of draped figures which perhaps inspired the sensuous fluidity of the perimeter line in this sculpture. Although schematised, the figure compels response to its delicate idea of containment; its shell-like form evokes an analogy with a womb rather than with the more aggressive and bone-like formations of pre-war Reclining Figures such as cat.39 (LH 208a). It follows on in a natural sequence from the hinge-like forms of cat.106 (LH 256).

223

106	RECLINING FIGURE 1945
	Bronze
	L.14 in; 35.5 cm
	Private Collection
	LH 256

The sinuous outlines of this sculpture in which the internal organs are cradled as in a boat, is very different from the pierced curves of the elmwood Reclining Figure that Moore began to carve in the same year (LH 263). Photographs of the progressive stages of carving (fig.24) show how the balk of wood was tunnelled, leaving a mysterious hollow between the leg forms which open like some giant shell. In contrast, the thigh and leg piece of the present sculpture gracefully arch over a containing rim which continues in one sweep right round the figure, almost as though Moore had joined two figures together in a symbolic act of copulation. A drawing from 1942 shows the figure, lying near another apparently in a hayfield (*Ideas for Sculpture*, HMF 2071, repr. in the catalogue of the exhibition held at The Museum of Modern Art in New York in 1946, p.82).

REFERENCE: J. Johnson Sweeney, *Henry Moore*, New York, The Museum of Modern Art, 1946.

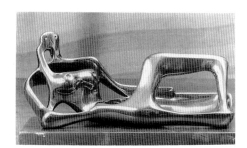

106 Also reproduced on p.84

107	FAMILY GROUP 1948–9
	Bronze
	H.60 in; 152.4 cm
	The Henry Moore Foundation
	LH 269

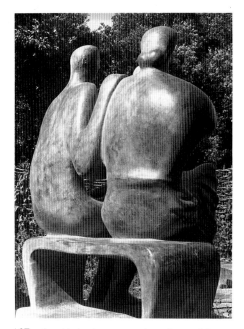

107 Another view reproduced on p.86

Two years after the completion of this sculpture, the artist recalled the circumstances of its evolution in a letter to Dorothy Miller. He described how the idea had originated before the Second World War, when the architect Walter Gropius was working in England and was asked by Henry Morris to design a Village College at Impington near Cambridge. Morris, the local Director for Education, felt that many rural areas were lacking in facilities and he wanted local schools to provide opportunities for parents as well as children. Impington College was to include space for films, plays, lectures etc. and become the heart of the community. Gropius asked Moore to make a sculpture for the school and Moore 'suggested that a family group would be the right subject'. However, no money was forthcoming for the scheme and Gropius left for Harvard University.

When Impington College was finally built to Maxwell Fry's revised design after the War, Moore was again approached by Morris and he worked for about nine months on *Family Group* themes and ideas, for instance, the drawings (cat.165–6, 169, HMF 2232, 2237a, 2504). He also made a number of terracotta maquettes which were not liked by the local Education Authority. It was not until 1947 that a new opportunity arose, when a friend of Morris, the Director of Education for Hertfordshire, asked if Moore would be prepared to do a piece of sculpture for Barclay Secondary School at Stevenage. There was a scheme in force at the time for spending one per cent of the building estimates on pictures and sculptures for new schools. The architects of Barclay School, F. R. S. Yorke and Partners, had designed a curved baffle-wall and Moore tried out a 'rough life-size silhouette made in cardboard of the *Family Group* for its scale'. Because of its position near the wall, it is not possible to walk right round the sculpture, even though it is not attached to the wall (see fig.7). However, other casts, for instance in the Museum of Modern Art in New York and the one in the Tate Gallery, do not suffer from this limitation.

Moore's considered attention to the family does not only imply a personal response to a subject near to his heart; it consolidates his move towards a wider and more humanist approach appropriate for public sculpture. Originally trained as a school teacher himself, his imagination was fired by the ideal of the extension of education to all sectors of the community.

REFERENCE: Henry Moore, 'Family Group', letter to Dorothy Miller, 31 January, 1951, published in James, 1966.

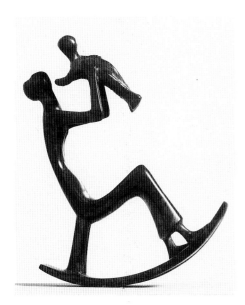

108

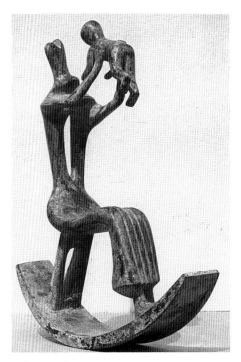

110 Another view reproduced on p.89

This is the second in a series of Rocking Chair sculptures. It differs from the first (cat.108, LH 274) and third (cat.110, LH 276) because the mother is sitting on a complete rocking chair. Her feet are placed one in front of the other and the child leans backwards from her knees thus allowing the sculpture to rock further than the other two. The curve of the back of the chair echoes the rocking mechanism, which gives an additional sensation of potential movement to the piece. The head of the mother is slightly more realistic than the other two and both her own eyes and those of the child are well-defined so that the heads appear to be joined by their gaze.

The artist made a series of Rocking Chair sculptures as toys for his young daughter, when she was four years old. Each one rocks at a different speed because, while he was making them, he discovered that the speed of the movement depended on the curvature of the base together with the disposition of the weights and balances. The originals were made in wax and subsequently cast in bronze (see cat.123, LH 312). Each differs from the other in subtle ways: for instance, both here and in No.3 (cat.110, LH 276) there is very little sign of a chair other than the figure of the mother. She is, as it were, sitting on an appendage which supports her back, and, like her own feet, is attached directly to the rocker. The distance of rocking is quite short as she holds the child above her knees and the child acts as a counterbalance.

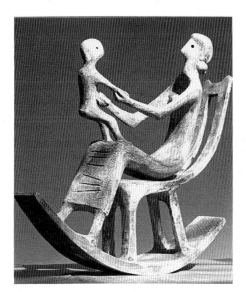

109 Another view reproduced on p.88

The third in the series of Rocking Chair sculptures made as toys for his young daughter, resembles in some ways the first (cat.108, LH 274), for the figure of the mother doubles as a chair; she is given only the barest support to sit on, and this is pierced as is her torso. Unlike the other two, the mother's head is schematised in a formula used by Moore in the earlier *Four-Piece Reclining Figure* (cat.20, LH 154) of 1934. But whereas there it is grotesquely oversize in relation to the other elements of torso and limbs, here it conforms to the size expected of a head. Although found in many drawings from the thirties, the type probably originates in small prehistoric Egyptian fertility goddesses to be found in the British Museum.

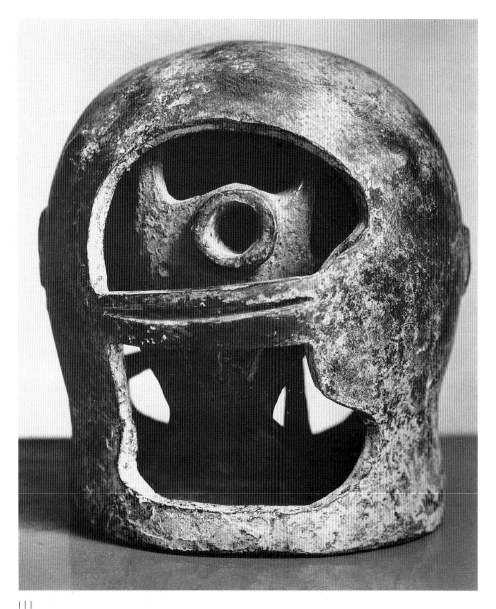

111

In his War drawings of coal-miners, Moore had depicted the light strapped to their heads to probe a way through the dark tunnels (see cat.154, HMF 1983). The analogy with the eye of a Cyclops (cat.158, HMF 1987) is equally appropriate here, for those legendary giants, equipped with a single eye, were the companions of Hephaestus, the ancient Greek god of beneficent metalworking, whose foundry glowed with the fire from his furnaces. Moore made unique bronze casts like this one in his own small foundry in his garden (Berthoud, 1987, p.228–9); the connection with Greek mythology is not unlikely as he was working on his Prometheus lithographs at the time (see cat.112, LH 289a). In 1963 Moore made a head which he named Cyclops (LH 507) and one of his very last maquettes was *Three-Quarter Figure, Cyclops* (1983, LH 888).

112 | MAQUETTE FOR STRAPWORK
 | HEAD 1950
 | *Lead*
 | *H.4 in; 10 cm*
 | *The Moore Danowski Trust*
 | LH 289a

111 | SMALL HELMET HEAD 1950
 | *Bronze, unique cast*
 | *H.4½ in; 11.4 cm*
 | *Mr and Mrs Harry A. Brooks*
 | LH 283

There is a subtle difference in the title 'Helmet Head' from the simpler 'Helmet' which Moore had given the first of these eerie forms some ten years before (cat.41, LH 212). Indeed, the resemblance to a human head is strongly conveyed by this fist-sized maquette with its protuberances in place of ears.

There the analogy ends, for a skull protects the soft brain tissue and the back of Moore's imaginary object is opened in segments to balance the 'facial' area at the front. Furthermore, the form that seems to be trapped inside the shell is itself not unlike part of a second head, with its single mysterious eye peering through the guarded aperture. The strips of metal are related to the strands of barbed wire in front of the head of the *Spanish Prisoner* (cat.94, HMF 1464), a drawing which is linked to the first helmet.

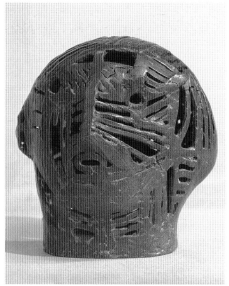

112

Although diminutive in size, this lead maquette gives an almost sinister effect, with its slashed surface, looking somewhat like bandages. Yet this suggests an inanimate entity which is far from the truth: the striations enhance the human quality, and may therefore be better equated with the markings on some traditional African tribal heads, or, alternatively, with the markings that Moore himself made at the time on many of his drawings. In 1950 Moore also completed his lithograph illustrations for the French translation of Goethe's *Prometheus* (CGM 18–32). The staring eyes and partitioned face of this sculpture are shared by the definitive study for the *Head of Prometheus* (HMF 2577, repr. Wilkinson, 1977, no. 219).

REFERENCE: Goethe, *Prométhée*, trans. A. Gide, Paris, P. A. Nicaise, 1950.

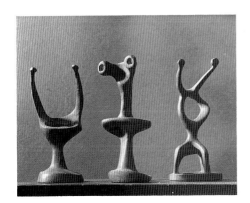

113

113 | **THREE FIGURES: INTERIORS FOR HELMETS** 1950
Lead
H.5 in; 12.7 cm each
The Henry Moore Foundation
LH 282

The first helmet (cat.41, LH 212) was made ten years before the second (cat.114, LH 279) which is contemporary with the separate *Interiors for Helmets*. Originally Moore cast five of these but two have been destroyed – one of them very similar to the interior of

Helmet Head No. 1. It appears that the artist conceived the interiors as independent of the helmet element of the sculptures, and put outer and inner forms together as appropriate because the *Maquette for Helmet Head No. 1* (LH 278) has a very different interior from the final *Helmet Head No.1 (cat.114)*.

The interior forms stand for the head inside the helmet, but already they go beyond the symbolic representation of the brain-stem and eyes and seem to suggest a figure. However, the interior of the earliest helmet appears benign beside these interiors of 1950 which seem more like monsters from the world of science fiction than a 'figure' inside a shell. That idea reappeared in a development from the helmet, the *Upright Internal/External Form* (cat.118, LH 295) in which the interior was subsequently cast as a separate sculpture (LH 296a).

114 | **HELMET HEAD NO.1** 1950
Lead
H.13⅓ in; 34 cm
The Henry Moore Foundation
LH 279

After an interval of ten years Moore returned to a theme which had intrigued him in 1939–40 when he made his first helmet (cat.41, LH 212). In 1950 he made several new versions which, in the immediate aftermath of the Second World War, produced an eerie and sinister effect on the viewer, for they seemed to encapsulate the uneasy mood of those years. Although the ancient Greek and Etruscan helmets to be seen in the British Museum perhaps contributed to the original notion of the helmet head, Moore has pushed the idea much further. In this first helmet of the new series, the 'visor' element is completely missing, revealing the vulnerable 'head' inside. Yet that part in turn

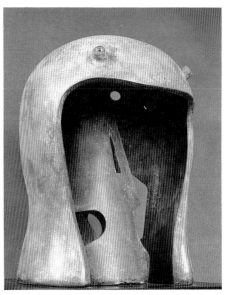

114 Another view reproduced on p.91

resembles armour, with a slit in it which suggests a further invisible 'interior'. The smaller maquette for this head (LH 278) has a similar exterior, but the interior is quite different: it is more open and far less intimidating. Moore regarded lead as sinister in itself, he felt that being poisonous it imparted an extra dimension to the helmets, and he chose the material for each of the first casts, though further casts were made in bronze.

115 | **HELMET HEAD NO. 2** 1950
Bronze
H.11¾ in; 30 cm
Museo d'Arte Moderna-Ca'Pesaro, Venice
LH 281

Related to the *Small Helmet Head* (cat.111, LH 283) made in the same year, this helmet is like an emblem of the *angst* that prevailed in the late forties and early fifties. It was the time when Existentialism was discussed by artists and writers: the play *Les Mouches* by Jean-Paul Sartre was published in translation in 1946 as *The Flies*; Jean Cocteau's

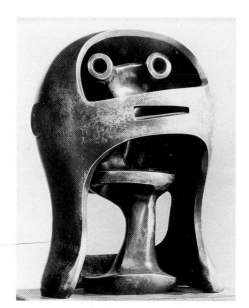

115 Also reproduced on p.90

Orphée was made into a film in 1951. The play was a modern interpretation of the legend of Orestes and Electra; in the film, motorcycle-riders, clad in black leather, rode in and out of an earthly hell. Moore was already familiar with Greek mythology, particularly the story of Odysseus, because he had illustrated an English modern version by Edward Sackville-West; furthermore, in 1950 he was working on lithographs for Goethe's play, *Prometheus*. The literary marriage of ancient myth and modern philosophy seems to be present in this primitive helmet; a connection with early Greece is made in the notes on *The Helmet* (cat.41, LH 212) and the legend of Hephaestus, the god of fire who excelled at metal working, is invoked in the notes on the *Small Helmet Head*.

In addition, both there and here, an uncanny likeness to an old-fashioned diver's helmet suggests a further source. In later life Moore recalled (albeit without apparent emotion) being present on the occasion when Salvador Dalí had delivered a 'lecture' while wearing a complete diver's suit, during the run of the International Surrealist exhibition in London in 1936. When

something went wrong with the oxygen flow and Dalí began to suffer, those around him mistook his desperate gestures for part of his lecture and it was some time before he was released. This traumatic Surrealist occasion would seem to underlie, consciously or not, the peering eyeball(s) inside each of these helmet heads.

REFERENCES: J.-P. Sartre, *The Flies and In Camera*, trans. S. Gilbert, London, Hamish Hamilton, 1946; E. Sackville-West, *The Rescue*, London, Secker and Warburg, 1945; Goethe, *Prométhée*, trans. A. Gide, Paris, P. Nicaise, 1950.

116 | **OPENWORK HEAD AND SHOULDERS 1950**
Bronze, unique cast
H.17½ in; 44.5 cm
Private Collection
LH 287

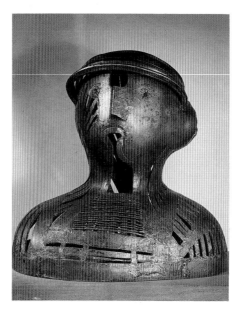

116 Another view reproduced on p.93

In the same year that he resumed the theme of the Helmet Head, Moore explored the head itself in a series of works that exist as unique casts. This is due to the fact that he made them himself, with his assistants, rather than

sending a plaster to a foundry as he had to for larger sculptures such as *Family Group* (cat.107, LH 269) and *Standing Figure* (cat.122, LH 290). The firebox for the little foundry that they built at the bottom of the garden was too big and Roger Berthoud records that 'it was difficult even when the bellows were strenuously pumped to get the bronze hot enough.' (Berthoud, 1987, p.228–9.)

The method that Moore evolved for this head, with spaces articulating the forms, had the technical advantage of decreasing the surface area of the solid bronze, thus facilitating the casting. However, it also has the effect of making the figure look as though it wears armour that is both substantial and vulnerable and strikes a delicate balance between realism and imagination.

117 | **OPENWORK HEAD NO. 2 1950**
Bronze, unique cast
H.15¾ in; 40 cm
Wakefield Art Galleries and Museums
LH 289

According to David Sylvester, the 'cage-like' inspiration for this head came directly from a Benin bronze of a tiger mauling a man that the artist had acquired in 1947 (*Sculpture and Drawings*, 1951, p.16). Moore himself recalled that:

When you cast in bronze, you cannot always just pour the molten bronze into the mould like pouring water into a jug, because air-pockets would become trapped within the intricate shapes in the mould, making the cast incomplete. Therefore wax "runners" are added to connect the sculpture throughout, so that the air can escape and the bronze flow into every crevice. (Hedgecoe, 1968, p.185.)

The method that Moore used for this head and others such as cat.112 and 116 (LH 289a, 287), with slashes breaking the continuous surface, must have been

228

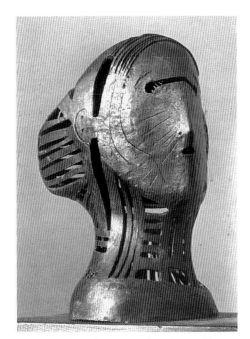

117 Another view reproduced on p.92

useful on such technical grounds, since at the time, he was doing the casting himself with his assistants and the bronze 'strapwork' resembles runners. David Sylvester has recognised a connection with the stringed figures of the thirties, though he also said that for Moore, 'the essential purpose of the open-work is that it enables the spectator to perceive the precise volume of the head by permitting him to see through it to the other side.' (*Sculpture and Drawings*, 1951, p.16.)

REFERENCE: *Sculpture and Drawings by Henry Moore*, London, The Arts Council of Great Britain, 1951.

118 | **WORKING MODEL FOR UPRIGHT INTERNAL/EXTERNAL FORM 1951**

Plaster

H.24½ in; 62 cm

The Henry Moore Foundation, on loan to The Henry Moore Centre for the Study of Sculpture, Leeds City Art Gallery

LH 295

Moore made this plaster working model for a sculpture which he envisaged as a wooden carving. He thought of it as nine or ten feet high but was unable to find a suitable piece of wood, so he enlarged the plaster to make a bronze cast (LH 296). Later, when he had found a piece of elm, he carved a large version, today sadly deteriorated (LH 297). During the thirties he had evolved related ideas in drawings for standing figures with opened bodies revealing an underlying structure, for instance cat.100 (HMF 1517). Moore compared the idea of one form protecting another with the helmets which he made from 1939 (see cat.41, LH 212), pointing out that the interior is really a figure; he also said, 'I suppose in my mind was also the Mother and Child idea and of birth and the child in embryo. All these things are connected in this interior and exterior idea.' (Hedgecoe, 1968, p.198.) He made a further analogy with the 'petals which enclose the stamen of a flower. Besides acting as a protection, they provide an attraction'. (*The Tate Gallery*, 1981. p.119.) The sculpture provided rich matter for the analytical psychologist Erich Neumann, who saw in it both the mother holding the unborn child inside her and the born child again in her embrace. He recognised the child as no less than the psyche itself:

It is no accident that this figure reminds us of those Egyptian sarcophagi in the form of mummies, showing the mother goddess as the sheltering womb that holds and contains the dead man like a child again as at the beginning. Mother of life, mother of

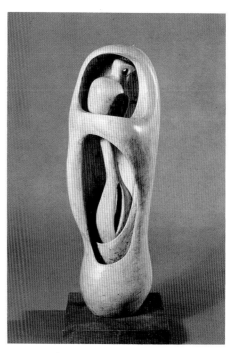

118 Another view reproduced on p.96

death, and all-embracing body-self, the archetypal mother of man's germinal ego consciousness – this truly great sculpture of Moore's is all these in one (Neumann, 1959, p.128.)

REFERENCES: *The Tate Gallery 1978–80, Illustrated Catalogue of Acquisitions*, London, Tate Gallery Publications, 1981; E. Neumann, *The Archetypal World of Henry Moore*, trans. R. F. C. Hull, Bollingen Series LXVIII, New York, Pantheon Books, 1959.

119 | **ANIMAL HEAD 1951**
Plaster
L.11⅝ in; 29.5 cm
The Trustees of the Tate Gallery
LH 301

Over the years Moore often invented mythical animals, whose shape seems far removed from the realistic rendering which more usually satisfies the instinctive human need to identify with other forms of nature. Yet this *Animal Head* makes visible many of the fears and

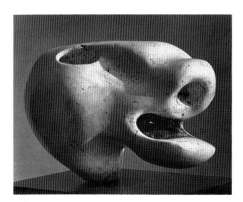

119 Another view reproduced on p.99

anxieties which the representation of the human head seems no longer able to convey. The artist often used flints with their natural cavities and strange shapes as the basis for maquettes (see Wilkinson, 1979, p.159). No doubt the power of this head lies in its inspiration in a natural form, most probably a flint; natural pittings and deformations in the stone then provided the idea for the eyes and mouth, which, by analogy suggest a skull; in this preparatory plaster, shaped by the artist's hand, the connection is even more vital than in the bronze casts made from it. Although Moore later on connected his *Animal Head* from 1956 with the ancient Egyptian *Alabaster Head of a Cow* in the British Museum (see cat.137, LH 396), there is already a resemblance in this earlier one, especially in the hole which looks like the seating for a horn.

120 | GOAT'S HEAD 1952
 | *Plaster*
 | *H.8 in; 20.5 cm*
 | *The Henry Moore Foundation*
 | *LH 302*

Unlike the *Animal Head* of the previous year (cat.119, LH 301), with its relationship to a flint almost more obvious than to a known animal, this small sculpture is identified by its title as the head of a goat and its shape suggests that it was

inspired by a bone. The plaster, made for casting into bronze, enhances the likeness by its colouring. In 1950 and 1951 Picasso had made sculptures entitled *Goat Skull and Bottle* and *She-Goat*, using assemblages of different materials (for the first, bicycle handlebars, nails, metal and ceramic elements, and the second, palm leaf, ceramic flowerpots, wicker basket, metal elements and plaster). None the less, Picasso's wittily contrived heads closely resemble a real goat, whereas Moore's artefact is removed from likeness to nature and conveys a calm gravity. It seems to share the nobility of the animal world with the vitality of the primitive sculpture that Moore continued to admire so much.

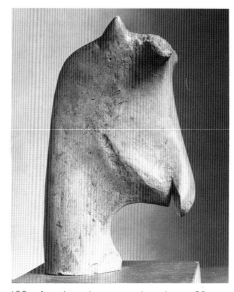

120 Another view reproduced on p.98

121 | RECLINING FIGURE: FESTIVAL
 | 1951
 | *Plaster*
 | *L.89½ in; 227.3 cm*
 | *The Trustees of the Tate Gallery*
 | *LH 293*

In 1950 Moore was asked by the Arts Council of Great Britain to make a sculpture for the forthcoming festival to

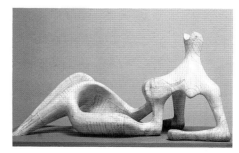

121 Another view reproduced on p.97

mark the centenary of the 1851 Exhibition. Sited on a raised plinth on the Festival site, on the South Bank near the Festival Hall, his large bronze reclining figure was one of a number of original art works made by invited artists. The bronze was cast from this full-size plaster. Moore has described how the lines of the bronze were produced by sticking thin string onto this plaster model so that they would come out as ridges when it was cast. The strings can still be seen on the plaster, providing an unexpected articulation of the otherwise smooth surface. They reflect in sculpture a preoccupation more often found in Moore's drawings, where he used what he called 'sectional lines' to emphasise the three dimensional nature of the figure. They often create a jigsaw-like effect, as though the figure was composed of many interlocking elements (see cat.168, HMF 2516). The Festival figure marks the continuation and masterly culmination of Moore's reclining figures with opened-out forms which he had begun in the thirties and continued in the forties. It also marks the end of this approach: his Time–Life figure and the one for UNESCO resulted in first a more classical, and second a more solid, rendering of the reclining figure (see cat.127 and 139, LH 336, 414).

122 | **STANDING FIGURE 1950**
Bronze
H.87 in; 221 cm
The Moore Danowski Trust
LH 290

The inspiration for this skeletal sculpture came from bones, which have tensile strength without undue mass; in addition, the connecting triangles are found in a drawing from the thirties (cat.80, HMF 1098). Though cast from a plaster maquette, the sculpture is built up on an additive scheme, as though it could have been welded together from separate parts. It is in marked contrast to the *Three Standing Figures* (LH 268 p.12) that Moore had carved in stone two years earlier and arranged on a single base. In 1955 Moore said that for some time before making the *Standing Figure* he had had an idea of making four separate figures standing in a row on the same base: when a second cast arrived from the foundry he placed two together on a base to form the *Double Standing Figure* (LH 291). Each, as he said, looks so different that most viewers would find it impossible to recognise them as identical. He contrasted the 'solid tree-trunk kind of sculpture' of the *Three Standing Figures* with the complex form relations of open sculpture of this kind, 'because the spaces between the exterior forms that can be seen from any one viewpoint give access to interior aspects of other forms.' (James, 1966, p.109.)

Donald Hall, and used this sculpture to describe some of the processes he had developed for bronze casting. He told Hall that it would be impossible to make a construction like the back of the chair in clay or plaster without 'awful trouble'. By modelling it directly in wax, 'all one had to do was to cover that with plaster and ground-up pottery and melt the wax out and cast it in bronze. By working direct in wax, one was able to make shapes and forms much thinner and more open than ever you could have done direct in plaster.' (James, 1966, p.139.)

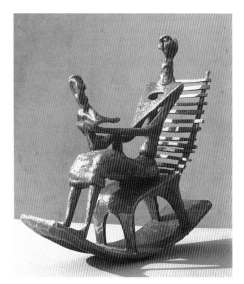

123

123 | **MOTHER AND CHILD ON LADDERBACK ROCKING CHAIR 1952**
Bronze
H.8½ in; 21 cm
The Moore Danowski Trust
LH 312

This sculpture is related to the series of Rocking Chairs which Moore originally conceived as toys for his four-year-old daughter (see cat.110, LH 276). In 1960 he gave an interview to the American,

124 | **MOTHER AND CHILD ON LADDERBACK CHAIR 1952**
Bronze
H.16 in; 40.5 cm
Ferens Art Gallery: Hull City Museums and Art Galleries, Gift of the Contemporary Art Society
LH 313

An enlargement of *Mother and Child on Ladderback Rocking Chair* (cat.123, LH 312) which it closely resembles, this sculpture was the only one of the series,

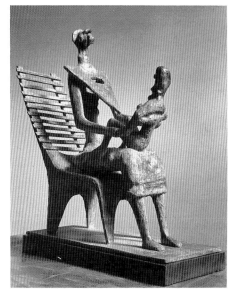

124

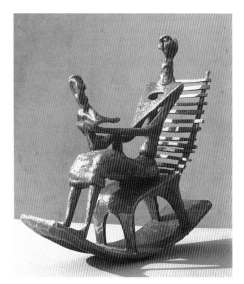

122 Another cast reproduced on p.94

dating mainly from 1950 (cat.108–10, LH 274, 275, 276) that Moore attempted at a greater size. The main difference from the smaller version is that on this scale the bronze is much heavier and would no doubt have been unstable if it had been put on a rocking mechanism. Both sculptures from 1952 differ from the earlier group in the use of a triangular bib-like form which protrudes from the mother's shoulders. This is close to a similar element on one of the figures in a drawing of 1948 entitled *Ideas for Metal Sculpture* (HMF 2417, repr., Clark, 1974, no.247), itself preceded by cat.80 (HMF 1098), dating from 1934. These drawings gave rise to the skeletal *Standing Figure* of 1950 (cat.122, LH 290) which, however, lacks the associations with humanity that characterise this mother and child. To remove the composition from any intimations of sentimentality, Moore has given the child a grotesque head apparently disproportionate in size.

125 | **WORKING MODEL FOR TIME–LIFE SCREEN 1952**
Bronze
L.39$\frac{3}{4}$in; 101 cm
The Henry Moore Foundation
LH 343

In 1952 while he was working on the *Draped Reclining Figure* (cat.127, LH 336) for the new Time and Life Building, the architects invited Moore to make the screen wall for the roof terrace where the figure was to be placed. According to Roger Berthoud, they had organised

125 Also reproduced on p.102

a competition for the wall which was to run along the terrace. This had produced ideas for reliefs based on the contents of *Time* and *Life* magazines. Moore was invited to see these narrative drawings for low reliefs and said that a pierced wall was needed; he was therefore invited to carry it out (Berthoud, 1987, p.241–2) and as it was to be visible from the terrace as well as from Bond Street, he decided to make it double-sided.

Moore made three preliminary maquettes (LH 339–41) before deciding on the fourth, which differs from them in having fewer, larger elements (LH 342). Even that differs slightly from the working model shown here, especially because Moore decided that the four pieces should pivot, so that different views of them could be seen from the street by turning them every month or so. Unfortunately, the only way this could have been achieved with the Portland stones chosen for carving, would have been to place each of them on a turntable. This proved impracticable as each sculpture weighs four or five tons and for them to move was considered dangerous in a public place. The scheme can perhaps be appreciated more easily from this working model than from the pavement in Bond Street, though the pavement opposite provides a better view than is often claimed. The pivoted shapes relate to Moore's abstracted stone figures from the thirties, as well as to drawings, especially those of square forms.

126 | **KING AND QUEEN 1952–3**
Bronze
H.64$\frac{1}{2}$in; 163.8 cm
The Trustees of the Tate Gallery
LH 350

In contrast to the *Family Group* (cat.107, LH 269) of four years earlier, the *King*

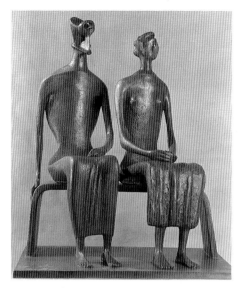

126 Another cast reproduced on p.95

and Queen are separate figures, sitting side by side on a bench which links them, as does the direction in which their heads are gazing. The naturalism of the anatomy, especially the hands and feet, and the folds of drapery allows us to identify the figures as human like ourselves. However, the heads remove them from the sphere of everyday life to another plane, suggested by the title, 'King and Queen'.

Moore gave an assurance that he had never set out to make a sculpture named 'King and Queen', but 'the naming of a piece of sculpture can start a line of thought for the person looking at it.' (Hedgecoe, 1968 p.109.) A starting point for the artist was the magnificent ancient Egyptian seated couple, from the late eighteenth century BC, which he reproduced in his book on the British Museum (Moore, 1981, p.38). His King and Queen share the same quiet dignity even though their heads are non-naturalistic. The head of the king was the first to be made and it exists as a separate sculpture (LH 351); the problem then, was to make the partner's head. Moore resolved it by making the Queen more naturalistic, which adds pathos to the sculpture.

The colour photograph, p.95, shows the cast on the Glenkiln Farm Estate in Dumfries, Scotland, where the figures powerfully relate to the surrounding landscape. They sit forever on a hillside, raised above a lake which they seem to contemplate; around them are low hills. In this setting they are a forceful reminder of history, especially, perhaps, of the distant past when kings and queens were gods. Indeed, in a foreword to a catalogue of 1954 when the sculptures were first shown, Moore explained: 'The "King and Queen" group has nothing to do with present-day Kings and Queens but is more connected with the archaic or primitive idea of a King. The "clue" to the group is perhaps the head of the King which is a head and crown, face and beard combined into one form and in my mind has some slight Pan-like suggestion, almost animal, and yet, I think, something Kingly.' (*Henry Moore*, 1954.)

REFERENCE: *Henry Moore*, New York, Curt Valentin Gallery, 1954.

127 | **DRAPED RECLINING FIGURE 1952–3**
Bronze
L.62 in; 157.5 cm
The Henry Moore Foundation
LH 336

This figure, made for the terrace of the Time and Life Building in Bond Street,

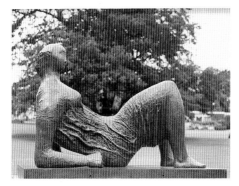

127 Another view reproduced on p.100

London, seems to illustrate some words in the catalogue of the Henry Moore exhibition held at the Tate Gallery in 1951. Moore wrote: 'I think that the most "alive" painting and sculpture from now on will go more "humanist".' (*Sculpture and Drawings*, 1951, p.4.) That same summer he visited Greece for the first time (on the occasion of an exhibition arranged by the British Council at the Zappeion Gallery in Athens) and was clearly surprised by the majesty of the classical sculpture that he saw as well as the landscape. This large reclining figure, the first made after his visit, breaks new ground in Moore's oeuvre: it is made in bronze and draped. Furthermore he used a technique very close to the classical tradition which up to then he had resisted, for Alan Wilkinson has pointed out that when making the full-size plaster from which the bronze was cast, Moore used real fabric to create the folds; it can be seen where the surface has worn away on the original plaster from which the bronze was cast (Wilkinson, 1979, p.120). Moore explained his choice of a draped figure for this terrace, because most people would see her from inside the heated offices and he felt they might experience a nude as suffering in cold wintry weather. Such attention to detail without sacrificing the nobility of the figure is typical of Moore's care when making public sculptures. Such concern was encouraged by Herbert Read whose study, *The Meaning of Art*, came out in a new paperback edition in 1949: 'No one will deny the profound inter-relation of artist and community.' (Read, 1949, p.190.) However, in his pages on Moore, Read had spoken of him primarily as a carver, but this and other bronzes show new possibilities of modelling.

REFERENCES: *Sculpture and Drawings by Henry Moore*, London, The Arts Council

of Great Britain, 1951; H. Read, *The Meaning of Art*, (originally published by Faber, 1931) revised edition, London, Penguin Books, 1949.

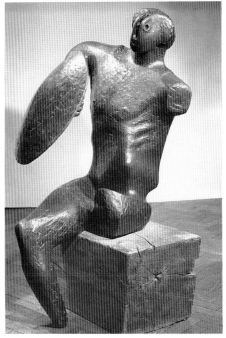

128

128 | **WARRIOR WITH SHIELD 1953–4**
Bronze
H.60¼ in; 153 cm
Birmingham City Museum and Art Gallery
LH 360

According to the artist, the inspiration for this sculpture, for which there are no preparatory drawings, came from a beach pebble. The small maquette (LH 357) 'evolved from a pebble I found on the seashore in the summer of 1952, and which reminded me of the stump of a leg, amputated at the hip.' (James, 1966, p.250.) Although Moore had used beach pebbles as the inspiration for sculpture in the thirties (see cat.23, LH 146), he had then been content to allow them to suggest metamorphosis. Now he has used the pebble as a starting point and

derived a human form from it.

The warrior is almost embryonic, for its truncated limbs seem to owe more to the ravages of time than the scars of battle. Before his visit to Greece in 1951 the artist had rejected classical Greek sculpture but he later admitted that four or five of his top visual experiences came in Greece (James, 1961, p.47).

In 1949 the Elgin Marbles in the British Museum went on view again (after having been stored away during the Second World War) in a new arrangement, with the single figures displayed in a separate room and the models and other illustrative material moved to an ante-room. The metopes show so-called Lapiths wounded by Centaurs. It can be surmised that individual figures on the metopes caught Moore's attention: South Metope IV shows a centaur about to strike a fallen Lapith with a water-pot (Cook, 1984, p.20, fig.16). Moore's seated warrior is very close to the Lapith and carries a similar shield. The way in which the ancient Greek marble has been broken is striking, with limbs severed at the weakest point. However, although Moore's *Warrior with Shield* is likewise an incomplete figure, it is not carved in marble but cast in bronze from plaster enlarged from a small maquette.

REFERENCE: B. F. Cook, *The Elgin Marbles*, London, British Museum Publications, 1984.

129

129 | *WALL RELIEF: MAQUETTE NO. 1 1955*
Bronze
H.10, W.22½ in; 25.4, 57.2 cm
The Henry Moore Foundation
LH 365

130

Rotterdam was largely destroyed in the Second World War and the rebuilding included many sculptural commissions.

In 1954 Moore was invited to make a wall relief for the façade of the Bouwcentrum (Building Centre, fig.10), a new building twenty-eight-feet high and sixty-three-feet long. As usual with such works, he made preparatory maquettes before deciding on the most suitable. There are ten in all (see cat.130–33, LH 368, 370, 371, 372) and the challenge was the choice of the local building material, brick, to be made into sculpture by the bricklayers as the wall was being built. This partially removed Moore's dislike of relief, since

234

the design was to be formed from the material itself, rather than cut into stone. While he was experimenting with different ideas, Moore was told that the bricklayers were so skilful that they could translate any of his ideas into brick. This enabled him to explore curved forms which might seem more suited to modelling for bronze than to brickwork. Photographs of the wall being built show how the curves were made (fig.11).

The trial relief No. 4 for the Bouwcentrum building in Rotterdam includes preliminary versions of the vertical elements which form such an important feature of the wall sculpture, which was finally made from the *Maquette No. 1* (cat.129, LH 365). The lines echo the fenestration on the top storey of the building rather like a curtain and they exploit the building material. By setting the bricks at an angle to the wall a strong vertical could be created, which would be impossible in a stone building and unsuitable in concrete. Other features, notably the small square elements and the horizontal beams pierced by holes are also present in the definitive maquette. Elements that look like the heads of screws were made by taking impressions of the real objects and incorporating them in the work. However, Moore evidently considered the overall appearance of No. 4 too abstract, because he finally used the striations as a frame for more organic forms.

131 Also reproduced on p. 103

In his catalogue of the Moore Collection in the Art Gallery of Ontario, Alan Wilkinson has described this maquette – No. 6 of the ideas for the Bouwcentrum (Building Centre) in Rotterdam – as 'reminiscent of Moore's sketchbook sheets with ideas for sculpture' (Wilkinson, 1979, p.134). He identified the form in the lower left corner as the same as – though the other way up from – one on a terracotta relief which the artist also gave to the same collection in 1974 (not in LH). Moore used the identical form, enlarged and the other way up on the base of the *Upright Motive No. 1: Glenkiln Cross* (cat.134, LH 377). Wilkinson also identified the elements on the right side of this maquette as connected with the Square Form sculptures that Moore had made in the thirties (see cat.26, LH 167). In addition he recognised a lobster claw, which can be seen next to the central form. This can be identified as a broken shuttle, using in weaving, formerly one of the principal occupations in Rotterdam. The claw also uncannily echoes the shape of a needle, thus encapsulating the maritime and industrial sides of the history of the city. To the left of the shuttle, there is the dismembered body

of a woman: a profile head (facing left) is separated from a primitive torso, inspired perhaps by some terracotta figure from ancient Greece. However, the notion of covering a flat surface with individual protruding parts arranged in rather random formation seems closely connected with a primitive *Wooden god from the Austral Islands* which Moore liked so much that in later life he had a bronze cast made especially for his home. The details of the original in the British Museum (repr., Moore, 1981 p.84–5) give a rather similar effect to the figurative elements on this relief.

Like No. 4 (cat.130, LH 368), this maquette (one of ten which Moore made as ideas for the relief) includes a chequerboard and striated effect which he used on the final wall sculpture for the Bouwcentrum (Building Centre) in Rotterdam. This seventh maquette includes elements connected with those on the *Time–Life Screen* (see cat.125, LH 343) which were intended to be read as figures. It also includes variations on the arrangements in *Maquette No. 4*: the small vertical rectangles and the three circular screw-like elements are used in both reliefs. Running along the entire length of the top is an impression taken from a file, a reminder perhaps of the engineering industries of the city.

As early as the *Openwork Head and Shoulders* (cat.116, LH 287) of 1950 Moore had been exploring ways to alter the texture of a cast sculpture by means of incisions and striations. In 1951 Picasso had made a bronze sculpture of a *Baboon and Young*, for which he had used

a collage technique, embedding metal and ceramic elements into his original plaster. Moore used a related process: David Sylvester has explained that some of the preliminary models for the wall relief 'were composed by making an impression in clay of pebbles, shells, metal objects – manufactured things for once – and old sketch models of Moore's, then taking plaster casts from these negatives.' (Sylvester, 1968, p.55.)

133 | WALL RELIEF: MAQUETTE
NO. 8 1955
Bronze
H.13, W.18 in; 33, 45.7 cm
Private Collection
LH 372

This is one of the most complicated designs of the ten which Moore made as trials for the Bouwcentrum wall relief (see cat.129, LH 365). In it he combined organic forms with ones which recall the engineering industries of Rotterdam, but he introduced areas of textured background which suggest the bricks in which the wall relief was to be carried out. This is the only example of such texturing in the maquettes, although the final sculpture naturally includes it as an overall patterning. It seems that Moore was here considering using some of the bricks end on in uniform patterns so that they would provide an unusual type of bond. In the final sculpture no traditional European bond (Flemish or English) is used and the arrangement is more like Mexican brickwork, which Moore admired on his visit to Mexico City in 1953 (Berthoud, 1987, p.252, and fig.120). There is considerable variety and unexpected combinations of short and long bricks, providing surface vitality in the material, which serves to distinguish the huge sculpture from the plain walls of the building (fig.10).

132

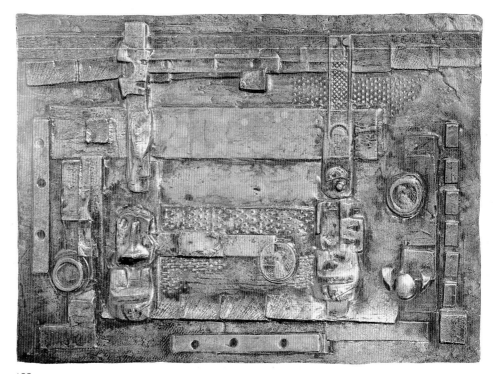

133

236

134 | **UPRIGHT MOTIVE NO. 1: GLENKILN CROSS 1955–6**
Bronze
H.131 in; 332.7 cm
The Trustees of the Tate Gallery
LH 377

This upright motif, 'a kind of worn-down body and a cross merged into one' (*Henry Moore*, 1965), became known as 'The Glenkiln Cross' because the first cast was placed on the Glenkiln Farm Estate in Scotland where, from a distance, it bears a resemblance to an ancient Celtic cross. It may not be a coincidence that during 1954 Moore had made a number of drawings of ideas for a Crucifixion sculpture which was not realised (see Wilkinson, 1977, pp.70–71). The group of three upright figures, which includes cat.135 (LH 379) and cat.136 (LH 386) enhances the relationship to a Cruxifixion, as Motives Nos 2 and 7 suggest the two thieves,

crucified on either side of Jesus. Moore later thought of them 'as though framed against the sky above Golgotha'. (*Henry Moore*, 1965.)

However, the original maquettes were made for a commission. Moore was invited by the firm of Olivetti to provide a sculpture to decorate the courtyard of a new headquarters in Milan. After visiting the site, he made thirteen small maquettes and chose to have several enlarged and cast at full size. In the end he discovered that the vertical figure that he had planned to contrast with the horizontal building would be sited virtually in a car park, so he declined the commission and the individual figures remain.

REFERENCE: Henry Moore, Drie Staande Motieven, Otterlo, Rijksmuseum Kröller-Müller, 1965.

135 | **UPRIGHT MOTIVE NO. 2 1955–6**
Bronze
H.132 in; 335.3 cm
The Trustees of the Tate Gallery
LH 379

In 1955 Moore's method changed and he began relying on direct handling of plaster rather than working from drawings as he had before. Thus the large *Upright Motives* were enlarged from five of thirteen small maquettes of 1955, each roughly twelve inches high, a size that allowed the artist complete freedom to shape each face in turn. (A drawing can only show one, or at most two surfaces of a sculpture and the artist must imagine the third dimension.) He said later that he had 'started by balancing different forms one above the other – with results rather like the North-West American totem poles – but as I continued the attempt gained more unity, also perhaps became more organic, . . .'. (*Henry Moore*, 1965.)

Like *Upright Motive No. 1*, this sculpture was originally conceived as a maquette for the Olivetti sculpture (see cat.134, LH 377). In 1965 Moore explained, 'When I came to carry out some of these maquettes in their final full size, three of them grouped themselves together, and in my mind, assumed the aspect of a crucifixion scene . . .'. (*Henry Moore*, 1965.) In 1953, when Moore was a trustee, the Tate Gallery had acquired the painting by Francis Bacon entitled *Three Figures at the Base of a Crucifixion*, and it is tempting to imagine Moore's reading of these three sculptures as that Crucifixion.

REFERENCE: Henry Moore, Drie Staande Motieven, Otterlo, Rijksmuseum Kröller-Müller, 1965.

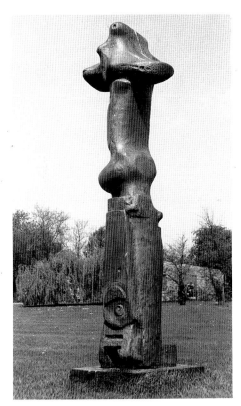

134 Another view reproduced on p.101

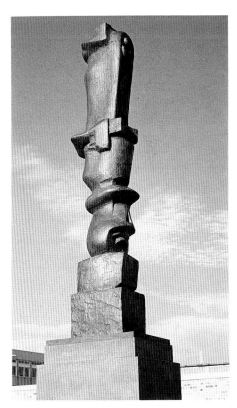

135 Another cast reproduced on p.101

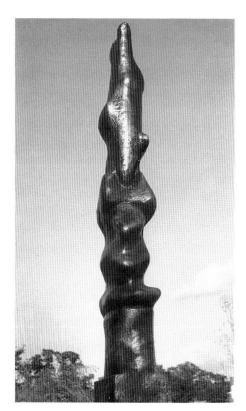

136 Another view reproduced on p.101

136 | UPRIGHT MOTIVE NO. 7 1955–6
Bronze
H.134 in; 340 cm
The Trustees of the Tate Gallery
LH 386

With Nos 1 and 2 of the five upright sculptures which Moore enlarged from among thirteen small maquettes of 1955. No. 7 forms a group (see p.101) seen by the artist as a crucifixion scene. However, he stressed to the compiler of the Tate Gallery catalogue 'that the religious content was generalised' (*The Tate Gallery*, 1981, p.122) and had earlier expressed a caveat, 'but I do not especially expect others to find this symbolism in the group.' (*Henry Moore*, 1965.) In the artist's reading, No. 7 should be seen as one of the two thieves crucified on each side of Jesus, and the top appears from one viewpoint as the profile of a tormented, thrown-back head. Another view totally negates this view which only emphasises the

impossibility of reading Moore's sculptures in a literal way, or trying to give them a single interpretation, which he did not like. What is certain is that however tenuous the relationship of his forms to what the viewer expects of the human figure, the underlying basis is organic; moreover they almost always relate so fundamentally to the human form in scale and generality of shape that the viewer finally has no difficulty in recognising the relationship.

REFERENCES: *The Tate Gallery, Illustrated Catalogue of Acquisitions, 1978–80*, London, Tate Gallery Publications, 1981; *Henry Moore, Drie Staande Motieven*, Otterlo, Rijksmuseum Kröller-Müller, 1965.

137 | ANIMAL HEAD 1956
Bronze
L.22 in; 56 cm
The Henry Moore Foundation
LH 396

At various times in his life Moore made animal sculptures which are more or less lifelike (see cat.119, LH 301). When he came to prepare photographs for his book on ancient art in the British Museum he chose to illustrate this *Animal Head* with an *Alabaster Head of a Cow* from Deir el-Bahri (Thebes), dating from about 1480 BC (Moore, 1981, p.40). The comparison brings out an unexpected relationship between Moore's animal and the ancient Egyptian rendering of a heifer, whose ears are represented by bumps on the top of the head and horns by holes, which may once have held real horns. Nevertheless the relationship is marginal, and this head seems closer to the profile of a goat or even a Caribbean sculpture that he had drawn in a notebook of 1922–4 where the *Crawling Figure* as he drew it has an animal-like head (repr. Moore, 1981, p.114). As has been suggested in the

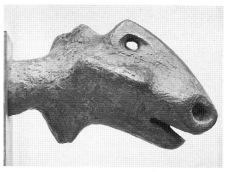

137

notes for cat.119, the use of an animal head often allowed Moore to explore a wider range of emotions than might have been possible with a human head. As a bronze mounted on the wall it gives the effect of some ancient gargoyle, or of the unexpected trophy of a huntsman.

138 | FALLING WARRIOR 1956–7
Bronze
L.59 in; 149 cm
The Trustees of the Tate Gallery
LH 405

The title *Falling Warrior* directs the appreciation of this figure which Moore deliberately caught in the act of falling. This distinguishes it from the *Fallen Warrior* maquette (LH 404) of 1956 which did not satisfy the artist because it appeared to be dead. He made a new version to emphasise 'the dramatic moment that precedes death'. (Hedgecoe, 1968, p.279.) The *Falling Warrior* thus supports himself on his right arm, left leg and shield, with his body and right leg raised off the ground, as it were in the throes of death, making the figure active rather than passive.

Moore had made his *Warrior with Shield* in 1953–4 (cat.128, LH 360) and the subject continued to fascinate him, for he made the *Goslar Warrior* in 1973 (cat.191, LH 641). As he stated several times, his early distrust of classical Greek sculpture was dispelled after his

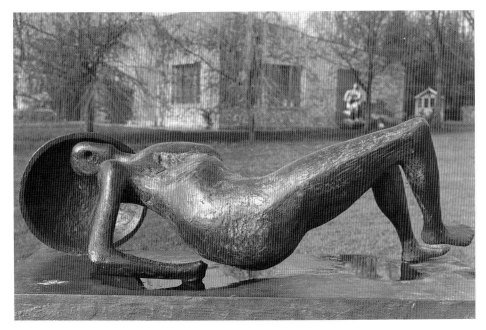

138

visit to Greece in 1951, and it would seem that he then looked again at the Elgin Marbles in the British Museum (see cat.128). A specific link is the shield carried by the Lapith in South metope IV which seems to provide a prototype for the one carried by all of Moore's warriors. Another of the metopes, scenes of so-called Lapiths wounded by Centaurs, shows a centaur prancing in triumph over a fallen Lapith (South metope XXVIII, Cook, 1984, p.23, fig.22). This may have inspired the *Fallen Warrior* maquette which gave rise to the present work.

REFERENCE: B. F. Cook, *The Elgin Marbles*, London, British Museum Publications, 1984.

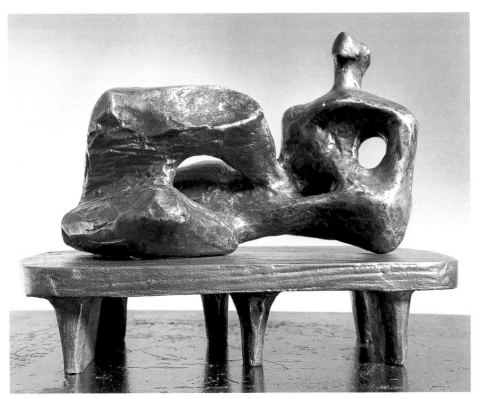

139

139	MAQUETTE FOR UNESCO RECLINING FIGURE 1956
	Bronze
	L.8½ in; 22 cm
	The Henry Moore Foundation
	LH 414

The invitation to provide a sculpture to stand in front of the new Paris headquarters of the United Nations Educational, Scientific and Cultural Organisation, presented Moore with considerable problems. The building itself has a largely glass façade, and the thin vertical detailing on the balconies gives it an unexpectedly fussy appearance. The original commission was for a bronze, and Moore attempted a number of solutions before deciding on a stone reclining figure (see cat.140–42, LH 418, 422, 424). He also discussed the aims of UNESCO with the first Director General, his friend the scientist Julian Huxley. Another close friend, Herbert Read, had been charged with advising on the commissions and he outlined the difficulties caused by the lack of provision by the architects for the siting of works of art, which could therefore only be added on as 'largely irrelevant decor'.

(Read, 1965, p.212–13.) In order to marry the sculpture with the building, Moore replaced bronze by travertine marble, which was used on the upper stories of the building (fig.12).

After rejecting his earlier studies, Moore chose a reclining figure because it completely lacks connotations of story-telling. Indeed, he later said that he 'wanted to avoid any kind of allegorical interpretation that is now trite.' (James, 1966, p.258.) The deliberate roughness of surface of the maquette reflects the qualities of travertine marble which he carved in Italy from the working model size which was made in plaster and enlarged from this tiny maquette.

REFERENCE: H. Read, *Henry Moore*, London, Thames and Hudson, 1965.

140 | *MOTHER AND CHILD AGAINST OPEN WALL 1956*
Bronze
H.8½in; 21.5 cm
Art Gallery of Ontario, Gift of Sam and Ayala Zacks, 1970
LH 418

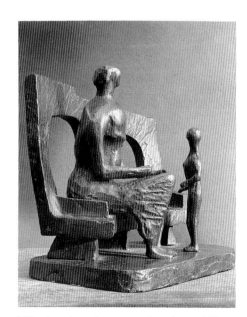

140 Another view reproduced on p.105

In attempting to solve the problem of providing a sculpture to stand in front of the open façade of the new UNESCO building in Paris, Moore has here raised the back of the bench on which he has seated his figure to form an open screen wall. His choice of subject reflects his understanding of the role of UNESCO as an educational force in the world: he had written on a drawing from the thirties when attempting to find the right subject for reliefs for the University of London Senate House: 'Think of subject matter/Mother and Child – the University the mother – child the students'. (Wilkinson, 1979, p.71) In a published sketchbook which includes pages of notes and ideas for UNESCO, with drawings of heads of mothers and a child, there is a table in which Moore summarised the Educational, Scientific and Cultural aims of UNESCO. He had made it after a discussion with Julian Huxley:

Theme – *The passing-on by humanity of the E.S.C.*	
Education	*to the succeeding generations*
Science Culture	*In the hope that the next generations will both enjoy and employ them better*

Below these words, Moore wrote 'Mother figure bending towards a child figure representing growing humanity', which explains the basic idea for the subject of this maquette.

REFERENCE: Henry Moore, *Heads, Figures & Ideas*, London, Rainbird, and Greenwich, Conn., New York Graphic Society, 1958.

141 | *SEATED FIGURE AGAINST CURVED WALL 1956–7*
Bronze
L.36 in; 91.4 cm
Arts Council of Great Britain
LH 422

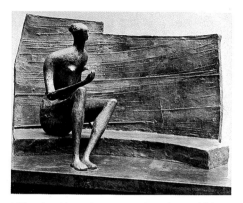

141 Another view reproduced on p.104

This working-model-sized sculpture was one of the few to be enlarged from a smaller maquette (LH 421) when Moore was working on the invitation to provide a sculpture to stand in front of the UNESCO building in Paris. He was exploring the possibility of using a wall to protect his sculpture from the architecture behind it. The idea here is closely related to a draped figure seated on a higher block against a similar wall, which was not taken beyond the maquette (LH 423). This size enabled the artist easily to hold the sculpture in his hand and see it almost simultaneously from every direction. At this working model size he could consider more realistically the architectural element of the piece and what the relationship of figure and wall would be if he were further to enlarge it. Surprisingly he has chosen a curved, baffle wall a little like the one made by the architects of Barclay School, Stevenage, behind Moore's *Family Group* (see fig.7). He had not liked the conjunction at the time, but the curved wall here complements the figure and Moore had written on a page of notes relating to the

project, 'Contrast ... Figures with settings/Figures with backgrounds/Do figures (& then make background to echo figure's rhythms.' (Moore, 1958.)

REFERENCE: Henry Moore, *Heads, Figures & Ideas*, London, Rainbird, and Greenwich, Conn., New York Graphic Society, 1958.

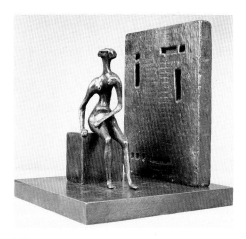

142

142 | MAQUETTE FOR GIRL SEATED AGAINST SQUARE WALL 1957
Bronze
H.9½ in; 24.1 cm
The Henry Moore Foundation
LH 424

This maquette is another in the series made by the artist in 1957 when exploring ideas for a sculpture to stand in front of the UNESCO headquarters in Paris. He played with the idea of incorporating a screen and here his stark wall resembles some that he had invented in drawings in the thirties, for instance cat.88 (HMF 1319), where the background can be interpreted as a sculptural relief or as a prison wall. In this maquette Moore has positioned the figure on a block set at right angles to his wall, thus removing any connection with relief sculpture. He has thus provided a strong contrast to the project for seated figures for the Senate House of the University of London (cat.95, HMF 1424) drawn twenty

years before. There the seated women occupied upright, more frontal positions, reflecting the nature of relief carving in stone; here the choice of modelling for bronze has allowed the artist technical freedom both to distort and enliven the figure. Although he had rejected the Senate House commission because he did not want to carve figures in relief, a note in a sketchbook suggests that at one moment he had considered using relief for the UNESCO sculpture: 'Seated Figure (of Madonna (or Christ)/ with arms extended in front/Figure in relief & arms in the round (probably arms attached separately)'. (Moore, 1958.)

REFERENCE: Henry Moore, *Heads, Figures & Ideas*, London, Rainbird, and Greenwich, Conn., New York Graphic Society, 1958.

143 | ARMLESS SEATED FIGURE AGAINST ROUND WALL 1957
Plaster
H.11 in; 28 cm
The Henry Moore Foundation
LH 438

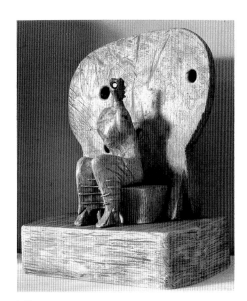

143

This is another idea for a figure with its own wall, to protect the sculpture from being lost against the strongly articulated façade of the UNESCO building behind it. While he worked on the project, Moore seems to have become fascinated by the possibilities of relating a figure to a wall designed by himself rather than one dictated by an architect. The screen itself evidently became so interesting to the artist that he eventually made a much larger free-standing wall (cat.181, LH 483). Here the upper part of the seated figure has become abstracted to harmonise with the rounded wall which, by analogy, seems to replace her missing shoulders. In contrast, the detail of the bench and the drapery stretched over the knees returns the sculpture to the realm of the possible. The apparent contradictions in this work reflect the fecundity of Moore's ideas; he not only investigated different subjects, but ways of carrying them out. This was not due to an inability to make up his mind but a determination to reach a suitable solution to the problems of making public sculpture.

144 | MAQUETTE FOR SEATED FIGURE: ARMS OUTSTRETCHED 1960
Bronze
H.6½ in; 16.5 cm
The Henry Moore Foundation
LH 463

Between 1950 and 1960 the theme of the seated woman was one which fascinated Moore. Some of the maquettes that he made led to enlargements like cat.145–6, (LH 435, 428); others such as this one were never increased beyond the working-model size. By 1960 Moore had already invented the first *Two-Piece Reclining Figure* (cat.177, LH 457) whose torso is less naturalistic than this one. A

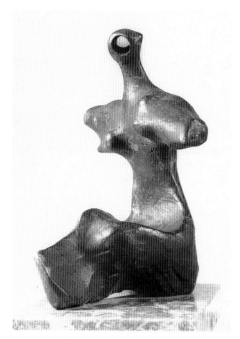

144

comparison is not inappropriate, since the artist so often worked on contrasting and related ideas. As this seated figure lacks legs other than the most basic stumps, unlike the torso of that reclining figure, she has been allowed rudimentary arms which protract the expressive curve of her left side. Instead of features, the head is pierced, giving it an analogy with a skull. Although the distortions are so great and so little of the anatomy of a woman survives, the tiny figure none the less has masterly balance and poise.

145	SEATED WOMAN 1957
	Bronze
	H.62¼ in; 158 cm
	Staatliche Museen Preussischer Kulturbesitz, Nationalgalerie, Berlin
	LH 435

Seated Woman is an enlargement of one of the many maquettes deriving from an invitation to make a sculpture to stand in front of the UNESCO building in Paris. Moore later described the figure as pregnant and accounted for having unconsciously given it fullness towards the right by remembering that his wife had told him before their baby was born, that sometimes she could feel the baby more on one side and sometimes on the other (Hedgecoe, 1968, p.329). Unlike other sculptures of the same year, such as the slightly later cat.146 (LH 428), the figure is not draped. She is sitting on a bench with legs fully extended to one side in a life-like pose which belies the distortions, for the large, surprisingly realistic left hand is apparently resting on a thigh which in reality could not be. In its own way, the figure is as unreal as the ones that the artist more nearly derived from bone formations, yet it

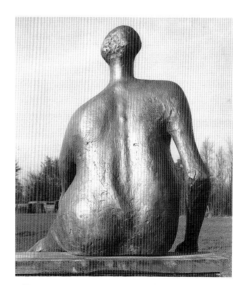

145 Another view reproduced on p.106

gives a reassurance of humanity and fertility. Moore recalled that one of his contemporary sculptures, *Woman* (LH 439), was like the Paleolithic Venuses with their exaggerated roundness and fullness of form (Hedgecoe, 1968, p.263); he had drawn one of the best-known, an ivory statuette from the cave of Les Rideaux at Lespugne, Hte Garonne, (Larousse, 1959, p.6) in 1926 (*Female Figure*, p.74, Notebook No. 6, repr., Mitchinson, 1971, p.51). The ample back of this figure is a reminder of one of the artist's earliest experiences, when, as a boy, his mother had regularly asked him to rub her aching back with liniment.

REFERENCES: Larousse Encyclopedia of Mythology, London, Hamlyn, 1959; D. Mitchinson, *Henry Moore, Unpublished Drawings*, New York, Abrams, 1971.

146	DRAPED SEATED WOMAN 1957–8
	Bronze
	H.73 in; 185.5 cm
	Private Collection (Switzerland), Courtesy of Thomas Gibson Fine Art
	LH 428

This figure was one of several that Moore made when he was considering what kind of sculpture would be suitable for placement in front of the UNESCO headquarters in Paris. He made a large number of maquettes, including nudes as well as draped figures (see cat.141, LH 422); several, like this one, were enlarged, first to working-model and then to life size and have been sited in other public spaces (see cat.145, LH 435).

The first draped figure that Moore had conceived as a bronze was the Time–Life figure (cat.127, LH 336) of 1952–3. He later on explained that he had explored drapery in the Shelter drawings made in the early forties, but

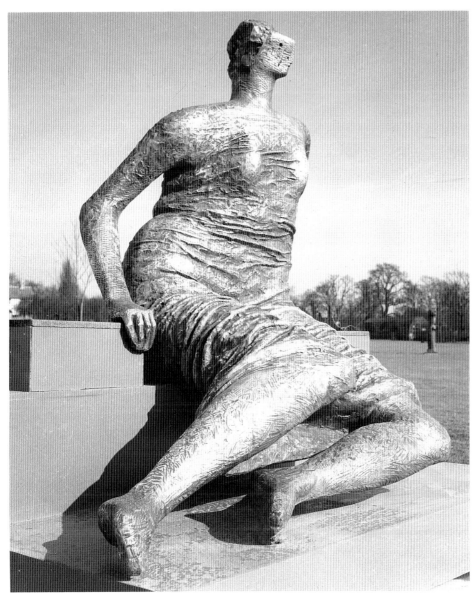

146 Another view reproduced on p.107

that his visit to Greece in 1951 'perhaps strengthened this intention'. (James 1966, p.231.) Certainly he was considering late Greek sculpture when he was working on ideas for UNESCO, because he listed various contrasts including 'Contrast primitive with *Greek* (late)/Contrast abstract & human/ powerful & sweet . . .'. On another page in the same sketchbook he exhorted himself: 'The great (the continual, everlasting)/problem (for me) is to combine/sculptural form (POWER)/ with human sensitivity & meaning/i.e. to try to keep Primitive Power with humanist content.' He continued, 'Not to bother about stone sculpture versus modelling – Bronze versus plaster/ construction – welding etc – but finding the common essentials in all kinds of sculpture.' (Moore, 1958.) In this monumental figure he has created a timeless emblem of woman, who draws a multitude of strengths from the past but is most surely a figure of the present day.

REFERENCE: Henry Moore, *Heads, Figures & Ideas*, London, Rainbird, and Greenwich, Conn., New York Graphic Society, 1958.

DRAWINGS 1940–1961

147 Reproduced in colour on p.140

147 | *GREY TUBE SHELTER 1940*
Pen and ink, chalk, wash, gouache
11 x 15 in, 279 x 381 mm
The Trustees of the Tate Gallery
HMF 1724

Titles such as 'Grey Tube Shelter' and 'Shadowy Shelter' are a reminder of the twilight atmosphere of the London Underground at night, which Moore has suggested by the moon-like disk of the London Transport logo on the wall and the monochrome colouring, relieved only by occasional touches of yellow and red. Fluorescent lighting now illuminates platforms and passages to levels unthinkable in wartime Britain where the conservation of energy was vital; furthermore, there was blackout to make the ground as unrecognisable as possible from the air, so the entrance to the Underground was pitch dark. Below ground hundreds of people sought refuge from the nightly bomb attacks, making a temporary home on the platforms, which Moore has here envisaged as like a stage. In contrast to the stark reality of a photograph Moore has captured the mystery, as well as the normality of the place. Thus in these unusual surroundings, ordinary activity is taking place, with two women winding wool on the right and another knitting on the left. Women and children provide his subject, because most men and single women were either away as soldiers or working as Air Raid Wardens above ground. None the less the number of babies and children in this drawing is surprising as many were evacuated from the capital to safer parts of the country.

148 | *SLEEPING SHELTERERS: TWO*
WOMEN AND A CHILD 1941
Pen and ink, wax crayon,
watercolour
$13\frac{1}{8}$ x $20\frac{5}{8}$ in; 333 x 524 mm
Robert and Lisa Sainsbury
Collection, University of East
Anglia
HMF 1738

148 Reproduced in colour on p.142

Among the Shelter drawings there are several studies and finished drawings of pairs of sleepers in close up view; this, however, is the only one which includes a small child nestling between them. All of the Shelter drawings were based on observations made by Moore as an Official War Artist during the Blitz when thousands of people slept each night in the London Underground. Since the shelterers were sleeping on the platforms, unless he could descend on to the train tracks Moore would have looked down upon them rather than seeing the highly dramatic foreshortened view that he has represented here. Although the drawing was not intended for transformation into three dimensions, Moore made use of his invention of 'sectional lines' which he later defined as a 'shorthand method of describing three-dimensional form.' (*Henry Moore Drawings*, 1979, p.5.)

149

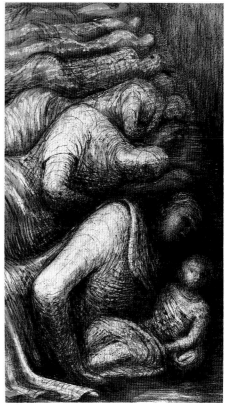

1649, repr., Wilkinson, 1977, p.110). The present drawing is freer and more schematic than either and the use of highlights in white and pink and yellow chalks against the dense grey and black background, gives it an ethereal light.

150 | ROW OF SLEEPERS 1941
Pen and ink, chalk, crayon, watercolour
$21\frac{7}{16}$ x $12\frac{9}{16}$ in; 545 x 320 mm
The British Council
HMF 1799

150 Reproduced in colour on p.145

149 | TUBE SHELTER PERSPECTIVE 1941
Pencil, wax crayon, watercolour, wash, postercolour
$11\frac{1}{2}$ x $9\frac{1}{2}$ in; 292 x 242 mm
The Henry Moore Foundation
HMF 1773

The length of tunnel depicted here with its deep recession and its two rows of figures apparently caught in a vortex, was due to the character of this particular shelter. At Liverpool Street, the tunnel for an extension to the underground railway had been dug but tracks had not yet been laid; there were no platforms and sleepers lay along the bottom of the tunnel itself. Moore described his fascination for this mysterious space with 'no lines, just a hole, no platform and the tremendous perspective'. (Wilkinson, 1977, p.32.) For the War Artists' Commissioners he rationalised the scene by providing a more orderly arrangement (HMF 1801, *Tube Shelter Perspective*, Tate Gallery 5709), closely based on a detailed sketch on page 24 of the Second Shelter Sketchbook (both drawing and sketch, HMF

In later life Moore confessed to Alan Wilkinson: 'If I had not been interested in drawing, and spent fifteen years doing life drawing, and put so much time and effort into my drawings for sculpture up to the war, I couldn't possibly have done the shelter drawings.' (Wilkinson, 1977, p.35.) Moore had previously explained

in a statement in 1946:

... I felt the need to accept and interpret a more "outward" attitude. And here, curiously enough, is where, in looking back, my Italian trip and the Mediterranean tradition came once more to the surface. There was no discarding of those other interests in archaic art and the art of primitive peoples, but rather a clearer tension between this approach and the humanist emphasis. (James, 1966 pp.216–18.)

Looking particularly at the tender but unsentimental relationship of the foreground mother and child in this drawing and remembering his travelling scholarship to Italy in 1925, it is easy to understand what Moore meant when he further admitted that the shelter drawings, as well as the *Madonna and Child* for Northampton (cat.102, LH 226) and the later Family groups, were 'perhaps a temporary resolution of that conflict which caused me those miserable first six months after I had left Masaccio behind in Florence and had once again come within the attraction of the archaic and primitive sculptures of the British Museum.' (James, 1966, p.218.)

151	GROUP OF SHELTERERS DURING AN AIR RAID 1941

Pen and ink, wax crayon, chalk, watercolour

15 x 21⁷⁄₈ in 381 x 555 mm

Art Gallery of Ontario, Gift of the Contemporary Art Society, 1951

HMF 1808

Photographs of people taking shelter from the air raids in the tunnels of the London Underground stations reveal groups huddling together on the crowded platforms, lit up by the photographer's flash gun. Moore spent nights among the shelterers and observed the gloom that was the reality. He has here evoked the timelessness of waiting, the uncertainty of darkness and

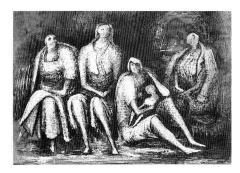

151 Reproduced in colour on p.141

the mystery of the barely lit spaces. The group of women do not have the symbolic overtones of the compositions of two or three figures, nor are they as anonymous as the crowd in *Grey Tube Shelter* (cat.147, HMF 1724). In contrast, they appear as Moore remembered them, since he made notes in the Underground, and worked them up in the daylight hours following his nights of watching. The appeal of such drawings of shelterers, particularly during the years of bombardment, was that he captured their predicament. In generalising it, he made it seem universal, but it also remained particular enough to touch the consciousness of those who might normally never look at 'modern' art. The drawing was worked up and enlarged from a squared-up page in the Second Shelter Sketchbook (HMF 1642, repr. Wilkinson, 1979, p.73), and the grid is visible in this drawing.

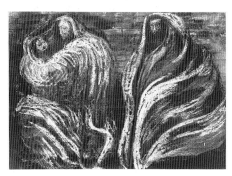

152 Reproduced in colour on p.144

152	SHELTER SCENE: TWO SWATHED FIGURES 1941

Chalk, pen and ink and wash, gouache, wax crayon

10⁷⁄₈ x 15¹⁄₁₆ in; 277 x 382 mm

Manchester City Art Galleries

HMF 1825

Before the Second World War Moore had regarded drapery generally as a hindrance to form, and only a few of his drawings included material. Some reclining figures, such as one in cat.75 (HMF 1089), were 'wrapped' to obscure the form and make it more mysterious. Here, however, the forms are created by the curves of the blankets which enclose them and seem to serve as protection from hostile forces. The figure on the right is, indeed, only recognisable as human from its peering head, which appears to emerge from a carapace, as a hermit-crab would do. The idea is reinforced by the resemblance to a shell of the ridged and convoluted folds, which balance the sweeping and more natural formation of the swathed figure on the left. A drawing from 1932 includes two upright shells (cat.71, HMF 946) and here Moore has derived from such natural forms a composition that has its own 'reality' which seems entirely convincing because of these organic associations.

153	TWO SLEEPING SHELTERERS 1941

Pen and ink, crayon, wax crayon, watercolour wash

15 x 22 in; 381 x 559 mm

Private Collection, Courtesy of Thomas Gibson Fine Art

HMF 1848

This drawing was bought directly from the artist by the composer Sir William Walton and has not been exhibited or reproduced for many years. It is thus far less well-known than the *Pink and Green Sleepers* belonging to the Tate Gallery

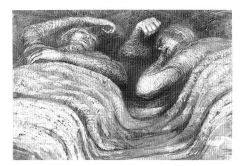

153 Reproduced in colour on p.143

(HMF 1845) which also shows a close-up view of two figures in a deep sleep. However, the present composition is even more monumental with the two figures and the ridged blankets presenting a more than usually sculptural appearance for a drawing; the colour has been reduced to those tones which Moore had used in the twenties for modelling. Furthermore the detail of the blanket enclosing the head of one of the figures, which gives such psychological reassurance in the Tate drawing (and the related studies), is here omitted, increasing the effect of tension in the scene. Alan Wilkinson drew attention to the similarity of figures in related compositions to the sleeping apostles in *The Agony in the Garden* by Mantegna, from the collection in the National Gallery, which had been taken away from London for safe keeping during the Blitz (Wilkinson, 1977, p.112).

154 | *PAGE FROM COAL-MINE SKETCHBOOK: MINER'S FACES*
1942

Pencil, wax crayon, ink and watercolour wash, pen and Indian ink, crayon

$9\frac{13}{16}$ x $6\frac{13}{16}$ in; 250 x 175 mm

The Moore Danowski Trust

HMF 1983

This sheet from the Coal-Mine Sketchbook is an unusual record of individual heads, for the artist was rarely drawn to particularities. Indeed, the acceptance

154

of an invitation from the War Artists' Commission to make drawings of miners and their work, resulted in the greatest number of male figures in Moore's entire oeuvre. Here he has blackened the whole sketchbook page, except for a strip near the perforations

on which he has written: 'Miners faces – lips white because of licking – brilliant whites of eyes – cheekbones whiter than rest – most black round nose & creases from nose, etc.', and the highlights on the miners' blackened faces do indeed appear out of the gloom. Characteristic

247

of the enlarged finished drawings (such as cat.156, HMF 1993) are the lighting effects which Moore derived from miners' lamps and the light attached to their helmets, seen here on three of the heads (which may be different views of the same person). A photograph of the artist drawing down the mine shows him wearing one of the lights himself (Berthoud, 1987, fig.78).

155

155 | PAGE FROM COAL-MINE SKETCHBOOK: MINERS' HEADS AND STUDY FOR PIT BOYS AT PITHEAD 1942

Pencil, wax crayon, watercolour, Indian ink wash, pen and Indian ink, crayon
9 13/16 x 6 13/16 in; 250 x 175 mm
Private Collection
HMF 1984

Inscriptions on this sheet identify the figure at top right as a pit boy: the artist has squared up his face with the intention of enlarging from this sketch. Other idividual heads remain as sketches, though at centre left, a group of four miners showing head and shoulders are framed and also squared up ready for enlargement. They provided the basis for the drawing *Pit Boys at Pit Head* (HMF 1985) now in the collection of Wakefield City Art Gallery. Moore has here specified the scale of enlargement, giving the conversion of three-and-a-half by two-and-a-quarter inches, to twenty-one by thirteen-and-a-half. In practice, the Wakefield sheet measures twenty by thirteen and the composition differs only slightly; however, there is a surprising change from the inky darkness of this sheet to the lightest of Moore's mining drawings, giving to the Wakefield sheet the effect of recording, rather than of making a dramatic picture, which this preliminary sketch suggests.

156 | AT THE COAL-FACE 1942

Wax crayon, crayons, watercolour wash, brush and ink, pencil, scratching on watercolour surface
13 1/2 x 26 in; 343 x 661 mm
Glasgow Art Gallery and Museum
HMF 1993

This is one of a series of works bought by the War Artists' Advisory Committee and is a composition elaborated from finished horizontal studies of miners

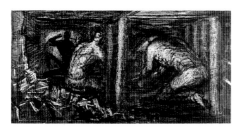

156 Reproduced in colour on p.148

(such as the one in the collection of Birmingham City Art Gallery, HMF 1992). Here, however, Moore has added an element of colour, using yellow on the pillars and silvery-white highlights on the bodies of the miners as well as on the jagged heap of coal, which relieves the uniformity of the composition. The crouching figure on the right side carries his light on his head; on the left Moore has used the device of a light beyond to silhouette a figure in stark blackness, indeed, he has achieved a sooty black similar in density to coal-dust. The inventive use of colour and the complexity of technique relates this drawing to the contemporary work of John Piper, who was also working as a War Artist.

157 | COAL-MINER CARRYING LAMP
 | 1942
 | *Pencil, wax crayon, watercolour*
 | *wash, crayon*
 | $18\frac{15}{16}$ x $15\frac{5}{16}$ in; 481 x 390 mm
 | *The Moore Danowski Trust*
 | HMF 1986

This poignant drawing is a marriage of the observations that the artist made at Wheldale Colliery, Castleford, and the well-known composition *The Light of the World*, painted by the PreRaphaelite, William Holman Hunt, in 1853. A print of the picture had hung in Moore's childhood home in Castleford and the connection no doubt arose as a result of the strong emotions Moore must have experienced in 1941 on his first visit to Castleford for many years. Further-

more, he had asked, and been granted, permission to make his sketches as an Official War Artist in the very pit where his father had worked, where he had never been before – no doubt because the danger was too great. On this occasion he was guided by a deputy manager and much later he wrote down his vivid remembrance of his first day: 'Crawling on sore hands and knees and reaching the actual coal-face was the biggest experience. If one were asked to describe what Hell might be like, this would do.' (Wilkinson, 1974, pp. 314–15.) By equating the figure of the miner with Christ, he has taken away some of the terror of the pit.

REFERENCE: A. G. Wilkinson, *The Drawings of Henry Moore*, PhD thesis for the University of London, Courtauld Institute of Art, 1974, published London, Garland, 1984.

157 Reproduced in colour on p.147

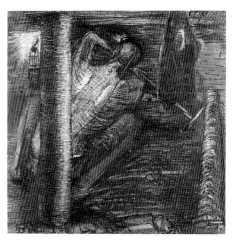

158 Reproduced in colour on p.146

158 | MINER AT WORK 1942
 | *Ink, chalk*
 | $19\frac{3}{8}$ x $19\frac{1}{2}$ in; 492 x 495 mm
 | *The Trustees of the Imperial War*
 | *Museum*
 | HMF 1987

Although the popular conception of a coal-mine is a tunnel similar to those of the London Underground, it was only the large tunnels along which miners could walk that bore a resemblance; this was caught by Moore in a sketch (HMF 1943, p.39 from the Coal-Mining Subject Sketchbook, repr. Wilkinson, 1977, p.38, fig.51). In the part of the mine where the work was done there was no room to stand and the shafts supported by wooden pit props were roughly square in section. Thus Moore's mining drawings closely fit the size of the page, both in the sketchbooks and the drawings like this, enlarged from them. Here he has depicted the miner hacking away at the solid seam of coal that is barring his way forward and is the reason for his activity. The only light is from the brass lamp hanging at his side and from the headlamp attached to his helmet like the eye of a Cyclops. Moore has derived colour from these two sources which allow generous highlights against the dense blackness. As coal was the major

249

source of energy in wartime Britain, coal-mining was an essential occupation for the war effort and Moore's drawings were therefore commissioned in his capacity as an Official War Artist.

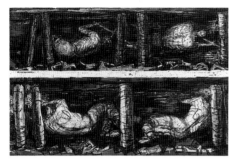

159 Reproduced in colour on p.149

159	FOUR STUDIES OF MINERS AT THE COAL-FACE 1942
	Pencil, coloured crayons over white wax crayon, watercolour wash, pen and Indian ink, gouache, Indian ink wash
	14$\frac{3}{8}$ x 22$\frac{1}{8}$ in; 365 x 562 mm
	The Henry Moore Foundation
	HMF 2000a

In this drawing, made after his visit to Wheldale Colliery, Castleford, Moore has grouped individual miners in a composition arranged as two sectional views along the underground workings. The long and narrow proportions of the two parts are inspired by geology, for the shallowness of the seam of coal forced the men to work in an almost horizontal position. In contrast to cat.156 (HMF 1993) where he used lighting to emphasise the depth of the working, Moore has used the short pit props to create a sequence of 'frames' rather like those on a roll of photographic negatives. However, the analogy, perhaps fortuitous, is belied by the addition of unexpectedly warm colouring, inspired by the reddish-brown bark of pine trees which provided the props. Each figure is in a different pose and the artist has conveyed something of the struggle

waged by the men wielding their picks against the 'black gold'. As an Official War Artist he no doubt felt compelled to invent informative drawings although the extremely constricted space at the coal-face forced an artificial composition upon him when he came to work on these drawings afterwards in his studio in Hertfordshire.

160	SCULPTURE AND RED ROCKS 1942
	Crayon, wash, pen and ink
	19$\frac{1}{8}$ x 14$\frac{1}{4}$ in; 486 x 362 mm
	The Museum of Modern Art, New York, Gift of Philip L. Goodwin
	HMF 2067

The figure in the foreground is not a sketch for a sculpture, but is related to the large elmwood *Reclining Figure* (LH 210) which Moore had carved just before the outbreak of the Second World War (see cat.35, LH 185). Now, in the darkest days of war when, as an Official War Artist, his time was devoted to drawing rather than to carving, he made at least three drawings of sculpture in conjunction with rocks, following a visit to Castleford, his boyhood home town in December 1941. He had gone to Yorkshire to make sketches for coal-mining drawings (see cat.157, HMF 1986), returning to a familiar landscape, far more dramatic than the undulating county of Hertfordshire, where he was then living.

The best-known of these drawings is horizontal and belongs to the British Museum; there the figure is not related to a known sculpture. A second drawing, vertical like the present one, is in the collection of the Albright-Knox Art Gallery; it shows a first idea for the elmwood reclining figure that Moore carved after the War (see cat.104, LH 247). But here, although the resemblance is probably fortuitous, the rocks themselves can be linked to later sculp-

160 Reproduced in colour on p.150

ture, particularly to the first *Two-Piece Reclining Figure* of 1959 (cat.178, LH 458). The tiny figures in the background, put in to indicate scale, suggest the puniness of man in comparison with the grandeur of nature.

161	PAGE FROM MADONNA AND CHILD SKETCHBOOK 1943
	Pen and ink, crayon, watercolour
	8$\frac{7}{8}$ x 6$\frac{7}{8}$ in; 225 x 175 mm
	Mr and Mrs Harry A. Brooks
	HMF 2174

When the artist was invited to carve a Madonna and Child (see cat.102, LH 226) for the church of St Matthew's, Northampton, he recognised that religion had been the inspiration for most of the greatest European art, but 'the great tradition of religious art seems to have got lost completely in the present day'. He therefore decided to make drawings and clay models to see whether he could 'produce something which would be satisfactory as sculpture and also satisfy my idea of the "Madonna and Child" theme as well.' (Moore, 1944, p.189.) As

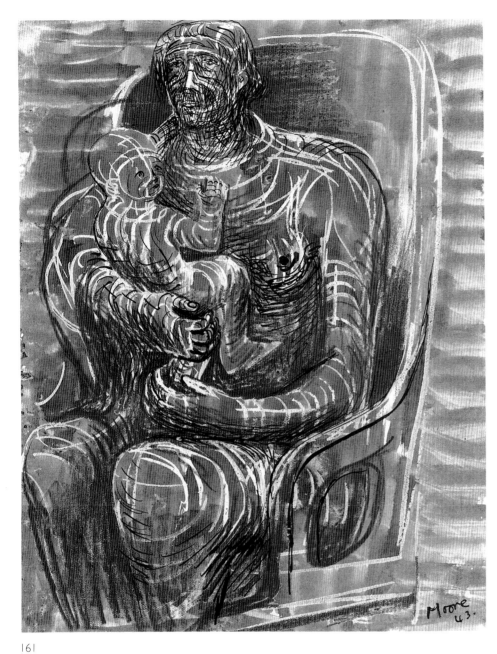

161

REFERENCE: H. Moore, E. Newton et al., 'Henry Moore's Madonna and Child', London, *The Architectural Review*, vol. xcv, May 1944.

162 | NINE HEADS 1944
Chalk, pen and watercolour
18¼ x 16 in; 464 x 406 mm
Private Collection
HMF 2252

When reproduced as Plate xxxi in 1974 in *Henry Moore Drawings*, this drawing was given the subtitle, 'Ideas for Metal Sculpture'; it makes an interesting comparison with a sheet of eighteen similar heads from 1940 (HMF 1508, repr. Clark, 1974, p.219). The artist's concern here is with exploring the skull itself as a hollow form, rather than as a 'container' as he had in the pre-War *Two heads: Drawing for Metal Sculpture* (cat.93, HMF 1462). Eight of the nine ideas on this sheet have a haunted expression, and the overall warm colouring seems to suggest wood as much as metal. The ninth, the head in the centre, is seen unexpectedly from a three-quarter view, with emphasis on the stylised arrangement of hair, and it

can be seen from the size of this sheet, the sketchbook was of a small format and here he has been unable to show more then a close-up view of his idea for a full-length statue. None the less it is clear that he was already considering the relationship of the sculpture to the wall behind it, for the figures are protected from its rough surface by a high-backed throne. The sketch must therefore predate a visit to the church, where the wall is made of large smooth blocks of brownish sandstone, which allowed Moore to place the sculpture on a low stool with no intervening screen. In this preliminary idea he has shown the child with a halo and a hand raised in blessing; in the carving he abandoned the halo and revised the position of the mother's hand to enclose the infant's hand instead of his foot. The Madonna's head is here very much more like the final one than the head in most of the clay maquettes (nine are reproduced, 1944, p.189).

162 Reproduced in colour on p.151

lacks the anguish of the others. The mood conveyed by these imagined heads presages the general feeling of anxiety which characterised the later forties, after the brief euphoria following the cessation of hostilities in Europe and then in the Far East in 1945. A bronze from 1955 entitled *Head: Lines* (LH 397) is apparently a sculptural equivalent of these ideas.

163 | DRAPED STANDING FIGURES IN RED 1944
Pen and ink, crayon, watercolour
15¾ x 12¼ in; 400 x 311 mm
Private Collection
HMF 2253

After the drab colour of the Shelter and Coal-Mine drawings that Moore had made in his role of Official War Artist, unexpected colour has flooded into this drawing, made in the year of the ending of hostilities in Europe. Indeed the use of such painterly colour is new in Moore's work, as is the exploration of drapery. No doubt this is an extension of the drapery in the Shelter drawings, but it is more naturalistic than that of the *Two Swathed Figures* (cat.152, HMF

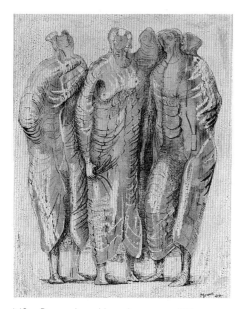

163 Reproduced in colour on p.154

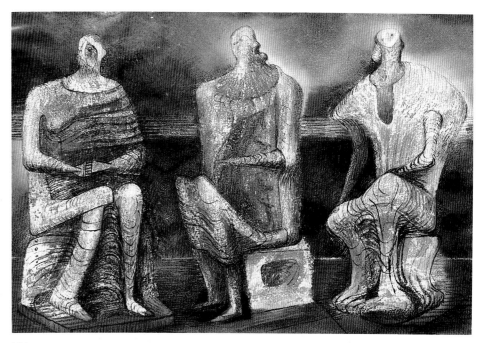

164

1825). The figures are mythical rather than real, for only the one on the right has recognisable facial features, but the degree of likeness to the human frame is greater than in earlier drawings such as *Two Standing Figures* (cat.100, HMF 1517). The intervening experience of making narrative illustrations for a modern Odyssey by Edward Sackville-West seems to have given the artist freedom to explore a group of figures not simply as ideas for sculpture.

REFERENCE: E. Sackville-West, *The Rescue*, London, Secker and Warburg, 1945.

164 | THREE SEATED FIGURES 1944
Pen and ink, chalk, crayon and wash
13¼ x 22¾ in; 337 x 578 mm
The Moore Danowski Trust
HMF 2266

Moore was always aware of the format of paper that he chose for finished drawings. It varies a good deal, but this drawing is longer in proportion to its height than most of the post-war ones.

Indeed, the shape resembles that of the horizontal drawings of miners working in the pit, where the paper often divides naturally into two compartments, suggesting the confined space in which the men are working. In the same year he made compartmentalised sheets such as *Family Groups* (cat.165, HMF 2232), in which each unit occupies its allotted quarter of the sheet. The choice of three seated figures, clearly differentiated one from another, implies a rudimentary subject, and the analytical psychologist, Erich Neumann, suggested that Moore's drawings of three women signify the 'Fate Goddesses' (Neumann, 1959, pp.93–7). Neumann may have been unaware that Moore had provided illustrations for Edward Sackville-West and was at this time drawn back to ancient Greek mythology.

REFERENCES: E. Neumann, *The Archetypal World of Henry Moore*, trans. R. F. C. Hull, Bollingen Series LXVIII, New York, Pantheon Books, 1959; E. Sackville-West, *The Rescue*, London, Secker and Warburg, 1945.

252

165 | FAMILY GROUPS 1944
Chalk, pen, wax crayon, watercolour
22 x 15 in; 559 x 381 mm
Private Collection
HMF 2232

Moore has compartmentalised this large sheet of paper in order to accommodate two versions of family groups, each seen from two different views. They differ both from the final large sculpture of 1948–9, cast in bronze (cat.107, LH 269) and from other drawings made in 1944. For instance, whereas the large *Family Group* (cat.166, HMF 2237a) seems flattened to serve as a drawing, Moore has here exaggerated the space that would be seen through a sculpture. He has done this by omitting the background tint in the lower compartments where, when sculpted, space between the figures would provide interesting shapes. By making the father stand up, he has relied on the smaller child to serve as a linking device between the adult figures, but even though the older child leans on his mother's knee, he seems

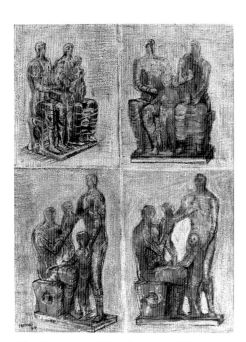

165 Reproduced in colour on p.152

dissociated from the group. By adding a book in the other drawing, Moore was able to link the children together, though in the two large sculptures (LH 269, 364) he gave each family group a single child.

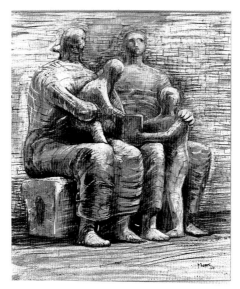

166 Reproduced in colour on p.153

166 | FAMILY GROUP 1944
Watercolour, ink, crayon, chalk
20 x 16⅞ in; 508 x 420 mm
Scottish National Gallery of Modern Art, Edinburgh
HMF 2237a

This family is depicted against a brick wall rather than as a free-standing group, a somewhat surprising choice since Moore disliked the wall against which his *Family Group* sculpture was later positioned (see cat.107, LH 269). Furthermore, it is difficult to imagine the mother and father with their two children in three dimensions, as the artist has used the terracotta of both wall and ground to flatten the composition. Thus, in spite of the grey and white highlights and his yellow/gold sectional lines on the figures, the effect is of a picture rather than an idea for sculpture. This is of course not unusual

in the forties when, following the intensive work that Moore had done on drawings as a War Artist, he continued to devote time and attention to finished works on paper. The artist himself came from a large family with a sister younger than himself; he understood very well the relationships of parents to their children, which he has idealised here. In other drawings and maquettes he explored the concept of the Family for he had been invited to make a sculpture for the Village College at Impington, Cambridge, designed by Walter Gropius (see cat.107).

167 | GIRL READING TO A WOMAN AND CHILD c.1946
Pen and ink, crayon and wash
17½ x 24 in; 445 x 610 mm
Lord and Lady Walston
HMF 2385

At first glance this is one of the most homely of Moore's drawings, where a mother with a child clambering on her lap sits in three-quarter view, entertained by a similarly positioned young woman with a book. The setting is precisely indicated, their two chairs are positioned near a wall, with a picture hanging above the mother's head, and the curtains are fastened back on each side of a window. However, this domestic scene is shattered by the view through the window, where Moore has

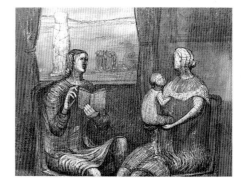

167 Reproduced in colour on p.156

inserted one of his most haunting compositions, taken from the 1942 drawing entitled *Crowd Looking at a Tied-Up Object* (HMF 2064). In the same deserted countryside (which here might have been the 'real' view from the window) a group of figures stand in a densely packed crowd, with their faces lifted to gaze at a huge, wrapped-up object, which itself looks like a figure. Both here and in the original, the landscape is completed by three stones which lie behind the crowd. The origin of the image may have been a chance remark made by Max Ernst, who was brought to visit Moore's studio by Roland Penrose around 1938. Penrose recalled that Ernst commented on the way Moore's sculptures were draped in white sheets (Penrose, 1981, p.102). There was also Man Ray's haunting Surrealist image *L'Enigme d'Isidore Ducasse*, a sewing-machine, wrapped in material and tied round with rope. Alan Wilkinson suggested a primitive source (Wilkinson 1977, fig.57, p.123).

REFERENCE: R. Penrose, *Scrapbook 1900–1981*, London, Thames and Hudson, 1981.

168

168	THE ROCKING CHAIR 1948
	Pencil, wax crayon, watercolour, gouache
	20¼ x 27⅞ in; 521 x 708 mm
	Birmingham City Museum and Art Gallery
	HMF 2516

In the thirties Moore had made several multi-part finished drawings with an asymmetrical design (cat.75, HMF 1089) and he has here used the arrangement again. However, he has replaced the mystery of the abstracted reclining figures with more or less naturalistic representations of a mother and child playing on a rocking chair. It is probable that the inspiration was his wife and their infant

daughter, for whom, two years later, he made a series of sculptures based on the same idea (cat.108–10, LH 274–6.) In 1924, on one of his earliest drawings of a mother and child, Moore had written 'poising of weights' (see cat.49, HMF 139) and it is clear that the same problem still fascinated him in 1948, for in this drawing, as in the later sculptures, the child is shown in different positions. This caused changes in the stance of the mother who was forced to counterbalance the movement of the rockers caused by the child's shifting weight. The drapery, in this and related drawings reinforced by Moore's 'sectional lines', is more naturalistic than in the stylised sculptures.

169	FAMILY GROUP 1948
	Pen and ink, crayon and wash
	22¼ x 27⅜ in; 564 x 697 mm
	Art Gallery of Ontario, Purchase 1974
	HMF 2504

Compared with the *Family Groups* drawn four years earlier (cat.165, HMF 2232), Moore has chosen a more geometric arrangement for the four figures that make up this family. Indeed, the right-angled triangle suggests the traditional composition for half of the pediment of a classical building and would have been known to the artist from his early art school training, which was based on traditional academic principles. It is unlikely that this was in Moore's mind when he made this drawing in the same year that he made his *Family Group* for Barclay School in Stevenage (cat.107, LH 269). That group has only three figures, a mother and father linked by the infant held between them. The reduction to a single child gave Moore a tighter composition for his sculpture, but he evidently thought of a family group as bigger, since all his enlarged drawings include two children. Here the psychological links between the members of the family are achieved by physical proximity alone; although the older child is allowed the detail of a book, a timeless effect is given by the distant and impassive gaze of the adult figures.

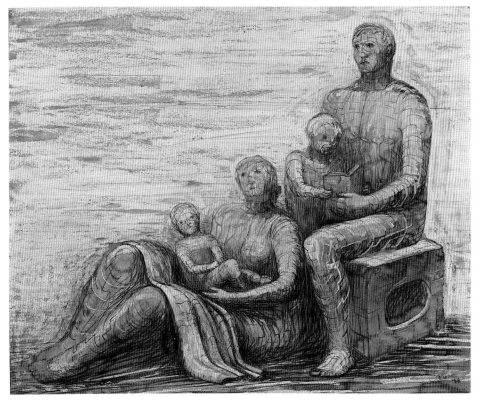

169

170

170 | THREE STANDING FIGURES IN A SETTING 1948
Pen and ink, chalk, watercolour
$19\frac{1}{2}$ x $24\frac{3}{4}$ in; 495 x 627 mm
The Board of Trustees of the Victoria and Albert Museum
HMF 2484

After the claustrophobic settings of the Shelter drawings, Moore was able symbolically to break open the prison walls and place his figures against the sea. The walls still resemble the abstract inventions of 1937 (see cat.88, HMF 1319), but, instead of forming a simple plane or barrier behind the figures, they are positioned at each side, occupying the front and middle distance of the composition. Although they retain an element of threat (for they can be read as barriers as easily as abstract designs) there is a new sense of psychological release, for the figures are standing apparently at the edge of the sea, bathed in light, streaming from a hidden source. The sea in this drawing was heralded by the analytical psychologist, Erich Neumann, as a symbol of the creative unconscious from which new life springs; he named the figures the Three Fates, and applied the same title to the *Three Standing Figures* (LH 268, p.12) of 1947–8 (Neumann, 1959, p.97). Moore said that he did not read beyond the first chapter of Neumann's book, because he felt that if his creative processes were so convincingly explained, he might lose his powers of artistic invention.

REFERENCE: E. Neumann, *The Archetypal World of Henry Moore*, trans. R. F. C. Hull, Bollingen Series LXVIII, New York, Pantheon, 1959.

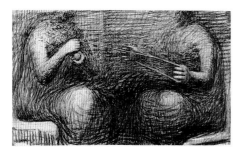

171 Reproduced in colour on p.155

171 | WOMEN WINDING WOOL 1949
Watercolour, crayon
13¾ x 25 in; 348 x 636 mm
The Museum of Modern Art, New York, Gift of Mr and Mrs John A. Pope in honour of Paul J. Sachs
HMF 2530

This large drawing is unusual in Moore's oeuvre because he has combined a realistic rendering of an everyday occupation with a partial view of the two figures, whose heads are cut and feet not visible. Furthermore the technique is unlike his contemporary work in owing a debt to the drawings of Seurat. In later life, Moore formed his own collection of works from the past and owned three drawings by Seurat, including the one described in the notes for cat.221, HMF 80 (305).

Here the figures emerge from the variously textured background, the chequerboard pattern to the right of the figure holding the ball of wool contrasting with the parallel lines to the right of the woman holding the skein. The grave monumentality of the figures is suggested by the lightening of the repeated strokes on the parts nearest to the viewer. The great variety of lines magically extends the activity of wool winding to the whole drawing, with its skeins of subdued colour.

172 | SCULPTURE SETTINGS BY THE SEA 1950
Ink, watercolour, gouache, coloured crayons, wax crayon
21⅝ x 15¾ in; 550 x 391 mm
Art Gallery of Ontario, Gift of Mary R. Jackman 1988
HMF 2621

Moore occasionally made sheets of individual drawings like this, arranged as though they were pictures in an exhibition. The top is titled 'Sculpture settings by the sea' and the artist has provided seaside backgrounds for his sculptural ideas. He had visited the sea in the summer months from 1922 when his family moved to Norfolk from Yorkshire, though the coastline had varied from the dunes of Norfolk to the chalk cliffs of Kent, after he had acquired a cottage in that county in 1932. Here the settings suggest the variety of landscapes round the coasts of Britain and the vast horizons of sky and sea. Some of the sculptures resemble known works, though the skeletal reclining figures are even more bone-like than existing ones. Perhaps the most surprising one is the

172 Reproduced in colour on p.157

straining figure at lower left, for it anticipates the *Draped Reclining Figure* (cat.127, LH 336) of 1952–3 which is usually thought to derive from the artist's experience of antique sculpture on his visit to Greece in 1951. Likewise the seated mother and child at top left is close in feeling to Moore's much later sculptures of the theme.

173 | IDEAS FOR UPRIGHT INTERNAL/EXTERNAL FORMS 1950
Pencil, pen and ink, chalk, crayon, watercolour, ballpoint pen
10¾ x 8⅞ in; 264 x 225 mm
The Moore Danowski Trust
HMF 2605

In 1937 Moore had saluted Constantin Brancusi for making 'us once more shape-conscious' with forms like the egg, used by Brancusi for its sculptural simplicity and poetic associations. Moore, however, had also recognised a need to 'open out, to relate and combine together several forms of varied sizes, sections and directions into an organic whole' (Sylvester, ed., 1969, p. xxxiv). The genesis of the idea developed here is in drawings such as *Two Standing Figures* (cat.100, HMF 1517) of 1940, but, as well as being more directly translatable into three dimensions, these new images have a more explicit generative metaphor – the womb, the seed. The largest form leads directly to the *Working Model for Upright International/External Form* (cat.118, LH295); here it reveals its origin in the very methods of making sculpture in metal, for the interior form is shown, as it were, at the moment of final revelation, when its mould is broken open. Surprisingly the smaller element, above right, points to a much later development, the *Mother and Child: Hood* (cat.201, LH 850), where the secondary

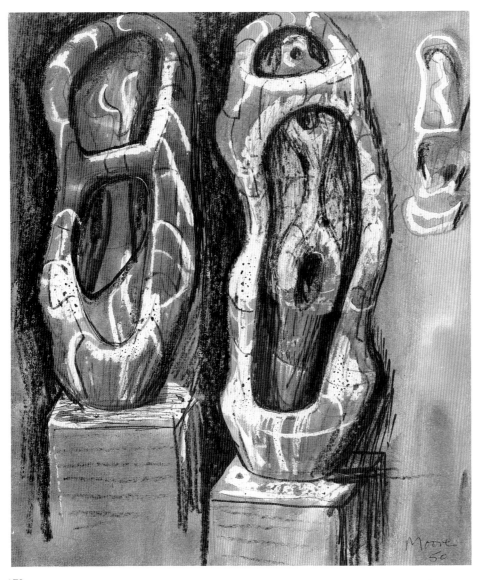

173

the interior, reflect the artist's continuing fascination for internal/external forms, most clearly exemplified in sculpture (see cat.118, LH 295). Here Moore has further explored the idea, though superficially in pictorial terms rather than sculptural. However, the means for flattening the head is the underlying grey wash, covering the whole page, and, by ignoring this, the whole head can be seen as a skeletal device. It is a little like the armature which underlies the plaster that is a preliminary stage for a bronze casting, so the haunting quality of this head has an unexpected connection with contemporary sculpture, and Moore is seen still to be fascinated by the secret, internal structures of the head.

174 Reproduced in colour on p.158

form reveals itself as a child, not enclosed but enveloped by its mother.

REFERENCE: H. Moore, 'The Sculpture Speaks', *The Listener*, 18 August, 1937, reprinted in *Henry Moore Sculpture and Drawings*, London, Lund Humphries, 1969.

174 | **PAGE FROM SKETCHBOOK: HEAD** 1958

Wax crayon, watercolour wash, ink
$11\frac{3}{8}$ x $9\frac{3}{8}$ in; 289 x 249 mm
The Henry Moore Foundation
HMF 2979

The naturalistic details that identify the markings on this grey page as a head are few indeed. Paramount are the eyes which gaze with acuity in spite of the crushed appearance of the skull. Nevertheless, the glow of the light-coloured structural lines that appear to open up

175 | **RECLINING FIGURE: BUNCHED** 1961

Coloured chalks with brush and water
$15\frac{1}{2}$ x $21\frac{1}{8}$ in; 394 x 535 mm
Private Collection
HMF 3025

The principal figure was drawn from a maquette (LH 489) which gave rise to the *Reclining Figure* carved in travertine

175 Reproduced in colour on p.160

marble (LH 489a) between 1961 and 1969. The maquette cast in bronze is one of Moore's most clearly modelled inventions, almost as though the shape had been squeezed and moulded in the artist's hands; the head and torso are deliberately shaped, so that the flowing hair is confined like the handle of some primitive pot. The surface of other parts of the maquette, in contrast, look as though they found their origin in the worn surfaces of flints. In the drawing these characteristics have mainly gone: the figure is on its way to being carved and the cave-like forms of the belly and leg area are hollowed out in front of a black unhewn shape. Colour is used to give depth to the mysterious cavities, which look, in the finished marble, as though they have been eroded by the relentless working of the sea. The same idea is suggested here by the all over turquoise that Moore has chosen for this drawing, where phantom shapes, drawn with coloured crayons, inhabit the background. In the foreground, a second, partial figure emerges from behind the main one: this is related to the *Reclining Figure: Festival* (cat.121, LH 293), of ten years before, which provides cave-like vistas when seen from end on (fig.8). Here Moore has unified the two main figures with horizontal stripes of maroon, also used for vaguely defined, figural shapes in the middle distance. The generally very free use of colour and form is a reminder of the

work of the American Abstract Expressionist painters that was seen in important exhibitions in London at the Tate Gallery in 1956 and 1959. However, Moore developed this personal style independently, for it is anticipated in some of his own drawings of the thirties, and reappeared in a *Seated Group of Figures* (HMF 2612) of 1950. He continued to develop this very free style in lithographs in the sixties and seventies.

176 | **PAGE FROM SKETCHBOOK 1961–6: TWO RECLINING FIGURES 1961**

Pencil, wax crayon, pastel, watercolour wash, felt-tip pen, chalk

$11\frac{1}{2}$ x $9\frac{1}{2}$ in; 292 x 242 mm

The Henry Moore Foundation

HMF 3029

176 Reproduced in colour on p.159

Although by the mid-fifties Moore had stopped using drawing as a means of generating ideas for sculpture and was using maquettes instead, he continued to draw occasionally and he began to enjoy making prints. On this page from a sketchbook he has changed the re-

lationship of figure to paper in keeping with the enlarged scale of the reclining figure sculptures of the early sixties. However, unlike the contemporary large bronzes (such as cat.178, LH 458) these massive forms are not read as split into parts, though there is an unaccountable gap between the leg parts of the upper figure. No doubt as a result of his interest in lithography, the artist has used colour washes in a new, freer way; maroon and black are puddled on to the paper and have dried unevenly, leaving different densities of tone. Patches of white are used almost as much for decorative reasons as to suggest light falling on sculpture.

SCULPTURE 1959–1983

177 | *TWO-PIECE RECLINING FIGURE NO. 1 1959*

Bronze

L.76 in; 193 cm

Chelsea School of Art (A Constituent College of the London Institute)

LH 457

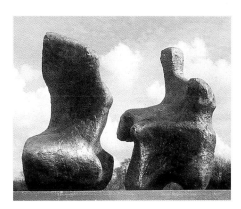

177 Another view reproduced on p.108

Although Moore had made sculptures consisting of more than one piece in the thirties, this is his first life-size sculpture in which the torso is entirely separate from the element which stands for the remainder of the figure. He had, however, made drawings of reclining figures in conjunction with rocks and in cat.160 (HMF 2067) the rocks are arranged in two parts with the left one not unlike some views of this sculpture.

The immediate source for the shapes of the two parts of *Two-Piece Reclining Figure No. 1* was the natural formation of bones or flints. However, in the maquette size where this is more obvious, the figure was not divided; it was only while working on the enlargement that Moore 'realised what an advantage a separate two-piece composition could have in relating figures to landscape. Knees and breasts are mountains. Once these two parts become separated you don't expect it to be a naturalistic figure; therefore, you can more justifiably make it like a landscape or a rock.' (Sylvester, 1968, p.93, quoted from Lake, 1962, p.44.) The artist later recalled that as he was making the leg end he was reminded of *Le Bec du Hoc* by Seurat (Tate Gallery, London). At the time it was owned by Kenneth Clark, and Moore said that he had seen the picture many times and had always admired it tremendously (Hedgecoe, 1968, p.338).

David Sylvester found strong sexual connotations in the two-piece reclining figures: here he reads the 'leg' piece as a giant phallus. (Sylvester, 1968, p.93.) This interpretation is partly borne out by Moore who admitted: 'The two-piece sculptures pose a problem of relationship: the kind of relationship between two people. It's very different once you divide a thing into three.' (*Henry Moore*, 1963, p.306.)

In an interview with Gert Schiff originally published in German, Moore had explained the basis of his attitude:

All experience of space and world starts from physical sensation. This also explains the deformation of my figures. They are not at all distortions of the body's shape. I think, rather, that in the image of the human body one can also express something nonhuman – landscape, for instance – in exactly the same way as we live over again mountains and valleys in our bodily sensations. Or think of the basic poetic element in metaphor: there too we express one thing in the image of another. It seems to me that I can say more about the world as a whole by means of such poetic interpenetrations than I could with the human figure alone. (Neumann, 1959, pp.57–8.)

REFERENCES: Carlton Lake, *Atlantic Monthly*, vol.209, no.1, Boston, January 1962; 'Henry Moore Talking to David Sylvester' (Extracts from a BBC radio interview), *Henry Moore: Recent Work*, London, Marlborough Fine Art, 1963; G. Schiff, 'Die Plastik, der Mensch und die Natur. Eindrucke von einem Besuch bei Henry Moore', extract in E. Neumann, trans. R. F. C. Hull, *The Archetypal World of Henry Moore*, Bollingen Series LXVIII, New York, Pantheon Books, 1959.

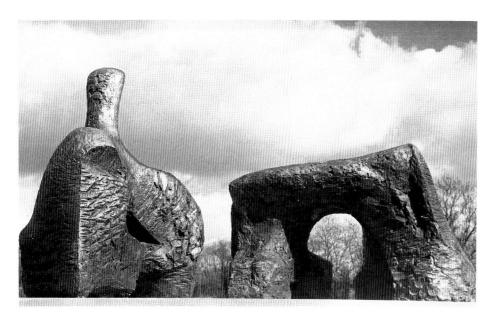

178

179 | *WORKING MODEL FOR STANDING FIGURE: KNIFE EDGE 1961*

Bronze

H.64 in; 162.5 cm

Collection Marina and Willy Staehelin, Feldmeilen

LH 481

178 | *TWO-PIECE RECLINING FIGURE NO. 2 1960*

Bronze

L.101 ½ in; 257.8 cm

The Trustees of the Tate Gallery

LH 458

This over life-size figure is a natural development from the one made the previous year (cat.177, LH 457). Once again, Moore described the leg end in terms of a familiar landscape painting, Monet's *Cliff at Etretat* (Metropolitan Museum of Art, New York). As he was completing the sculpture, he remembered that he thought of the arch form as though it were emerging from the sea.

Moore stressed the importance of choosing the interval between the two pieces, likening it to the reconstruction of a broken antique figure. Interestingly, he suggested that it is as though there remain only the knees, a foot and the head and room must be left for the missing parts in order to achieve a correctly proportioned figure (Hedgecoe, 1968, p.349). Our instinctive and innate tactile sense allows us generally to pass easily from one piece to another, though we may experience the forms as landscape elements, as rocks or cliffs as Moore himself did. The artist always gave these sculptures surprisingly high plinths, no doubt so that the viewer has the opportunity to walk round and appreciate the multiplicity of views which their complex arched forms provide.

Like cat.177, the bronze cast was made from a plaster (now in the Art Gallery of Ontario, Toronto), which was built up in stages on a metal framework, an armature. This gave a rough but firm structure on which the plaster could set. Instead of leaving the surface smooth as in the earlier *Reclining Figure: Festival* (cat.121, LH 293) the dry plaster was carved; Moore pock-marked and striated it to give the bronze casts the weathered appearance which makes the figures look as though they have been carved rather than modelled.

The small maquette from which this sculpture was enlarged originated in a fragment of real bone to which the artist attached a head modelled in plasticine; he used the same substance to enable it to stand upright (fig.19). Moore said that when he was at the Royal College of Art he used to visit the Natural History Museum where he was interested by bones, particularly fossilised prehistoric ones. A drawing, cat.72 (HMF 941), testifies to his fascination in the thirties with bones and their transformation into figures. Although some pre-War sculptures, such as cat.36 (LH 192) incorporated bone-shapes, in this sculpture the metamorphosis from bone to figure is complete, so that the wider areas even suggest drapery. The sculpture has subsequently been enlarged

179 Another view reproduced on p. 109

several times, most recently to over twice the size of this one, which was the first, the working model; although small for lifesize, its presence is monumental.

The figure has had other titles, *Standing Figure, Bone*, and unexpectedly, *Winged Figure*, because Moore felt that 'somewhere in this work there is a connection with' the classical Greek *Victory of Samothrace* in the collection of the Louvre. Moreover he hoped that others would see 'something Greek in this *Standing Figure*'. (James, 1966, p.278.) One cast is sited on St Stephen's Green in Dublin where, in 1967, it was unveiled in the artist's presence as a memorial to the poet, W. B. Yeats. This was particularly appropriate because Moore had encountered the notion of a knife edge in connection with a poet. In a 'Preamble' to his modern Odyssey, Edward Sackville-West had described Homer's character Phemius, whom Moore had chosen to illustrate in 1945, as invested 'with something of the mysterious timelessness, the knife edge balance between being and not being, which only the poetic imagination seems able to achieve'. (Sackville-West, 1945, p.13.)

REFERENCE: E. Sackville-West, *The Rescue*, London, Secker and Warburg, 1945.

180 | THREE-PIECE RECLINING FIGURE NO. I 1961–2
Bronze
L.113 ½ in; 287 cm
The Trustees of the Tate Gallery
LH 500

Following close on the two-piece reclining figures (cat.177–8, LH 457, 458), Moore explored the analogy of figure with landscape in an even grander and more dramatic way by increasing the size and consequently the number of individual pieces. Here the articulation of the three forms suggests colossal

vertebrae as well as those unexpected outcrops of rock that may be found on moorland in Britain. Yet, because of our instinctive experience of the human body, we have no difficulty in associating Moore's craggy forms with elements of a reclining figure, especially since they are bronze and therefore man-made. (Had they been hewn in stone it might have been harder to make the connection.)

In a radio interview with David Sylvester in 1963, the artist discussed both the origin of these figures and the difference between two- and three-piece reclining figures. 'In the two-piece you have just the head end and the body end or the head end and the leg end, but once you get the three-piece you have the middle and the two ends and this became something that I wanted to do, having done the two-piece.' About this first three-piece sculpture Moore explained: '... the middle piece, was suggested by a vertebra – of I don't know

what animal it was – that I found in the garden. And the connection of one piece through to the other is the kind of connection that a backbone will have with one section through to the next section. But they've been separated. It's as though you've left the slipped disc out of them, but it's there.'

REFERENCE: 'Henry Moore Talking to David Sylvester', (Extracts from a BBC radio interview) *Henry Moore: Recent Work*, London, Marlborough Fine Art, 1963.

181 | THE WALL: BACKGROUND FOR SCULPTURE 1962
Bronze
L.100 in; 254 cm
The Henry Moore Foundation
LH 483

Originally conceived as a background for *Standing Figure: Knife Edge* (cat.179, LH 481), *The Wall* has subsequently

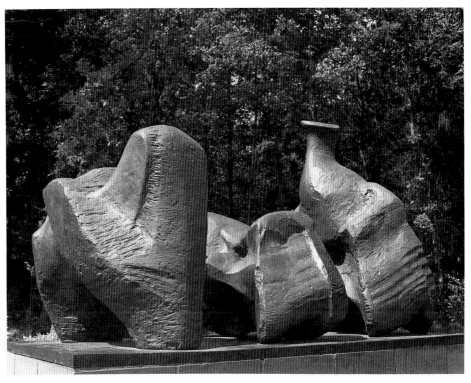

180 Another view reproduced on p.112

taken on the status of an independent work. Its craggy and mountainous form bridges a gap between sculpture and architecture, resolving a dichotomy that had held Moore's attention since 1928 when he had accepted a request to make a relief sculpture for the new Headquarters of the London Underground railway (fig.2). More recently, he had worked on numerous trials for a sculpture to stand in front of the UNESCO building in Paris (see cat.139, LH 414). In many of these Moore had placed a figure against a screen wall (cat.140, LH 418) which provided the sculpture with its own protective environment.

An existing modern building usually presented problems to the sculptor, either on account of its block-like façade (Senate House, University of London, see cat.95, HMF 1424), or because of continuous fenestration (like the UNESCO building, fig.12). Only for the Bouwcentrum in Rotterdam did Moore have the opportunity to shape the façade itself (fig.10) and achieve a freely chosen sculptural modification of the architect's idea.

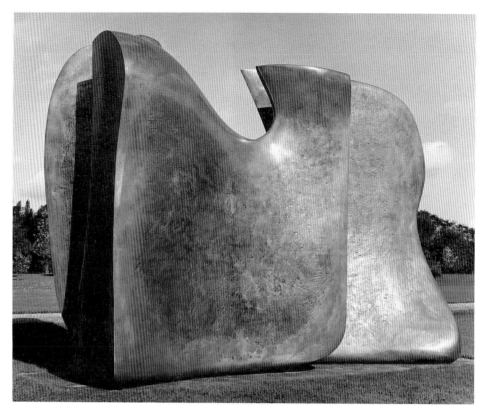

182 Another view reproduced on p.111

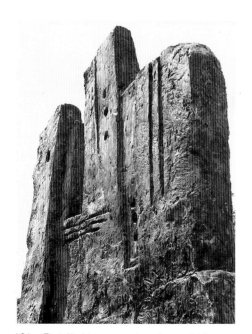

181 Detail. Also reproduced on p.110

182 | *KNIFE EDGE TWO-PIECE*
1962–5
Bronze
L.144 in; 366 cm
The Henry Moore Foundation
LH 516

In Moore's oeuvre, the decade of the sixties is characterised by exploitation of scale and mature freedom of form invention. Here he has brought together characteristics from the *Standing Figure: Knife Edge* of 1961 (cat.179, LH 481) and *The Wall: Background for Sculpture* (cat.181, LH 483) conceived in the same year as this sculpture, which was enlarged from a smaller version dating from 1962. Its innovation lies in the apparent proximity, but physical separation of the elements, which creates an architectural space.

The finish of the great bronze curves, including that of the knife-like element, has an organic connection with bone formations. Moore had described bones as the inspiration for sculpture (see cat.180, LH 500) and he was fortunate in finding a hoard of them in the garden of his Hertfordshire home, Hoglands, where an old dump of sawn animal bones was unearthed. The smooth surface makes a strong contrast with the roughness of *The Wall*, which is textured more like rock formations

183 | *MOON HEAD 1964*
Porcelain
H.12½ in; 32 cm
The Henry Moore Foundation
LH 522

In 1969 Moore agreed to exhibit a sculpture alongside Cycladic pieces in the British Museum and he wrote to the Chairman of the Trustees in June:

The white two-form sculpture I call 'Moon-Head' is one of several recent

'Knife Edge' sculptures I've made — which have all come about through my interest in thin bone forms — for example the breast bones of birds — so light, so delicate, & yet so strong — But I can also think that my Knife-Edge sculptures may be unconsciously influenced by my liking for the sharp-edged Cycladic idols!' (Moore, 1981, p.13.)

The white version referred to may be the original plaster (today in Toronto in the collection of the Art Gallery of Ontario) from which the bronze edition (LH 521) was cast, or this smaller version made in porcelain in 1964 by Thomas Rosenthal. Moore was originally interested in comparing versions in white and black porcelain (Wilkinson, 1979, p.186) and when he decided to make a bronze version he specially treated the casts to give a pale golden patina. The result was that the two parts of the sculpture reflect each other with a 'strange almost ghostly light'. (Hedgecoe, 1968, p.466.) This effect reminded the artist of the full moon and its light and caused him to change the name of the piece to *Moon Head*; in the small version, it was originally called 'Head – Hand', the hand being the piece at the front in the view below.

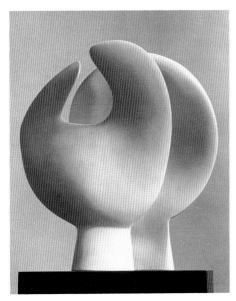

183

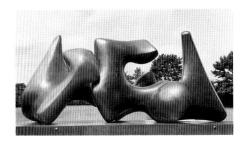

184 Another view reproduced on p.114

184 | *ATOM PIECE (WORKING MODEL FOR NUCLEAR ENERGY) 1964–5*
Bronze
H.46½ in; 118.1 cm
The Trustees of the Tate Gallery
LH 525

Atom Piece is the working model for the twelve-foot-high unique bronze on the University of Chicago campus; this commemorates the twenty-fifth anniversary of the first self-sustaining nuclear chain reaction, achieved in a laboratory there, on 2 December 1942. Moore was approached in 1963 and, although he felt honoured, he was unsure of what to make. While the University of Chicago Committee was visiting Much Hadham to discuss the sculpture, in his studio he found a skull-like maquette, recently made, which they agreed was suitable. This working model is an enlargement from that maquette (LH 524). The underlying idea is related to the helmet heads which Moore had worked on after the ending of the Second World War by atomic bomb attacks on Hiroshima and Nagasaki; as Alan Wilkinson has pointed out, the 'dome-like skull' becomes 'an ominous reminder of a mushroom cloud from an atmospheric atomic explosion.' (Wilkinson, 1979, p.188.) The title of the monument was changed from 'Atom Piece' to *Nuclear Energy* because people might confuse the sound of 'piece' and 'peace' (see fig.13).

While he was making the working model, Moore visited his friends the Huxleys who at the time had an elephant skull in their garden, and he noticed an affinity (Berthoud, 1987, p.347). The comparative ease with which the viewer can make multiple associations to 'read' the meaning of the sculpture, indicates the changed artistic climate of today. Abstract works of art have become so usual that a title now provides clues to understanding. But Moore himself had so enriched his metamorphic ideas begun in the thirties, that his sculptures from the sixties, though 'abstract', retain an organic vitality.

185 | *WORKING MODEL FOR THREE-PIECE NO. 3: VERTEBRAE 1968*
Bronze
L.93 in; 236.3 cm
The Trustees of the Tate Gallery
LH 579

Like so many of Moore's later works this one is based on a maquette that could be held in the hand (LH 578). This enabled the artist to work out the formal relationship of one part to another as well as the placing of one part in relation to

185 Another view reproduced on p.113

another. Although already large, the version shown here is only the working model for a sculpture more than twenty-four feet long (LH 580). The three elements of the working model are intended to be shown closed up together, but in the large size they can be opened out so that the spaces between can be walked through. The artist told the compiler of the Tate Gallery catalogue entry on this work that 'each form resembled the joints between vertebrae. What interested him was the idea of a series or progression of similar forms.' (*The Tate Gallery*, 1981, p.142.)

Moore had explained to David Sylvester in 1963 that the solution to making his first three-piece reclining figure (cat.180, LH 500) had been the finding of 'a little piece of bone' in his garden, which had provided the starting point for the middle element. Six years later he developed the idea with this figure, achieving an organic equivalent to parts of the human body to which the viewer can relate as though they were indeed individual elements of a single spine.

REFERENCES: *The Tate Gallery, Illustrated Catalogue of Acquisitions 1978–80*, London, Tate Gallery Publications, 1981; 'Henry Moore Talking to David Sylvester', (Extracts from a BBC radio interview) *Henry Moore: Recent Work*, London, Marlborough Fine Art, 1963.

186 | **WORKING MODEL FOR OVAL WITH POINTS 1968–9**
Bronze
H. 43¼ in; 110 cm
The Henry Moore Foundation
LH 595

The genesis of the idea for this sculpture is found in a drawing of c.1938 inscribed 'points practically touching' (cat.101, HMF 1496). The immediate result was

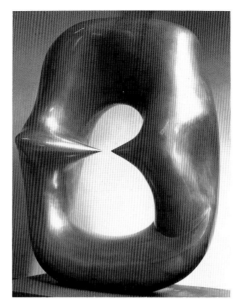

186 Another view reproduced on p.115

the sculpture *Three Points* (cat.40, LH 211) and it was not until the sixties that Moore again took up the idea in several sculptures including *Oval with Points* (LH 596), for which this version is the middle size, the preliminary being the original plaster maquette in the Art Gallery of Ontario, also dating from 1968. The curator of that collection, Alan Wilkinson, recalled a small stone, with two points touching at the centre of a hollowed-out oval form, which he saw on a visit to Moore's studio and thought might account for the idea, as well as the drawing mentioned above. (Wilkinson, 1979, p.204.)

Moore himself felt it was dangerous to look for a single source for his sculptures, and here, by giving such a generalised title, he has left interpretation to each viewer. The working model is related to the contemporary *Two-Piece Points: Skull* (LH 600) where the sharp points appear in a more complex arrangement based on the elephant's skull which Moore was given by Lady Huxley (the wife of Sir Julian) in 1968 (David Mitchinson in conversation with the author).

187 | **ANIMAL FORM 1969**
Travertine marble
L.47¾ in; 121.2 cm
Wexler Collection
LH 616

Throughout his working life Moore occasionally carved animals or their heads (see cat.119–20, LH 301, 302). But in this carving the artist seems to suggest the locomotion as well as the structure of an animal, without recourse to naturalistic detail. The immediate response must be to the derivation from a bone, which enables the viewer to identify the structure as related to his own. Moreover, because it stands on two closely distanced 'front legs' with one of them off the ground, it is read as a four-legged beast, the two back legs joined, like those of a galloping horse which were long imagined as touching the ground at the same time. The sculpture is thus perceived, or received, like Moore's Surrealistic work from the thirties, as so intrinsically organic that the viewer can take its totality without being bewildered by its deviations from nature. By 1969, moreover, the avant-garde had moved so far ahead that Moore's art no longer seemed as extreme as it had done thirty years before. Indeed, notwithstanding his powers of invention, the *Animal Form* with its reassuring title might seem almost comfortingly familiar. The piece exists as a bronze working model

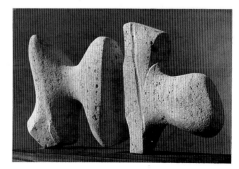

187 Another view reproduced on p.116

(LH 615) and a larger travertine version (LH 617, in the Museum of Modern Art, New York). Both carved versions were made in the Henraux Quarries at Querceta, Italy, where Moore had first used travertine for the UNESCO figure in 1957 (see also cat.8, LH 60).

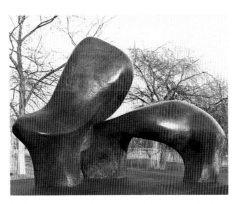
188 Another view reproduced on p.117

188 | **WORKING MODEL FOR SHEEP PIECE 1971**
Bronze
L.56 in; 142 cm
The Henry Moore Foundation
LH 626

It is an awe-inspiring sight to see the large version of this sculpture in the field behind the studios where Moore worked at Hoglands. From the nearby farm gate one sees a meadow sloping gently upwards to a tree-fringed rise with the foreground dominated by the majestic bronze which serves as a shelter for the flock of sheep grazing nearby. Indeed, it is not uncommon to see several sheep lying under its arches. Yet however tempting it may be to imagine the rounded forms as related to the sheep of the title, it is unlikely that the sculpture owes its form to a simplistic analogy; Moore himself was adamant that titles merely allowed the viewer to begin a train of thought.

Alan Wilkinson has connected the piece with the *Large Two Forms* (LH 556) which was the first sculpture that Moore made using polystyrene instead of an armature to support the plaster. Because polystyrene is lightweight, its use made it possible to enlarge a bronze to twenty feet, impracticable using conventional methods (Wilkinson, 1979, p.199). The large scale thus achieved allows the organic, and even, erotic nature of both sculptures to carry the force of architecture. The grandeur gives the celebration of embrace a superhuman quality: even on the smaller scale shown here, the sculpture ranks among the great paeans to sexuality.

189 | **WORKING MODEL FOR HILL ARCHES 1972**
Bronze
L.43 in; 109 cm
The Henry Moore Foundation
LH 635

Although the curved form overshadowing a smaller one had attained a striking measure of perfection in the *Two Forms* of 1934 (cat.22, LH 153), the idea is here expanded and opened out. Moreover, a third element balances the two, extending the protective outer curve so that it becomes part of a semi-circle, an irregular composition that evokes the hill of the title. The result is a new type of sculptural invention, which Moore had already explored in an etching in 1969 (*Projects for Hill Sculptures*, CGM 105), although the forms are less free there. In the sculpture Moore has changed the curves of the arches making them more upright.

A year before this transformation, Moore had been honoured by a retrospective exhibition in Florence, where his sculptures were shown at the Forte di Belvedere. They were thus positioned on a terrace overlooking the towers and domes of the city with views of the hills opposite. Photographs were taken for the catalogue, showing some of his most recent monumental sculptures with the Duomo in the background (see particularly the coloured frontispiece). It is not surprising that Moore was profoundly and creatively stimulated by experiencing his own work in this environment, so steeped in art history, and the new configuration of the arches in this sculpture echoes the ribs of the dome of the Cathedral.

In its enlarged size *Hill Arches* (LH 636) is not self-supporting and is therefore attached to girders, which are usually hidden by grass, gravel or water. These girders provide a strange contrast with the sinuous forms of the cast bronze sculpture. Moore always resisted using such materials associated with modern building techniques as an integral part of sculpture, just as he resisted making welded sculpture from premade sections (although, of course, the parts of a bronze cast are in fact finally welded together).

In this case, a further inspiration may have come from a work by Alexander Calder, whose monumental *Teodelapio*, which is constructed in sheet metal, had straddled the streets of Spoleto since 1962. Moore must have seen it at least in 1967, when he provided his own *Large Torso Arch* (LH 503) as decor for an opera there (see cat.223, HMF 81 (227)).

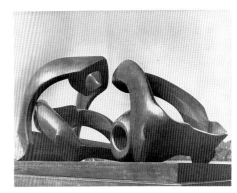
189 Another view reproduced on p.118

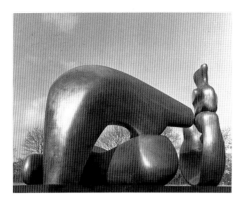

190 Another view reproduced on p.119

190 | LARGE FOUR-PIECE RECLINING
 | FIGURE 1972–3
 | Bronze
 | L.158¼ in; 402 cm
 | The Henry Moore Foundation
 | LH 629

In the early sixties Moore had extended the repertoire of sculptural form by creating monumental reclining two- and then three-piece sculptures with the parts separated one from another, carrying the metaphor of figure and landscape further than he had before (cat.177, 180, LH 457, 500). In the early seventies when he came to make this figure in four pieces, he seems to have found inspiration in his earlier works from the thirties. He had then experimented on a small scale with a *Four-Piece Composition*, subtitled *Reclining Figure* (cat.20, LH 154), which has a tenuous relationship to the viewer's experience of the rounded forms of the human body. Here, from some viewpoints, there is a connection between the elements and the human skeleton. From experience of Moore's use of bones as a starting point for sculpture, the organic forms, ordered in sequence, appear as an equivalent of the head, the torso, the pelvis and limbs in their most basic structure.

It is clear from an interview that Moore gave David Sylvester in 1963 (just before his first three-piece reclin-ing figure – cat.180 – was exhibited) that he was fascinated by the idea of being able to make an analogy to a spine. What he said on that occasion seems parti-cularly applicable to this figure, made ten years later: 'I realised then that perhaps the connection through, of one piece to another, could have gone on and made a four- or five-piece, like a snake with its vertebrae right through from one end to the other.'

REFERENCE: 'Henry Moore Talking to David Sylvester', (Extracts from a BBC radio interview) *Henry Moore: Recent Work*, London, Marlborough Fine Art, 1963.

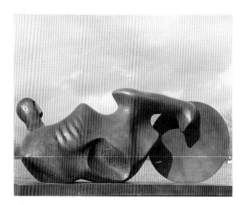

191 Another view reproduced on p.121

191 | GOSLAR WARRIOR 1973–4
 | Bronze
 | L.98 in; 249 cm
 | The Henry Moore Foundation
 | LH 641

This majestic figure is named after the city in West Germany where the first cast was placed. Although related to the earlier warriors made in the fifties (cat.138. LH 405, and LH 404), it is both less representational and more forceful. In the earlier *Falling Warrior* Moore had wanted to represent the moment before death, here even the idea of death seems somehow irrelev-ant, since such sure balance is achieved by the poised head acting as a perma-nent counterbalance to the shield. As in the earlier figures, Moore has used a type of round shield similar to one from a relief on a metope from the Acropolis (see cat.128, LH 360). However, the *Goslar Warrior* seems more like one of the larger figures of the Elgin Marbles – thought to be Dionysus or Heracles – from the left side of the east pediment. Earlier in his career such an antecedent would have been unthinkable, but in his maturity Moore so transformed any underlying source that even to mention it is almost irrelevant, except that it links him with the classical tradition of sculpture-making, in which the human figure is never abandoned.

192 | MAQUETTE FOR RECLINING
 | MOTHER AND CHILD 1974
 | Bronze
 | L.7¼ in; 18.4 cm
 | The Henry Moore Foundation
 | LH 647

Twenty years earlier, Moore had made one of his most enigmatic inventions of a mother and child, a bronze seated figure nearly twenty inches high, joined to a ferocious-looking creature, whose bird-like head is poised, open-mouthed, over her stylised breast, which itself looks like an egg (LH 315). Alan Wilkinson drew attention to the connection with the incisions on an ancient Peruvian pot, photographed in a book belonging to the artist (Wilkinson, 1977, p.44). Here the baby cradled by a reclining figure has something of the same angularity, though it lacks the savagery: the primi-tive connection seems to be with a swaddled Red-Indian papoose. Indeed, the baby has become an object, such as the mirror for a reclining nude to hold up, that another artist might give to his model. But Moore's choice of symbol is

vital to the work, for a child is not the image of its mother but her fruition, so he has ensured that it does not resemble her but fulfils her: the *unlikeness* is integral to the meaning. His earlier reclining figures were too self-contained or analogous to landscape to encompass a child; but here Moore has succeeded in combining two of his dearest images.

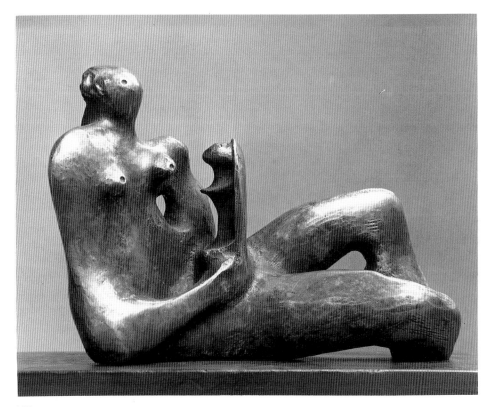

192

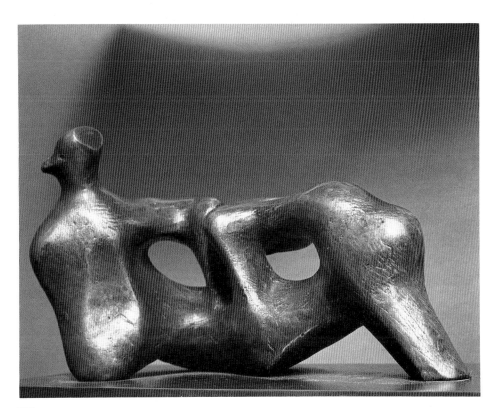

193

193 | *RECLINING FIGURE: HOLES*
1975
Bronze
L.9¼ in; 23.5 cm
The Henry Moore Foundation
LH 656

This maquette gave rise to the last of Moore's elmwood reclining figures (LH 657) which was carved from 1976–8 and first shown at the exhibition held at the Serpentine Gallery to celebrate the artist's eightieth birthday. After inclusion in an exhibition of drawings at Wildenstein (1979, ex. cat.), it was lent to the Metropolitan Museum and serves as a reminder in New York of Moore's lasting powers of invention. Like the slightly earlier *Goslar Warrior* (cat.191, LH 641) the concept of this *Reclining Figure* is not a new one, indeed, where the previous warriors date from the fifties, the antecedents for this figure are found in carved reclining figures from the thirties. But the play on the hole is here within the realms of the possible in nature, the first being provided by the left arm bent at right angles, the second by the junction of elbow and knee, the third by the left leg with foot resting on the right knee, and the fourth triangular hole, indicating the bent right leg. In practice, the wooden enlargement, which is over life-size, does not allow such a simplistic reading and the holes convey the mystery of a figure experienced as land-

scape. This idea remained so fruitful to the artist that he continued to use it in watercolours even later in his life, for instance, cat.232–3 (HMF 82 (359, 360)).

194 | STANDING MOTHER AND CHILD 1975
Bronze
H.9 in; 23 cm
The Henry Moore Foundation
LH 683

In his late years Moore made a number of sculptures of the Mother and Child, a subject that had fascinated him throughout his life. He used the technique he had developed in the fifties, of building up plaster on an armature. Unlike clay, which only remains pliable if wet, plaster can be added to even when it has dried out. Furthermore, when it is dry it can be worked with a variety of tools, so the technique becomes more like carving. Moore described it to Gemma Levine: 'Good quality plaster mixed with water sets to the hardness of soft stone. I use plaster for my maquettes in preference to clay because I can both build it up and cut it down. It is easily worked, while clay hardens and dries, so that it cannot be added to.' (Levine, 1978, p.124.) 'Any tools can be used for plasterwork, for example, kitchen tools such as cheese graters or nutmeg graters, spatulas, knives, or anything.' (Levine, 1978, p.114.) Here the marks of such tools are very obvious even in a photograph of the maquette, which was never enlarged. Both mother and child have a degree of naturalness provided by the relationship of the heads which allows recognition of the subject; nevertheless, the figures are linked almost as closely as the *Mother and Child* (cat.30, LH 165) carved nearly forty years before.

REFERENCE: G. Levine, *With Henry Moore: The Artist at Work*, London, Sidgwick and Jackson, 1978.

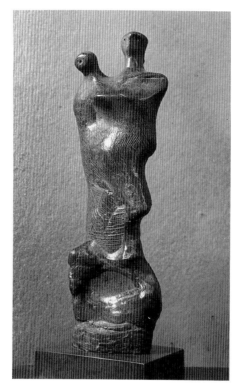

194

195 | MAQUETTE FOR RECLINING FIGURE: ANGLES 1975
Bronze
L.9¼ in; 23.5 cm
The Henry Moore Foundation
LH 673

The sub-title given to this sculpture aptly describes the character of the pose. Although the figure is related to the *Draped Reclining Figure* made for the Time and Life Building in 1952–3

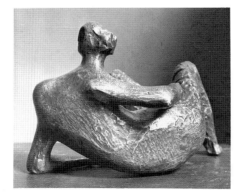

195

(cat.127, LH 336), it is more confident, if not ruthless, than that earlier one which has an aura of surprised classicism, with its softly rendered drapery. *Angles* turns her head with a look of defiance: her left shoulder juts out sharply and her right is almost distorted, seen from the back view. Although throughout the greater part of his mature working life Moore had created analogies between the female form and the landscape, approaching his eightieth year, he apparently felt able to return woman to herself. It seems as though he could afford to explore a more representational figure, saved from the too sensual women of Maillol or Renoir by his own oeuvre and his continuing admiration for Cézanne. Over the years Moore had often worked simultaneously on the enlargement of two ideas, usually a cast figure and a carved one; in this case, the enlargement from maquette to the bronze working model (LH 674) with its solid form makes an interesting contrast to the contemporary pierced elmwood carving *Reclining Figure: Holes* (LH 657) which originated in the maquette cat.193 (LH 656).

196 | HEAD 1976
Black marble
H.15 in; 38.1 cm
Private Collection
LH 701

At various times in his life Moore chose the head alone as a subject for sculpture; beginning with masks based on primitive models in the twenties, he lessened the likeness to the expected appearance in both carved and modelled heads. None the less, this head, carved in black marble towards the end of his life, is completely identifiable as human in spite of the unexpected protrusions on the left side of the skull. These resemble in miniature the abstracted forms of larger sculptures, as though they were

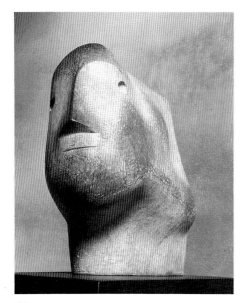

196

emanating from the contemplative head itself.

The surprising texture as well as the sharply defined nose make a contrast to the wafer thin sections and ultra-smooth surface of the earlier *Moon Head* (cat.183, LH 522) though there is an unexpected connection between the two sculptures. As has been mentioned in the notes for *Moon Head*, Moore was originally interested in comparing versions in black and white porcelain. He was unable to do so as only white porcelain and bronze versions were made; he did not achieve a black porcelain example. If Moore was still interested in the contrast of white and black when he made this head, it provided a comparison indeed. For black marble naturally lacks the translucence of white porcelain and by choosing not to create a polished surface he has suppressed all possibility of the sculpture reflecting light.

197 | **RECLINING FIGURE: HAND 1979**
Bronze
L.87 in; 221 cm
The Henry Moore Foundation
LH 709

Moore has described his fascination for the reclining figure which provided a recurring theme for his sculpture throughout his life. In the sixties the figure became closely identified with landscape, but in the mid-seventies Moore returned to a mode which allows the viewer to relate the sculpture more closely to the human form. In 1976 he made the maquette on which this sculpture is based; it is less representational than the one for *Reclining Figure: Angles* (cat.195, LH 673), which was also enlarged to nearly the same size as *Reclining Figure: Hand* in 1979. This was the year after Moore had completed the elm-wood reclining figure with its subtitle *Holes*, to which the present sculpture is related (see cat.193, LH 656), but here the malleability of bronze casting has paradoxically given rise to a figure of greater bulk with its parts no longer pulled apart but compressed into forms of mysterious power. The torso could be a discrete sculpture, heaving itself upright from the ground: the rest of the body is wrapped and seems related to drawings of shrouded figures from the forties, especially the *Crowd Looking at a Tied-up Object* (see cat.167, HMF 2385). No doubt such drawings were generated by the necessity for a sculptor to wrap clay models in wet cloth if he had to leave them, for instance, overnight; otherwise the clay would dry out and further work would be impossible. Moore has explained his rejection of clay in the forties in favour of plaster which did not create that problem (see Levine, 1978, p.124). Here, the shrouded surface of the figure serves as a kind of equivalent of skin, through which the underlying bony structure

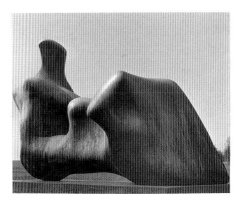

197 Another view reproduced on p.120

presses. The result is not perceived by the viewer as an anatomical reality, but experienced as an internal awareness of the physical stresses and forces of the human body.

REFERENCE: G. Levine, *With Henry Moore: The Artist at Work*, London, Sidgwick and Jackson, 1978.

198 | **MOTHER AND CHILD: TOWEL 1979**
Bronze
H.10⅝ in; 27 cm
The Henry Moore Foundation
LH 763

In the fifties when Moore was considering the subject for the UNESCO sculpture he made several almost narrative maquettes for a bronze mother with her child. In one, the seated mother holds an apple in her right hand and supports the baby on her knee with an awkwardly positioned left arm while the baby reaches forward towards the apple (LH 406). In spite of its title, there is no such narrative content in this maquette, even though like cat.200 (LH 876), the relationship between mother and infant is more explicit and detached than it had been in Moore's early years. At that time he had explored the intimacy of a mother with her infant and physical proximity suited his chosen medium,

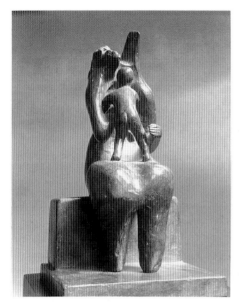

198

stone carving. In this late bronze, anecdotal detail is reserved for the child and the unexpected abstraction of the mother's head creates an archetypal detachment.

199	*STANDING FIGURE 1982*
	Bronze
	H.9 in; 23 cm
	The Henry Moore Foundation
	LH 866

Moore's preferred subject was the human figure, standing, seated or reclining. There are as many drawings of the standing model in the twenties as other drawings from life; there are many abstracted drawings of upright figures in the thirties, most of them ideas for sculpture. None the less, in sculpture, reclining and seated figures far outnumber standing ones, perhaps for technical reasons rather than imaginative ones; Moore's standing figures include some of his most potent ideas. There is the *Upright Motive No. 1*, evocatively named *Glenkiln Cross* (cat.134, LH 377). The *Standing Figure Knife-Edge* has a resonant alternative title, *Winged Figure* (see

cat.179, LH 481) which reactivates Greek ideals in a totally twentieth-century idiom. The *Upright Internal/ External Form* (cat.118, LH 295), though lacking a head, encapsulates the inherent dualism of the free spirit and the rigidity of the encapsulating persona, or, as Moore himself saw it, the child protected by the mother. This late figure, now complete with head, may be seen as an amalgam of these ideas. It has some of the formal elements of all three, with the symbolism of the upright internal/external forms. But the inner form is no longer enclosed; it resembles a beating heart nestling against the breast instead of an infant, sheltered and protected. Dualism is present but resolved in this maquette that was never enlarged and retains the imprints of the artist's hands.

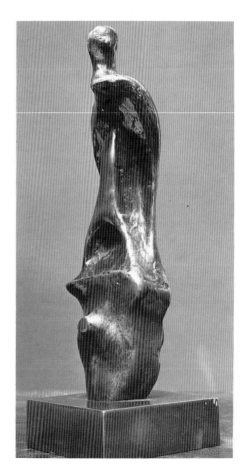

199

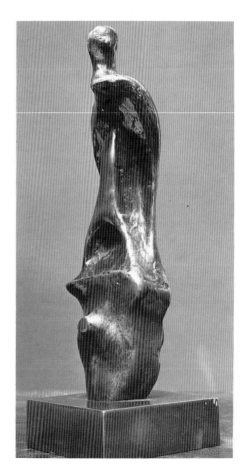

200

200	*SEATED WOMAN HOLDING CHILD 1982*
	Bronze
	H.6⅞ in; 17.5 cm
	The Henry Moore Foundation
	LH 876

Following the birth of his first grandson, Moore again took up the theme of mother and child that had engaged him so often before. In this tiny maquette he has balanced the curiously upright form of the infant against the erect back of the seated mother. Seen from the rear, the mother's broad back seems to enclose the fragile child; from another viewpoint her knees and arms form an enclave to protect it from the surrounding world. In the thirties he had expressed the sheltering nature of motherhood in the abstracted *Two Forms* (cat.22, LH 153) which he had formalised in a bronze of 1981 (*Point and Oval*, LH 819). The idea has found expression here in a more explicit way, but still without the risk of story telling that might have made the theme sentimental.

201 | WORKING MODEL FOR MOTHER AND CHILD: HOOD 1982
Bronze
H.30 in; 76 cm
The Henry Moore Foundation
LH 850

Over thirty years after the completion of the commissions to make a Madonna and Child for two churches (St Matthew's Northampton and St Peter's Claydon, Suffolk, cat.102, LH 226, and LH 270), the large carving based on this working model found a home in St Paul's Cathedral, where the seven-foot-high version in travertine marble (LH 851) was dedicated in 1983. Unlike the earlier carvings, for which Moore had taken full account of the fact that he was sculpting no ordinary Mother and Child, this image, conceived in his last year of working, is neither intended as Mary and Jesus, nor can it be interpreted literally.

The working model differs both from the carving and the maquette (LH 849) from which both larger versions were derived; this is particularly the case from front view, where the child seems to be displayed on formalised drapery. All three versions convey the protective feeling that a mother has for her child; Moore has paradoxically encompassed the sheltering nature of the relationship by avoiding representation. In many ways he has returned to ideas that he had explored in the thirties; particularly relevant is the upright elmwood *Mother and Child* (LH 194), belonging to the Museum of Modern Art in New York, with its flattened hood-like forms. Like *Mother and Child: Hood* it suggests rather than informs, but the late sculpture with its curving stance, appeals at an even deeper level to the feelings about motherhood which the viewer is sometimes reluctant to explore.

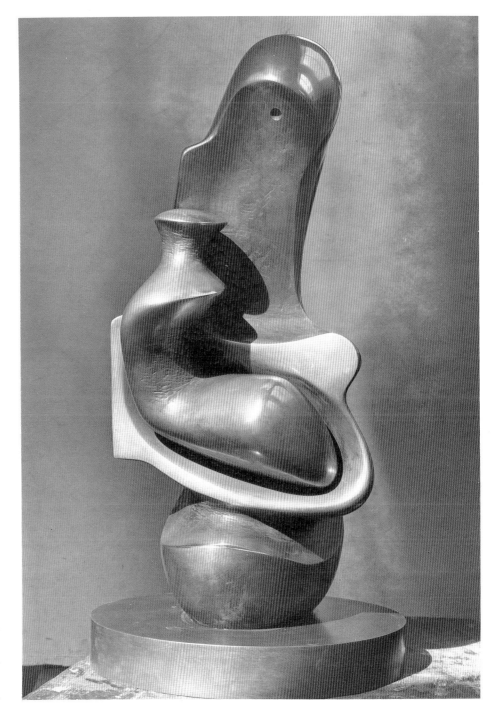

201

271

DRAWINGS
1970–1983

202

202 | PAGE FROM SKETCHBOOK
1970–71: STORM AT SEA 1970
Pen and ink, white gouache
6⅞ x 10 in; 175 x 254 mm
The Henry Moore Foundation
HMF 3272

This page is from a sketchbook which included many 'pen exercise' drawings, all made in 1970, a year when, Moore later said, he had been inspired by pen drawings by Rembrandt. On that occasion this admission was accompanied by the reproduction of Rembrandt's *Saskia Asleep in Bed*, in the collection of the Ashmolean Museum, Oxford, but Moore generally worked from postcards and reproductions of drawings, which he pinned on the wall or had lying on his desk. Alan Wilkinson has identified this drawing as an adaptation of Rembrandt's *Christ in the Storm on the Sea of Galilee*, in the Kupferstichkabinett, Dresden (Wilkinson, 1977, p.135). Moore himself told Wilkinson that it was inspired by a storm that he had seen from his house near the beach at Forte dei Marmi in Italy; it could be argued

that the two sources are not incompatible. Moore particularly admired what he called the 'calligraphic flourishes' in Rembrandt's drawings and said that in his own pen exercises he was finding 'expressive pleasure in the free use of pen and ink. The drawings began in that way, and some of them I later turned into figures or landscape ...'. (Transcription of a tape recording, *Henry Moore Drawings*, 1979, p.56.) The related etching, CGM 156, was based on this drawing.

203 | PAGE FROM SKETCHBOOK
1970–71: PEN EXERCISE NO.
XVIII: MOTHER NURSING CHILD
IN SUMMER HOUSE
Brush and ink wash, felt-tip pen,
wax crayon, pen and ink
10 x 6⅞ in; 254 x 175 mm
The Henry Moore Foundation
HMF 3257

The calligraphic style makes a link with a number of drawings which Moore began in 1970 in response to visiting the Harari collection of Japanese art in the

Victoria and Albert Museum. 'For about a year, in responding to this, I got conscious enjoyment from doing pen exercises', he told Pat Gilmour when she was preparing a catalogue to celebrate the artist's gift of prints to the Tate Gallery (Gilmour, 1975, p.16). He has varied his marks from those indicating the background, which are abstract, to the more representational ones on the right. There is a certain amount of overlap, so that similar marks are repeated beyond the outline of the figures, thus blurring the 'sense' or perhaps suggesting movement. This is especially apparent near the mother's right arm and the head of the child and may indicate that she is rocking her child. Before drawing with pen and ink, he wetted the paper so that the ink would run. This caused the random marks which characterise these 'pen exercises'.

REFERENCE: P. Gilmour, *Henry Moore Graphics in the Making*, London, Tate Gallery Publications, 1975.

203

204

204 | **PAGE FROM SKETCHBOOK 1970–71: IDEAS FOR SCULPTURE 1970**
Pen and black ink, brush and ink, wash, black chalk
6⅞ x 10 in; 175 x 254 mm
The Henry Moore Foundation
HMF 3302

This sheet of sculptural ideas makes a strong contrast to the one of ten years earlier (cat.176. HMF 3029). At that time the artist seemed to be developing a much more painterly style in response to his interest in lithography, but here his pen nib seems to have scratched the paper, as though he were using an etching needle on a copper plate. This is not surprising, because two etchings of reclining figures (CGM 195 and 204 of 1970 and 1972 respectively) were based on forms in this drawing which was originally vertical as can be seen by the second signature. In that form there were six ideas for sculpture. The alterations make it resemble a 1966 lithograph. *Ideas for Sculpture* (CGM 60), which shows a more clustered group of half-length figures with a clearer relationship to human anatomy. In the new spirit of 'pen exercises' (see cat.203, HMF 3257) Moore here felt free to link his torsos both sideways and vertically, uniting what appear to be separate figures into unexpected groups.

205 | **STONEHENGE 1972**
Charcoal (washed), pen and ink, black chalk (or chinagraph)
10⅝ x 7¾ in; 270 x 197 mm
The Henry Moore Foundation
HMF 3431

Moore told Stephen Spender that he had been fascinated by Stonehenge since childhood and had first seen the ring of standing stones by moonlight in 1921. This is one of ten drawings that he made from photographs in preparation for a portfolio of prints (CGM 207–23) with an introduction by his poet-friend. He began by making two etchings (CGM 202, 203), but since his aim was to convey the variations in texture of the weather-beaten stones, he found lithography a more suitable medium. In the present drawing he has chosen a close-up view between the stones; this emphasises the enclosed, mysterious space, where magical rites may have been performed by the ancient people who erected them.

205

206

206 | **CLASSICAL LANDSCAPE WITH TEMPLE** c.1972

Charcoal, crayon, chalk

$8\frac{3}{4}$ x $11\frac{7}{16}$ ins; 213 x 290 mm

The Henry Moore Foundation

HMF 3436

When Moore began drawing again in earnest in the early seventies after a period when he had preferred print-making, he sometimes reconsidered earlier subject matter. Just as cat.207 (HMF 3314) contains enough elements to provoke comparison with previous drawings, this classical landscape evokes the *Stones in Landscape* (cat.85, HMF 1259) from 1936. However, that drawing gives a surprisingly flat effect and Moore has here piled up and exaggerated the foreground rock formation to convey extra depth. He has balanced it with a distant edifice suggesting a Greek temple, not, as in 1936 by means of white lines superimposed on a landscape, but by incorporating it into the landscape where it seems to belong. In 1979 Moore admitted that, 'In my drawings of landscape, a human scale is sometimes given by the presence of a temple, church steeple or similar object.' (Transcription of a tape recording in *Henry Moore Drawings*, 1979, p.22.)

207 | **THREE SEATED MOTHER AND CHILD FIGURES** 1971

Charcoal, wash, Indian ink wash, chinagraph

$11\frac{3}{4}$ x 17 in; 298 x 432 mm

The Henry Moore Foundation

HMF 3314

207

Lifelike only in the bulkiness of form, these figures are a re-creation in contemporary terms of ideas from earlier periods of Moore's working life. They do not conform to his realistic approach to the subject in the twenties to be seen in the *Montage of Mother and Child Studies* (cat.64, HMF 731), though one of

the figures in that collage holds a puppy and the centre figure here holds a small cat on her knees as well as a barely defined baby. In the forties Moore had often arranged his figures in threes in compositions where they have been interpreted as the Three Fates (see cat.164, HMF 2266). The three bulky figures depicted here are even less representational than those *Three Seated Figures* of 1944; the bone-like split heads and distorted but sculptural bodies are a reminder of the many maquettes for women, sometimes with children, dating from the early fifties. However, the babies are here attached to their mothers both more literally and symbolically.

By restricting colour, Moore has achieved a new effect somewhat akin to the tonal under-painting often employed by Old Masters, though he may have been thinking of Seurat's drawings. Their connection with Moore is discussed in the notes for cat.221 (HMF 80(305)).

208	PAGE FROM BLUE HOMEWORK NOTEBOOK: GIRL DOING HOMEWORK 1973

208 | *PAGE FROM BLUE HOMEWORK NOTEBOOK: GIRL DOING HOMEWORK 1973*

Wax crayon, watercolour and pastel wash, pen, brush and ink, black crayon

9 1/16 x 6 15/16 in; 230 x 176 mm

The Henry Moore Foundation

HMF 73/4(6)

208

There are two homework drawings in a sketchbook of 1954 and Moore returned to the subject, making ten more drawings in a sketchbook dated 1967–74; there are also six etchings entitled *Girl Doing Homework, I–VI* (CGM 326–31). The artist remembered that he began the subject when his daughter had to do homework in her school holidays. As a possible idea for sculpture, he saw 'the human form connected but contrasted with architecture, with the geometric forms of the furniture (which is a kind of architecture)'. (Transcription of a tape recording, *Henry Moore Drawings*, 1979, p.55.) In the series of drawings the child is shown, not only in a variety of positions, but with different chairs, tables, or desks. In addition there was scope for psychological interpretation; Moore explained: 'The idea also aimed at expressing the girl's mental struggle, the concentration needed to do something like homework – activity in the mind going on without physical activity.' (ibid, 1979, p.55.) Moore has used a variety of media; he had first discovered cheap wax crayons from his young niece in the late thirties and had exploited them for the 'resist' they gave to subsequently applied colour. In this case he has used watercolour and pastel with ink and black crayon to provide extra density and depth.

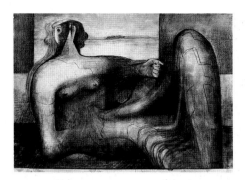

209 Reproduced in colour on p.161

209	RECLINING WOMAN IN A SETTING 1974

209 | RECLINING WOMAN IN A SETTING 1974

Charcoal, pastel and watercolour wash, conté crayon, chinagraph

13 x 19 in; 330 x 483 mm

The Henry Moore Foundation

HMF 73/4(17)

The monumental nude imagined here owes something to the life drawings that the artist had made in the twenties, for it includes the 'sectional lines' he had invented to increase the three-dimensional effect, and he has given the woman a relatively naturalistic head. However, the figure owes its freedom of pose to his own recent sculpture, as can be seen by the daring conjunction of one view with another. Beginning with the head and shoulders, the greater part of the body is placed parallel to the picture plane, a position emphasised by the forceful gesture of the upper arm and hand. In contrast, the lower part of the body, with raised left knee and a right one that is anatomically implausible, sweeps suddenly round into a front view, threatening to disturb the equilibrium. To keep compositional unity, Moore has used the device of dark and light rectangular areas behind and adjacent to the figure, which create a secondary rhythm, rather like an accompaniment, to give the design additional balance. There is also a lithograph (CGM 332) of the same title which is based on the drawing.

210 | LANDSCAPE WITH BONFIRE IX 1975

Pencil, watercolour and wash, pastel, black chalk

10 13/16 x 13 in; 275 x 330 mm

The Henry Moore Foundation

HMF 75(27)

The inspiration for a series of drawings of this subject came from the fires that the artist's wife often lit to dispose of the garden rubbish. Irina is a celebrated gardener and over the years she has designed the grounds round the scattered studio buildings in an informal but effective way, so that there is plenty of open space to site sculptures, with groups of informally planted trees screening one area from another. Moore has imagined a view including the hill in the sheep field beyond his studios; in this drawing, it seems to form part of a valley, perhaps transported from the Dales of Yorkshire. He described how, looking at his wife's bonfires, he wanted to express the movement of the rising smoke. 'The bonfire drawings, like those of trees, have a connection with my ideas about sculpture: from a static base, the flames move upwards with a twisting rhythm.' (Transcription of a tape recording, *Henry Moore Drawings*, 1979, p.26.)

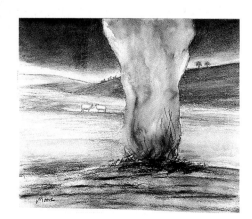

210 Reproduced in colour on p.162

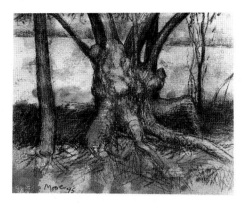

211 Reproduced in colour on p.163

211 | TREES VII 1975

Wash offset, charcoal, conté crayon

8 3/8 x 10 7/16 in; 213 x 265 mm

The Henry Moore Foundation

HMF 75(35)

By using blotting paper as a support, Moore was able to place watercolour where he wanted it, knowing that it would spread automatically and give an element of chance to his work. Indeed, he could even make use of blots and splashes in the way, as he said himself, that the English watercolourist, Alexander Cozens had done in the eighteenth century. When exhibited in 1979, this drawing was subtitled *Hedgerow Trees, Gnarled Trunk* and Moore explained,

Between two of our fields, where the sheep graze, there is an old hedge. Some parts of it must be nearly two hundred years old. It has been chopped down again and again, it has been neglected, and severely massacred. So it has a long history, and its roots and branches suggested to me human figures — tortured, crucified and upside down. (Transcription of a tape recording, *Henry Moore Drawings*, 1979).

212 | NORTHERN LANDSCAPE 1977
Charcoal, chalks, pencil, gouache, watercolour
$8\frac{3}{4}$ x $6\frac{7}{16}$ in; 222 x 164 mm
The Henry Moore Foundation
HMF 77(19)

Although Moore had left Castleford in Yorkshire in 1921 he retained loyalty and affection for the county that had provided his early surroundings. Even in the industrial areas there is a sense of expansive wilderness that is unrivalled in the agricultural lands of Norfolk, Kent and Hertfordshire, where he subsequently lived (when not in London). This *Northern Landscape* gives the impression of an imaginary space, conjured from the depths of the artist's imagination. He worked on blotting paper, a technique which, he said, 'could be compared with the blot drawings of Alexander Cozens who made splashes of ink on paper and turned them into landscapes'. (Transcription of a tape recording, *Henry Moore Drawings*, 1979, p.22.) In this drawing, the undulating terrain lies like a mantle over underly-

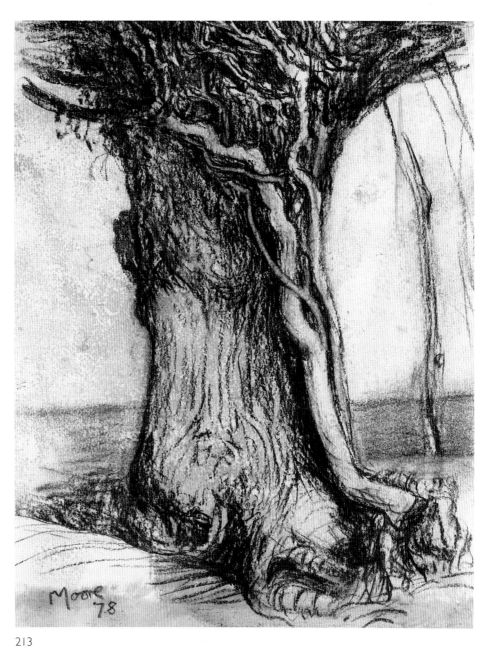

213

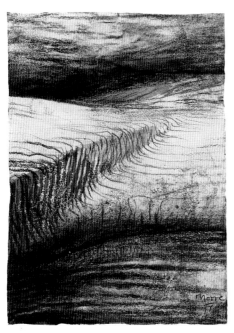

212

ing formations, creating an analogy with the human skin that covers bones. That such effects came instinctively to Moore can be seen in his *Landscape Interpretation from the 'Portrait of Conrad Verkell' by Albrecht Dürer (1508)* (cat.219, HMF 73/4(23)).

213 | TREE WITH IVY (OAK AND IVY) 1978
Charcoal on watercoloured blotting paper
$11\frac{1}{8}$ x $8\frac{11}{16}$ in; 283 x 221 mm
The Henry Moore Foundation
HMF 78(5)

In his later years Moore derived much of his inspiration from the landscape around his home in Hertfordshire. Trees particularly interested him, and he saw the human figure in their gnarled

shapes: '... their limbs branch out like arms and legs from the trunk of a figure.' (Transcription of a tape recording, *Henry Moore Drawings*, 1979, p.18.) In this drawing he has suggested the almost human dependence of the lithe ivy on the massive trunk to which it clings, before the mingling of branches takes place. The artist particularly noticed root formations, also describing them in terms of human figures; indeed, he entitled the related graphic *Bole and Creeper* (CGM 547). The roots of ivy and oak are prominent in this drawing, illustrating another of Moore's observations: 'The immobility of a tree, rooted in the ground, has the kind of stability that I like in sculpture. (A sculpture jumping off its pedestal is something I greatly dislike.)' (ibid, 1979, p.18.)

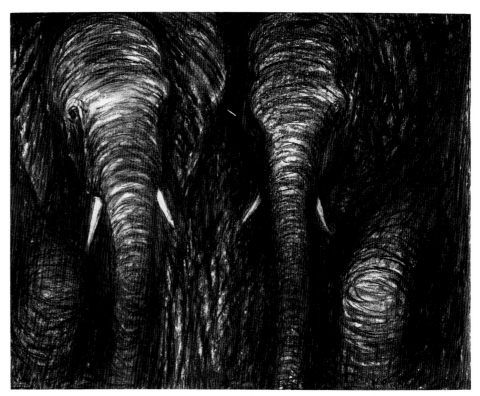

214

214 | FOREST ELEPHANTS 1977
Charcoal, chalk
12⅛ x 15¼ in; 307 x 386 mm
The Henry Moore Foundation
HMF 77(14)

Moore had been given an elephant skull by his friends Juliette and Julian Huxley in 1968, and, in 1970, his portfolio of thirty-seven etchings of the subject was published by Gerald Cramer in Geneva. Because Moore had found the cave-like interior of the elephant's skull so fascinating, it is not surprising that he subsequently turned to the head of the living animal. Later he drew single close-up heads in pencil (HMF 80(213), 80(214)), but here he has placed two together and exploited the blackness of charcoal to suggest the darkness of the forest, the natural habitat of these great, grey beasts. The drawing was used as the poster for an exhibition of Moore's late drawings held in New York at Wildenstein in 1979, although it was not included in that catalogue; there is also an earlier related drawing

for an etching, with a third elephant's trunk to the left (HMF 74/6(29), CGM 502).

REFERENCE: H. Moore, *The Elephant Skull*, Geneva, Cramer, 1970.

215 | THE ARTIST'S HANDS 1977
Carbon line, ballpoint, charcoal, faded felt-tip pen
12¹⁵⁄₁₆ x 9½ in; 329 x 241 mm
The Henry Moore Foundation
HMF 77(10)

In a notebook begun in 1969 there are ten drawings of the artist's hands; in addition he made some larger drawings and related lithographs and etchings (CGM 553–7). In 1979 he said that he felt the expressive power of hands to be almost as important as that of the head and face, a quality he had noticed in the work of other artists, particularly Rembrandt: 'If one likes drawing hands, as I do, the nearest model is one's own two

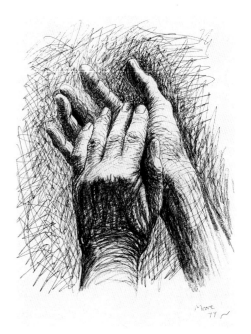

215

hands. These drawings were made to study hands generally.' (Transcription of a tape recording, *Henry Moore Drawings*, 1979, p.10.) Even in his earliest days Moore was interested in hands; he

278

told Donald Hall in 1960 that the hand he had modelled when he was a student at Leeds College of Art had been sent to other art schools to show how it should be done.

REFERENCE: D. Hall, 'An Interview with Henry Moore', *Horizon*, Vol.III, no.2, New York, 1960.

216 | *DOROTHY HODGKIN'S HANDS 1978*
Charcoal, pencil
9 15/16 x 12 7/8 in; 252 x 327 mm
The Henry Moore Foundation
HMF 78(43)

After the twenties Moore had rarely drawn portraits – an exception are the heads of Stephen Spender (HMF 1069–72) – but in 1978 he was asked by the Vice-Chancellor of Oxford University, Sir Rex Richards, to draw the hands of the Nobel Prizewinner, Dorothy

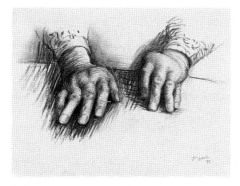

216

Hodgkin, since he knew of Moore's liking for the subject. Like Sir Rex, Dorothy Hodgkin was a Fellow of the Royal Society, which wanted a portrait of her, because of her distinguished work on X-ray crystallography. She had achieved her scientific study in spite of having suffered from childhood from an arthritic condition of the hands, which many people might have found an insuperable handicap. Thus she was happy for her hands to represent her as a

portrait, and one of Moore's drawings now hangs in the Royal Society (see transcription of a tape recording, *Henry Moore Drawings*, 1979, p.13). The final drawing was worked up from a number of studies which Moore drew of the misshapen hands in a variety of positions, upturned, sideways on, or, as in the present instance, front view, always resting on a table and conveying the immense determination underlying the infirmity.

217

217 | *THE ARTIST'S FEET, TWO STUDIES 1979*
Charcoal, ballpoint pen, wax crayon, watercolour
8 1/4 x 12 1/16 in; 204 x 306 mm
The Henry Moore Foundation
HMF 79(59)

This monumental drawing was executed from sketches and photographs of the artist's own feet, made on the beach at Forte dei Marmi in June 1979. In conversation with the present author, just a few days before he died, Moore attributed his longevity to his regular summer visits to Italy which he had clearly so much enjoyed. In these studies he has imagined the foreshortened view that he could only have obtained when lying at full length with his head raised in a most uncomfortable position, or photographed with the camera held at arm's length. Yet, in spite of the apparent naturalism, the viewer is reminded of sculptures from the past, the remains of dismembered

classical figures, imagined, perhaps, by de Chirico.

In his own sculptures of reclining figures, Moore often omitted the feet because they would have added an element of inappropriate realism; an exception is the *Draped Reclining Figure* (cat.127, LH 336), itself remarkably classical in conception.

218 | *GUS ASLEEP (IN HIS BOILER-SUIT) 1978*
Ballpoint, pencil, watercolour, gouache
12 1/8 x 9 5/8 in; 307 x 245 mm
The Henry Moore Foundation
HMF 78(63)

Moore rarely wrote a title on his drawings, but here he has done so because the subject was his first grandchild, whose birth in 1977 gave him intense pride and joy. This he has celebrated by drawing from the life the perfect model, a sleeping child, totally relaxed and unmoving. It creates a strong contrast with the less representational drawing of a *Mother Nursing Child in Summer House* (cat.203, HMF 3257) of eight years before, where the baby is suggested rather than observed. As was

218

the case thirty years previously, when his own daughter was born, Moore accurately records the real child, showing that he had never lost his skill at life-drawing.

219

In 1979 Moore described his admiration for the original drawing in the Print Room of the British Museum:

Dürer's 'Portrait of Conrad Verkell' is a tremendous drawing, and for some years I have had a reproduction of it on the wall in my studio. Dürer has given the portrait such variety of form and has seen it in such a monumental way, that in explaining this to a friend, I said that I could easily make a landscape from the head. The lower part of the drawing is a demonstration of this. (Transcription of a tape recording, *Henry Moore Drawings*, 1979, p.69.)

He had acquired the reproduction in

1973 and was so intrigued by it that he made a second version in 1979 (repr. ibid, 1979, p.71). From 1930 at least Moore's vision of the relationship of the human figure to the landscape had been strong (see cat.76, HMF 1042). In this pencil 'demonstration' made late in his life, the artist revealed his ability to imagine the transformation of a two-dimensional view of a head into another plane, and even the metamorphosis of facial features into hills and dales.

The Italian sculptor Andrea Pisano (c.1290–1348) is best known for the gilt bronze doors of the Baptistery in Florence, on which he worked from 1330 to

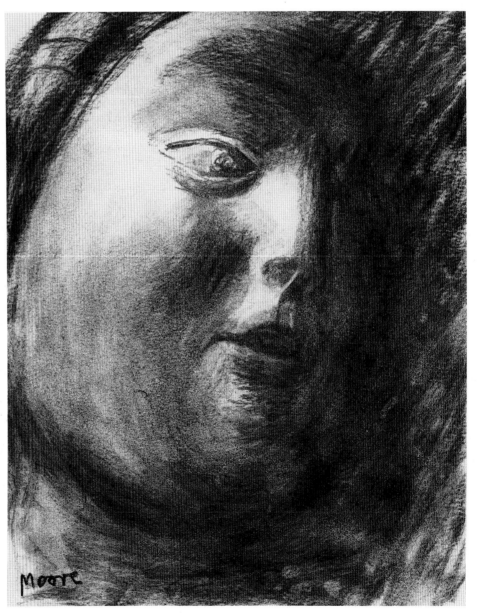

220

1336. As well as narrative reliefs, the lower door panels include the allegorical figures of the Cardinal Virtues extolled by Plato and the Stoics. They are Prudence, Justice, Fortitude and Temperance, and Moore based his drawing on the head of the last named. He no doubt chose her for the unusual shape of her face, which he copied from a book of photographs taken by a friend (Finn, 1980, p.83). David Finn had often photographed Moore's sculpture and indeed published books of them in 1970, 1976 and 1981.

Moore has homed in on the strangely shaped head which no doubt fascinated him by its unusual expression. The subject of masks had intrigued him as a young sculptor in the twenties and here he has created a mask-like shape, though allowing slightly more naturalism in the facial expression than in early work, such as cat.4 (LH 46). This drawing is one of a series, another included here is the *Head of a Girl* (cat.221, HMF 80(305)) which he had drawn the year before. He described heads as, 'the most expressive part of a human being, so they have always been treated in art as a subject on their own'. He went on to enumerate the many ways an artist can use the theme 'for portraiture, for expressive purposes in an imaginary head, or as a study for part of a larger work.' (Transcription of a Tape Recording, *Henry Moore Drawings*, 1979, p.65.)

REFERENCE: D. Finn, *Florence Baptistery Doors*, London, Thames and Hudson, 1980; D. Finn, D. Hall, *As the Eye Moves: a sculpture by Henry Moore*, New York, Abrams, 1970; D. Finn, *Henry Moore, sculpture and environment*, New York, Abrams, 1976; D. Finn, *A Henry Moore Odyssey*. London, Thames and Hudson, 1977; D. Finn, *Large Two Forms, a sculpture by Henry Moore*, New York, Abbeville 1981.

221 | *HEAD OF A GIRL* 1980
Charcoal, wash, gouache, chinagraph
$10\frac{11}{16}$ x $9\frac{1}{2}$ in; 272 x 241 mm
The Henry Moore Foundation
HMF 80(305)

Moore drew single heads at various times in his working life (for instance, cat.174, HMF 2979), but in his last years he concentrated on the head and shoulders. Sometimes, as in cat.220 (HMF 81(82)), they were derived from specific classical models. Although there is no recognised source for this particular drawing, the treatment of the profile, almost hidden by dense black strokes, seems to owe a debt to the drawings of Georges Seurat of which he owned several fine examples, including *La Lampe*. Abandoning line, from the early 1880s Seurat had drawn exclusively with black conté crayon on textured paper, allowing the forms to emerge by pressing harder or softer and coating the rough paper more or less densely. The resulting sensitively modelled forms emerge from a scribbled or shaded background, aided by the grain of the paper, now totally visible, now veiled and now obscured by the varying density of particles from the black

221

conté. In his own drawing, Moore has added a pink wash to a dense black, achieved with the modern technique of chinagraph, a type of crayon which, when wetted, produces added depth of tone.

222 | THE SEVEN AGES OF MAN FROM 'AS YOU LIKE IT', SHAKESPEARE, SANS EYES, SANS TEETH, SANS TASTE 1982

Ballpoint, charcoal (rubbed)
11 7/16 x 8 1/4 in; 290 x 209 mm
The Henry Moore Foundation
HMF 82(136)

222

This is the seventh in a series of drawings made for a set of lithographs (CGM 658–67) based on a speech from the Second Act of *As You Like It* by William Shakespeare. It represents the ultimate stage, and Moore has inscribed it thus:

7. *Last scene of all that ends this strange eventful history. In second childishness and mere oblivion, sans teeth, sans eyes, sans taste sans everything.*

Moore is not usually known either for wit or for caricature. Both are present here, as he parodies one of his favourite themes, the Mother and Child, imagining the old man in his infirmity, returned to the first stage of life: 'mewling and puking in the nurse's arms'. Moreover, psychologically, the artist has revealed another truth: the 'nurse' is the man himself, observing the shrunken creature that represents his own weakened body with an expression of tolerant puzzlement. It is impossible to resist seeing the drawing as a reflection on Moore's own experience, since he was eighty-four when he made it; the wry humour is reassuring: physical handicap is not the end of the story. Above all, the artist still has a strong, firm hand and mind, which is revealed by his writing as well as the skill of interpretation.

REFERENCE: Henry Moore, *Seven Ages of Man*, portfolio of 8 lithographs, Much Hadham, Raymond Spencer Company, 1986.

223 | THREE FIGURES ON A STAGE 1981

Chalk, charcoal, wax crayon, ink and watercolour wash, gouache
11 13/16 x 15 1/4 in; 301 x 387 mm
The Henry Moore Foundation
HMF 81(227)

Unique as an explicit rendering of a stage, this drawing represents the artist's life-long interest in the theatre. As an art student he had written a play, *Narayana and Bhataryan*, which was performed at his old school in Castleford and again at the Royal College of Art in London (see photographs, Packer, 1985 p.42). In later life, he was asked to provide the settings for an evening in memory of the poet T. S. Eliot, at the Globe Theatre, in London in June 1965; Moore was too busy to make a backdrop, but a plaster cast of *The Archer* (LH 535), placed on the stage on a rotating plinth, was used as decor for the read-

223

ings of Eliot's poetry by Laurence Olivier, Paul Scofield and others. Moving the sculpture and varying the lighting had made Moore think that there was a future for sculpture on the stage (Berthoud, 1987, p.316). Thus he used *Large Torso Arch* (LH 503) when invited by Gian Carlo Menotti to make sets for Mozart's opera, *Don Giovanni*, at the 1967 Spoleto festival.

It was not until he made this drawing that he invented a backdrop and wings to convey the wide-open space of some Italianate piazza against which to deploy three sculpted figures. Their striking silhouettes are exaggerated by imagined theatre lighting penetrating the inky blue shadows. The conception is particularly inventive and leaves a sense of regret that Moore did not realise his potential in the field of theatre decoration. However, in 1973 John Russell cited Moore's fear of becoming swamped by the theatre: 'I was frightened of it. If I got my coat-tails into the mangle of the theatre I'd be drawn in bodily. . . . Sculpture takes up so much of one's time, and it would be the simplest thing in the world to have one's energies dissipated in other ways.' (Russell, 1973, p.117.)

REFERENCE: W. Packer, *Henry Moore, an Illustrated Biography*, London, Weidenfeld and Nicolson, 1985.

224 | *MOTHER WITH CHILD HOLDING APPLE I 1981*
Black chalk, wax crayon, pastel, gouache
10$\frac{3}{8}$ x 9$\frac{1}{4}$ in; 264 x 235 mm
The Henry Moore Foundation
HMF 81(252)

The Mother and Child theme had been of the greatest significance to Moore from his earliest days. He had often chosen it in the twenties and thirties both in drawings and sculpture (see

cat.64, HMF 731). He returned to it in 1977 with numerous maquettes of a mother and child in informal positions. In 1981 he treated the theme here and in a closely related drawing; both are closer in feeling to the studies for the sculptures of the Madonna and Child that he had made in the forties for St Matthew's, Northampton (cat.106, LH 226) and St Peter's, Claydon. However, the distancing of the two figures which makes those images hierarchic is here replaced by the representation of a relationship which is tender and solicitous.

225 | *SHEEP GRAZING IN LONG GRASS (NO. 1) 1981*
Ballpoint, charcoal, wax crayon, chinagraph, watercolour wash
14 x 10 in; 355 x 254 mm
The Henry Moore Foundation
HMF 81(310)

One of the smallest of the studios in the grounds of Moore's Hertfordshire home had a window overlooking a large field grazed by sheep. Moore began drawing them in a sketchbook in 1972 when the 'sculpture studios were pandemonium' because the sculptures were being crated for the exhibition in

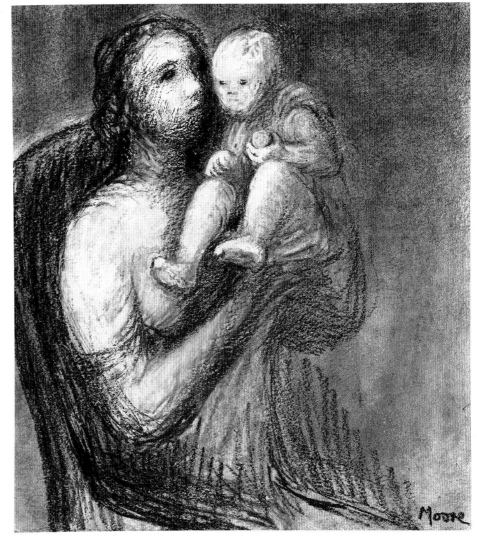

224

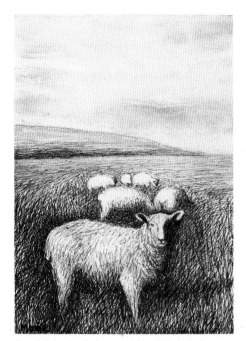

225 Reproduced in colour on p.166

Florence. In 1979 Moore also recalled:

I began drawing the sheep, just for the pleasure I get out of drawing for its own sake. At first I saw each sheep only as a big ball of wool with a head and four legs. But gradually, as I got interested, I began to look more intensely – which is what drawing from life always makes you do. As I continued working, I came to love the sheep, and began to think also about their immensely strong biblical associations. (Transcription of a tape recording, *Henry Moore Drawings*, 1979, p.15.)

The subject continued to fascinate the artist and this is one of a series of later drawings on a larger scale. The grey-blue wash, used to define the distant landscape, is a reminder of the rather similar Kent landscape viewed from his house, with three small animals in the distance, which Moore had painted in 1938 as the background for a Surrealistic bone formation, *Sculptural Object in Landscape* (cat.96, HMF 1441). In contrast, the sheep here retain their expected shape and size, and the one in the foreground seems to acknowledge the artist.

226 | **SHEEP GRAZING IN LONG GRASS (NO. 2) 1981**
Charcoal, ballpoint, chinagraph, chalk, pencil, rubbed charcoal
10 x 14 in; 254 x 355 mm
The Henry Moore Foundation
HMF 81(311)

This is one of a series of drawings that Moore made of sheep in 1981 (see cat.225, HMF 81(310)), nearly ten years after the first series of sheep, drawn in a sketchbook in 1972. By 1981 the sculpture *Sheep Piece* (see cat.188, LH 626) had been in the field adjoining Moore's small studio for some years, serving as a natural shelter for the animals who lie underneath its protective forms. The contours of this field were altered by Moore so that it has a low hill in the distance and whereas the slope is indicated in cat.225, the sheep in this drawing are spread out in an apparently flat field. None the less they give the impression of being observed from the life and Moore said that he used to go 'into the field and see them in their natural surroundings' ... 'I began to recognize the individual sheep over a time, I would know that I'd drawn that one already and that one I hadn't.' (*Moore*, 1986, p.182.)

REFERENCE: *Henry Moore: My Ideas, Inspiration and Life as an Artist*, photographs by John Hedgecoe, London, Ebury Press, 1986.

227 | **ROCK FORMS IN LANDSCAPE 1981**
Charcoal, chalk, gouache
11 3/8 x 8 in; 290 x 204 mm
The Henry Moore Foundation
HMF 81(55)

Metamorphosis had been at the heart of Moore's drawings of the thirties, when he was experimenting with Surrealist ideas. Nearly fifty years later, many of his drawings are metamorphic in a more naturalistic way. *Rock Forms in a Landscape* may be interpreted simply as the observation of geological formations, but beyond the boundary of nature, a

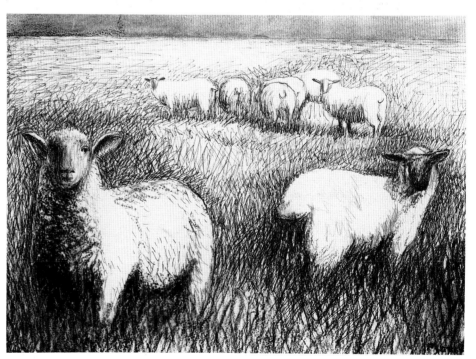

226

reclining figure seems to emerge, its form wrapped in sedimentary rocks. Perhaps the connection in this drawing is only obvious to those who know that Moore had made his sculptural figures look like rocks. As Peter Fuller has pointed out in his essay (see pp.37–44). the analogy has a long history in the English romantic tradition; he quotes John Ruskin, who, he says, 'had found in the lowlands "a spirit of repose", but saw "the fiery peaks" as "heaving bosoms and exulting limbs, with the clouds drifting like hair from their bright foreheads".' Moore himself may not have been reading Ruskin in the eighties, though he told Peter Fuller that he had read him as a young man, and the quotations are especially relevant to many of the late landscapes illustrated here.

228

227

228 | *ROCK FORMATION I 1982*
Carbon line, charcoal (part rubbed), pastel, ballpoint, gouache
10 x 12⅛ in; 254 x 303 mm
The Henry Moore Foundation
HMF 82(64)

Moore had explained in 1979 that he no longer regarded drawing as a tool for sculpture, for instead he used small models that he could hold in his hand, 'As a result, my drawing is no longer just a handmaiden, a servant of my sculpture – it can follow an independent path.' (*Henry Moore Drawings*, 1979, p.6.) Many of the sculpture maquettes were based on flints which the artist collected. Of rock drawings he said: 'All large forms, all rocks in landscape have a primitive appeal. For example, people have always given names to isolated rocks, standing out at sea.' (Transcription of a tape recording, ibid, 1979, p.22.) No doubt he was thinking of Le

Bec du Hoc in Brittany which had inspired his two-piece reclining figures (see cat.177, LH 457), but here the formation is far more sinister. It seems more like the product of imagination, a rock so penetrated with holes, that it becomes analogous to a skull. It may have been inspired by some flint in Moore's own collection, as it forms the first of several related drawings.

229 | *ROCK IN LANDSCAPE 1982*
Carbon line, charcoal and pastel (both rubbed), black ballpoint
11 5/16 x 7 15/16 in; 288 x 201 mm
The Henry Moore Foundation
HMF 82(87)

In publications on Moore's work, mention is frequently made of the rock formation at Adel on the Yorkshire moors 'once seen by the artist when about ten years old', according to the caption on a photograph in Philip

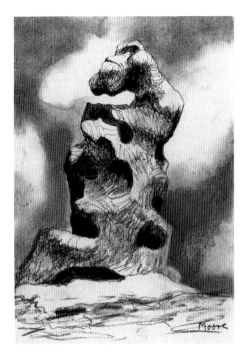

229 Reproduced in colour on p.167

James's book (James, 1966, fig.119). Because it rears up in a dramatic way, this craggy outcrop was there invoked as a source for the leg piece in the *Two-Piece Reclining Figure No.1* (cat.177, LH 457) and in this late drawing, Moore has enjoyed re-creating a similar form, based on a different geological formation. It may have been inspired by the pebbles that he kept in boxes in his studio, or even by coral reefs explored by deep sea divers in television nature films, though the form rises in isolation against a cloudy blue sky. It has a sinister analogy with a human figure and the metamorphosis is not dissimilar from that found in the paintings of Paul Nash and Graham Sutherland (who both had major retrospectives at the Tate Gallery in the seventies). None the less, Moore's 'figure' remains entirely sculptural in its effect.

230 | **MOUNTAINS AND SKY 1982**
Charcoal, pastel, watercolour wash, pencil
$7\frac{3}{8} \times 10\frac{5}{16}$ *in; 187 x 278 mm*
The Henry Moore Foundation
HMF 82(248)

In a series of drawings dating from 1982 Moore broke entirely new ground in his oeuvre by using water-based colour as a medium for conveying a marriage of landscape and the human form. As has often been said, from the late twenties he had appropriated Gaudier-Brzeska's 1914 dictum: 'Sculptural energy is the Mountain', which was made all the clearer by the naming of one of his early Reclining Figures as *Mountains* (see cat.76, HMF 1042). Not, however, till the end of his working life did he explore the metamorphosis of landscape and the human form with such evident freedom and enjoyment in watercolours. The ridge of a range of mountains or hills heaves upwards like some giantess, for the element on the right seems like a head rising above the curve of a breast which falls away towards stomach and pelvis. Such analogies would be taken for granted in a discussion of the bronze reclining figures of the sixties, but in these Turner-esque landscapes the human connotations are one step further away.

230 Reproduced in colour on p.164

231 Reproduced in colour on p.165

231 | **CLOUDS IN SKY 1982**
Charcoal, washed pastel, watercolour
$6\frac{3}{16} \times 14$ *in; 158 x 356 mm*
The Henry Moore Foundation
HMF 82(249)

When Moore was making a series of lithographs entitled *Helmet Heads* in 1974 (CGM 356–60), he used as a colour guide for one of them (CGM 359) a fragment from an invitation to a Turner exhibition. His admiration for the originality of Turner was intense:

He did something that nobody else did until his time and that no one else has done since. . . . Turner painted real space for the first time. Space that has almost the solid quality that a fog can have, that smoke can have. And his space is really three-dimensional space. He makes a flat canvas have all the space of miles in it. . . . For me as a sculptor, three-dimensional space, whether it is made of solid stone, or it is made of cloud, or it is made of distance between a few things, it is form. And form and space are one. (Gilmour, 1975, p.43.)

In almost his last working year, Moore himself explored a world of colour as form, finding it in the clouds in the sky which he has rendered here with the eye of a sculptor as well as the unexpected sensitivity of a painter. The undulating landscape of Hertfordshire provides endlessly changing skyscapes which no doubt served as inspiration for this painting.

REFERENCE: P. Gilmour, *Henry Moore, Graphics in the Making*, London, The Tate Gallery, 1975.

232

233

232 | SUNSET IN HILLS 1982
Watercolour, charcoal
$7\frac{1}{4}$ x $10\frac{7}{8}$ in; 184 x 276 mm
The Henry Moore Foundation
HMF 82(359)

Like the three related works (cat. 230–31, 233, HMF 82(248–9, 360)), this small page surprises by its intensely romantic use of colour and atmospheric effects. But in spite of the image of the setting sun, the hills suggest a human form, no doubt a female reclining figure as in *Mountains and Sky* (cat.230,). While Moore admired Turner and here paid him due homage, the landscape was entirely of his own invention and unrelated to anything he saw near his Hertfordshire home. Nor can it be surmised that he was remembering the sterner landscapes of his Yorkshire childhood, for the workings of his imagination are revealed in the *Landscape Interpretation* that he made from Dürer's *Portrait of Conrad Verkell* (cat.219, HMF 73/4(23)). There he demonstrated his ability to imagine a head metamorphosed into landscape and that example gives a clue to the way in which this magical *Sunset in Hills* may be read.

233 | ROCKY LANDSCAPE – SUNSET 1982
Charcoal and watercolour, ballpoint, gouache over chalk
$7\frac{1}{4}$ x 9 in; 184 x 229 mm
The Henry Moore Foundation
HMF 82(360)

In his later years Moore enjoyed openly exploiting chance effects of colour on paper, in the true vein of Surrealist imagination that had played such an important role in the development of his ideas in the thirties. Here he combines smudges and even blotches with his admiration for the work of Turner, as in the other drawings from this series

(cat.230–2, HMF 82 (248–9, 359)). How-ever, the landscape here is even fiercer with forms apparently rearing up to the right. But the stark and craggy rocks of a series of landscapes made earlier in the same year (cat.228–9, HMF 82(64 and 87)), have here been tamed by the materialisation of the 'distance between things' which Moore admired in Turner (see cat.231) and has here rendered through the medium of watercolour.

234 Reproduced in colour on p.168

234 | MAN DRAWING ROCK FORMATION 1982

Charcoal, chinagraph, chalk, pencil over lithographed frottage

12⅝ x 15¹⁵⁄₁₆ in; 321 x 402 mm

The Henry Moore Foundation

HMF 82(437)

The basis of this drawing is brown lithographed *frottage*. Without litho-graphy, *frottage* is a technique inven-ted by Max Ernst, who, in 1925, was inspired by hallucinatory images seen in the wooden floor of his hotel room (see cat.98, HMF 1435). He had published a series of *frottages* in 1926 under the title *Histoire naturelle*; these drawings were based on the structure of natural materials, so it is appropriate that Moore should have used the technique as the basis for his *Man Drawing Rock Formation*.

In a definitive study of twentieth-century painting first published in Eng-lish translation in 1961, Werner Haft-mann had connected Ernst and Moore (Haftmann, 1965, p.270). On the pre-vious page he had described Ernst's purpose in words appropriate to this drawing by Moore:

By reflectively penetrating into the formal diagrams of nature the contemplating, marvelling mind clears the way to the Orphic sources, and a symbolic message from man's unconscious experience of the world. The structural copies of nature open a view into the forgotten domain in which man himself is still nature, and his uncon-scious experience of the world is defined in images. These images have the character of the marvellous and can become myth-ical, if by "mythical" we mean the intui-tive symbols of an experience of the world which lies beyond the world of the senses and the intellect. (Haftmann, 1965, p.269.)

REFERENCE: W. Haftmann, *Painting in the Twentieth Century*, Vol.I, trans. R. Manheim, London, Lund Humphries, 2nd ed., 1965.

235 | FOUR IDEAS FOR SCULPTURE 1982

Charcoal, washed pastels, wax crayons, ballpoint

9¼ x 12⅛ in; 236 x 308 mm

The Henry Moore Foundation

HMF 82(365)

This unusual and colourful drawing also exists as a print (CGM 649). The inspiration for the slanted forms that seem halfway between humans and rocks may lie in the rock form-ations in the foreground of *Class-ical Landscape with Temple* (cat.206, HMF 3436). The figures, with rock-like legs, seem to be seen from the back view, in positions rather like the miners working at the coal-face in drawings of 1942 (see cat.158, HMF 1987), but Moore showed miners working indiv-idually rather than in a group, and here, although four ideas are indicated in the title, it is difficult to separate the pile of figures into discrete forms.

235

236 | *ROCKY LANDSCAPE 1982*
Charcoal, chinagraph, ballpoint,
chalk
12⅛ x 8⅝ in; 308 x 220 mm
The Henry Moore Foundation
HMF 82(445)

In this evocation of a rocky landscape,
Moore captures the essence of such
terrain. The drawing may be based on a
photograph, but if so, he has chosen a
view that evokes the narrow pathways
that, in Italy, have been hewn from the
stones in the monumental quarries
behind Forte dei Marmi, where the
artist had a house. From Yorkshire, the
cliff faces of Malham Tarn come to mind;
in Dorset, where Moore had spent
holidays in the fifties, such paths be-
tween rocks lead from the quarries by
the sea up on to the open spaces of the
downs. None of these real places may
have inspired this drawing, it may be a
development from the views of Stone-
henge (see cat.205, HMF 3431) of ten
years before. The remembrance of that
stone circle had remained vivid in the
artist's mind ever since he had first seen
it, and no doubt other formations were
not lost to his memory. However, in
1979 he admitted that 'Many of the
landscape drawings I make now are not
done through direct observation but
are evidence of my general liking for
landscape.' (Transcription of a tape re-
cording, *Henry Moore Drawings*, 1979,
p.22.) Although Moore was known as a
humanist, he admitted on the same
occasion that the sheep he drew had
'immensely strong biblical associations'
(ibid, 1979, p.15); it is therefore possible
that this late drawing, made when the
artist was growing infirm, also recalls
the words of the Psalmist, 'Yea though I
walk through the valley of the shadow of
death'. (Psalm 23: iv.)

Indeed it may be rash to discount the
long term effects of Moore's religious
upbringing, even though he was in-

236

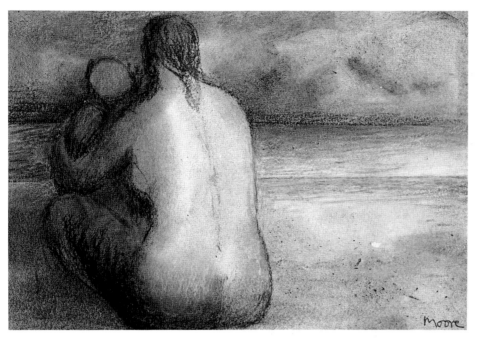

237

back as a child, he was early impressed by the backs of bathers painted by Cézanne. He had modelled some in three dimensions in 1978 (LH 741) and there is an echo of those figures to be found here.

REFERENCE: E. Neumann, trans. R. F. C. Hull, *The Archetypal World of Henry Moore*, Bollingen Series LXVIII, New York, Pantheon Books, 1959.

238 | KNEELING WOMAN 1982

Charcoal, white wax crayon, watercolour and pastel wash, black chinagraph

$12\frac{7}{8} \times 9\frac{15}{16}$ in; 327 x 253 mm

The Henry Moore Foundation

HMF 82(346)

clined in his late years to describe artists such as Giovanni Bellini as great humanists. None the less Moore returned to specifically Christian themes, such as the meeting of Mary and Elizabeth in the print *Visitation* (CGM 629), a subject he had copied in 1925 (see cat.53, HMF 355).

237 | MOTHER AND CHILD ON SEASHORE II 1982

Charcoal, pastel, watercolour wash, white chalk, gouache

$7 \times 10\frac{9}{16}$ in; 178 x 268 mm

The Henry Moore Foundation

HMF 82(223)

Resuming a subject that had always fascinated him, Moore has here imagined a mother with her child on a beach. He has given them only half of the sheet, thus allowing himself plenty of room for the shoreline, with the sea differentiated from the sky. Over twenty years earlier, the Jungian analyst Erich Neumann had described the sea viewed by Moore's *Three Standing Figures in a Setting* (cat.170, HMF 2484),

which, he said, 'has always and everywhere been the symbol of the creative unconscious from which new life springs'. (Neumann, 1959, p.97.) It is thus particularly appropriate that Moore has given the sea half of the composition and that it is paired by the mother and her child. The theme of Mother and Child had fascinated him since his earliest days (see cat.64, HMF 731), but in his last years he evidently felt freer to treat it – as here – in a pictorial manner. This was partly because he now enjoyed drawing as an end in itself and he seems to have been attempting to allow his figures a closer approximation to what the eye normally sees. Here they are treated in a comparatively naturalistic way, especially in comparison with the *Seated Woman holding Child* (cat.200, LH 876), a small bronze made in the same year. Yet the emphasis on the mother's back is as strong there as here and in his last years Moore continued to be as fascinated by the female back as he had ever been. Although he often spoke of the indelible effect of rubbing his mother's aching

The image of a kneeling draped woman is rare in Moore's oeuvre, he generally preferred to seat her, without clothes, on a low stool in a position which gave more prominence to the legs. Here drapery occludes the details of the lower part of the figure, but her foot escapes and forms a lever-like shape which accentuates the upward move-

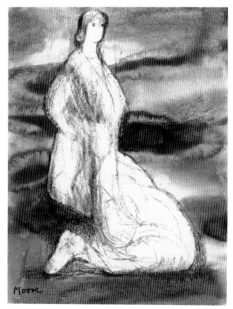

238

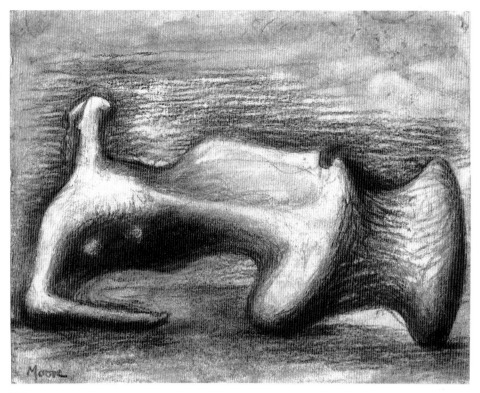

239

ment of her straight back and alert head. In contrast, the background is vague, with sinuous horizontal blots. Such random, painterly effects are more typical of Moore's lithographs; this drawing was itself used for a print (CGM 650).

239 | *RECLINING FIGURE: IDEA FOR SCULPTURE 1983*
Charcoal, wax crayon, watercolour wash, white chalk
$9\frac{9}{16}$ x $12\frac{5}{16}$ in; 243 x 314 mm
The Henry Moore Foundation
HMF 83(21)

One of his last drawings, this reclining figure extends and clarifies the metamorphic ideas that Moore had first explored in Transformation drawings from the early thirties (see cat.71, HMF 946). As they were made at a time when he used drawing as a quick means of noting down sculptural ideas, they consisted of many images tried out roughly

on each sheet of paper (see cat.72, HMF 941). Here, in contrast, in a finished design made when small models served for sculpture and work on paper was done for pleasure, he has turned a single bone into an imaginary woman. He thus gives the viewer a different insight into the human body, relying not on what is seen, but what is felt. Moore's world beyond appearances is none the less totally familiar because bones remain long after their cladding has decayed. The drawing can be seen as an example of his new formal language for sculpture, but it also conveys a deeper meaning. His mythical figure, made up of voids and solid forms and lacking the elements of female anatomy essential for procreation, paradoxically promotes the nurturing and embracing qualities of woman by means of this incompleteness.

CHRONOLOGY WITH MAJOR EXHIBITIONS

1898

Born at Castleford, Yorkshire, 30 July, the seventh child of Raymond Spencer Moore (1849–1922) and Mary Baker Moore (1857–1944).

1902

Attended elementary school in Castleford.

1910

Won scholarship to Castleford Secondary (later Grammar) School.

1915

Received Cambridge Leaving Certificate; trained as an elementary school teacher by practice in local schools.

1916

Taught at his old school in Temple Street, Castleford.

1917

Enlistment in the Civil Service Rifles, 15th London Regiment accepted, because of his teaching qualification; after training as a Lewis Gunner, sent to France; gassed at the Battle of Cambrai in December.

1918

Two months in hospital at Cardiff, followed by army physical training course; promoted to instructor and lance corporal; volunteered for active service but reached France just before Armistice Day.

1919

Returned to teaching in Castleford; obtained grant to begin study at Leeds College of Art in September.

1920

Sculpture department set up at Leeds for Autumn Term with Moore the sole student; his play, *Narayana and Bhataryan*, produced by Castleford Grammar School amateur dramatic group; Moore played Bhataryan.

1921

Won a scholarship to the Royal College of Art, London, to study sculpture; first visit to Stonehenge.

1922

His family moved from Castleford to Norfolk; visited his sisters there during most vacations.

1923

First of many visits to Paris; went to the Auguste Pellerin collection to study Cézanne.

1924

Took part in a mixed exhibition at the Redfern Gallery; awarded Royal College of Art Travelling Scholarship; travel postponed because, on completion of his training, accepted seven year appointment as instructor in the RCA Sculpture School.

1925

End of January to mid-July, travelled to Paris and Rome, Florence, Pisa, Siena, Assisi, Padua, Ravenna and Venice.

1926

Exhibited in a group show at St George's Gallery, London.

1927

Participated in a group exhibition at the Beaux-Arts Gallery, London.

1928

First one-man exhibition at the Warren Gallery, London (42 sculptures, 51 drawings).

1929

Completion of relief sculpture on the north wall of the Headquarters of the London Underground Railway; married Irina Radetsky, a painting student at the Royal College of Art; they moved to Parkhill Road, Hampstead.

1930

'Contemporary English Sculptors', *The Architectural Association Journal*, vol. XLV, London, May; elected to the '7 and 5 Society'; exhibited with Young Painters' Society and the London Group and in British Pavilion at Venice Biennale.

1931

Second one-man exhibition held at the Leicester Galleries, London (34 sculptures, 19 drawings); catalogue introduction by Epstein; bought cottage at Barfreston, Kent for use in vacations; resigned from teaching post at the Royal College of Art.

1932

Became first head of sculpture in new department at Chelsea School of Art.

1933

Chosen to be a member of Unit One; exhibition at the Leicester Galleries, London (19 sculptures, 20 drawings).

1934

Contributed to 'Unit One' at the Mayor Gallery, London; left Barfreston for cottage with land at Kingston, near Canterbury; visited Altamira, Madrid, Barcelona, Les Eyzies on motoring holiday in Spain and France.

1935

'Mesopotamian Art', *The Listener*, vol. XIII, no. 334, 5 June; exhibition at Zwemmer's, London (45 drawings).

1936

Exhibition at the Leicester Galleries, London (19 sculptures, 16 drawings); served on the Organising Committee and participated in the International Surrealist Exhibition at the New Burlington Galleries, London; outbreak of Civil War in Spain in June; one of fifteen signatories of a manifesto against non-intervention in Spain drawn up by the Artists' International Congress.

1937

'The Sculptor Speaks', *The Listener*, vol. XVIII, no. 449, 18 August.

1938

Took part in the International Exhibition of Abstract Art at the Stedelijk Museum, Amsterdam.

1939

Exhibition at the Mayor Gallery, London (31 drawings); declaration of war with Germany, 3 September; gave up teaching when Chelsea School of Art was evacuated to Northampton.

1940

Volunteered for course in precision tool-making at the Chelsea Polytechnic, but course over-subscribed; beginning of Blitz on London; began Shelter drawings; Hampstead studio bombed, moved to farmhouse at Perry Green, near Much Hadham in Hertfordshire; exhibition at Leicester Galleries, London (20 sculptures, 31 drawings).

1941

Appointed an Official War Artist (until 1942); 'Primitive art', *The Listener*, vol. XXV, no. 641, 24 August; first retrospective exhibition at Temple Newsam House, Leeds (36 sculptures, 59 drawings) with Graham Sutherland and John Piper; appointed a Trustee of the Tate Gallery (1941–8); visited Wheldale Colliery, Castleford to draw miners.

1942

Designed cover for *Poetry London*, No. 8.

1943

First one-man exhibition in New York at Buchholz Gallery (40 drawings).

1944

Installation of *Madonna and Child* in St Matthew's Church, Northampton.

1945

Appointed to the Arts Panel of the Arts Council of Great Britain (1945–51); first post-War visit to Paris.

1946

Birth of his only child, Mary; installation of *Memorial Figure* at Dartington Hall, Devon; first visit to New York for retrospective at The Museum of Modern Art (58 sculptures, 49 drawings); this travelled in 1947 to the Art Institute of Chicago and the San Francisco Museum of Art.

1947

Appointed member of the Royal Fine Arts Commission (1947–52); British Council exhibition in Australia – Melbourne, Adelaide, Perth (14 sculptures, 27 drawings).

1948

Committee member of the First London County Council Open-Air Exhibition of Sculpture held in Battersea Park; visit to Venice for one-man exhibition in British Pavilion (30 sculptures, 33 drawings) at XXIV Biennale, where he won the International Prize for Sculpture.

1949

'Was der Bildhauer anstrebt', *Thema* No. 5, Munich; *Family Group* installed at Barclay School, Stevenage; *Madonna and Child* installed at St Peter's Claydon, Suffolk; reappointed Trustee of the Tate Gallery (1949–56). British Council exhibition in Brussels and Paris, travelling in 1950 to Amsterdam, Hamburg, Düsseldorf, Bern (53 sculptures, 44 drawings); visited Belgium, Holland and Switzerland.

1950

Designed cover for *Eidos, A Journal of Painting, Sculpture and Design*, No. 1, May–June.

1951

'Message de la sculpture', *XXe Siècle*, nouvelle série, No. 1, Paris; 'Tribal sculpture', recorded interview in *Man*, vol. LI, no. 165, (Royal Anthropological Institute), July; retrospective at the Tate Gallery (73 sculptures, 96 drawings) on occasion of the Festival of Britain; *Reclining Figure: Festival* exhibited on the South Bank Festival site; visit to Mycenae, Corinth, Delphi, Olympia and the Acropolis on the occasion of a British Council exhibition at the Zappeion Gallery, Athens (53 sculptures, 44 drawings).

1952

'Témoignage: l'espace', *XX siècle*, nouvelle série, No. 2, Paris, January; read paper, 'The Sculptor in Modern Society', at the International Congress of Artists, Venice; this published in *Art News*, vol. 5, no. 6, November.

1953

Completion of *Draped Reclining Figure* and *Screen* for Time–Life Building, Bond Street, London; awarded International Sculpture Prize at the second São Paulo Bienal (29 sculptures, 40 drawings); visited Brazil and Mexico; reappointed to Royal Fine Arts Commission (1953–8); exhibition at the ICA, London (106 drawings).

1954

Travelled to Italy, Germany and the Netherlands.

1955

Appointed member of the Order of the Companions of Honour, also, Trustee of the National Gallery, London (1955–62); elected foreign honorary member of the American Academy of Arts and Sciences.

1956

Visited Rotterdam to supervise wall relief on new Building Centre – Bouwcentrum; completion of *Family Group* for Harlow Arts Trust.

1957

Exhibited at Galerie Berggruen, Paris (30 sculptures, 32 drawings); awarded prize at the Carnegie International, Pittsburg and the Stefan Lochner medal by the City of Cologne; 'The Hidden Struggle', *The Observer*, 29 November, London.

1958

Installation of *Reclining Figure* outside the UNESCO Headquarters in Paris; appointed Chairman of the Auschwitz Memorial Committee; British Council exhibition in Warsaw, Krakow, Poznan, Wroclaw, Stettin (30 sculptures, 30 drawings); visited Poland, France and the United States.

1959

Awarded Gold Medal by the Society of the Friends of Art, Krakow, and International Sculpture Prize, 5th Biennale, Tokyo; 'Jacob Epstein', *The Sunday Times*, 23 August, London.

1960

Exhibition at the Whitechapel Gallery (73 sculptures); reappointed to the Royal Fine Arts Commission (1960–65).

1961

Exhibition at the Scottish National Gallery of Modern Art, Edinburgh, 'Henry Moore, 1928–1961' (19 sculptures, 29 drawings); elected member of the American Academy and the Institute of Arts and Letters, and of the Akademie der Künste, Berlin.

1962

Arts Council touring exhibition, Cambridge, York, Nottingham, Aldeburgh (53 sculptures, 23 drawings); elected Honorary Fellow of Lincoln College, Oxford; created Honorary Freeman of the Borough of Castleford; Knoedler exhibition (59 sculptures); appointed member of the National Theatre Board.

1963

Invested with the insignia of a Member of the Order of Merit (Civil Division); awarded the Antonio Feltrinelli Prize for sculpture; exhibition at Wakefield City Art Gallery (59 sculptures, 13 drawings).

1964

'The Michelangelo Vision', *Sunday Times Colour Magazine*, 16 February, London; appointed member of the Arts Council of Great Britain; reappointed as Trustee of the National Gallery, London (1964–71); awarded Fine Arts Medal by the Institute of Architects, USA.

1965

Bought summer house at Forte dei Marmi, near Carrara marble quarries; elected Honorary Fellow of Churchill College, Cambridge; visited Holland.

1966

Travelled to Canada for presentation ceremony for *Three Way Piece No. 2 (The Archer)*, Nathan Phillips Square, Toronto; elected Fellow of the British Academy.

1967

Nuclear Energy unveiled on University of Chicago campus; created Honorary Doctor, Royal College of Art, London; 'Biographical Notes', *The Times*, 2 November, London.

1968

Received the Einstein Prize in New York; retrospective at the Tate Gallery, London (142 sculptures, 90 drawings) to mark his seventieth birthday; exhibition at the Rijksmuseum Kröller-Müller, Otterlo (69 sculptures, 55 drawings and notebooks), where he was given the Erasmus Prize; awarded the Order of Merit by the Federal Republic of Germany.

1969

Elected Honorary Member of the Vienna Secession.

1970

Visited New York, exhibitions at Knoedler (16 sculptures) and Marlborough Gallery 'Recent Bronzes' (42 sculptures).

1971

Elected Honorary Fellow of the Royal Institute of British Architects; visit to Toronto to plan Henry Moore Sculpture Centre at Art Gallery of Ontario.

1972

Retrospective exhibition at Forte di Belvedere, Florence (168 sculptures, 132 drawings, 42 prints); created Cavaliere di Gran Croce dell'Ordine al Merito della Repubblica Italiana; created Foreign Member of the Orden pour le Mérite für Wissenschaften und Künste, West Germany.

1973

Awarded the Premio Umberto Biancamano, Milan; created Commandeur de l'Ordre des Arts et des Lettres, Paris; exhibition at Los Angeles County Museum (106 sculptures, 27 drawings and prints).

1974

Visited Toronto for the installation and opening of the Henry Moore Sculpture Centre at the Art Gallery of Ontario (126 sculptures, 73 drawings, complete graphics, bar 2); elected Honorary Member of the Royal Scottish Academy of Painting, Sculpture and Architecture, Edinburgh.

1975

'Henry Moore Graphics in the Making' held at the Tate Gallery on occasion of gift of graphics by the artist; created Honorary Member of the Akademie der Bildenden Künste, Vienna; elected Membre de l'Institut, Académie des Beaux-Arts, Paris; awarded the Kaiserring der Stadt Goslar, West Germany; created Associate of the Académie Royale des Sciences, des Lettres et des Beaux-Arts de Belgique.

1976

Exhibition at the Imperial War Museum (98 Shelter and Coal-Mine drawings).

1977

Inauguration of The Henry Moore Foundation at Much Hadham, Hertfordshire; exhibition at the Orangerie and in the Tuileries gardens in Paris (116 sculptures, 108 drawings).

1978

Gift of thirty-six sculptures to the Tate Gallery; eightieth birthday exhibitions in London, 'Henry Moore Drawings' (261 drawings) at the Tate Gallery; 'Henry Moore at the Serpentine' (24 sculptures); and at the City Art Gallery, Bradford (117 sculptures, 65 drawings, 41 prints); *Mirror, Knife Edge* installed at the National Gallery of Art, Washington DC.

1980

Victoria and Albert Museum, 'Tapestry, Henry Moore & West Dean', exhibition of tapestries made at West Dean, Sussex after the artist's drawings; *The Arch* given to the Department of the Environment for permanent position in Kensington Gardens, London; awarded the Grand Cross of the Order of Merit of the Federal Republic of Germany.

1981

British Council exhibition in Madrid (230 sculptures, 195 drawings, 121 prints), this travelled to Lisbon and Barcelona; elected Full Member of Académie Européenne des Sciences, des Arts et des Lettres, Paris; created Honorary Freeman of the City of Leeds.

1982

The Henry Moore Sculpture Gallery and Centre for the Study of Sculpture opened by HM The Queen as an extension to Leeds City Art Gallery with exhibition, 'Henry Moore, Early Carvings 1920–1940' (33 sculptures, 5 drawings, 3 prints, jug and plate); exhibitions in Mexico City (145 sculptures, 88 drawings, 46 prints) and Caracas.

1983

Exhibition at the Metropolitan Museum of Art, New York (165 sculptures, 76 drawings, 86 prints); awarded Mexican Order of Aguila Azteca.

1984

Created Commandeur de l'Ordre National de la Légion d'Honneur when President Mitterand visited Much Hadham.

1986

Exhibition in Hong Kong, Tokyo and Fukuoka (169 sculptures, 67 drawings, 72 prints); died at Much Hadham, Hertfordshire on 31 August.
Service of Thanksgiving for the life and work of Henry Moore in Westminster Abbey, London, 18 November.

1987

Exhibition in the Yorkshire Sculpture Park, Bretton Hall, near Wakefield (33 sculptures); British Council exhibition in New Delhi, India (100 sculptures, 20 drawings, 80 prints).

SELECTED BIBLIOGRAPHY

Ayrton, M. and Moore, H., *Giovanni Pisano, Sculptor*, London, Thames and Hudson, 1969

Berthoud, R., *The Life of Henry Moore*, London, Faber, 1987; New York, Dutton, 1987

Bowness, A., ed., *Henry Moore, Complete Sculpture*, 6 vols., London, Lund Humphries, 1944–88 (see also Read, H.)

Clark, K., *Henry Moore Drawings*, London, Thames and Hudson, 1974

Cramer, P., Grant, A., Mitchinson, D., eds, *Henry Moore Catalogue of the Graphic Work*, 4 vols., Geneva, Cramer, 1973–86

Finn, D., *Henry Moore, Sculpture and Environment / A Henry Moore Odyssey*, New York, Abrams, 1976; London, Thames and Hudson, 1977

Friedman, T., ed., *Henry Moore, Early Carvings 1920–1940*, Leeds City Art Galleries, 1982

Grigson, G., *Henry Moore*, Harmondsworth, Penguin, 1943

Grohmann, W., trans. M. Bullock, *The Art of Henry Moore*, London, Thames and Hudson, 1960; New York, Abrams, 1960

Hall, D., *Henry Moore, the Life and Work of a Great Sculptor*, London, Gollancz, 1960; New York, Harper, 1960

Hedgecoe, J. and Moore, H., *Henry Moore*, London, Thomas Nelson, 1968

Hedgecoe, J., *Henry Moore, My Ideas, Inspiration and Life as an Artist*, London, Ebury, 1986

James, P., ed., *Henry Moore on Sculpture*, London, Macdonald, 1966; New York, Viking, 1967, revised and expanded, 1971

Levine, G., *With Henry Moore, The Artist at Work*, London, Sidgwick and Jackson, 1978

Lieberman, W., *Henry Moore, 60 Years of his Art*, New York, Metropolitan Museum of Art, 1983; London, Thames and Hudson, 1983

Lynton, N., 'Henry Moore', *Henry Moore*, New Delhi, London, The British Council, 1987

Melville, R., *Henry Moore, Sculpture and Drawings*, London, Thames and Hudson, 1970; New York, Abrams, 1970

Mitchinson, D., *Henry Moore, Unpublished Drawings*, New York, Abrams, 1971

Moore, H., *Heads, Figures & Ideas*, with commentary by G. Grigson, London, Rainbird; Greenwich, Conn., New York Graphic Society, 1958

Henry Moore's Sheep Sketchbook, London, Thames and Hudson, 1980

Moore, H., *Henry Moore at the British Museum*, London, British Museum Publications, 1981; New York, Abrams, 1982

Henry Moore, A Shelter Sketchbook, with commentary by F. Carey, London, British Museum Publications, 1988

Neumann, E., trans. R.F.C. Hull, *The Archetypal World of Henry Moore*, London, Routledge, 1959; New York, Pantheon Books, 1959

Packer, W., *Henry Moore, an Illustrated Biography*, London, Weidenfeld and Nicolson, 1985

Read, H., *Henry Moore, Sculptor*, London, Zwemmer, 1934

Read, H., *Henry Moore, Sculpture and Drawings, 1921–44*, London, Lund Humphries, 1944; revised edition, A.D.B. Sylvester, ed., 1949 and reprints.

Read, H., *Henry Moore, a Study of his Life and Work*, London, Thames and Hudson, 1965

Read, J., *Henry Moore, Portrait of an Artist*, London, Whizzard Press with André Deutsch, 1979; New York, Hacker, 1979

Russell, J., *Henry Moore*, London, Allen Lane, 1968; New York, Putnam, 1968; revised edition, Harmondsworth, Penguin, 1973

Spender, S., *In Irina's Garden, with Henry Moore's Sculpture*, London, Thames and Hudson, 1986

Sweeney, J. Johnson, *Henry Moore*, New York, The Museum of Modern Art with Simon and Schuster, 1947

(Sylvester, A.D.B.), *Sculpture and Drawings by Henry Moore*, London, The Arts Council, 1951

Sylvester, A.D.B., *Henry Moore*, London, The Arts Council, 1968

Wilkinson, A.G., *The Drawings of Henry Moore*, London, Tate Gallery (with Art Gallery of Ontario, Toronto) 1977

Wilkinson, A.G., *The Moore Collection in the Art Gallery of Ontario*, Toronto, 1979; revised as: *Henry Moore Remembered, The Collection at the Art Gallery of Ontario in Toronto*, Art Gallery of Ontario, Key Porter Books, 1987

Wilkinson, A.G., *The Drawings of Henry Moore*, New York and London, Garland, 1984 (1974 PhD thesis)

LIST OF LENDERS

Great Britain

Birmingham, City Museum and Art Gallery *cat. 128, 168*

Edinburgh, Scottish National Gallery of Modern Art *cat. 166*

Collection of the late W.A. Evill *cat. 42*

Glasgow, Art Gallery and Museum *cat. 156*

Ursula Goldfinger and Family *cat. 33*

Hull City Museums and Art Galleries, Ferens Art Gallery *cat. 124*

Leeds, City Art Galleries *cat. 6, 9, 29*

London, The Arts Council of Great Britain *cat. 60, 71, 78, 141*

London, The British Council *cat. 10, 12, 30, 54, 68, 150*

London, The Trustees of the British Museum *cat. 44, 57, 65*

London, Chelsea School of Art *cat. 177*

London, James Kirkman *cat. 31*

London, The Trustees of the Imperial War Museum *cat. 158*

London, The Moore Danowski Trust *cat. 2, 7, 15, 24, 32, 73, 81, 88, 92, 94, 99, 112, 122, 123, 154, 157, 164, 173*

London, The Trustees of the Tate Gallery *cat. 17, 18, 20, 34, 89, 119, 121, 126, 134–6, 138, 147, 178, 180, 184, 185*

London, The Board of Trustees of the Victoria and Albert Museum *cat. 66, 77, 170*

Manchester, City Art Galleries *cat. 152*

Manchester, University of, Whitworth Art Gallery *cat. 47*

Much Hadham, The Henry Moore Foundation *cat. 1, 16, 21, 35, 38, 39, 40, 45, 46, 48, 51, 55, 67, 70, 72, 82, 83, 98, 104, 107, 113, 114, 118, 120, 125, 127, 129, 130, 132, 136, 137, 139, 142–4, 149, 159, 174, 176, 181–3, 186, 188–95, 197–239*

Northampton, St Matthew's Church *cat. 102*

Norwich, University of East Anglia, Robert and Lisa Sainsbury Collection *cat. 26, 96, 148*

Oxford, Visitors of the Ashmolean Museum *cat. 97, 100*

The Roland Collection *cat. 3*

Wakefield, Art Galleries and Museums *cat. 117*

Lord and Lady Walston *cat. 167*

Austria

Vienna, Graphische Sammlung Albertina *cat. 101*

Canada

Toronto, Art Gallery of Ontario *cat. 13, 43, 49, 50, 52, 53, 59, 62, 64, 69, 75, 79, 80, 95, 131, 140, 151, 169, 172*

West Germany

Berlin, Staatliche Museen Preussischer Kulturbesitz, Nationalgalerie *cat. 145*

Israel

The Tel Aviv Museum of Art *cat. 8*

Italy

Venice, Museo d'Arte Moderna-Ca'Pesaro *cat. 115*

The Netherlands

Otterlo, Rikjsmuseum Kröller-Müller *cat. 74*

Switzerland

Geneva, Gérald Cramer *cat. 87*

Feldmeilen, Collection Marina and Willy Staehelin *cat. 179*

United States of America

Mr and Mrs Harry A. Brooks *cat. 111, 161*

Buffalo, Albright-Knox Art Gallery *cat. 25*

J.S. Cook and D.M. Skinner *cat. 23*

New York, The Museum of Modern Art *cat. 22, 36, 160, 171*

Philadelphia Museum of Art *cat. 28*

San Francisco Museum of Modern Art *cat. 105*

Wexler Collection *cat. 187*

Also many owners who prefer to remain anonymous

INDEX

Page numbers in **bold type** refer to plates.
Page numbers in *italics* refer to illustrations in the text.

ROYAL ACADEMY TRUST

The Trustees of the Royal Academy Trust wish to express their gratitude to the many companies and individuals who have already given their support to the appeal. In particular they would like to extend their thanks to:

H.M. The Queen
H.R.H. Princess Alexandra
The Hon. Angus Ogilvy
Air Seychelles Limited
Russell Aitken
Allied-Lyons PLC
American Airways
American Associates of the Royal Academy Trust
American Express Europe Limited
Mr and Mrs Tobin Armstrong
The Arthur Anderson Foundation
Mrs John W. Anderson II
Anglia Television Limited
The Hon. Walter & Mrs Annenberg
James Archibald
Atlantic Richfield Company
Mr & Mrs Stanton Avery
Miss Nancy Balfour
The Astor Foundation
Mrs Henry Bagley
Mr & Mrs Alan Bain
The Bank of England
Bankers Trust Company
Barclays Bank PLC
The Baring Foundation
B.A.T. Industries PLC
Tom Bendham
Mr & Mrs James Benson
B-CH 1971 Charitable Trust
BICC plc
Elizabeth Blackadder, RA
Norman Blamey, RA
In Memoriam: Ida Rose Biggs
The BOC Group
Bollinger Champagne
Mr & Mrs Gerrit P van de Bovenkamp
C.T. Bowring & Co. Limited
Peter Bowring
British Airways
British Caledonian Airways
The British Electric Traction Company PLC
British Gas Corporation
British Olivetti Limited
The British Petroleum Company PLC
British Telecommunications Ltd
Britoil plc
Brooke Bond Group
The Brown Foundation
Gilbert Brown
BTR plc
Mr & Mrs Walter Burke
Bunzl PLC
Capel Charitable Trust
The Capital Group Inc
Mrs Winifred Carter
Christies's
Citibank N.A.
The Cleary Foundation

The Trustees of the Clore Foundation
The Clothworkers Company
The John S. Cohen Foundation
Mr & Mrs Terence Cole
The Ernest Cook Trust
Joseph Collier Charitable Trust
Commercial Union Assurance Company plc
Mrs Jan Cowles
Crown Decorative Products Ltd
Cula Charitable Trust
Mr & Mrs Marvin Davis
Mr & Mrs James Dean
The De La Rue Company plc
The Hon. C. Douglas & Mrs Dillon
The Distiller's Company
Mr & Mrs Gaylord Donnelly
Alfred Dunhill Limited
The Durrington Corporation
Eagle Star Insurance Group
The Gilbert & Eileen Edgar Charitable Trust
The Ells Will Trust
Roberta Entwistle
Esso UK plc
The Esmee Fairbairn Charitable Trust
Mr & Mrs T.M. Evans
Anthony Eyton, RA
Mr & Mrs Donald R. Findlay
The Hon. Leonard & Mrs Firestone
The Fishmongers' Company
Mr Christopher Forbes
Forbes Magazine
The Henry Ford II Fund
Ms Maud Frizon
John Frye Bourne
Dr Kenzo Fujii
Gallaher Limited
The Garfield Weston Foundation
The J. Paul Getty Trust
Mrs Pat H. Gerber
Glaxo Holdings (1972) Charity Trust
Gleneagles Hotel
Mr Guildford Glazer
The Jack Goldhill Charitable Trust
The Goldsmiths' Company
The Horace W. Goldsmith Foundation
Frederick Gore, RA
Her Majesty's Government
The Greentree Foundation
Mr Lewis Grinnon
The Grocers' Company
Mr & Mrs Wallace Grubman
Guest, Keen & Nettlefolds plc
Calouste Gulbenkian Foundation
The Haberdashers' Company
Mr & Mrs Melville Wakeman Hall
Donald Hamilton-Fraser, RA
Dr & Mrs Armand Hammer
Mrs Sue Hammerson OBE
The Hammerson Group of Companies
The Lord Hanson
Mrs John Hay Whitney
The Hayward Foundation
Hayward Tyler

Hazlitt, Gooden & Fox
The Hedley Foundation
H.J. Heinz Charitable Trust
Mr Henry J. Heinz II
Norman Hepple, RA
Herring Son & Daw Rating Ltd
Hertz (UK) Ltd
Mr & Mrs Norman Hickman
High Winds Fund
Hill Samuel Group PLC
Hilton Hotel Corporation
David Hockney BBC Radio 4 Appeal
Mrs James Stewart Hooker
Ken Howard, RA
IBM United Kingdom Limited
The Idlewild Trust
Imperial Chemical Industries PLC
Imperial Tobacco Limited
Inchape Charitable Trust
Inter Continental Hotels Corporation
International Thompson Organisation
Elin & Lewis Johnson
R.J. Kiln Limited
Mrs D. King
The Kress Foundation
Maurice Laing Foundation
Mr & Mrs Larry Lawrence
Roland P. Lay
Miss R.A. Le Bas
Leading Hotels of the World
The Leche Trust
Mr & Mrs Panagiotis Lemos
Mr & Mrs William M. Lese
Lord Leverhulme's Charitable Trust
Mr & Mrs Leon Levy
John Lewis Partnership plc
Lex Services PLC
Mr and Mrs Sydney Lipworth
Lloyds Bank PLC
The Corporation and Members of Lloyd's and Lloyd's Brokers
Sir Jack & Lady Lyons
The Manor Charitable Trust
The Manifold Trust
Marks & Spencer plc
Sir George Martin Charitable Trust
Mr & Mrs Jack C. Massey
Matheson & Co. Limited
McKenna & Co.
Paul Mellon, KBE
The Anthony & Elizabeth Mellows Charitable Trust
The Mercers' Company
The Merchant Taylors' Company
Meridien Hotels Ltd
Midland Bank plc
The Miller and Tiley Charitable Trust
Mobil Oil Company Limited
The Moorgate Trust Fund
Morgan Grenfell & Co. Ltd
The National Magazine Co.
National Westminster Bank plc
Mrs Mary Newman
News International plc
Stavros S. Niarchos

Occidental International Oil Inc.
Mr & Mrs Peter O'Donnell
H.R. Owen Limited
P & O Steam Navigation Company
Pearson plc
Peerless Pump
Mr & Mrs Milton Petrie
Petrofina UK Ltd
P.F. Charitable Trust
The Pilgrim Trust
The Plessey Company plc
The Private Capital Group
Mr & Mrs Loring G. Pratt
Prudential Assurance Company Ltd
Mr & Mrs J.A. Pye's Charitable Settlement
The Radcliffe Trust
The Rank Foundation
The Rank Organisation plc
Ranks Hovis McDougall PLC
The Rayne Foundation
Reed International PLC
The Ronson Charitable Foundation
The Jacob Rothschild Charitable Trust
Rowntree Macintosh
The Royal Bank of Scotland
RTZ Services Limited
Dr & Mrs Arthur Sackler
The Sainsbury Family Charitable Trust
Jean Sainsbury Charitable Trust
Mr & Mrs Benno C. Schmidt
J. Henry Schroder Wagg & Co. Ltd
Peter Samuel Charitable Trust
Mrs Frances Scaife
Mr & Mrs Sam Scali
Sea Containers Limited
Shell UK Limited
Harry & Abe Sherman Foundation
Dr Francis Singer
The Skinners' Company
The Sloane Street Trust
The Sloane Club
Mr Marvin Sloves
Mr & Mrs Edward Byron Smith
Mrs Frederick Stafford
Standard Chartered Bank
Standard Telephones & Cables PLC
Mr & Mrs Dennis C. Stanfill
The Starr Foundation
Sterling Guarantee PLC
Robert L. Sterling Jr
The Bernard Sunley Charitable Foundation
Tarmac Plc
Mr & Mrs A. Alfred Taubman
Technical Indexes Limited
Thames Television Limited
Sir Jules Thorn Charitable Trust
THORN EMI plc
Thomas Tilling plc
Trafalgar House Public Limited Company
Mr G. Ware Travelstead
The Triangle Trust (1949) Fund
Trident Television plc
Trustee Saving Bank (Holdings) Limited
TWA
Unilever PLC
Venice Simplon-Orient Express
Vista do Mar Hotel, The Seychelles
S.G. Warburg & Company Limited
The Wates Foundation
Mrs Keith S. Wellin
Anthony Whishaw, RA
Whitbread & Company PLC
Wilde Sapte
HDH Wills 1965 Charitable Trust
Winsor Newton (part of the Reckitt & Colman Group)
The Wolfson Foundation
Sir John Woolf
Mr Lawrence Wood
Mr Ian Woodner

Mr & Mrs William Wood Prince
Mr Charles Wrightsman
Dr Tomozo Yano

CORPORATE MEMBERS

Arthur Andersen & Co
BAT Industries plc.
British Airways
British Alcan Aluminium plc
Chelsfield plc
Cookson Group Plc
CoxMoore plc
The Daily Telegraph
Diamond Trading Company Limited
Ford Motor Company Limited
John Laing plc
Josef Gartner & Co (UK) Ltd
Glaxo Holdings p.l.c.
Grand Metropolitan plc
Hillier Parker
MoMart Limited
Mountleigh Group
Nico Construction Limited
Royal Insurance plc
R.J. Reynolds International Inc
Shearson Lehman Hutton International Inc.
TI Group plc
Unilever
Williams Lea Group Limited

CORPORATE ASSOCIATES

Allen & Overy
American Express Europe Limited
Apple Computer U.K. Limited
Arco British Limited
Arthur Young
The Arts Club
Ashurst Morris Crisp
Bankers Trust
Banque Paribas
Barclays Bank PLC
Bass plc
Beecham Group plc
The BOC Group
Booker plc
Bovis Construction Limited
British & Commonwealth Holdings plc
British Olivetti Limited
British Telecom
Brixton Estate plc
Burmah Oil Trading Limited
H P Bulmer Holdings PLC
C & A
Cable and Wireless plc
Campbell Johnston Associates Limited
Canadian Imperial Bank of Commerce
Carlton Beck
Charterhouse plc
Christie's
Clifford Chance
Courage Charitable Trust
Coutts & Co
Deutsche Bank AG
Durrington Corporation
Eagle Star Insurance Company Limited
English China Clays plc
Gavin Martin Limited
General Accident
Global Asset Management
Goldman Sachs
Gordon Yates
Granada Group
Guilford Kapwood Limited
Guinness plc
The Hammerson Group
H.J. Heinz Company Limited
Ibstock Johnsen plc

Inchcape plc
Investors in Industry
Jaguar Cars Ltd
Johnson Wax Ltd
KHBB Humphreys Bull & Barker Ltd
Kleinwort Benson Group plc
Kodak Ltd
Laurentian Holding Company Ltd
Lewis Briggs International
John Lewis Partnership plc
Lex Service PLC
London & Edinburgh Trust Plc
Marlborough Fine Art (London) Ltd
Martini & Rossi
McCann-Erickson
McCormick Publicis Limited
MEPC plc
The Worshipful Company of Mercers
Mercury Asset Management Group plc
Michael Peters Group
JP Morgan
Morgan, Lewis & Bockius
Nabarro Nathanson
National Westminster Bank plc
NCR Limited
NEC (UK) Ltd
The Nestlé Charitable Trust
Occidental International Oil Inc
P. & D. Colnaghi & Co. Ltd
The Park Lane Hotel
Pearson plc
The Peninsular & Oriental Steam Navigation Company
Pentagram Design Ltd
Pentland Industries plc
The Post Office
Renton Howard Wood Levin (Partnership)
Richard Ellis Services Ltd
The Royal Bank of Scotland plc
RTZ Limited
J. Sainsbury
J Henry Schroder Wagg & Co Limited
The Sedgwick Group plc
S.G. Warburg & Co. Ltd.
W.H. Smith & Son Limited
Solaglas International BV
SONY UK Limited
Sotheby's
Stanhope Properties plc.
Staveley Industries plc
StoyHayward
Thames Television PLC
Thos. Agnew & Sons Ltd.
United Biscuits (UK) Limited
Waldron Allen Henry And Thompson Limited
The Wellcome Foundation Ltd
Wickes plc
Wolff Olins Business Ltd
Wood & Wood International Signs Limited
Yamaichi International (Europe) Ltd

FRIENDS OF THE ROYAL ACADEMY

BENEFACTORS

Mrs Hilda Benham
Lady Brinton
Sir Nigel & Lady Broackes
Keith Bromley Esq.
The John S. Cohen Foundation
The Colby Trust
Michael E. Flintoff Esq.
The Lady Gibson
Jack Goldhill Esq.
Mrs Mary Graves
D.J. Hoare Esq.
Irene & Hyman Kreitman
The Landmark Trust
Roland Lay Esq.
The Trustees of the Leach Fourteenth
 Trust
Sir Hugh Leggatt
Mr & Mrs M.S. Lipworth
Sir Jack Lyons CBE
The Manor Charitable Trustees
Lieut.-Col. L.S. Michael OBE
Jan Mitchell Esq.
The Lord Moyne
The Lady Moyne
Mrs Sylvia Mulcahy
C.R. Nicholas Esq.
Lieut.-Col. Vincent Paravicini
Mrs Vincent Paravicini
Richard Park Esq.
Phillips Fine Art Auctioneers
Mrs Denise Rapp
Mrs Adrianne Reed
The Late Anne M. Roxburgh
Mrs Basil Samuel
Sir Eric Sharp CBE
The Revd Prebendary E.F. Shotter
Dr Francis Singer
Lady Daphne Straight
Mrs Pamela Synge
Harry Teacher Esq.
Henry Vyner Charitable Trust
A. Witkin, Vacuum Instruments &
 Products Ltd
Charles Wollaston Esq.

INDIVIDUAL SPONSORS

Gerald M. Abraham Esq.
Richard Alston Esq.
I.F.C. Anstruther Esq.
Mrs Anne Appelbe
Dwight W. Arundale Esq.
Nick Ashley Esq.
Edgar Astaire Esq.
Selenk Avcí Esq.
Brian A. Bailey Esq.
W.M. Ballantyne Esq.
M.E. Bell Esq.
Mrs Oliver Bell
E.P. Bennett Esq.
P.F.J. Bennett Esq.
Miss A.S. Bergman

Mrs Susan Besser
P.G. Bird Esq.
Mrs L. Blackstone
Peter Boizot Esq.
Miss Julia Borden
Peter Bowring Esq.
Miss Betty Box OBE
Mrs Susan Bradman
John A. Brandler Esq.
Mrs K. Brewster
Mrs David L. Britton
Cornelius Broere Esq.
Lady Brown
Jeremy Brown Esq.
Mrs Susan Burns
Richard Butler Esq.
Mr and Mrs R. Cadbury
Mrs L. Cantor
Miss E.M. Cassin
Mrs F.M. Cator
W.J. Chapman Esq.
Ian Christie Esq.
Mrs Joanna V. Clarke
Henry M. Cohen Esq.
Mrs N.S. Conrad
Mrs Elizabeth Corob
C. Cotton Esq.
Philip Daubeny Esq.
Miss C.H. Dawes
John Denham Esq.
The Marquess of Douro
Kenneth Edwards Esq.
Miss Beryl Eeman
Charles & Lady Katherine Farrell
Miss A. Chilcott Fawcett
S. Isern Feliu Esq.
Mrs J.G.G. Firth
Dr Gert-Rudolf Flick
J.G. Fogel Esq.
M.J. Foley Esq.
Ronald D. Fowler Esq.
Miss C. Fox
Princess Ira von Furstenberg
Graham Gauld Esq.
M.V. Gauntlett Esq.
Robert Gavron Esq.
Stephen A. Geiger Esq.
Lady Gibberd
Mrs E.J. GIllespie
Michael I. Godbee Esq.
Michael P. Goodman Esq.
P.G. Goulandris Esq.
Gavin Graham Esq.
Mrs J.M. Grant
R. Wallington Green Esq.
Mrs O. Grogan
Mrs P.O.V.H. Grogan
Mrs W. Grubman
Mr and Mrs Earl Guitar
J.A. Hadjipateras Esq.
Mrs L. Hadjipateras
Richard M. Harris Esq.
Robert Harris Esq.

Mrs Frances A.J. Hawkins
Miss Julia Hazandras
Mrs Penelope Heseltine
N. Hickmet Esq.
Mrs K.S. Hill
R.J. Hoare Esq.
Reginald Hoe Esq.
Mrs Mark Hoffman
Charles Howard Esq.
Mrs A. Howitt
John Hughes Esq.
Chrisopher R. Hull, Esq.
Norman J. Hyams Esq.
David Hyman Esq.
Mrs Manya Igel
Mr & Mrs Evan Innes
Mrs I.A.N. Irvine
J.P. Jacobs Esq.
Mrs J.C. Jaqua
Alan Jeavons Esq.
Ms S. Jenkins
H. Joels Esq.
Irwin Joffe Esq.
Lady Joseph
G.M.A. Joseph Esq.
Roger Jospe Esq.
Mr & Mrs S.H. Karmel
Peter W. Kininmonth Esq.
Mrs C. Kirkham
Andria Thal Lass
Mrs J.H. Lavender
Miss Ailsey Lazarus
Morris Leigh Esq.
Mr and Mrs N.S. Lersten
David Levinson Esq.
David Lewis Esq.
S. Lewis Esq.
Owen Luder Esq.
Mrs Graham Lyons
Ciarán Macgonigal Esq.
Peter McMean Esq.
Stuart MacWhirter Esq.
Mrs S.G. Maddocks
Dr Abraham Marcus
The Hon. Simon Marks
B.P. Marsh Esq.
Dr A.D. Spalding Martin
R.C. Martin Esq.
Christopher Mason-Watts Esq.
Dr D.S.J. Maw
M.H. Meissner Esq.
The Hon. Stephen Monson
Mrs Alan Morgan
Mrs Angela Morrison
Mrs A.K.S. Morton
A.H.J. Muir Esq.
Nufford Foundation
The Oakmoor Trust
Mrs E.M. Oppenheim Sandelson
A. Osmond-Evans Esq.
Brian R. Oury Esq.
Mrs Jo Palmer
J.G. Pereira Esq.

Mrs Olive Pettit
Mrs M.C.S. Philip
Ralph Picken Esq.
G.B. Pincus Esq.
William Plapinger Esq.
Harold Quitman Esq.
Barry G. Rebell Esq.
Mrs Margaret Reeves
Mrs M.P. Renton
F. Peter Robinson Esq.
Miss Lucy Roland-Smith
The Rt Hon. Lord Rootes
Baron Elie de Rothschild
Mr & Mrs O. Roux
The Hon. Sir Steven Runciman CH
Sir Robert Sainsbury
Gregoire Salamanowitz Esq.
Mrs Bernice Sandelson
Friedhelm Schulz-Robson Esq.
Mrs Bern L. Schwartz
Christopher Shaw Esq.
Stuart Shaw Esq.
Mrs Pamela Sheridan
Desmond de Silva Esq. QC
R.J. Simia Esq.
R.J. Simmons Esq.
Cyril Stein Esq.
Mrs G.M. Stokes
James Q. Stringer Esq.
Mrs B. Stubbs
Mrs A. Susman
Robin Symes Esq.
Nikolas Tarling Esq.
G.C.A. Thorn Esq.
J.E. Thomas Esq.
Herbert R. Towning Esq.
W. Van Der Spek Esq.
Andrew Vicari Esq.
Kenneth J. Wardell Esq.
Neil Warren Esq.
Mrs V. Watson
J.B. Watton Esq.
Frank S. Wenstrom Esq.
R.A.M. Whitaker Esq.
Graham V. Willcox Esq.
Mrs Bella Wingate
B. G. Wolfson Esq.
Mrs S. Wood
W.M. Wood Esq.
Fred S. Worms
John P. Zinn Esq.

SPONSORS OF PAST EXHIBITIONS

The Council of the Royal Academy thanks sponsors of past exhibitions for their support. Sponsors of major exhibitions during the last ten years have been included.

American Express Foundation
Masters of 17th-Century Dutch Genre Painting 1984
'Je suis le cahier': The Sketchbooks of Picasso 1986

Arts Council of Great Britain
Robert Motherwell 1978
Rodrigo Moynihan 1978
John Flaxman 1979
Ivan Hitchens 1979
Algernon Newton 1980
New Spirit in Painting 1981
Gertrude Hermes 1981
Carel Weight 1982
Elizabeth Blackadder 1982
Allan Gwynne Jones 1983
The Hague School 1983
Peter Greenham 1985

BAT Industries plc
Murillo 1983
Paintings from the Royal Academy US Tour 1982/4, RA 1984

Beck's Bier
German Art in the 20th Century 1985

Benson & Hedges
The Gold of El Dorado 1979

Boris Construction Ltd
New Architecture 1986

British Alcan Aluminium
Sir Alfred Gilbert 1986

British Gypsum Ltd
New Architecture 1986

British Petroleum plc
British Art in the 20th Century 1987

Canary Wharf Development Co
New Architecture 1986

The Chase Manhattan Bank
Cézanne: The Early Years 1988

Christie's
Treasures from Chatsworth 1980

Coutts & Co
Derby Day 200 1979

The Daily Telegraph
Treasures from Chatsworth 1980

Deutsche Bank AG
German Art in the 20th Century 1985

Electricity Council
New Architecture 1986

Esso Petroleum Company Ltd
British Art Now: An American Perspective 1980
Summer Exhibition 1988

Financial Times
Derby Day 200 1979

First National Bank of Chicago
Chagall 1985

Friends of the Royal Academy
Elizabeth Blackadder 1982
Carel Weight 1982
Allan Gwynne Jones 1983
Peter Greenham 1985
Sir Alfred Gilbert 1986

Joseph Gartner
New Architecture 1986

J. Paul Getty Jr. Charitable Trust
Age of Chivalry 1987

Glaxo Holdings plc
From Byzantium to El Greco 1987

Calouste Gulbenkian Foundation
Portuguese Art Since 1910 1978

Dr Armand Hammer
& The Armand Hammer Foundation
Honoré Daumier 1981
Leonardo da Vinci Nature Studies
Codex Hammer 1981

Hoechst (UK) Ltd
German Art in the 20th Century 1985

IBM United Kingdom Limited
Post-Impressionism 1979
Summer Exhibition 1983

The Japan Foundation
The Great Japan Exhibition 1981

Joannou & Paraskevaides (Overseas) Ltd
From Byzantium to El Greco 1987

Lloyds Bank
Age of Chivalry 1987

Lufthansa
German Art in the 20th Century 1985

Martini & Rossi Ltd
Painting in Naples from Caravaggio to Giordano 1982

Melitta
German Art in the 20th Century 1985

Mellon Foundation
Rowlandson Drawings 1978

Mercedes-Benz
German Art in the 20th Century 1985

Midland Bank plc
The Great Japan Exhibition 1981

Mobil
Treasures from Ancient Nigeria 1982
Modern Masters from the Thyssen-Bornemisza Collection 1984
From Byzantium to El Greco 1987

Möet & Chandon
Derby Day 200 1979

National Westminster Bank
Reynolds 1986

The Observer
Stanley Spencer 1980
The Great Japan Exhibition 1981

Olivetti
Horses of San Marco 1979
The Cimabue Crucifix 1983
The Last Supper 1988

Otis Elevators
New Architecture 1986

Overseas Containers Limited
The Great Japan Exhibition 1981

Pearson plc
Eduardo Paolozzi Underground 1986

Pilkington Glass
New Architecture 1986

Pringle of Scotland
The Great Japan Exhibition 1981

Republic New York Corporation
Andrew Wyeth 1980

Robert Bosch Limited
German Art in the 20th Century 1985

Arthur M. Sackler Foundation
Jewels of the Ancients 1987

Sea Containers & Venice Simplon-Orient Express
Genius of Venice 1983

Shell (UK) Ltd
Treasures from Chatsworth 1980

The Shell Companies of Japan
The Great Japan Exhibition 1981

Siemens
German Art in the 20th Century 1985

Sotheby's
Derby Day 200 1979

Swan Hellenic
Edward Lear 1985

John Swire
The Great Japan Exhibition 1981

The Times
Old Master Paintings from the Thyssen-Bornemisza Collection 1988

Trafalgar House
Elisabeth Frink 1985

Trusthouse Forte
Edward Lear 1985

Unilever
Lord Leverhulme 1980
The Hague School 1983

Walker Books Limited
Edward Lear 1985

Wedgewood
John Flaxman 1979

Winsor & Newton with Reckitt & Colman
Algernon Newton 1980